MW00636886

'05

PHOTOGRAPHING MONTANA, 1894–1928

SPRINGDALE PUBLIC LIBRARY
405 South Pleasant
Springdale Arkansas 72764

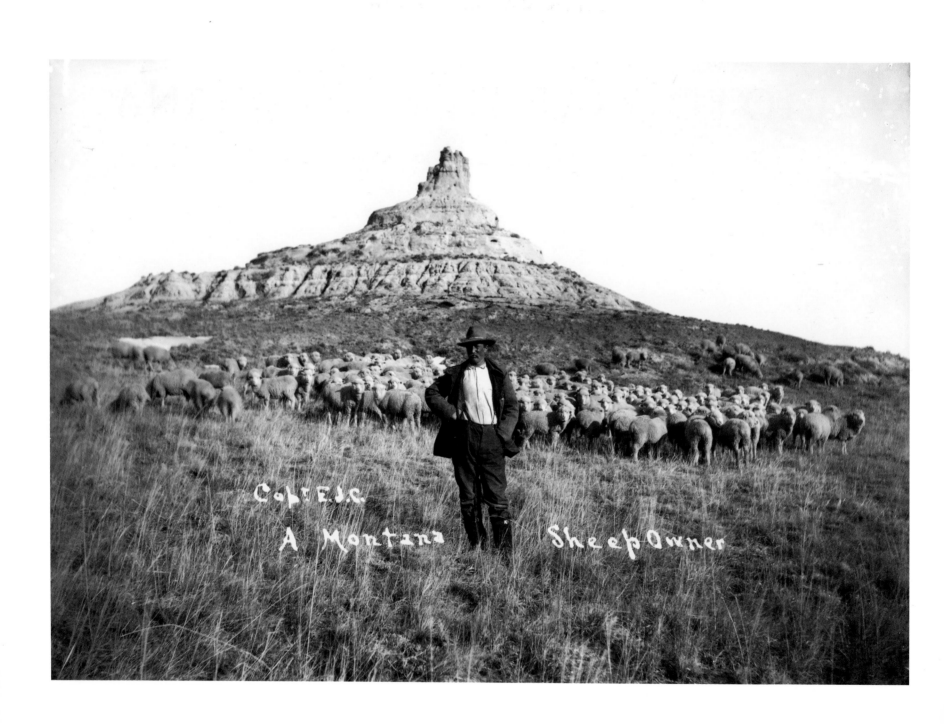

Capt. E.J.C.
A Montana Sheep Owner

DONNA M. LUCEY

PHOTOGRAPHING MONTANA
1894–1928

The Life and Work of
Evelyn Cameron

MOUNTAIN PRESS PUBLISHING COMPANY

Missoula, Montana

2001

SPRINGDALE PUBLIC LIBRARY
405 South Pleasant
Springdale, Arkansas 72764

© 1990, 2001 by Donna M. Lucey
All rights reserved

Original Edition published by Alfred A. Knopf, Inc., November 1990

Mountain Press Edition, January 2001
Second Printing, August 2004

Front cover photo by Evelyn Cameron
Back cover photo (self-portrait) by Evelyn Cameron
Frontispiece: Sheep rancher, Montana 1905

Photographs on pages 4, 11, 35, 36, 79, 103, and 140 courtesy of Paul Renn; page 39 courtesy of the Montana Historical Society; pages 43, 123, and 143 courtesy of the Prairie County Historical Society.

Library of Congress Cataloging-in-Publication Data

Lucey, Donna M., 1951
 Photographing Montana, 1894–1928: the life and work of Evelyn Cameron / Donna M. Lucey.
 p. cm.
 Reprint. Originally published: New York : Knopf, 1990.
 Includes bibliographical references and index.
 ISBN 0-87842-425-3 (paper : alk. paper) – ISBN 0-87842-426-1 (cloth : alk. paper)
 1. Cameron, Evelyn, d. 1928. 2. Women photographers–Montana–Biography. I. Title.

TR140.C27 L83 2000
770'.92–dc21
[B]
 00-060958

MANUFACTURED IN HONG KONG

Mountain Press Publishing Company
P.O. Box 2399, Missoula, MT 59806
(406) 728-1900

For both of my Henrys

Contents

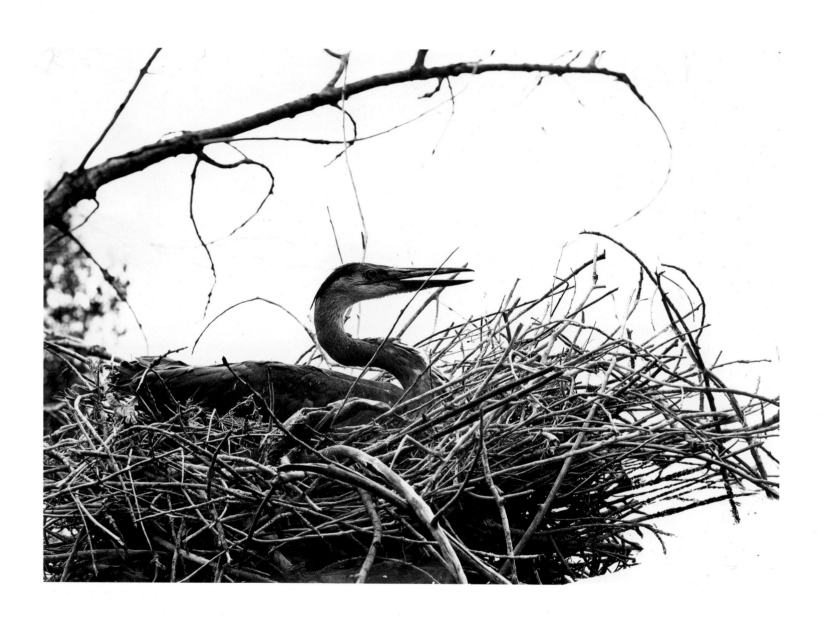

Introduction

IN 1978 I was canvassing museums and historical societies throughout the Northern Plains states, looking for photographs to illustrate a history of women pioneers in the West. A curator at the Montana Historical Society in Helena mentioned that there was an old farm woman in the eastern part of the state who was hoarding a cache of glass-plate negatives made by a woman during the frontier days. The curator had no idea of the size or quality of the collection; the owner had deflected all efforts by the historical society to view it. By telephone I tracked down the elusive owner, Janet Williams, and after some arm-twisting persuaded her to send me a few sample prints.

I was astonished by what I saw. For years I had been traveling throughout the West, combing photo collections for Time-Life Books' series on the Old West, and I had never found anything like these pictures. They presented an intimate view of pioneer life in eastern Montana, a close-up portrait of the men and women who settled one of the most remote and desolate regions of the West.

As remarkable as the pictures themselves was the fact that the photographer, whose name was Evelyn Cameron, was almost entirely unknown except by a few historians in Montana, none of whom had seen more than a small sampling of her work. Janet Williams, who had been the photographer's best friend, had kept the photographs tucked away in her basement and had resisted all efforts to make them public. As a result, Cameron's name appeared in no general histories of the West nor of western photography. But the few images I had in hand were proof that Evelyn Cameron was a master photographer of the West.

Eager to see the rest of the collection, I began a correspondence with Janet Williams, who graciously invited me to visit her at her home in the ranching and wheat-farming town of Terry. (Terry is by far the largest town in Prairie County, which, with slightly more than a million acres of semi-arid badlands and plains, is bigger than the state of Rhode Island, yet boasts fewer than 2,000 citizens.) I had no idea what to expect as the Greyhound bus pulled up to Terry's café just after midnight on August 1, 1979, and I emerged nervously into the crisp prairie air. Despite the late hour, I was greeted

in person by Janet Williams, a diminutive ninety-five-year-old woman, and her niece from California. Hobbling about on her cane and choked with asthma, Janet seemed frail; yet it became quickly apparent that her pioneer spirit and energy had not dimmed.

Although I was consumed with curiosity about the Cameron photos, I sensed that Janet was not going to let me see her hoard right away. She wanted to get to know me first, to see if I could be trusted. So on my first day in Montana Janet proudly showed me her vast fields of wheat, which were being "thrashed"—harvested by an enormous threshing machine—and then told me tales of her pioneering days at the turn of the century.

Janet had been one of the original homesteaders in the area, arriving with her father and brother Roy on the train in the fall of 1907 to stake her claim. Though the conductor warned the twenty-four-year-old woman against settling in such a godforsaken land, she was thrilled with what she found: she had suffered terribly with asthma as a child in Milwaukee and the dry Montana air was the perfect cure. "When we came out here . . . I felt as if I was just lifted up out of the air, things were so light. It was just lovely. You could run for a mile and not breathe hard." Moreover, she would not be alone: her brother filed on an adjoining homestead; her sister Mabel would soon file on another adjacent section; and her parents bought nearby land outright from the Northern Pacific Railroad.

The following spring Janet settled in, moving with all of her possessions, including her piano, into a tar-paper shack that her brother had built for her. She had scarcely unpacked when she was initiated into the vagaries of Montana's weather: a three-day blizzard kept her huddled by her pot-bellied stove.

Not long after this, the Williams family was visited by an intriguing middle-aged couple on horseback. Neighboring ranchers who had been among the early settlers of the area, they spoke with aristocratic English accents and rode magnificent horses. Their names were Evelyn and Ewen Cameron,

and they and the Williamses became fast friends. In short order there was a well-traveled path, which they referred to as "Williams Boulevard," connecting "Williamstown" to "Cameronville."

Janet in particular captivated the Camerons, and she became a kind of surrogate daughter to the childless couple, living a good part of the time at their Eve Ranch. Evelyn and Ewen taught the sickly young woman from the city how to ride horseback, and took her along on overnight trips herding their cattle and horses. They also tried to teach her French and encouraged her musical talent as a pianist.

Evelyn Cameron's mother had been a composer and musician in England, but for long years music had been replaced in Evelyn's life by the profound quiet of the Montana wilderness. Now, suddenly, music—and friendship and love—flooded Eve Ranch. Janet referred fondly to Evelyn as "Madre" and to Ewen as "Mon Père," and it was Janet who inherited the Cameron ranch together with all its contents when the widow Evelyn died in 1928. Fifty years later she still could not bear to part with any of that legacy.

Janet had rented the Cameron land to a local wheat farmer, who agreed to take us out to the old ranch house, which was reachable only by four-wheel-drive truck. It sat far from any road, sheltered in a cozy hillside for protection against the vicious prairie winds, looking out upon a magnificent panoramic view of the Yellowstone River.

Because of her own ill health Janet had not been to the ranch in years, so she was dismayed when we arrived to see the decrepit condition of the house and grounds. The once flourishing vegetable garden and fruit trees, meticulously cultivated by Evelyn, were now a wild tangle of overgrown bushes and weeds. The windows of the house had long since gone, and there were gaping holes in the roof and between the railroad ties that made up the walls. Poles inside the house propped up the drooping walls and ceiling, but sections of the roof had caved in completely, and from beneath the floorboards came the unmistakable chattering of rattle-

snakes, drawn to the place by the natural springs that surrounded the house.

The tumbledown condition of the house and the serenade of snakes almost dissuaded me from going inside, but in the end I couldn't resist. I scrambled through an opening and found myself in Evelyn's kitchen. A wooden corner cabinet, which I would later see in several of her self-portraits, had survived, still a bright blue-green color. And though the roof over it had collapsed, it was possible to imagine Evelyn at work in the small cavelike darkroom built off the kitchen—laboriously dug out of the side of the hill against which the ranch house nestled.

After our return from the ranch, Janet slowly began sharing her treasures with me, beginning with Evelyn's photo albums, filled with her 5″×7″ prints. Beneath each photograph was a handwritten note identifying her subject or subjects and giving the date, the weather conditions when the image was made, and technical information on the aperture and shutter speed used. There was also a large red leather album of professional portraits made of Evelyn and her family in England—evidence of the genteel life she had left behind her when she came to frontier Montana.

Finally, having won Janet's confidence, I was allowed to venture down into the basement. There, while she hovered nervously at the head of the stairs, I discovered over a hundred boxes full of fragile sixty- to eighty-year-old prints, glass-plate negatives, and film negatives piled up haphazardly—and precariously—on the basement floor and on wooden shelves next to stacks of aluminum TV-dinner trays (Janet never threw anything out). There was also a camera—a 5″×7″ Graflex with a German-made Goerz lens—as well as a tripod, plate holders, and equipment for developing, all strewn about the floor.

The negatives and vintage prints were stored in the original cardboard plate boxes, each designed to hold a dozen 5″×7″ glass plates, sent by mail to Evelyn from eastern photo suppliers. Though coated with fifty years of dust and dirt, the boxes were still clearly emblazoned with the company names—"Seed's Dry Plates," "Lumière Dry Plates," "Cramer's Dry Plates"; still visible as well on the side of each was a terse description of the subject matter of the images it contained, scrawled in black ink by the photographer. They provided a kind of capsule history of life in the region around the turn of the century—"Eagle's Eyrie," "⦵ Branding," "Cattle Swimming," "XIT Remuda," "Undem's Lambs," "Baker's Shearing Pens," "Dry Farmer's Thrashing," "Rosie Roesler's Homestead," "Carrie's Wedding," "Thorston Baby," "Mrs. Roesler Mort," "Inauguration Marsh Church July 25th 1920."

There was more. Scattered amidst the boxes, tucked into every conceivable corner, were Evelyn Cameron's diaries, many bound in elegant maroon or green leather, imported from Houghton & Gunn, stationers and engravers on New Bond Street in London; the spines announced the years in gilt lettering. Thirty-five eventually surfaced, spanning every year but one from 1893 to 1928, and crammed with information from cover to cover.

I found handwritten articles by Ewen Cameron on the wildlife of Montana, as well as notes for an encyclopedic book he planned on the state's birds. The Camerons' leather-bound library was there, with volumes ranging from a text on taxidermy to medical guides and an impressive array of source books on animals, including nine volumes of *The Auk,* an ornithological journal published in Cambridge, Massachusetts, to which Ewen contributed articles. Miscellaneous letters, scrapbooks, official documents, newspaper clippings, and fragments of old English sporting magazines were interspersed with monogrammed rifle cases made in London.

Inside a wooden wardrobe were the Camerons' clothes, including the red wool cutaway with black velvet collar that Ewen wore when hunting fox in Great Britain—and coyote in Montana. Evelyn's elegant, two-piece red satin bodice and skirt with a black lace overlay were also there. In a corner was a large camel-back trunk with the initials "E.J.F." (for Evelyn Jephson Flower, her maiden name) painted on the top. It was filled with monogrammed petticoats and hand-

made undergarments, a silk scarf and cravat, embroidered pillow covers, and a needlepoint sampler inscribed "Evelyn Flower Jan 1st 1886."

Buried beneath the handwork were two large, stately photographic portraits, a man and woman, splendidly dressed and stiffly posed. Janet recalled that the portraits had graced the crude walls of the Camerons' living room, and identified the couple as Evelyn's half-brother and his wife. It was apparent from the portraits that Evelyn's relatives were people of high social standing, but it was only later that I discovered that her half-brother was Cyril Flower, a member of Gladstone's cabinet who was elevated by Queen Victoria to a life peerage as Lord Battersea. His wife was the former Constance de Rothschild, of the renowned banking family. In British society, there was no couple more prominent than Lord and Lady Battersea.

Despite the dust and the dirt and the disarray, all this material was in splendid condition—there was only one box of negatives water-damaged beyond repair. The dry Montana air had evidently been as great a boon to the Cameron collection as it had been to Janet Williams's health. (Thanks were due to luck as well. Among the glass-plate negatives were early film negatives that were made with a nitrate base. Janet had no idea that these negatives are extremely unstable and flammable; if she had known, she would never have nestled Evelyn's rifles and live ammunition next to the furnace in the center of the room. Fortunately, a horrified Williams relative, returning from service in World War II, insisted that the cartridges and weapons be removed. He had seen more ammunition in Janet's basement, he said, than on the beaches of Guadalcanal.)

If Janet's basement was an archivist's nightmare, it was a historian's dream: some 1,800 negatives, 2,500 original prints, letters, manuscripts, and diaries detailing life in pioneer Montana over a period of 35 years. And beyond the unlikely fact that such a collection had survived intact was its astonishing quality: as I sifted through the negatives and diaries, surrounded by all of Evelyn Cameron's personal possessions, I realized that I had stumbled upon a frontier character of rare abilities.

There were many women who preserved in their diaries accounts of daily life in the early West. And there were a surprising number of women in frontier towns who worked as professional photographers. (Most often they started out as darkroom assistants—in many cases they were married to the photographer—and took over the studio upon the owner's death or departure.) However, Evelyn's combined talents as a photographer and diarist put her in a class by herself. Hers is perhaps the most complete portrait we have of one woman's pioneer experience—a virtual home movie of life on the frontier.

The fact that Evelyn was female, British, and well born led me to expect that her diaries would be a chronicle of exasperation with the drudgery and boredom of the frontier, animated only by lofty contempt for the crude American frontiersman. I found the opposite: a woman who was thrilled by the independence, the rigors, and the dangers of pioneer life. Despite her well-to-do background, Evelyn herself had little money, so she did not pass her years on the plains in leisurely pursuits. She had to struggle mightily to survive; but instead of quitting the harsh life in Montana and taking refuge among her prosperous relatives, she chose to remain on a hardscrabble ranch—because she loved it. Evelyn wrote proudly to a niece in England:

> Manual labour . . . is about all I care about, and, after all, is what will really make a strong woman. I like to break colts, brand calves, cut down trees, ride & work in a garden . . .

Unlike many pioneer women who deplored the untamed state of the West and busied themselves trying to recreate the civilized society they had left behind, Evelyn reveled in the wildness of the Northern Plains. When, in 1900, she and Ewen returned to Great Britain and stayed for a year, she went nearly mad with the forced inactivity. Teatime did not compare to ranching in her estimation, and the gentle mead-

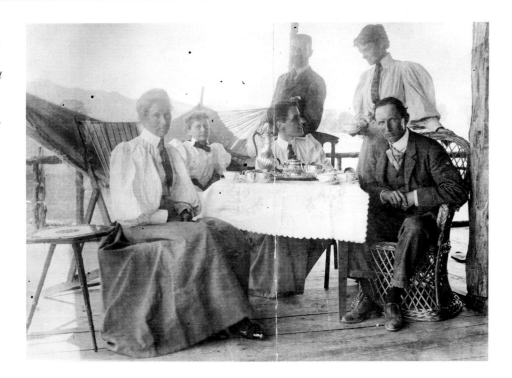

Teatime was observed by the British even on a rugged Montana ranch. Evelyn, shown on the left, was visiting at the Cross S when this photo was snapped by a servant in July 1897. Evelyn was not usually so well dressed, but while at the Cross S, she borrowed a "grand evening tea blouse" from Mrs. Lindsay, seated at center, and a pair of shoes from Mrs. Dowson, seated next to Evelyn.

ows of England offered none of the adventure she found in Montana. She was proud of her wilderness exploits, boasting of them in 1906 to a newspaper reporter for the New York *Sun:*

> I've spent January and February in a tiny Indian tent . . . with the mercury 40 degrees below zero, and our noses and chins were all blistered with the cold. And I've had my hair frizzled by lightning so that it made a crackling sound and the people at home asked me how I came to burn it. And I've had the tent blow down on me in a hurricane and have slept night after night with only a blanket between me and the frozen ground.

A tireless chronicler of the extraordinary and ordinary events of her life, Evelyn noted in the pages of her diary everything that happened in a given day in a kind of staccato shorthand—beginning with the weather and including all of her daily chores; reports on any person or animal she en-

countered; snippets of national and international news and local events. After finishing each entry, she distilled the day's events into a one- or two-line summation that she wrote across the top of the page.

In addition to the daily entries, Evelyn carefully listed in her diaries—and often copied verbatim—all the letters that she wrote and received in a given year. These letters, especially those to family members in England, are particularly valuable, for they are enlivened by astute observations and opinions and tend to be more descriptive than the diary entries, which were not written with an audience in mind.

The diaries are also crammed with innumerable fascinating tidbits that reveal the fabric of her life—records of the number of eggs gathered and chickens killed per month; notes on the amount of butter churned; lists of books read; methods of skinning a coyote and breaking a horse; accounts of the money made from her photography and from sales of garden produce; an exhaustive list of the supplies brought

Evelyn photographed this Fourth of July picnic near Fallon, Montana, in 1908.

along on a three-month winter hunt in the wilds; Evelyn's favorite aphorisms and poems, as well as home remedies for afflictions such as rattlesnake bite, diphtheria, and frozen feet.

Such details give a palpable sense of life in pioneer Montana—of high drama, and monotony. The constant repetition of Evelyn's daily chores in the diaries takes on its own rhythm—and captures the rhythm of her days. She wrote very well, though the manner in which she wrote was less important to her than the facts she was inscribing. Clarity was her aim. A short article she snipped out of a contemporary paper and saved in one of her diaries reads in part:

> The first and indispensable quality of a good style is clearness. Generally it is enough if the writer devote his efforts simply to being understood. Plainness and clearness are the foundations upon which all other qualities are built. . . . The strongest thoughts find brief expression.

Evelyn's clipped and precise style was a model of efficiency—and a reflection of her character. She was impatient with pretense and came right to the point. And she had a nose for concrete detail that sometimes makes her diary entries read like scientific reports. Rarely did she reflect philosophically or emotionally on her days—there was no time for that.

A fascinating story unfolds in these volumes. The early days in Montana were marked by struggle and loneliness. The ranch was failing; Ewen was ill-tempered and distant; for years Evelyn was saddled with her dim-witted and difficult brother Alec as a boarder. The companionship of other women was scarce. Privacy was nonexistent. Work was endless and recreation rare.

Yet her diaries are no mere litany of drudgery. The harshness of her world is softened considerably by her sense of humor and by unexpected twists. She coins charming turns of phrase and creates startling juxtapositions. (The death of a beloved creature is immediately followed by a report on what flowers are in bloom.) The diaries are also sprinkled with French, Italian, and German phrases, revealing her status as an educated woman.

Evelyn's total acceptance of western life was unusual for a well-bred Briton. Late Victorian England produced a number of adventurous women who set out to remote, "uncivilized" places—including the American West—and wrote accounts of their travels. Among them was Isabelle Randall, who came as a bride to Montana in the 1880s and ranched in the foothills of the Rocky Mountains with her husband for two years. She chronicled her experiences in a book entitled *A Lady's Ranche Life in Montana*, published in London in 1887.

Mrs. Randall was startled by the prevailing social equality she discovered. She had brought along servants from England, and she was horrified at their growing insolence as they became infected with the independent spirit of the West. "How can anyone keep servants in their place," she despaired in her memoirs, "when the people whom we associate with invite them to their house as equals."

Captain Edward Pennell Elmhirst, another Briton who ranched for a short time near the Camerons and wrote about the experience, was both appalled and amused by the inhabitants of eastern Montana. (The amusement was mutual. The local Montanans found Captain Elmhirst and his wife an exotic pair as they traveled through the countryside accompanied by a valet and maid, and lugging such necessities as Mrs. Elmhirst's collapsible bathtub and an umbrella to protect her complexion from the sun.) Elmhirst's memoir of his sporting life in England and America, entitled *Fox-Hound, Forest, and Prairie* and published in London in 1892, contains this account of the Britisher's shocking initiation into range life:

> Year by Year do the great cattle-grazing grounds of the Far West attract a larger influx of men of birth and education from the Old Country. . . . They are in a very few days transported from the society and surroundings which make men gentle . . . into a world as unlike their own as an

English-speaking world can be. . . . Western Americans are crudely simple in their domestic habits; and their sleeping arrangements especially denote a freedom from the trammels of conventionality that should be refreshing were it not positively distasteful and uncomfortable. . . . [The Briton] has been accustomed to courtesy on the part of superiors, and to respect from inferiors. . . . Imagine him, then, brought on terms of the closest intimacy, of the most unsparing familiarity, with men in his own employ in menial capacities—men whose only claim to intellect is based upon their talent for chopping a log, whose accomplishments are confined to squirting tobacco juice across the floor, whose tastes soar no higher than New Orleans molasses when at work and the most fiery of whiskey when at play; whose conversation, often unintelligible through its thickly interlarded and senseless oaths, is utterly pointless when purged of the same; whose personal cleanliness is limited to a dash of water (when not too cold) on hands and face once a day, and whose underclothing leaves not their bodies—night nor day—till absolute necessity demands that the decayed garments be replaced by new. This is the company in which, at least till his house and premises be completed, he will have to spend day and night, probably in an old log shanty that is destitute of flooring, and consists only of a single room 12 feet by 14.

Evelyn Cameron's viewpoint was different. The self-sufficient ethic of the West appealed to her own high-spirited nature, and she thrived on the lack of pretense and formality. "No," she wrote to her incredulous sister, "I have no servant & I do all my own house work, & infinitely prefer doing it and being independent of 'hired help.'" From her photographs it is obvious that she admired the ingenuity and propensity for hard work that characterized the Montana pioneer, and her diaries exhibit none of the condescension and arrogance that color the accounts of other upper-class Britons.

Evelyn did enjoy the company of the handful of well-bred British ranchers in the area, sharing with them the love of the outdoors and sport common to English aristocrats. Cricket and polo were imported to the Montana prairie, and British hunting parties set off after local prey. "The Irish wolfhounds are a great acquisition," Evelyn wrote to a compatriot in 1897. "We really ought to get up a ladies wolf hunting pack and have meets at our respective ranches. Wouldn't it be fun!"

Distances, however, precluded frequent visits. And for virtually all of the Camerons' circle of expatriate friends, ranching in Montana was either a romantic lark that was abandoned after the crushing difficulties became evident, or a part-time occupation and diversion with only the pleasant months of spring and summer spent in Montana. Thus, particularly in the early years, Evelyn's diaries reveal considerable intellectual and emotional isolation. For the most part, she was surrounded by rough men—and a few women—of the range who were barely literate and were unschooled in the social graces. Socializing with them was a painful affair. The arrival at the Cameron ranch one spring morning in 1893 of a neighboring rancher was heralded, Evelyn wrote, by the "knocking and scraping of boots. . . . He came in, lit his pipe, sat down, spat once on the floor, said a few words and departed." On another occasion, when some of the locals stopped by for the afternoon, "we were at our wit's end to entertain them." In 1896 she described the inhabitants of nearby Terry and their socializing to her mother-in-law:

People there are not very ambitious for enlightenment beyond their St. Paul or Chicago weekly [newspaper]. I lent "The Handbook" & two "Banners" to a Mrs. Brackett who . . . seemed grateful for the loan of this litterature. She is a woman of some enterprise & started a Debating Society this winter; the meetings being held in the Schoolhouse & attracting a great many people. We never go to any of the Terry "Reunions": balls of a most riotous description, (where the men outnumber the women by about

a dozen to one), and the above mentioned [Debating Society] meetings being all in the way of social gatherings.

The social isolation Evelyn felt never hardened into contempt for her fellow pioneers, however; indeed, she had the greatest respect for her hardworking neighbors. And despite her privileged background and elegant accent, Evelyn was not looked upon as a haughty English interloper. On the contrary, she was considered a loyal friend who could be depended upon in time of trouble. When the neighbor's son, a three-year-old with a fondness for whiskey, mistakenly drank a bottle of carbolic acid, it was Evelyn who was summoned to the bedside. When a railroad worker was killed on the job, Evelyn sent the widow a generous supply of vegetables, even though they had never met. When another local woman, having been found in a "scandalous way" by her husband, was abandoned by him and became the pariah of the town, Evelyn made no secret of her sympathy for the outcast and gave her dressmaking work.

Evelyn's relationship with her fellow pioneers—sympathetic and compassionate, yet distant—made her a sharp-eyed chronicler of the frontier experience. The camera was her bridge to the world around her. She felt uneasy as a guest at picnics, parties, and other gatherings (she refused to attend dances) because the social gulf was too great; but her camera gave Evelyn a purpose and place in her Montana community and brought her deeper into the life around her. When sheep were to be shorn, or a wedding to be held, it was Evelyn Cameron who was called upon to make a record of the event. Her reputation was such that almost as soon as immigrant farm families and non–English-speaking railroad workers arrived in the area, they immediately sought out the acclaimed Evelyn Cameron to make portraits to send back home to relatives.

In her remote frontier world Evelyn became a respected, almost mythic figure. Yet she saw nothing unusual or noteworthy in her life. Until she died she remained very much the twenty-five-year-old pioneer woman who wrote wistfully in her diary, "I wish I could lead a life worthy to look back upon. I am far out of the path now." Her neighbors thought otherwise. Among her papers there is the typescript of an article by an English writer, Marguerite Remington Charter, who had visited Evelyn on a trip through Montana. Charter wrote that

> from the moment we got into Billings, Montana, we were never one whit surprised when whoever we might happen to be talking with would say: "Oh, be sure to go to the Eve Ranch and see Mrs. Cameron, she is one of the wonders of Montana."

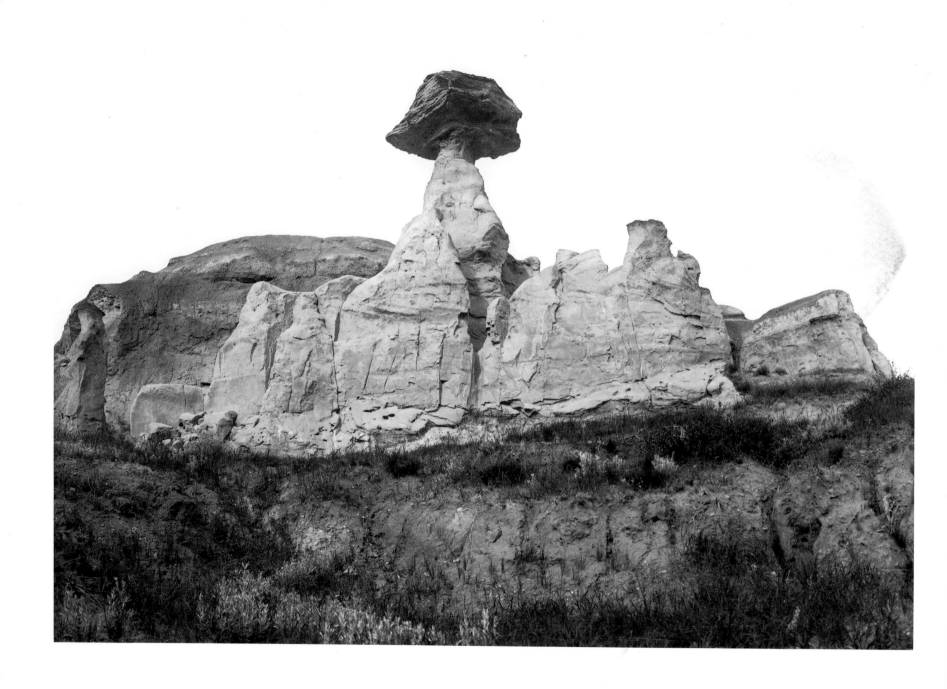

*The spectacular buttes in the badlands of eastern Montana, the domain of eagles and
mountain sheep, photographed by Evelyn Cameron around the turn of the century.*

PHOTOGRAPHING MONTANA, 1894–1928

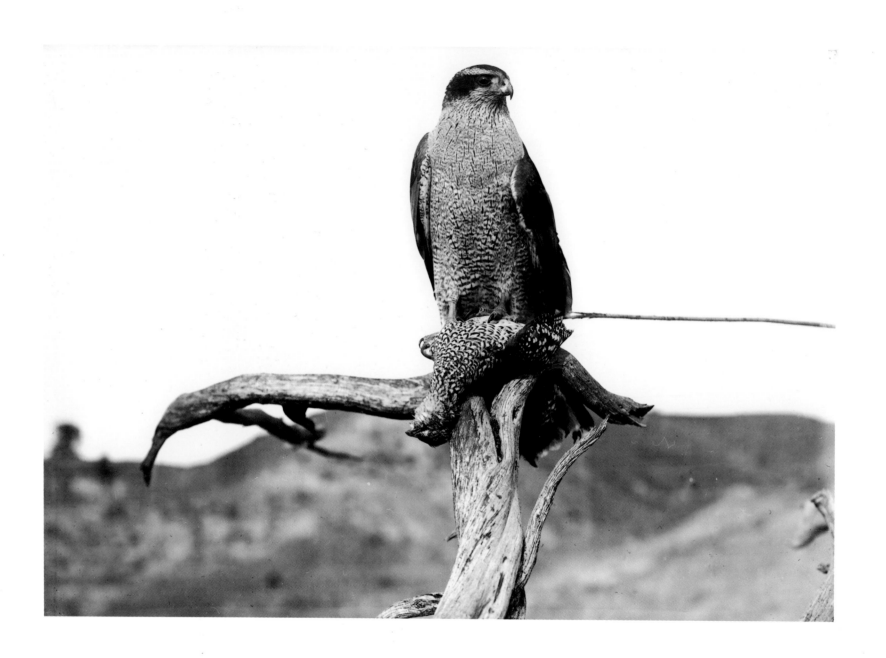

Evelyn, without a telephoto lens, relied upon her gift for handling animals to get close-up views, such as this one of a goshawk with its prey, a sharp-tailed grouse, in 1906.

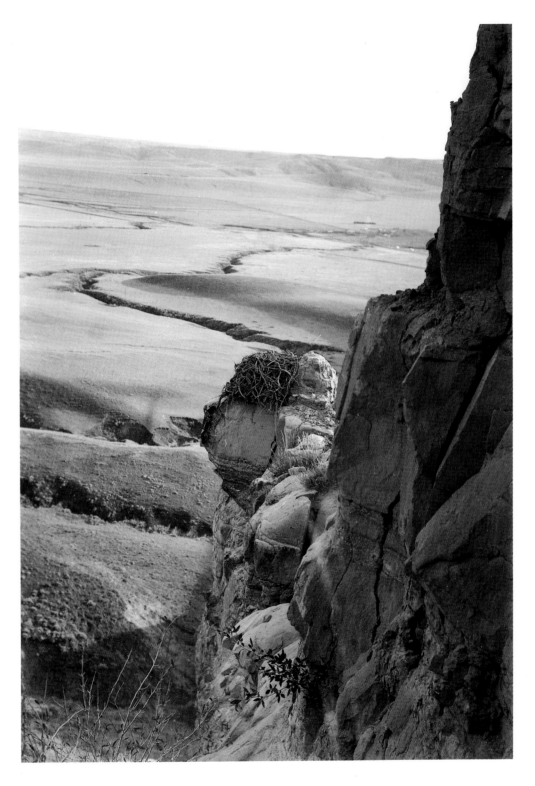

The 4-foot-high by 3¹/₂-foot-wide nest of a red-tailed hawk atop a "high pillar of rock."
On a birding expedition near Great Falls with her husband, Ewen, Evelyn photographed
the nest after carrying her 9-pound camera up the steep approach.

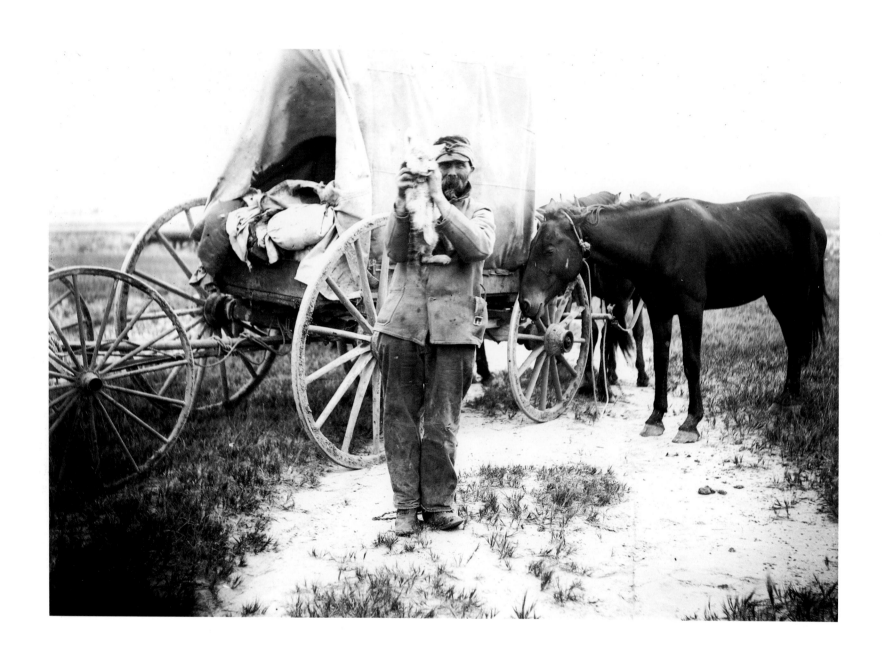

*A professional hunter, or "wolfer," Michael Lavy, on a "nasty, windy day"
in September 1902. He claimed to have killed 242 wolves and coyotes for the
$5 bounty offered by the state for each skin.*

Charles McKay's remote cattle ranch on the eastern Montana prairie. Evelyn visited the ranch in September 1905 and was charmed by McKay's wife, an eastern sophisticate more accustomed to literary salons than cattle roundups.

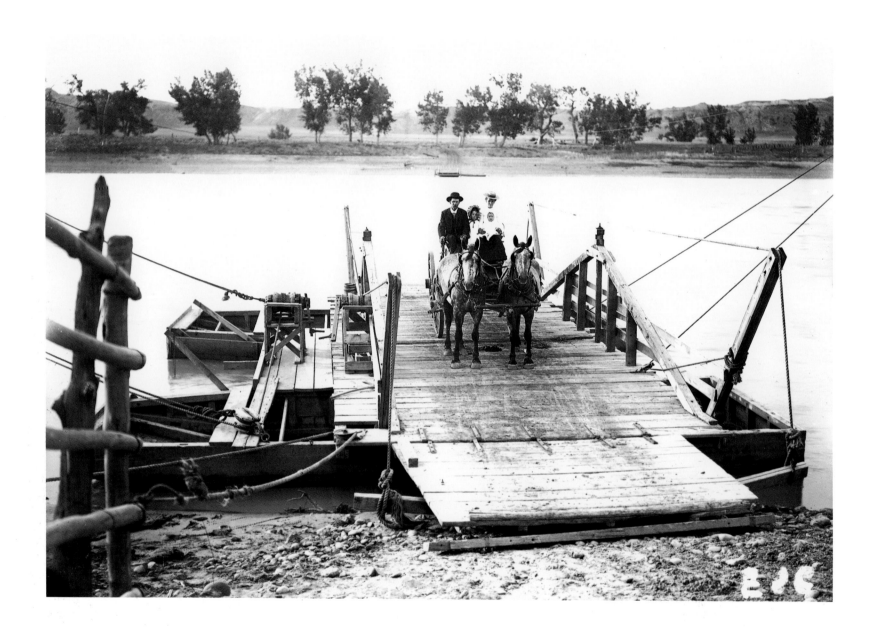

Reno Walters and his family on the Yellowstone River. Before a bridge was built in 1910,
cable-drawn ferries operated by local ranchers were the only means of transport across the river.

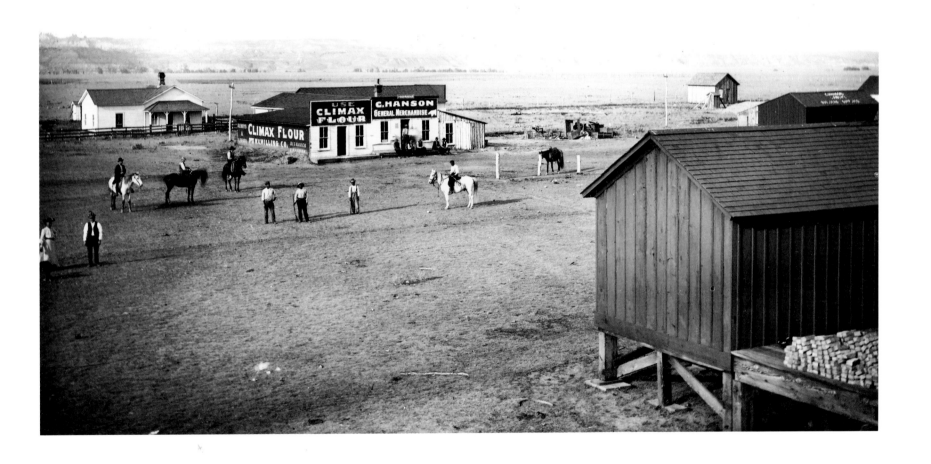

Downtown Fallon and its denizens in October 1904 photographed by Evelyn from the top of a railroad car. The town was founded and settled by Texas cowhands and was the central shipping point for the local cattle industry.

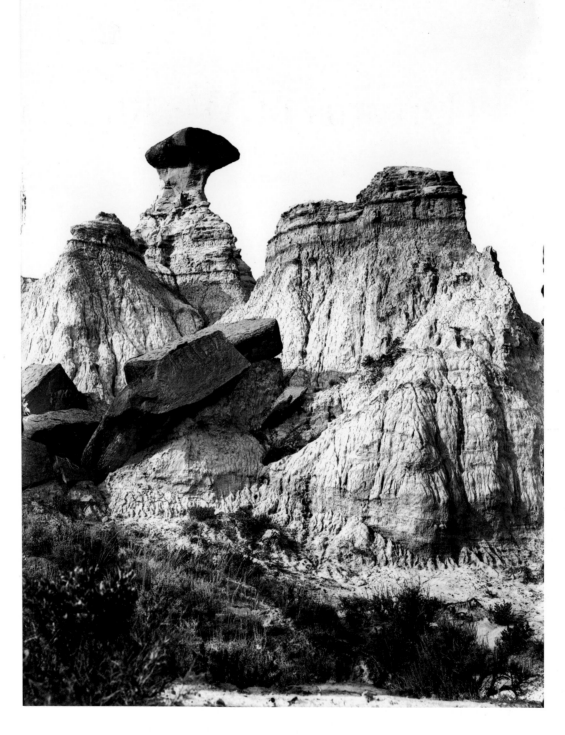

Evelyn photographed these blocks of petrified trees that litter the badlands and top a pedestal of gumbo clay. The silicified trees are remnants of the marshy, richly vegetated plateau that existed here tens of millions of years ago. As the climate became drier, wind, rain, and streams carved out the unearthly landscape.

Dreams of Wealth

IN THE FALL of 1889 a honeymoon couple fresh from Great Britain arrived in the remote badlands of eastern Montana Territory. The young Evelyn Jephson Cameron and her Scottish husband, Ewen, had decided to spend their wedding trip hunting there, accompanied by an English cook and one of General Custer's old scouts to guide them.

The bride was twenty-one years old, with green eyes and long, light brown hair swept straight back and pinned up in the style of the day. Her face was full and when she smiled she revealed a slight gap between her front teeth. Though she would hardly be called beautiful, she had a youthful, girlish charm. Ewen, fourteen years her senior, carried his slight frame with an erect bearing. His long thin face, hollow cheeks, handlebar mustache, and piercing eyes gave him a stern, even forbidding look.

They were an unlikely couple to appear in a most unlikely setting. When the newlyweds arrived in Montana Territory they discovered a sparsely populated wilderness, with a sprinkling of horse, cattle, and sheep ranches, and an eccentric landscape dotted with random outcroppings of sandstone and gumbo clay that nature had sculpted into bizarre formations. Ewen wrote several articles about the region; in one he observed that "huge petrified tree trunks are seen, either whole or in great blocks flung from the buttes by the forces of nature. Here and there, where the supporting clay has been entirely eroded, sections are left on gumbo pedestals, looking like gigantic toadstools."

The starkness of this surreal landscape was heightened by its unearthly silence, its "intense solitude. Miles may be traversed with never a sign of man nor a sound more civilized than the Falcon's angry scream," Ewen wrote.

Yet the desolate region had a subtle, mysterious beauty. The "adobe clay buttes which rise tier upon tier to the sky in impassable grandeur" were striated with shades of vibrant red and muted pink and coral and every variation of charcoal, brown, and yellow. Seams of coal ran boldly through the hills—soft lignite coal that the pioneers dug out and used as fuel. Occasionally, columns of smoke could be seen spewing from the ground, indicating subterranean coal fires ignited by lightning, brush fires, or even spontaneous combustion.

Vegetation was sparse, so its unlikely appearance made it

all the more dramatic. "In the badlands of the Yellowstone, despite their reputed aridness," Ewen noted with the precise eye of a trained naturalist and the lyricism of a romantic, "there are surprising bursts of sporadic vegetation. Over the sombre clay walls and terraces the flowery month of June splashes a bright blaze of brilliant colors, as on a painter's palette—here a rich gamboge of yellow daisies, there the deep mauve of hyacinthine blooms, elsewhere the delicate carmine of clustering vetches, and the chaste white of Mariposa lilies." And hidden within the countless sheltered ravines were clumps of pine, fir, and red cedar.

Cutting through the heart of this curious terrain and giving it life was the Yellowstone River, along whose edges were stands of luxuriant cottonwood trees—a rare and welcome sight in that parched area. Just as unexpected was the abrupt transformation of the quirky badland hills and formations into a seemingly limitless expanse of grassy prairie. The succulent grass of these plains had once sustained immense herds of buffalo; now it nurtured the livestock that roamed freely on the open range.

The buffalo's last stand had been in 1883, when turkey buzzards flocked by the thousands along a tributary of the Yellowstone to feast on the carnage. To the delight of the newlyweds, however, other game was abundant. The badlands, Ewen wrote, "constituted a regular sportsman's paradise, being full of mule deer, mountain sheep, and grizzly bears." Indeed, the Camerons had decided to venture into the wilds of eastern Montana after hearing wondrous tales of the area's bountiful wildlife from Evelyn's older brother Percy, who years before had traveled up the Yellowstone as far as Miles City on a hunting expedition.

But the Camerons were probably drawn to Montana by other considerations than brother Percy's enthusiasm and their shared love of hunting. It was undoubtedly a relief to the newlyweds to honeymoon as far from Great Britain as possible. Evelyn's family apparently did not approve of her choice of husband. The reasons are not clear. Perhaps it was Ewen's age and the fact that he was not in the best of health.

More likely it was because, at age thirty-five and without either an established career or a substantial inheritance, he had limited prospects for success.

Ewen Somerled Cameron, first son of the Reverend Allan Gordon Cameron, had grown up on a vast 20,000 acre estate overlooking Loch Creran on the spectacularly beautiful west coast of Scotland. The property boasted extensive shooting grounds as well as anchorage for yachts. Several substantial residences were included on the estate, as well as the ruins of Barcaldine Castle, a sixteenth-century towerhouse—complete with secret passages and its own dungeon—built by "Black Duncan" Campbell of Glenorchy. Though the Reverend Cameron and his sons, Ewen and Allan, were prominent members of the community, their social position was based on their extensive landholdings alone. Whatever family money there had been was long gone.

By the time of Ewen's marriage, his mother, who had been widowed in 1871 when Ewen was seventeen, no longer lived on the Barcaldine estate, having retired in genteel poverty to Tunbridge Wells, a popular resort with natural springs located southeast of London. Improvident with what little money she did have, she was continually begging Ewen for financial help.

The sin of Ewen's poverty was compounded by his eccentricity. Although his father and his brother Allan were both educated at Oxford, Ewen studied in Belgium and lived for a time in Milan. His great interest, which he shared with his brother, was in wildlife. Before he married Evelyn, his address was listed as Eynhallow, a virtually uninhabited island among the seventy-odd Orkney Islands off the northern coast of Scotland. Except for the ruins of a twelfth-century monastery, the island was home only to a fascinating array of seabirds. Here Ewen studied the habits of gulls and terns and amassed an impressive collection of stuffed birds. And for some twenty-five years he was to study and write about the fauna—particularly the birds—of eastern Montana, corresponding with his brother and sending him exotic specimens. Such scholarly pursuits, however, in the absence of the

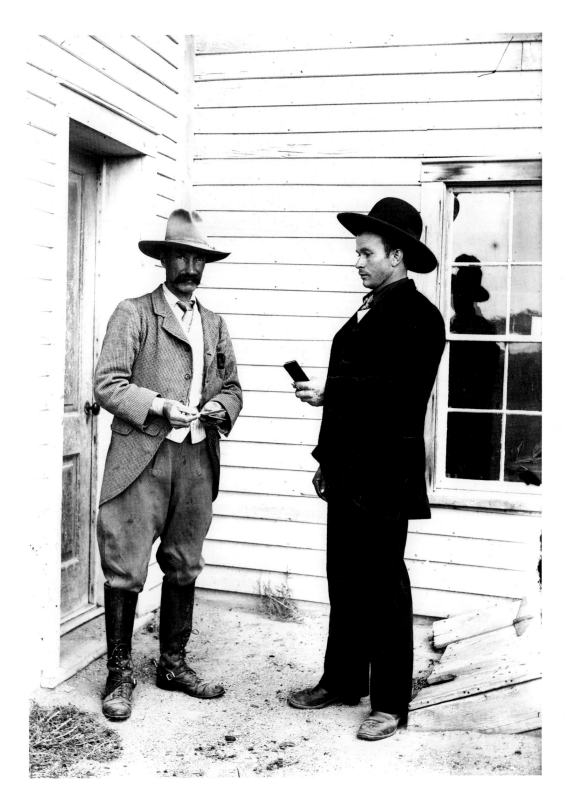

Ewen Cameron (left) settles accounts with Reno Walters in September 1902. The Swiss-born Walters ran a ranch along the Yellowstone River, and also worked as a ferry operator.

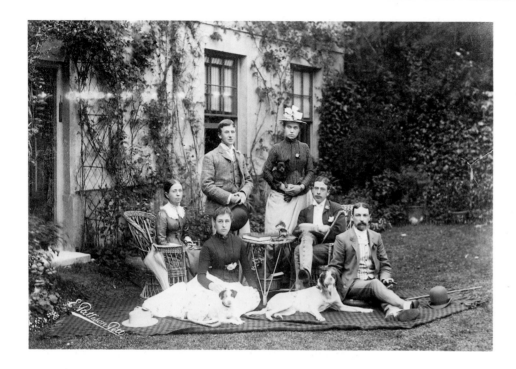

An 1880s portrait of Evelyn's family at their country house. Evelyn (standing in the rear clasping a dog) and, clockwise, her elder brothers Severin and Percy, her sister, Hilda, her mother, seated in a wicker chair, and her brother Alec, who would follow her to Montana.

wherewithal to support the scholar, much less a wife, were not likely to impress the relations of Evelyn Flower, who was the youngest daughter of a wealthy family, and the beneficiary of a fairly substantial trust fund that gave her an income of £300 a year.

Evelyn Jephson Flower was born on August 26, 1868, at Furze Down Park, a rambling country estate near the small town of Streatham, just south of London. She was the fifth child of Elizabeth Jephson Flower and Philip William Flower, a successful East India merchant.

Nearly sixty years old when Evelyn was born (she had not yet reached her fourth birthday when he died), Philip Flower headed a very large and comfortable household, which included, according to the census for 1871, fifteen servants. Numbered among these were a German-born governess and two nurses to help care for his six small children—seven-year-old Severin, six-year-old Percy, five-year-old Hilda, four-year-old Alec, two-year-old Evelyn, and one-year-old

Lionel. (The baby, Lionel, died several years later in London, leaving Evelyn the youngest of Philip Flower's children.)

Also at Furze Down in 1871 were five of the nine offspring born to Philip Flower and his first wife, Mary, who had died in the late 1850s. Among them was the dashing twenty-seven-year-old barrister, Cyril Flower. Educated at Harrow and Cambridge, where he was considered the handsomest man of his day, Cyril numbered Leopold de Rothschild of the banking family among his dearest friends. In 1877 he married Leopold's cousin, the prominent socialite Constance de Rothschild, and settled into life at Aston-Clinton, one of the lavish Rothschild country estates clustered in the pastoral Vale of Aylesbury in Buckinghamshire. Aston-Clinton was within easy reach of London, so Cyril could devote part of the week to sport, when not attending to duties in town. He became a Member of Parliament in 1880. In 1886 he served as Whip to the Liberal Party and Junior Lord of the Treasury

under Gladstone, and in 1892 was raised to noble rank with the title Lord Battersea.

Lord and Lady Battersea were at the center of the London social scene; among their friends were the most prominent political, artistic, and literary figures of their day. They lunched with the Shah of Persia, greeted Queen Victoria, welcomed Princess Louise to their home, became close friends and patrons of artists such as Burne-Jones, Tissot, and Whistler, and visited the poet laureate Alfred Lord Tennyson at his island home.

The Batterseas entertained on a grand scale at their various residences. Surrey House was their elegant, formal home in London, overlooking Hyde Park. In Norfolk they had "The Pleasaunce," a sprawling cliffside mansion, with stables, a tennis court, and cricket pitch, which had been created from two existing villas by Edwin Lutyens, the most sought-after architect of country houses at that time. The enormous Rothschild estate of Aston-Clinton, nestled at the base of the gentle Chiltern Hills, boasted a magnificent park and gardens. Hunting was the ruling passion at Aston-Clinton, and even the Prince of Wales—the future Edward VII—joined the family there for pheasant shooting.

The Batterseas' every move was eagerly reported in the English press—whether it be building new stables at The Pleasaunce or sailing to Constantinople—and Evelyn, in Montana, kept abreast of her half-brother's glamorous life through the British newspapers and sporting magazines she received, often pasting articles about him onto the front and back pages of her diaries. One contemporary magazine reported:

> Lord Battersea, who, by the way, won the House of Commons Steeplechase in 1889, is an art connoisseur of considerable fame. At his splendid house opposite the Marble Arch he possesses many valuable paintings, including the "Annunciation" of Burne-Jones, an original "Madonna and Child" by Botticelli, and several noted masterpieces in portraiture by Rubens, Moroni, Whistler and Morretti. He is a keen devotee of yachting, hunting, botany, and gardening, and has "done" Europe as have few other men of his age.

Evelyn's decision to leave this elegant social whirl and live humbly in Montana was greeted with astonishment by fellow countrymen. One Englishwoman she met in 1900 was so stunned upon hearing of her relationship to Lord Battersea that her "eyes nearly dropped out of her head."

Yet Evelyn turned her back on the world of English country houses and London parties with little regret. Indeed, the prospect of a life in a remote wilderness suited her perfectly. Not only could she lead the outdoor life of riding and hunting she adored, she could also escape the scrutiny of her disapproving relations. In May of 1893 she stumbled across a packet of letters from members of her family in an old crocodile bag. The letters were dated 1889, the year she married Ewen—to their dismay—and headed off to America. She noted in her diary: "Shall have no more [letters] in the same

Evelyn, the model of the proper Victorian gentlewoman. She would shortly give up this genteel life—and the English sidesaddle—to ride astride through the Montana wilds.

strain ever, but I certainly (if possible) wouldn't change my lot for all their love."

The contrast between her new life and the old world of fox hunts and tea parties is evident from two portraits which she mounted side by side in her family photo album. In one she is seated sidesaddle on a horse whose tail and mane have been precisely clipped. Her riding habit, with its ankle-length skirt and form-fitting jacket nipped in at her tiny waist, is tailored impeccably. She sits stiffly, a riding crop in her gloved hand, a derby covering her neatly upswept hair; in the background is a great stone house. The other photograph is the first one taken of Evelyn in Montana. She is informally posed on a riverbank, with hills in the distance. As in England, she sits sidesaddle (later she would pioneer the split skirt and ride astride), but now the horse is unclipped. Her skin has been browned by the sun and wind, and her hair is pulled back carelessly into a ponytail. A nondescript, boxy jacket and a formless hat squashed on top of her head complete her riding outfit. In her lap is a bear cub.

When the Camerons settled in Montana they had every reason to believe that they would strike it rich. They could see for themselves that the prairie grass was abundant, free, and full of promise. Moreover, for years English newspapers had trumpeted the easy fortunes to be made on the Western Plains: yearlings purchased at $4 or $5 per head could, it was reported, be sold at a $60 to $70 net profit. The Earl of Dunraven, an Irish traveler in the 1870s, wrote that "cattle wander about the plain—or try to wander, for they are so fat they can scarcely move." Equally attractive to another roaming Briton was the romance of the outdoor life "in the most delightfully bracing climate in the world," where "manly sport is an ever-present element."

Much of the reporting of the day reflected the optimistic claims made by General James S. Brisbin, an American whose expertise was soldiering, not ranching. Nonetheless, in 1881 he wrote a popular book, the title of which hints at its unbridled enthusiasm: *The Beef Bonanza; or, How to Get Rich on the Plains*. According to Brisbin, not only was easy money to be had in the West, so was a life of high adventure and moral superiority. "The West! The mighty West!" Brisbin crowed. "That land where the buffalo still roams and the wild savage dwells; where the broad rivers flow and the boundless prairie stretches away for thousands of miles; . . . where the poor, professional young man, flying from the overcrowded East and the tyranny of a moneyed aristocracy, finds honor and wealth . . . "

This rallying call was enough to inspire many a young Briton to head west, while not entirely turning his back on the "tyranny of a moneyed aristocracy"—for it was often funds remitted from home that allowed him to continue his western adventure and earned him the sobriquet "remittance man" from the locals.

By the end of 1883 the railroad stretched clear across Montana Territory, linking it to eastern markets; the buffalo had been exterminated and the Indians were largely confined to reservations, leaving behind enormous expanses of open grazing land. With the prospect of unlimited profits and adventure, British investors poured money into stock-raising ventures. And ranchers from as far away as Texas began to drive their longhorn cattle 1,600 miles to reach the rich feeding grounds of eastern Montana where their herds could be fattened before being shipped by rail to midwestern and eastern markets. The route north was long and arduous, and not exactly clearly marked. One twenty-two-year-old cowboy for a Texas outfit was given the following instructions by his boss before setting out for Montana with a herd of 2,500 two-year-old cattle: "Jean, tonight you locate the north star and you drive straight toward it for three months and you will be in the neighborhood of where I want you to turn loose."

The rush of money and livestock to the eastern Montana range reached its peak in 1886. By then, enormous corporate ranches backed by both American and foreign investors had dangerously overstocked the grasslands. After a warm dry winter and summer drought, by fall the rangelands were

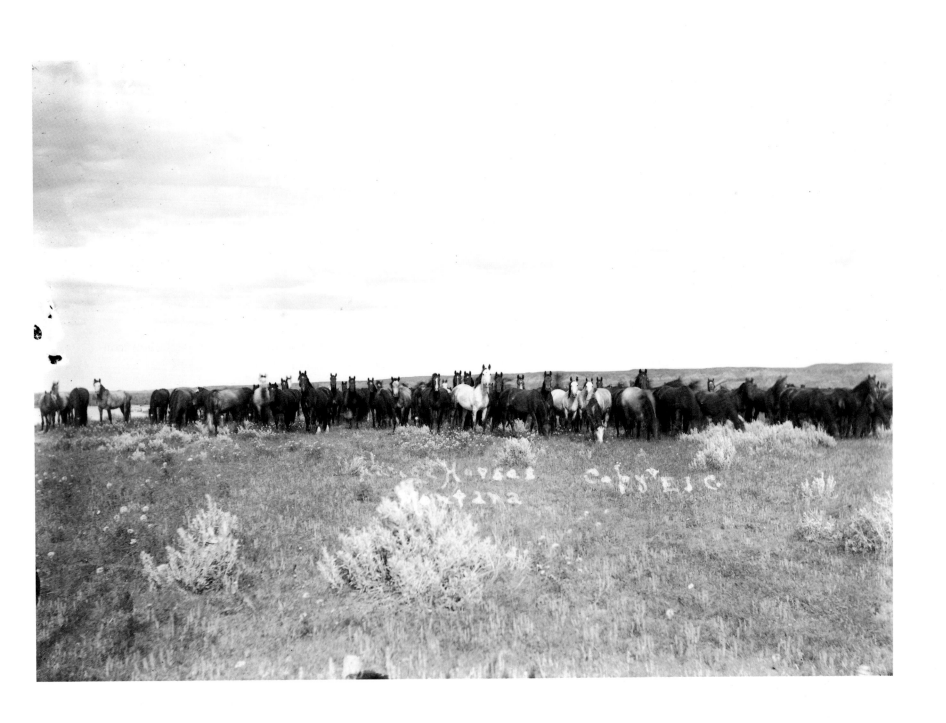

*Range horses that roamed freely over eastern Montana's open grasslands. In the late summer
of 1893 Evelyn complained that "the stallions now on the range are numerous & dangerous."*

nearly bare. An early winter descended in November—with a vengeance. Terrible blizzards blanketed the grasses with a thick covering of ice and snow, and temperatures plummeted, reaching 60 degrees below zero at some ranches. In March, when the countryside was finally released from winter's deadly grasp, the scene was nightmarish. Cattle that had perished by the hundreds of thousands rotted where they lay. The greatest losses occurred in the barren reaches of eastern Montana Territory, where some ranchers suffered the loss of 90 percent of their livestock. In a matter of months many of the corporate ranches had been completely wiped out.

Miraculously, the area rebounded quickly, though the business of ranching was put on an entirely different footing. A few large, open-range ranches, such as the Texas-based XIT Ranch, prospered. (In 1890 the XIT bought a small ranch 60 miles north of Miles City and ran its cattle herd over two million unfenced Montana acres between the Yellowstone and Missouri Rivers.) The trend, however, was toward smaller, more manageable places. Investment from Britain

continued, but on a less speculative and more conservative basis. The range was no longer overrun with livestock, and ranchers began to see the wisdom of providing some winter feed for the animals. Some cattlemen turned to raising sheep, which were cheaper to buy and which had proved hardier during the deadly winter.

Horses generally also fared better in the deep Montana snows, because they instinctively paw away at frozen snow in search of forage. Cattle on the other hand do not have that instinct and, as Ewen observed, "merely plough with their noses, which become so painfully lacerated when there is a hard crust on the snow, that the poor brutes lose heart, give up the vain attempt, and stand miserably awaiting death."

When the Camerons appeared on the scene most of their fellow countrymen were raising horses, and it seemed the natural business for them to enter. Both Evelyn and Ewen loved horses and were astute judges of horseflesh. As it turned out, however, Ewen had the uncanny knack of making disastrous business decisions.

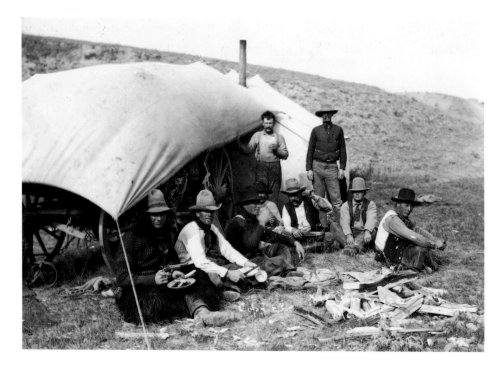

XIT *cowboys at midday during the fall roundup of cattle. To photograph them, Evelyn had to travel for miles by ferry and horse to reach the camp. While eating with the cowboys, she sold them $15 worth of her photographs.*

Initially the Camerons rented a ranch, the 4.4, that was set in the midst of pine-covered hills along the Powder River east of Miles City. It was a logical first step in Montana because, although the place was located far from any town, the general vicinity was sprinkled with expatriate British ranchers. The Camerons tried to raise horses there on the open range. They were apparently not very successful, because after a few years they rented another ranch some 30 miles east of the 4.4.

Evelyn's extant diaries open in 1893, just as she and Ewen were settling into this new home, which they christened the Eve Ranch in honor of Evelyn. The setting was dramatically different from the old 4.4—pine-covered hills and river views were now replaced by an endless vista of grassy rolling hills. Evelyn confided privately in her diary that she missed the old locale, but in a letter to her mother-in-law she waxed poetic about the new one, comparing it to the elegant estate of Ewen's youth:

> I like this place much better than the old 4.4 which was in a low situation amidst heavy timber surrounded by hills, something like the old Barcaldine house, but this [new ranch] on the contrary more resembles Barcaldine Castle, being high up on a hill sloping down to a hay meadow through which a creek runs.
>
> Large numbers of wild fruit trees grow all around & when these are in full bloom & the grass is green, there are little bits of views that will equal a Kent or Sussex landscape. You would certainly like this place the best for it is only six miles from a station & we hear the trains whistle when they pass, whereas the old 4.4 camp was 45 miles from anywhere. On the whole I think the move to the other side of our range was a very wise plan, especially as we are giving up holding horses on the open range & keeping them under fences for which this place is eminently suitable.

The depot six miles north of the ranch, from which the Camerons planned to ship their horses, was located in the tiny—but spirited—town of Terry, about which Evelyn wrote to her sister-in-law:

> Terry has been rather lively of late, cowboys shooting here, there & everywhere. One saloon is riddled with bullet holes & one cowpuncher held up the Justice of the "Piece" (this is his spelling not mine). In fact, they painted the town red & not one was arrested!

When the Camerons arrived at their new ranch, Terry had only been officially in existence for ten years. The town was located just south of the Yellowstone River midway between the larger towns of Miles City and Glendive, Montana. Seen from a distance in 1893, it looked like a mirage on the dusty treeless plain. Sagebrush and cactus were its only vegetation. The first tree in Terry—a wild plum—would be planted later that year.

What was not apparent to the eye was the resource that gave Terry its life: its ample underground water supply. In an area where water was scarce and often almost undrinkable due to alkali salts, this was no small matter. The town was spawned by the arrival of the work crews of the Northern Pacific Railroad, who were laying track through eastern Montana, roughly following the contour of the Yellowstone River. With its supply of water for men and steam engines, Terry became a shipping point for the livestock raised on the cattle and sheep ranches scattered throughout the area.

The Eve ranch house, a cozy but crude three-room cabin constructed of logs with a stone foundation, had been carefully sited by the original owners to exploit the few advantages nature provided. It was nestled on the side of a hill that shielded it from the unrelenting winds that swept across the prairies. Nearby was a creek that provided drinking water and nourished a charming thicket of fruit trees and rose brush that was alive with birds. Ewen described it in a July 1907 article for *The Auk:*

> My ranch . . . was a great haunt of Sharp-tailed Grouse and many other birds, acres and acres of rose brush cloth-

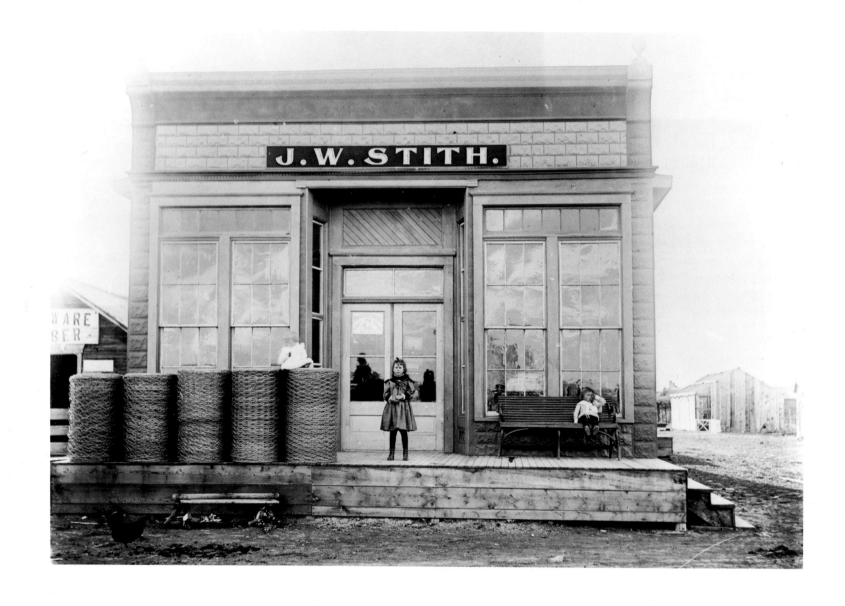

*The three Stith children in front of J. W. Stith's hardware store in Terry
on September 24, 1899. The shopkeeper, who was also the town's Justice of the Peace,
sold everything from English china to saddles, barbed wire, and plows.*

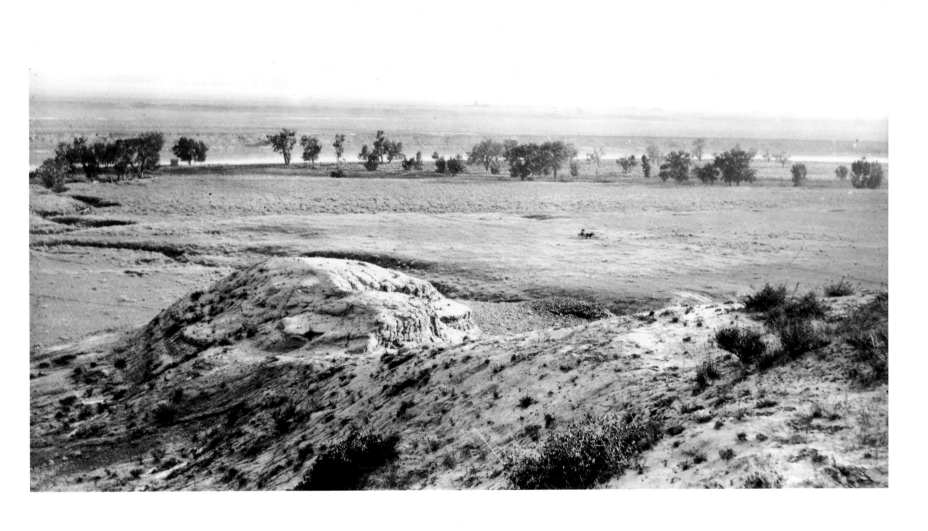

A view from the badlands toward the Yellowstone River and, in the far distance, the town of Terry, just visible on the barren prairie. The town was spawned by the railroad; the shrill sound of train whistles carried for miles over the empty landscape and was clearly heard at the Camerons' Eve Ranch.

ing the creek bottom while large patches of wild fruit trees were abundant on the hillsides. Under the taller ash and box elders spread a net-work of clematis, which intertwining with plum-trees and choke-cherries, overhung the smaller bushes, the whole forming an impenetrable covert, containing several springs of water while yielding its store of food to the birds. At one place so dense was the thicket, where it joined the north window of the ranch-house, that entry thereto was impossible save by using a fallen tree as a bridge.

Numbers of newly arrived migrants would work through this labyrinth from the north end until their further progress was barred by the window above mentioned. In this way many rare visitors were first observed from inside the room, such as Townsend's Warbler, White-crowned Sparrow, Olive-backed Thrush, etc.

My wife used to thread blue-bottle flies and hang them outside the glass, for the pleasure of watching the Long-tailed Chats and Redstarts, which would suddenly appear and pull them off the string. Many birds nested within these thickets; some of which, to the best of my knowledge, did not do so elsewhere in the county, such as the Black-billed Cuckoo and Cedar Waxwing.

Laid out in front of the ranch house was an extensive garden, lovingly tended by Evelyn, who irrigated it with water from the creek. She boasted of her gardening success to her mother-in-law on January 15, 1894:

I have an acre of kitchen garden, I attend to it entirely myself with aid from Alec [her brother]. Last summer we had all the vegetables we could use with some over to sell, even tomatoes, cucumbers & melons. For winter use [we stored] about 1,500 lbs. of potatoes, besides carrots, parsnips, turnips, beetroot & cabbages.

Beyond the garden and the creek and the fruit trees with their nesting birds, the rolling prairie stretched into the distance. The view was magnificent, and the house took full advantage of it. The windows looked out from the hillside perch toward the rising sun, and running the full length of the house was a wooden verandah nearly seven feet wide that was shaded from the blistering summer sun by a sloping roof.

When the warm weather arrived, the Camerons moved the table to the verandah and dined in the open air. During summer's daylight hours, Evelyn often did her chores or, if time permitted, read the papers on the "piazza." In the evening, summer thunderstorms created a spectacular show. "Lightening is perfectly beautiful & wonderful. [It] lights up the whole landscape for seconds," Evelyn noted on June 29, 1894. "Storm of lightening and wind raging," she wrote contentedly on another occasion. "Sat on verandah in cool wind, smoked bit of Ewen's cigar & sang."

The outdoor porch was especially welcome after the long winter months holed up in the small cabin. For it was not just Evelyn and Ewen who shared the cramped rooms; for the entire time they lived at the Eve Ranch south of Terry (from 1893 until their temporary return to England in 1900) they had to endure the company of Evelyn's older brother Alec, whose trustees paid a welcome £30 per quarter for his room and board, and who, in addition, invested in a limited way in the ranch by buying a few horses and equipment for the garden. He had clearly been sent abroad by Evelyn's family in the hope of keeping him out of trouble. But trouble he was for his sister.

In her precise fashion, Evelyn noted the exact dimensions of the three rooms of the house that she and Ewen shared with Alec. The kitchen, where she spent hours preparing meals, making bread, churning butter, and doing other chores, measured 13'5" by 13'1 1/2". Evelyn and Ewen's bedroom—which also served as the sitting room and the study where Ewen pored over his field notes and wrote his articles—was 19'4" by 12'9 1/2"; the north window in the room looked onto the rose-brush thicket. Alec's province, where he did "goodness only knows what," was his bedroom, which measured 13'5" by 13'1 1/2". Alec grudgingly shared this space with the occasional guest or hired hand, as well as with the first of two successive boarders whom the Camerons

Evelyn's brother Alec Flower stands next to an impressive harvest of cabbages at the Eve Ranch in October 1898. Alec helped Evelyn with her acre-large vegetable garden, and shared in its profits.

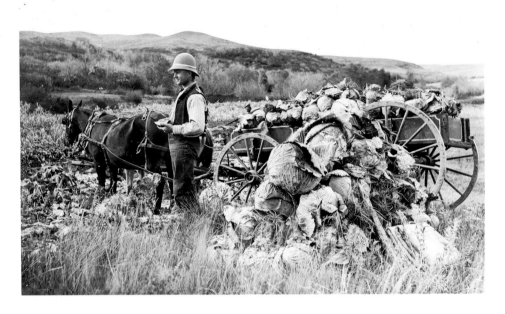

hoped would invest in the ranch. To accommodate their boarders—and to protect them from Alec's irritable disposition—they eventually built a guest house—a detached, one-room structure measuring 15′6″ by 11′5″, with a front stoop.

The Camerons settled into these modest surroundings in order to put into operation Ewen's romantic scheme for ranching in Montana. Not for him the prosaic job of raising herds of cattle or horses for the American market; instead, he planned to breed polo ponies in the invigorating air of the Great Plains, and sell them to Europe's wealthy sportsmen. Lacking the necessary funds to implement the scheme himself, in late 1892 he had entered into a partnership with one of eastern Montana's prominent "cattle kings," Henry Tusler, who provided the financial backing for Ewen to import two exotic Arabian stallions.

Tusler and his wife lived in Miles City, but they owned several ranches south of Terry, including the Eve and a neighboring place run by his twenty-two-year-old nephew

and namesake. The stallions were to be kept at young Tusler's ranch, though his knowledge of horse breeding was minimal. On February 28, 1893, Evelyn noted with dismay: "Henry discoursed, his dense stupidity was shown by asking how many crosses with mares out here (with the Arabs) would it take to make a pure Arab again!"

The imported stallions were magnificent creatures. A newspaper article Evelyn pasted into her 1893 diary describes the reaction of a noted old-time scout and hunter:

F. A. Lisk went down to Terry on Friday especially to see the handsome Arabian stallions recently imported by Capt. E. S. Cameron. Mr. Lisk was very much surprised at their appearance, and declared that they are without exception the prettiest piece of horseflesh he ever saw. One of them is a slightly dappled iron-gray, 6 years old, weighing 760 pounds, and is 14¼ hands high. The other is a mahogany bay, the same age and height, and weighs 800 pounds. There have never been more than half a dozen

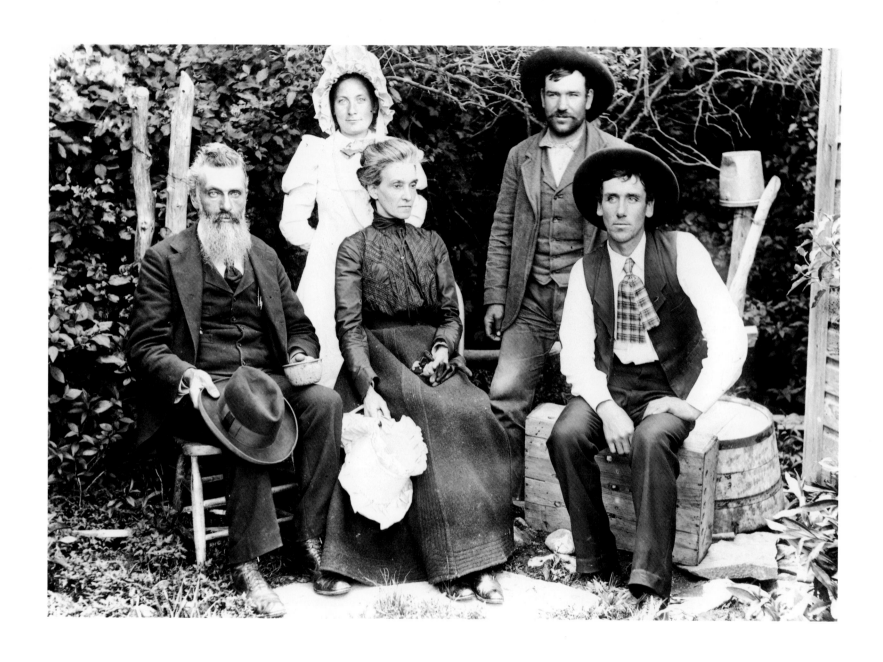

A portrait of the Tusler family made in 1898. Young Henry Tusler, whose ranch adjoined the Camerons', stands in back; he is surrounded, clockwise, by his brother George, his sister Melissa, his uncle Henry Kinsey and his sister-in-law Grace. Henry Tusler was a partner for a time in the Camerons' polo pony enterprise.

of these animals brought to this country, and they are almost a curiosity. They are modeled very much after the thoroughbred racer, only Mr. Lisk declares that they far exceed them all in point of beauty.

The year 1893 had barely begun—the Camerons' belongings had not even been unpacked at the new ranch—when Ewen's dreams for the future were dealt a harsh blow with the arrival on January 3 of a "very bothering letter" from the Stock Growers National Bank in Miles City. A £60 check that Ewen had written in connection with the horse business bounced—or in Evelyn's phrase, "dished"—for the second time. Wickham Flower, a London attorney who was one of Evelyn's cousins and a trustee for her inheritance, had promised to cover the check, but no funds had arrived at the Miles City bank. The impatient banker, Harry Batchelor, wrote Ewen "in a very irritated vein [that] in fact if not settled at once he threatens proceedings! We were kind o' stunned. . . . Both so very blue. Ewen wrote till 12 at a letter to Batchelor."

The next day Ewen set off with a heavy heart to Miles City to fend off their creditor. Evelyn's diary entry for January 4, 1893, glumly recounts his leavetaking:

> Worries paramount. Ewen to Miles City. . . . Packed things for Ewen. He is so terribly worried & I not enough up in these business affairs to know how to console him. . . . At 3 Ewen on [the horse] Porter, I on Steel started. Ewen said he felt like a man going to be hung, going to Miles on horrid business. Went down [to the railroad station] very slowly. . . . Ewen felt so terribly sick at tum that he got off [his horse] & stood awhile & walked rest o' way to Terry on foot. Got to Terry 'bout 4:45. No letter from Wickham as I had hoped. We think this will perhaps be a beneficial lesson for us in the long run. Sure I hope so. Very blue at parting. I am not a cheery companion in time of trouble as I ought to try and be.

Ewen returned from Miles City ten days later with the situation only partially resolved. Wickham Flower had cabled money to Batchelor to cover the check and to avert the immediate crisis with the bank; but according to the terms of his contract with the senior Tusler, Ewen's bad check left him liable for a $1,000 penalty.

Months elapsed as Ewen tried to negotiate some settlement with Tusler; a neighbor had warned the Camerons that Tusler was a "curious man [who] changes his mind often," and that assessment was now borne out. Eventually, however, a deal was struck whereby the Camerons bought the Eve Ranch from Tusler for $500. Tusler, in turn, purchased one of the Arabian stallions outright for $1,200 plus studding service for six of Ewen's mares. He also absolved the Camerons from having to pay the $1,000 breach-of-contract penalty.

But the underlying problem remained: the cost of ranching in the semi-arid wilds of Montana, even when the grass was free, was more than the Camerons had anticipated; despite the new arrangement, they were still in over their heads. Their debts were mounting and they were warned that "people in Miles [are] tired of waiting for their money & mean to sue Ewen." To make matters worse, there was a national economic crisis brewing; in consequence, credit was exceptionally tight, and the market for horses uncertain. Desperate for cash, the Camerons turned to a Mr. Coggshall, a longtime cattleman in the area. In June 1893, Evelyn wrote that Ewen had "mortgaged all to Coggshall so that if other creditors do press, as some threaten to do, Coggshall will have it all in his own hands." In addition, circumstances forced her to petition Wickham Flower, "explaining present uneasyness of the money market in the country, [&] asked for £100 advance. Such a crisis now in U.S. financially [as] never known before!"

A month later, Evelyn had still not heard anything from Wickham, and on the morning of August 4 she and Ewen discussed their predicament:

> At breakfast 7:15 Ewen & I talked our financial crisis over. Am so afraid Wickham will not advance the £100, ought to be a letter from him today. Ewen said he gave up managing

money, would turn the purse over to me. Discussed plans if have to give up this place.

Ewen then went off to Terry, and returned that afternoon with the shocking news that the Stock Growers National Bank in Miles City had failed, taking with it all of the Camerons' money. It turned out that their impatient banker was in deep trouble. On August 10, 1893 Evelyn wrote:

Harry Batchelor owes $52,000 to the *depositors* & bank. He will be put in the penitentiary if the reports circulated about his dealings are true! . . . Paget [an Englishman] lost lots of money in the bank.

The Stock Growers National Bank was one of hundreds of banks that folded during the financial Panic of 1893. The collapse of the Philadelphia & Reading Railroad in February started a chain reaction of business failures across the nation that brought on the worst depression the country had ever experienced. Evelyn reported to her mother in September:

Most of the people that we know around here are ruined or in great financial difficulties through a panic in the money market. . . . In some of the western towns all of the banks failed in one day.

The Camerons looked to Coggshall for some reassurance about the future; instead, he painted a bleak picture. Evelyn wrote on August 12, 1893:

I conversed in our room with Coggshall on bank's failure etc. He remembers 5 or 6 such crises as the present during his life—'56 to '60 was the worst, money had no value then. He thinks this [present situation] will continue for 5 or 6 years.

Facing ruin, Ewen was ready to concede defeat and return to Britain. Evelyn, however, was determined to forge ahead in Montana. In her diary entry for August 20, 1893, she wrote:

Ewen in great state about our situation, thinks to break up & fly home is our best purgative. I think it would cause congestion of our finances again & no ultimate good attained. Out here there is some chance of money making even if we kept quiet, saved, bought & sold osses.

For the short term, they were still counting on Wickham Flower to bail them out. Evelyn informed her English trustee that she and Ewen would be forced to return to Great Britain unless he sent them some money immediately.

Wrote out letter to Wickham, viz: must return . . . if our situation not relieved by £100 now & £50 in January [we will go to] live on an island of General Burrough's [in] Orkney. Explained the crisis, enclosed cuttings from paper here.

Wickham, however, was unmoved. He interrupted his vacation at Aix-les-Bains, a fashionable spa in the French Alps, just long enough to write that no advance was possible. The same mail brought a "dunning letter from Miles [City]." Evelyn noted sadly in her diary on September 8: "Felt terribly blue."

The next morning at breakfast Evelyn and Ewen discussed their options, with Ewen again leaning toward returning home.

Sat debating future course should Miles City creditors not press too hard. Stay here till spring, go back & live in Orkney. I photograph, Ewen write book. I would rather stay out here, I don't care about home now, feel as tho' I would like to never hear nor go near it.

Home for Evelyn was now Montana. And, as she wrote to her mother-in-law, returning to England "without having made any money out of the ranch after all our slaving and self sacrifice would be a severe blow." She was also convinced that, despite the mess they found themselves in, Montana still offered greater financial opportunity. "Going home means virtually collapsing into a comatose state as regards making money!" she noted in her diary.

As a last-ditch effort to maintain their independence in Montana, the Camerons hatched a new strategy. Evelyn outlined their plans in a letter to Mrs. Cameron dated January 15, 1894:

> We have been so hard pushed lately that we have tried the plan of taking pupils & one young man arrived from Ireland a short time ago. It is probable that he will put some money into this concern. . . . Should he not do so, we shall probably give up ranching on our own account altogether & "hold down" a ranch for Mr. Wallop in the Big Horn mountains.

Oliver Henry Wallop, or "O. H." as he was affectionately known on the Northern Plains, was the son of the Earl of Portsmouth and eventual heir to that title. He was a well-known breeder of horses in Montana, and since 1890 had been raising ponies on a ranch near Sheridan, Wyoming, another place that, like Miles City, Montana, was a magnet for English ranchers and hunters.

There was both a natural camaraderie and much commerce among the members of the two expatriate communities. They bought livestock from one another and visited each other's ranches, indulging in the English pleasures of hunting and polo. While delivering a couple of ponies to the Cameron ranch for their inspection on November 29, 1893, Wallop's bronco buster, a man named Denbeigh, reported that

> Mr. Evans & an English Colonel friend [have] gone up in [the] Big Horns on a hunt. They have organized a polo club, the English at Sheridan—when practicing once, one of them knocked another off his pony with [his] polo stick in an effort to reach the ball!

Wallop had offered Ewen the job of managing his polo pony ranch in Wyoming, and throughout most of 1893 and into 1894 the Camerons considered making the move; although it meant giving up their own ranch, the position would provide them with some measure of financial security.

From the outset, however, Evelyn disliked the idea, and she made her opposition plain on June 3, 1893:

> Jab on what to be done, situation is critical. He [Ewen] thinks best to sell out & go in with Wallop, at least live near him. I don't want to leave this place, we have never done any good moving & Mr. Wallop would only get Ewen into some ruining scheme.

As it turned out, Evelyn's assessment of Wallop was off the mark. A highly successful rancher, he was one of the chief horse buyers for the British government during the Boer War; later, after becoming a naturalized United States citizen, he was elected to the Wyoming State Legislature for two terms. But even if Evelyn had been able to foresee Wallop's substantial accomplishments, she undoubtedly still would have fought against the move to his ranch. She and Ewen had worked so hard to establish their own place, and she was determined not to give it up without a mighty struggle. She viewed the manager's position at Wallop's ranch as a last resort, to which she would agree only if there were no other way to stay in Montana. For Evelyn, a return to England in financial ruin would be the ultimate indignity.

As a last line of defense she began taking in wealthy boarders. It was not rent payments she was seeking; she and Ewen were convinced that after spending time on the ranch the newcomers would be sufficiently impressed with its economic potential to invest in its operations.

The first of these boarders was an Irish friend of Alec Flower named Adams (his first name was not recorded). He arrived "wrapped up in ulster [&] woollen helmet," wrote Evelyn, who had spent all of that Saturday, December 2, 1893, cleaning and cooking in preparation for his coming. Unfortunately, he was not a success. Accustomed neither to the biting Montana cold nor to the rugged, outdoor life, he was a terrible hunter to boot, unable to follow deer tracks that were plain as day. On one occasion, he excitedly showed Ewen a curious animal track he had found, convinced that he was on the trail of a puma. The "track" "proved to be

Mr. Adams' [own] hand marks when descending a steep little hill."

The butt of jokes on roundup—the cowboys "were very much amused at [his] exterior. They thought he looked very fat & lazy"—Adams was much more at home in the Terry saloon, where he baffled the locals with his "card tricks & wonderful sleight of hand." Unfortunately, the cowboys "refused to play poker with him when he offered because in his card tricks he could tell every card in the pack without looking." At first Evelyn enjoyed her boarder's jokes and tricks, but they soon grew tiresome—particularly when the joke was at her expense. Supper on December 31 was ruined by one of his silly jests:

> Mr. Adams said he could tell a tune if played on the back of a chair. When I tried he said I was "playing the fool." I was angry, Ewen also. Told him I thought he was the f--- not I. He admitted it, blew over after awhile after Ewen had pitched into him well.

But no matter how sorely their patience was tried, the Camerons had to put up with their "guest" because he held the key to their future. As soon as he arrived Adams "told Ewen he had capital he wished to invest & to find a partner for it." Ewen was overjoyed at the prospect but, not wanting to take advantage of the newcomer, warned him to "see more of the country first & then only invest £100 at first." Adams, however, was ready to plunge in headlong. He immediately wrote to his agent in Great Britain "concerning his wish to put in capital into the ranch, to have therein a ¹/₂ share amounting to £381."

It was a dream come true, a partnership that would rescue the Camerons from their financial morass. It was not to be. The trouble began as early as Christmas Day 1893, when Mr. Adams, on a grouse-shooting expedition with Evelyn and Ewen, confided that he was having problems with Alec.

> Mr. Adams told me he thought it was inconvenient for him to be in Alec's room, that Alec didn't like it. I asked why he thought so? Because Alec did all sorts of things to annoy him, as drawing his chair on one side when [he was] writing etc. etc. I said I thought Alec only meant it for fun as he had got into the habit of teasing from associating with his brothers, but said I would speak to him about it. . . . Sup at 7:40. I worked at it all afternoon. Roast turkey (21 lbs.), bread sauce, potatoes mashed, 3 mince pies, one plain plum pudding for Ewen & rich one for us. Mr. Adams put some of his whiskey on his pudding & on Alec's. After sup I spoke to Alec about Mr. Adams being in his room. He said he was tired of having him in his room. I reminded Alec of his oft repeated declaration that he did not mind Mr. Adams in his room until he could get his room built in the spring, & that it was at his invitation that Mr. Adams came out here. He was in a defiant mood. I got hopping mad [&] told him I would have him do nothing for me. So he eventually went into [the] other room & I did all work [my]self. He wants a thorough good thrashing [&] if I were like [our neighbor] Mrs. Kempton he wouldn't be long getting it.

The next day the situation was worse. Evelyn wrote:

> *Alec's bad conduct at its height & ended for [the] present.*
> Got breakfast at 8:30. Heard Alec whisper to Mr. Adams . . . to go home, the little beast has no more manners than a dog. At breakfast after Alec had gone, Mr. Adams asked if it was true that Ewen wished him to leave, also that he didn't want him for a partner! Of course [Ewen] said he did. Mr. Adams told us Alec had told him [in the] morn that Ewen didn't want him to stay any longer! also that when he arrived, Alec asked if he would return to England. . . . If so, Alec wished him to lend him the money to return with him! Later I spoke to Alec in kitchen, Ewen came in & joined. Alec had no reason for a quarrel with Mr. Adams except that he pushed his chair back when Alec wanted it forward. Such a child for his years was never seen outside of an idiot. Alec shook hands with Mr. Adams & kissed me, so it ended.

Ewen brought two young women settlers, the Williams sisters, to the roundup cook tent on September 28, 1910. Evelyn counted off a six-second exposure inside the tent to capture Ewen and the sisters, the cook, Claude McCracken, and the "nighthawk" (second from right), who guarded the cowboys' horses.

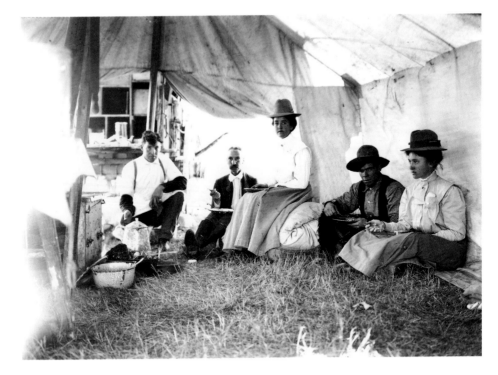

The peace, however, did not last very long. Alec continued to wage guerrilla warfare against his roommate, until finally the two came to blows on the evening of January 25.

> Alec & Mr. Adams had a "*set to*" last night the incentive being Alec taking coal out of his stove after Mr. Adams had put it in! We heard them in our room but didn't interfere. Mr. Adams told Ewen this morn that he knocked Alec down twice, 2nd time onto the bed & gave him a good pummeling. Alec this morn asked Mr. Adams to forgive him!! & also begged Mr. Adams not to tell us.

Ewen meanwhile was in a dither over the proposed partnership. Evelyn described the situation in her diary on January 9; the entry has an uncharacteristic note of resignation about their fate:

> Ewen feels very unsettled, Mr. Adams has had no advise from his agent yet, not knowing therefore our future to be with Mr. Wallop or stay here. I do not care much which

happens, [whatever has] most chances of financial success I am anxious to stay by. Mr. Allan Cameron thinks we ought to return & look after his mother, he himself has no wish to do this.

At the end of January, Adams got word from his agent that he "cannot raise any capital to put into a ranch until charges on his property [in Great Britain] are paid off." Still anxious to invest in the Camerons' ranch, he arranged to board for a year, pending the freeing up of his funds. Ewen put their agreement in writing.

> Mr. Adams to board for £120 [per] year from Jan 1st to Jan 1st, to have keep of a horse & a room built, privilege of accompanying us on hunting trips & next year to become, if he possibly can get the money, $1/2$ share partner or $1/4$ share.

No sooner had Adams made this commitment, however, than his enthusiasm for Montana began to wane. By spring-

time he was moping around with nothing to do—yet was unwilling to pitch in and help with the chores. "Out & chopped," Evelyn wrote on April 29. "Mr. Adams came & watched me. . . . He sat in seemingly rather a morose mood on the saw buck smoking his never absent pipe. He has also taken to chewing [tobacco] the last month."

Adams found ranch life dull, and Terry offered little in the way of excitement either, especially since the cowboys refused to play cards with him in the saloon—though on one occasion, he "saw the man with the performing rattlesnakes in Terry, & he [Adams] took one & coiled it round his neck & arm. Gave him a tight squeeze but not too strong!"

As Adams, bored, lost interest in the ranch, unpaid bills continued to pour in—even one that pre-dated the Camerons' arrival in Montana. On March 15, 1894, Evelyn received an angry letter from her mother concerning a long-overdue bill from an English shop.

[Letter] from Mum. Long rigmarole on not settling Gryl's account, latter having written to her again. Burnt the letter directly. . . . Unsettled me. I hate more than anything having unpaid bills on my conscience. Ma come si fa?

She sent a contrite letter to the shopkeeper explaining her present situation:

Dated & mailed June 13th [1894]
My dear Miss Grylls,—

I feel very much ashamed indeed that I should never have managed over such a length of time to settle your account amounting to £24.15.

The fact is I left England in the full belief that my trustees would settle all my debts, a list of which I handed to them, but after consultation they did not see fit to do so.

I quite believed I should have sufficient [funds] to settle some smaller & pressing liabilities, such as your account, but in this too I was disappointed having barely sufficient to enable me to reach Montana.

Since being here I [have] been in very reduced circumstances & found it a hard struggle to get along at all.

My debts have haunted me continually & in almost every letter I have teased my trustees to raise me the money to pay them off, as I have been unable to do so myself out of my attenuated income. I feel deeply sorry for the inconvenience you have suffered. Do not imagine for one moment that I would try to evade this debt, for nothing but the extreme smallness of my means has prevented me from settling with you earlier.

As I have no bank account in London I shall have to write to my cousin & trustee Mr. Wickham Flower & arrange with him to subtract the amount from such allowance as he sends me. Hoping the season has been a good one. Believe me,

Yours truly,
Evelyn J. Cameron

Subtracting the bill from her allowance would hurt, especially since she had just received a "horrid" notice from her trustees informing her that her income was being reduced from £300 to £200 per year (for reasons she never explained in her diary). Evelyn dashed off a letter to her cousin Wickham imploring him to "interfere & arrange that I should (at least for 2 years more, when the ranch could pay for itself) get £300 instead of £200."

Meanwhile Adams was becoming increasingly evasive about his plans. On June 4, 1894, Ewen confronted their boarder:

Ewen read out statement to give to Mr. Adams—wants to know for certain whether he is coming in as partner or not. . . . Ewen's talk very unsatisfactory with Mr. Adams, he is so doubtful about ever being able to put money into this concern. He seems homesick & wants to return home. Nothing to do here he says.

All through these months the Camerons' financial woes were compounded by those of the nation. The Panic of 1893

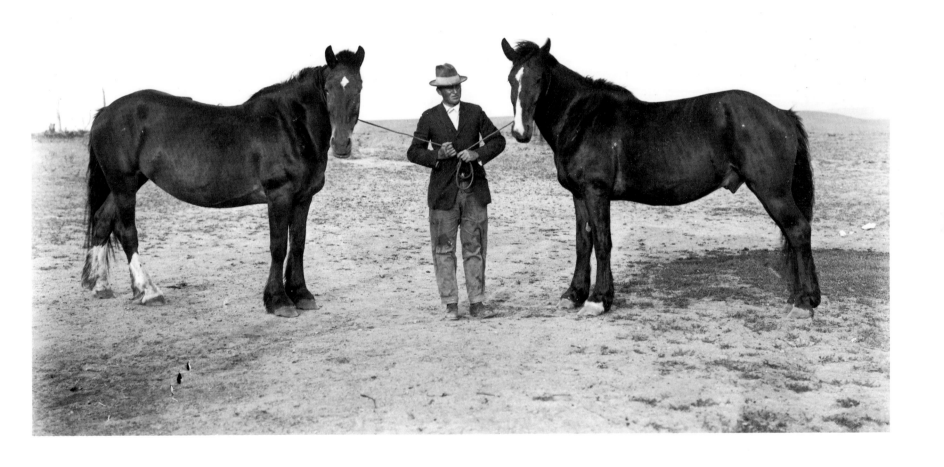

An unidentified man on the prairie.

had been followed by a deep, nationwide depression. A million people, perhaps more, were unemployed. Since there was no public assistance for the destitute, thousands of homeless, set adrift, roamed the country, sometimes in large gangs that terrorized communities as they begged for or stole food. The Northern Pacific Railroad—the very lifeline of eastern Montana—was forced into bankruptcy; at the same time, a bitter strike by its workers brought out the army to protect the rails. On July 10, 1894, Evelyn noted that black soldiers were in Terry to protect the railroad. Almost two weeks later the strike was still on, and supplies were getting very scarce.

> Cannot get bacon or sugar in Terry. Freight trains are not allowed to run. Strike still continues, mail train only carried thro' by military aid, bridges all guarded by military.

With train service to eastern markets disrupted, and with the prices of horses and cattle plummeting, the ranching business in eastern Montana came to a virtual standstill. By early July, cowboys who were usually kept busy on ranches through most of the summer were being laid off. On July 8, Evelyn wrote about the situation at the nearby 13 Ranch:

> Mr. Coggshall told Kimes [his foreman] to discharge all the cowboys, so Johnnie [Kimes] got on his horse & left after having first given wage cheques to his wife to distribute amongst the boys. [He was] too cowardly to do it himself, knowing how angry they would be.

The man who relayed to the Camerons the story of Johnnie Kimes's cowardice was a cowboy named Drew, and his own story reflected the terrible personal toll of the depression. He, his wife, and his three-and-a-half-year-old, "fearfully disobedient" son Jack who, Evelyn noted with horror, "actually swears like a man," had arrived from Miles City in April 1893 to "hold down" young Henry Tusler's ranch. Mrs. Drew took over the cooking (to Henry's great relief), and Mr. Drew served as the all-round ranch hand.

The arrangement worked out well for both Tusler and the Drews, and it also provided Evelyn with some female companionship; since the two ranches were within easy walking distance, she was able to visit frequently with Mrs. Drew. For her part, Mrs. Drew looked upon Evelyn as a tower of strength and called upon her in times of real—and imagined—emergencies. "Rose at 2 a.m. at Henry [Tusler's] call," Evelyn wrote on August 24, 1893.

> He said in a very doleful voice [that] Mrs. Drew wanted Mr. & Mrs. Cameron to go up, her husband was so ill. Dressed hurriedly & Henry drove us up in buggy. Drew in great pain, colic from eating unripe melon, pickles, cucumber. . . . Wife surprised when Ewen told her the cause!

Their young son Jack, however, was even less discriminating about what he ingested. On June 27, Evelyn had been summoned to help nurse the "awfully willful child," who had mistakenly drunk carbolic acid.

> Little Jack had got hold of a bottle in stable thinking it whiskey (which he loves!) & had drunk some. I rode Andy on Ewen's saddle full tilt up there. Mrs. Drew was with the child in bedroom. He looked well, nice colour, lively, no pains. . . . Made mustard & warm water, [&] by dint of a lot of coaxing he swallowed very few drops. Held him & tried to force some down.

Jack survived that mishap, but a little over a year later the Drews fell victim to the depression: Tusler had to let them go, and there was no other ranch work available in the area. Drew was psychologically broken, confiding to Ewen that "he feels so discouraged that he told his wife he wouldn't care if he broke his neck."

In desperation, Drew, the cowboy, took over running the Terry Hotel—a job for which he was eminently unsuited. From then on, his name appears only occasionally in Evelyn's diaries, but every mention of it reveals a man whose life was slowly unraveling.

Almost as soon as the Drews left the Tusler ranch, little Jack contracted scarlet fever. Late in the afternoon on August

17, 1894, the family came out to the Eve Ranch looking for melons. Evelyn went over to their buggy to greet them. "I went up & saw Jack," she wrote that night. "He has big sores on his face & looks very pale. Mrs. Drew looks pale. Drew says [there's] no pleasure to be had for a poor man." Within months the Drews' marriage was foundering; Evelyn noted on November 28: "Drew caught his wife in an indecent way in Miles City. They are separated. Drew is building a saloon in Terry."

In his new livelihood Drew was continually victimized by ill luck—and his own mean spirit. His establishment had just opened when, on February 9, 1895, Ewen and one of the British boarders went into Terry and "sampled whiskies & brandies at Drew's saloon." While they were there, Drew bemoaned the fact that "$130 worth of beer in barrels [had been] spoilt by freezing!" Stories circulated of Drew "picking up [a] man by seat of pants & dropping him into pool of muddy water etc." He was also the natural suspect when the local dogs of Terry were being mysteriously poisoned. "Ewen beat a hasty retreat from Terry," Evelyn wrote on March 30, 1895, "Mrs. Jordan having warned him of the great amount of poison laid about the town. Only 2 dogs left, the numerous curs much beloved by their owners have died from said poisoning. Who does it, no one knows. Drew suspected." By the end of May Drew's behavior had become so intolerable that he was "arrested for bullying people in Terry."

Mrs. Drew, meanwhile, had taken up dressmaking, tanning skins, and laundering to make ends meet. After separating from her husband she had initially planned to set up as a milliner in the nearby town of Glendive, but the plan fell through and she was stuck in Terry, where she was ostracized. Evelyn, however, had no patience with the gossip and petty cruelty of small-town life, and in May 1895 when one of the local busybodies invited Mrs. Cameron into her house to visit, Evelyn made her sympathies quite plain: "I thanked her saying I was going to call on Mrs. Drew. This

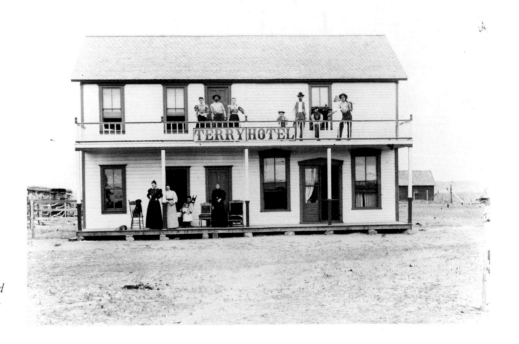

The Terry Hotel, where the out-of-work cowboy Drew found brief employment in 1894. The hotel was being run by the Scott family, and Evelyn tried without success to use the hotel as the center of her photography business.

Evelyn pasted this photograph of her British boarder, Colley, onto a back page of her 1895 diary, in the section that carried advertisements.

must have made her talk scandal by the hour after." She found Mrs. Drew "pale," but undoubtedly pleased to see her old neighbor.

Evelyn used Mrs. Drew as a dressmaker and was very pleased with the results, pronouncing her "as good as a London tailor." Her prices were well below those of

London—or even those of Miles City's dressmakers, who charged "up to $12 for simply making a dress." Evelyn paid her seven dollars for a dress and ten dollars for "2 skirts altered to style & divided skirt awfully well made [that] hangs beautifully." For laundering shirts Mrs. Drew charged fifteen cents apiece.

Reasonable as such prices were, Evelyn could barely afford the luxury. By the end of the summer of 1894, the Camerons' boarder, Mr. Adams, had had enough of Montana, and on August 25 he returned to Ireland. Though he "treated everyone to drinks & got quite soft at parting," he had not put a nickel into the ranch. He was immediately replaced, however, by another wealthy Briton named Colley. "We wish the day would come," Evelyn confided wistfully in her diary, "when ponies & not boarders paid the bill."

While Ewen concentrated on raising the ponies that he hoped would someday make the Camerons rich, and on studying the birds of Montana, it fell to Evelyn, the much more practical and resourceful of the two, to scratch and claw for the survival of their ranch. The boarders constituted one means. Another was her garden. With minimal assistance from Alec—and none whatsoever from Ewen—she raised huge quantities of vegetables, then loaded hundreds of pounds of her produce at a time onto wagons and traveled long distances hawking her wares. During the fall roundup in 1894 she sought out cook wagons on the range, and even cowboys at a saloon near the stockyards at Fallon, Montana, as customers; she drove to remote ranches and to the railroad section house. Her efforts made for a grueling day that began at 6:00 a.m. and ended when the wagon made its way back to the ranch under a "cloud covered moon." But the results were well worth the trouble. On September 8, 1894, for example, she hauled in $5.10—a not inconsiderable sum at a time when cowboys were making thirty to forty-five dollars per month.

Evelyn's third money-making scheme—and eventually the one that proved most successful—was her photography. It was Adams, her first boarder, who helped launch her in

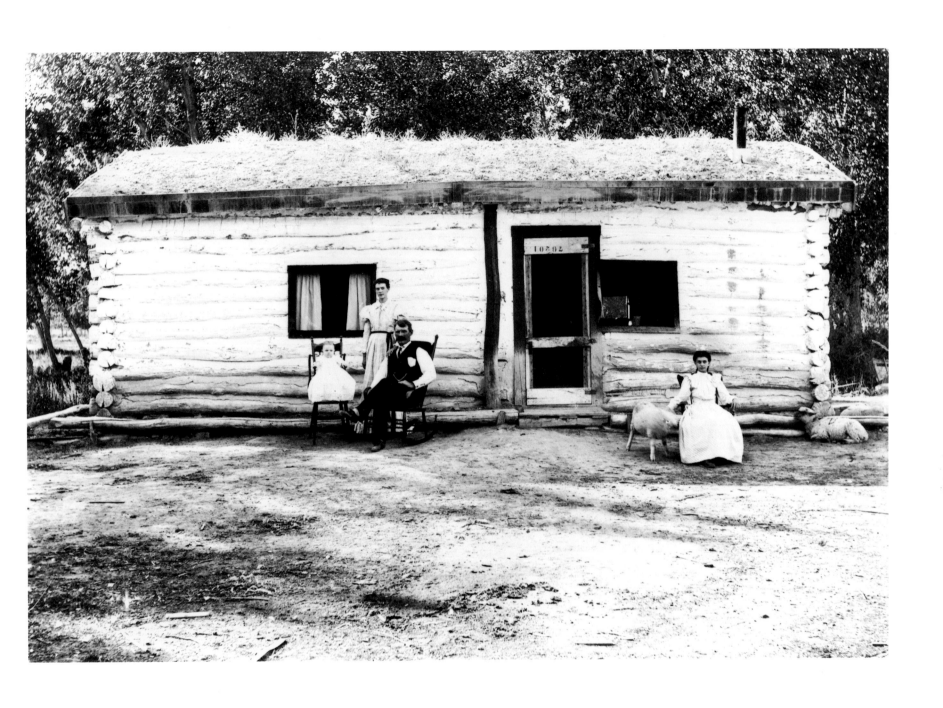

*An unidentified family in front of their log house. In 1902, Evelyn calculated
that by September she had made $94.40 from selling photographs.*

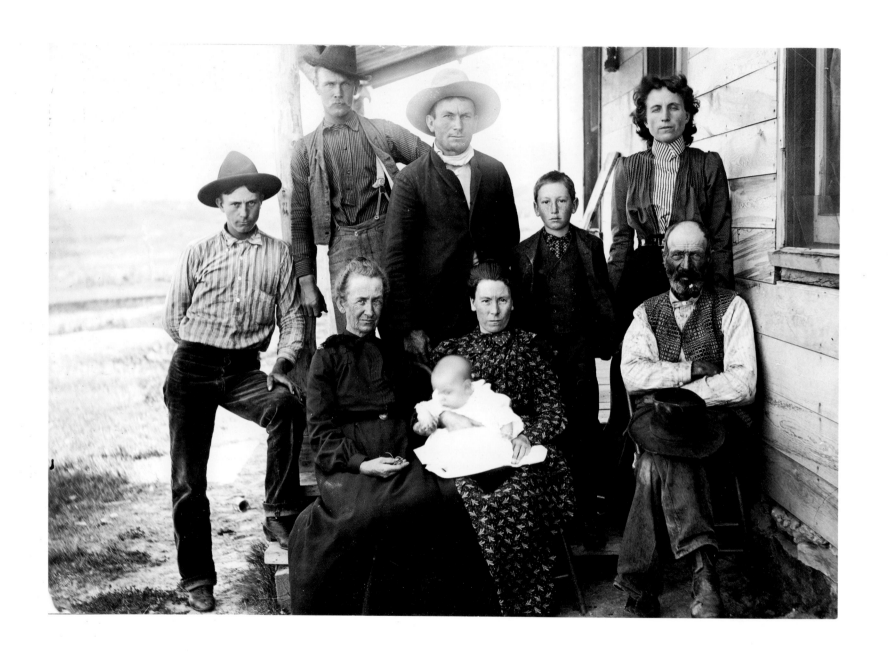

Before breakfast on a Sunday in September 1902, Evelyn rode out to a ranch south of Terry to make this family portrait of the Hamlins and the Braleys.

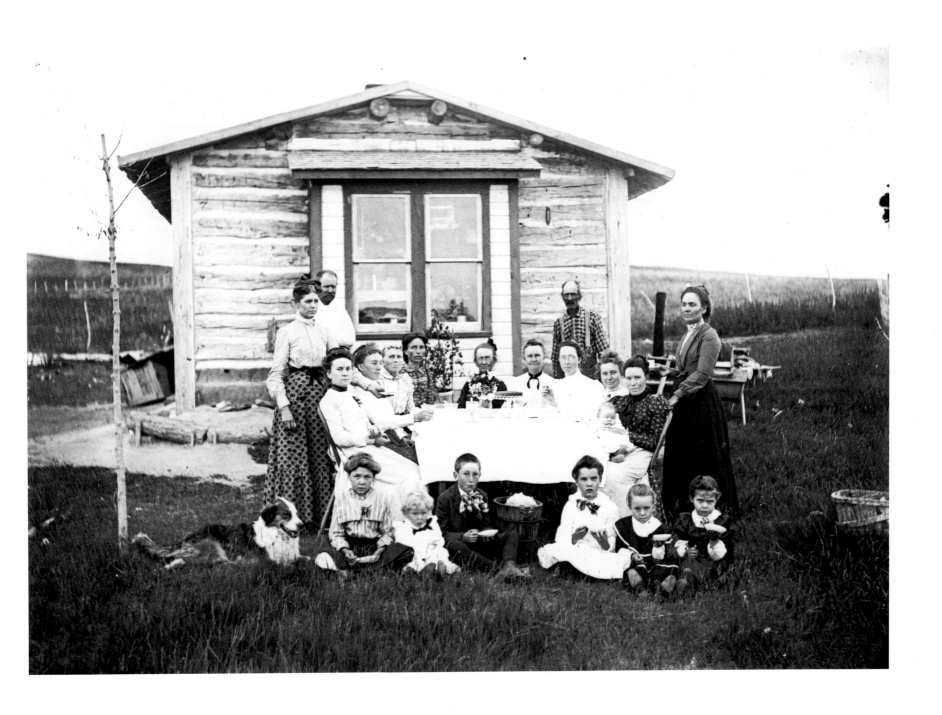

*An ice cream party at the home of Alice Hamlin, who is seated at right holding her infant
daughter, July 1902.*

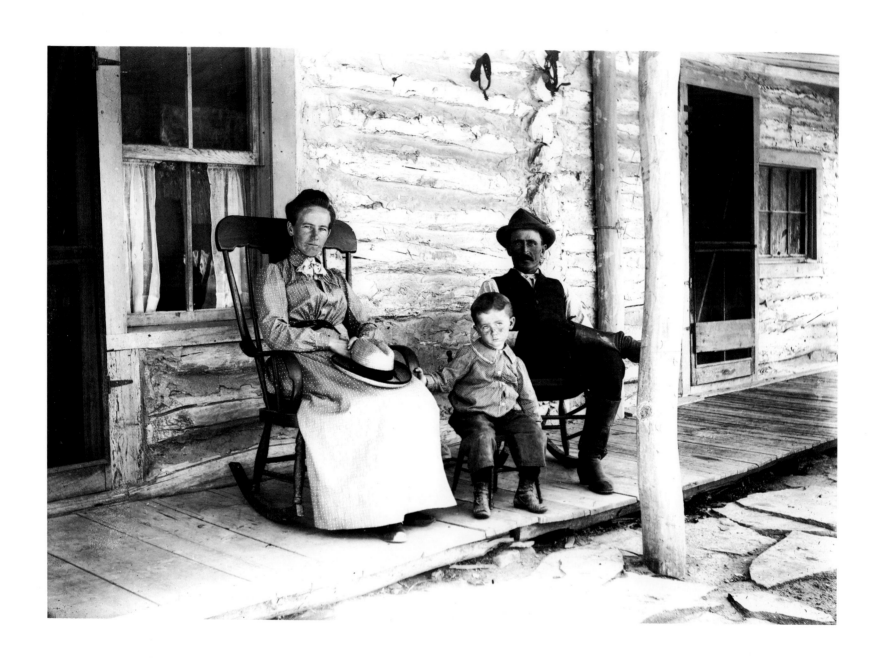

*Evelyn made a day-long trip to photograph Mr. and Mrs. Pope and their son Elmer,
at their sheep and cattle ranch on August 11, 1902. Evelyn had brought along her
hounds and hunting horn so that she could enjoy some sport on the way.*

her new career. A competent amateur, he tutored her in basic photographic techniques before leaving Montana.

Colley, Adams's replacement, whom Evelyn described as "quite good looking, great contrast to Mr. Adams," shared with his predecessor an interest in photography, and he worked with Evelyn on some of her earliest images. Like Adams, Colley had come to Montana brimming with enthusiasm and with the intention of investing in the Camerons' horse-raising venture. Like Adams, he was quickly worn down by Alec's behavior and the rigors of life in the wilds. Despite his initial promises he stayed for just over a year, and then he too left the ranch without putting any money into it.

Having been burned twice, Evelyn was very reluctant to take in another British boarder; yet Colley had been gone scarcely a week when Ewen's mother was pressing upon them another potential tenant. On December 8, 1895, Evelyn noted in her diary:

Ewen got a letter from his mother who writes about a Miss Brown who wishes to live on a ranch in Canada or U.S. . . . She seemed to think this [ranch] would suit. But I do not wish for such coin here.

A month later she wrote to her mother-in-law, tactfully discouraging the idea.

It was very kind of you indeed to take so much trouble about Miss Brown. Unfortunately, [with the onset of winter] it is too late to do anything about it now; but, as Ewen says, the stipend is the main consideration. Miss Brown does not appear to have mentioned what she was prepared to pay to be made comfortable on a Montana ranch. A lady that is devoted to riding could have plenty of it & enjoy herself immensely, but one fond of society would of course be very much out of her element.

Besides, as Evelyn went on to explain, she and Ewen were anxious to get out of the boarder business and begin to cash in on their horses. In the spring of 1895 they had begun sending ponies abroad to T. B. Drybrough, a wealthy British brewer and avid polo player, with whom Ewen was hoping to establish a formal partnership. "Should this come to pass & prosper," Evelyn wrote her mother-in-law, "we should then be independent of these impecunious boarders who, in the long run, give more anxiety than their remuneration can atone for."

The polo ponies, however, were proving even more troublesome than the boarders. One carload of horses had been seriously delayed in April 1895 when the railroad car that Ewen had arranged for in Fallon did not appear for over a week. Evelyn described what had happened to her mother-in-law in a letter dated May 15:

We have been in a regular tumult here since the 1st of April as Ewen has been gathering & sending off a second carload of horses to Mr. Drybrough in Edinburgh. These left [New York] on the 4th of May, but they ought to have left about the 12th of April, but thro' some unexplained reasons the railway companies did not send the car on which to load the horses and the greatest annoyance, trouble & expense has been occasioned all round. The steamer was changed three times & Mr. Drybrough was very much put out & Ewen will have to write him a long letter to pacify him.

They had more bad luck with the railroad the next spring, when one of their horses died on board a stock car before it had even pulled out of the depot in Terry.

Cady Scott [a local man who was tending the stock] went to look at horses 10 last night & 3 [in the] morn. . . . A freight from [the] East passed soon after he left them (3:30). This must have scared Curly so that he plunged, pulled back, broke the halter & his neck. Found on his back with his heels in the air.

Although the Camerons' Montana horses were receiving "very good mention" in the English sporting magazines, Drybrough, from the start, was not altogether pleased. On

Miles City, Mont., *March 5*th *1896*

E. S. Cameron

W. J. ZIMMERMAN,
SUCCESSOR TO
IN ACCOUNT WITH MORAN & CO., Miles City, Montana,
MORAN & CO.,
Wholesale ‡ and ‡ Retail ‡ Saddlers.

To Mdse. 60 days. Bill rendered.

Jany 21 Difference in Saddle $13 00

We are very short of funds
If convenient Kindly send
Check.

The Camerons endured persistent financial troubles when
they were trying to get their polo pony business started.
Ewen's saddler sent a gently worded but firm note
reminding him of his outstanding debt of
$13 in March 1896.

May 28, 1895, Ewen received an angry letter from him. Evelyn noted in her diary:

[Drybrough] is very irate at the look of lot of new ponies just arrived, but he always begins in that strain & then settles down into a contented tone.

Less than a week later, however, another "very unpleasant" letter from Drybrough arrived. "[I] think he is little crazy [to] write in such a wild pessimistic style about horses," Evelyn wrote.

The problem was that the high-spirited Montana ponies needed to be broken for polo—and that required additional time and money. So rather than the expected "immediate

returns from some of them which, as Ewen says, will greatly relieve the situation all round," profits from the horses were not forthcoming.

In fact, the Camerons were so strapped for cash in the spring of 1896 that their shipment of ponies was jeopardized. They were depending on Alec's quarterly stipend to help pay for the transport of the horses, and when it was late, they frantically made Alec cable Wickham Flower for the money. Afterward Evelyn wrote apologetically to Wickham and explained their dilemma:

My dear Cousin Wickham, *dated Ap 3rd [1896]*

I made Alec send you a cable the other day for which I was very sorry indeed, as I know it was a thing that you particularly dislike, & I write now to explain that circumstances left me no choice.

We were sending horses from New York to leave Terry on the 15th March. The horse car was in Terry, the space on the steamer had been engaged, & Mr. Drybrough was coming from France to meet the horses at Glasgow. I relied upon Alec's £30 to make up the money required as we were short, & supposed that your cashier had forgotten to send it—otherwise the delay in sending the money would not have made any difference. I am very much obliged to you for cabling it so quickly & the horses left New York all right.

I told you before that I would let you know what sort of prices the ponies fetched. We have sold some very well indeed considering the great prejudice there exists against American branded horses. One lady who was going to give a good price asked if the brand would go away, when told that it would not [she] refused to purchase. One pony was sold to the Earl of Howth for £88, one to Mr. Sidney Platt for £100 & another to Mr. Crawley [of the] 12th Lancers for 80 guineas. The Marquis de St. Vallier offered £100 for another but this offer was refused, this animal being the best of all we have sent over. These are the largest prices so far. Most of those sold in Edinburgh fetched between 50 &

60 guineas but as they had to be kept a year which means £60 on each . . . there was no profit. A number of ponies & horses are still in Edinburgh unsold; the climate being the great drawback to quick sales as it takes these Montana horses about a year to get properly acclimatised, & then the long keep eats up the profits. However they have been a success [at polo] & the correspondent in France of the "Field" under date Feb. 22nd remarks upon some of them which Mr. Drybrough took over [to France] as being very good.

By the spring of 1897 Ewen had decided that he himself should accompany a shipment of fifteen ponies to Britain. He could shepherd the horses safely abroad, and then have an opportunity to discuss the business personally with Drybrough. The Camerons had made virtually nothing on the horses thus far and, as Evelyn noted in her diary, unless Ewen could "arrange to go in more extensively with Mr. Drybrough . . . probably next summer we would go home."

Ewen had purchased some of the horses he was planning to sell in England from the Cross S Ranch, owned by an Anglo-Irishman and good friend, Walter Lindsay, in partnership with Major Philip S. Dowson. On July 29, Evelyn and Ewen, along with two cowboys from the Cross S, rounded up the horses to be sent abroad and led them down to the stockyards at Fallon. Things began to go awry even before Ewen left Montana, as Evelyn recounted in her diary:

Horses shipped. Ewen's horse fell, got concussion. To Terry.
Lovely day. Cool breeze.
Arose 6. Breakfast 8. Washed up. Got off at 10. Ewen on Pilot, I on Steel, Payne on Buttermilk, [Missouri] Kid on a Ƨ [Cross S] horse. Rounded up horses to be shipped in new pasture. Across flat & to the new road to Fallon. Kid on the lead. Men held them outside Fallon while Ewen & I hunted up Bright & Coggshall. I stayed by section house. Ewen got me a lemonade & egg drink. Mr. Coggshall & 2 tenderfeet & I [had] din at Section House. Mr. Coggshall paid for mine. Ewen was off with horses. I & tenderfeet went & sat on pens & watched cattle loaded [from] J-, 4.4,

On September 14, 1899, Evelyn and Ewen went to Fallon to watch cattle being loaded onto railroad cars. At far left is Mrs. Kempton, a rancher who was half Indian.

-101 [ranches] to make a train load. Last year each outfit had a train load, but this year cattle not fit. Smithy came to me & said Ewen had been hurt by his horse falling. I got down from pens & found him being supported along by George Rock. We got him in the caboose, he could walk & talk but knew not where or for what purpose he had come. Vomited often. Coggshall, Kempton, train men, cowboys came in to look at Ewen. I kept ice on his head. Backed us to section house where he sat in a chair & I kept ice on his head. Payne & Kid took our 2 osses back [to the ranch]. I took Ewen up to Terry [on] 3:20 train. Before leaving Fallon Ewen asked if osses had gone, 1st signs of recovery. . . . [In Terry] went to Scott's [hotel], questions filled the air. Nice 2 windowed room upstairs, got him to bed. Sup I had. Ewen drank down some broth. His head splitting, kept ice on it & he sucked ice. 2 drops of camphor in water to keep down the vomit.

Ewen recuperated at the hotel in Terry for nearly forty-eight hours, but days later he was still reeling from the effects of his accident. Nevertheless, on August 9 he set off for England. He would have liked Evelyn to come too, but, as she explained in a letter to her sister-in-law Jessie Cameron, "it had to be so as our funds would not admit of my accompanying him."

Evelyn was heartbroken as Ewen, whom she affectionately called "Oudally," boarded the eastbound train.

Dear old Oudally left for England. Sad & lonely. Allowed 150 lbs. on ticket to New York. . . .
Arose at 6:40. Breakfast on. Milked both cows. . . . Breakfast at 8:50 ham, boiled eggs, toast, porridge. Washed up. Cleaned overcoat of Ewen's. Henry [Tusler] came & talked a ½ hour or more with Ewen. . . . I got team up & harnessed them. Fini packing for Ewen, he took my little crocodile hand bag & my little portmanteau. I changed. Ewen great swell, [wearing] yellow duck waistcoat, new shepherd's check trousers, new tie & Lindsay pink shirt. Best old coat, cap. Started down [to Terry] at 12:10

about. Ewen had din at Scott's [hotel]. I drank cold tea. Train 1 hr. 10 m. late, we sat it out at Scott's. Cars arrived at 3:15 about & off they took him. I told O'Brien [railroad agent] that I never hated the cars so much in my life before.

Later she wrote to Jessie Cameron: "I never felt so lonely in my life as I did for some days after his departure."

Ewen Cameron was not the only man dreaming of striking it rich that summer of 1897. News of rich gold deposits in the Klondike reached Terry in July, and the town was gripped with gold fever. "Everybody in Terry wants to sell out & go to the Yukon River in Alaska," Evelyn noted. One day she discovered the Terry post office closed because the postman, "Old Snow," had "gone to the river to try the sand prospects of gold." By mid-September the bubble had burst, and the mania for gold was tempered by dreadful reports filtering back from the Yukon. "Many people will have to starve to death up in the Klondike region owing to scarcity of provisions & it is getting too late for ships to bring them back," Evelyn wrote on September 13.

At the same time, Ewen's hopes for riches were being shattered by a disastrous ocean crossing. In a series of letters to Walter Lindsay's wife, Kathleen, Evelyn relayed the news.

Sept 11th '97

My dear Kathleen,
I received a letter from Ewen to-day giving an account of the horses' arrival at the Albert Docks [in London]. In the event of his having neglected to write Mr. Lindsay I here quote verbatim from his letter dated August 31st—
"Drybrough was on hand & Billy Benson too to represent Major Dowson. I had immense difficulty in getting the horses off the ship & you would have cried to see the condition they were in. The little bay Robert . . . could not be got up & died on the ship. All of them were so weak they could hardly walk, excepting Avona & the Pinto which apparently had not suffered at all. I finally got them into a place at Plaistow near the docks but it was 12 o'clock at

night before I saw them able to feed & rest. The present situation is as under — Parachute has to be slung, [he] cannot stand. Farewell could not walk (kidneys wrong), had to be driven to a loose box in a van. It's a toss up whether Bessie lives or not. Major Dowson's horses were in a good condition with the exception of one."

Did you ever read such a doleful account? It makes one feel wretched. In a previous letter received last Monday & posted at Gravesend, Ewen states two horses had been thrown overboard, one being the 2nd best of a carload belonging to a Glendive [Montana] man. . . .

Ten days later:

My dear Kathleen,

. . . Poor old Ewen's horse reports get worse instead of better. I quote from his last letter dated Sept 5th: "The horses are dying like 'rotten sheep' to use the academic expression of the vet. Five are dead — Parachute (we slung him & everything possible was done but he died), Bessie, Storm, the little bay Conceit horse of which Drybrough had 3 photographs, & the little bay Robert horse. They all died of pneumonia accelerated by starvation. The big black (in at the knees) is very bad but I hope he will pull through. We have never been able to get the horses away from the docks & the expense altogether will be frightful. There is £140 insurance recoverable — £40 for the horse that died on the ship & £25 on each of the others. It may be some time before I get the insurance but the Company will be forced to pay on the certificates that the vet has given. I think we ought to claim damages in addition to the insurances, as it is all the fault of the Atlantic Transport Line. Their own vet who attends my horses agrees in this & says that in another case a man lost 18 out of 25. I said on the ship that the horses were being starved to death, but the horse foreman will not allow owners to interfere. I sometimes had the horses fed surreptitiously, & [I] told Freer (the Glendive man before alluded to) that his horses had fallen down from exhaustion consequent on starvation.

The horse foreman said that if the horses were well fed & bad weather came on, they would die. I should think the Company would pay damages rather than be branded with an indelible scandal. I have a meeting with Drybrough tomorrow & if he agrees to prosecute them I will put it in the hands of my lawyer."

On October 5th:

My dear Kathleen,

. . . Ewen writes that six horses are now dead. "The last one to go was the bay mare & although we fed her, & kept her alive, on cod liver oil, milk & eggs, she finally succumbed. The best vets can do nothing because they all died from pneumonia & at the last have no lungs left. The Company repudiated the insurance on the ground that the horses were insured 'far above their value' & Drybrough wrote a furious letter to the manager, Field, & he instructed me to put the matter at once in [my] solicitor's hands to recover the insurance. I thought I would try what persuasion would do. After two interviews I got Field, the manager for the Steamship Company, to write a cheque for £140 all that we claimed & which I have sent to Drybrough. This took a lot of hard talking because Field says he will have to lose the money as the Insurance people refuse to pay."

Having lost a full 40 percent of his horses to the aftereffects of the ocean voyage, Ewen brought the survivors to a farm in western England to recuperate — and to be trained for polo. Drybrough was horrified at how wild his imported horses were. In a letter, Ewen described a hair-raising ride:

I went for a ride with Drybrough on Putney Heath. I rode Cottontail, Drybrough [rode] Doughnut & a new man (rough rider) just engaged to ride the polo ponies [rode] Cattle Queen. Cottontail plunged & tried to run away the whole time; Doughnut nearly went over Putney Bridge & jerked the reins clean out of Drybrough's hands; & Cattle Queen reared persistently. . . . Drybrough's stud groom

A handler steadies "Sir Elmore," a product of the ranch run by J. B. Kempton and his family. The Kemptons were among the first ranchers in eastern Montana and had about 1,500 cattle and 3,000 horses on their spread.

says he can't ride these Montana horses because riding them makes him giddy!

Though spirited Montana ponies made a professional English trainer "giddy," they posed no problem to Evelyn. In fact it was Evelyn herself—and not the itinerant bronco busters Montana ranchers usually used—who gentled most of their horses. Drybrough made a point of acknowledging the success of several imported ponies that she had personally broken, referring to her as "that excellent horsewoman" in his book, *Polo*, published in London in 1898. In the book there is a long section on Montana ponies, written "in collaboration with my friend Mr. E. S. Cameron of the Eve Ranch, Terry, Montana, who during the last few years has selected and sent to England all my ponies and hunters." As the "only importer of Montana ponies for polo," Drybrough was all too aware of the formidable obstacles:

To save freight, not less than a car load of eighteen ponies should be sent at one time, and the cost per head to London would then run from £10 to £15 according to the transport arrangements. The ponies would require six months in England with constant handling and attention (meaning money) before they could be taken on to a polo ground. Even then, their prices as promising polo ponies would hardly pay expenses, so that the first educationary season over, there would be nearly another year's keep before the next season came round. Of course all the ponies would not turn out well; some would be too excitable and pull too hard; others so shy that they would "scare" at other ponies and players; and a few would never make polo ponies at all.

Drybrough claimed that "a really gentle, reliable horse is almost unknown in Montana, and one of this sort to carry a

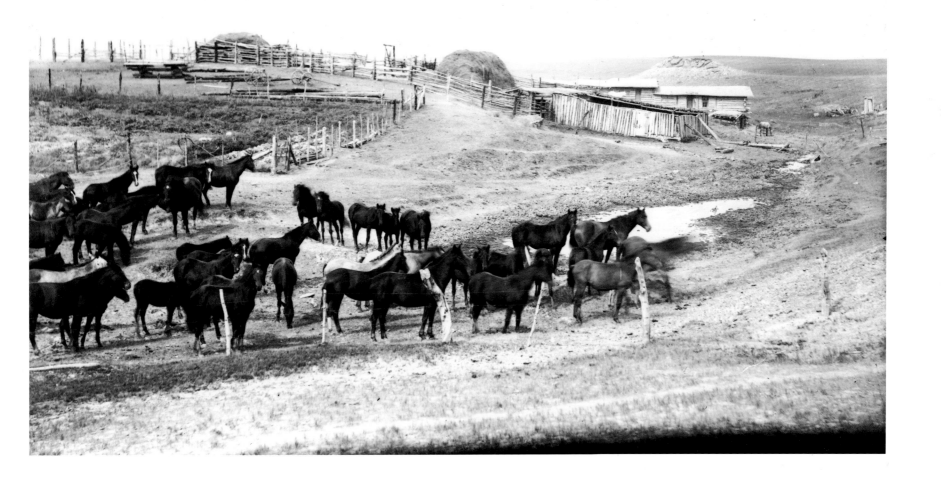

An unidentified horse ranch in eastern Montana. Evelyn broke ponies at the Camerons'
ranch; after struggling one day with a foal that "fought like a demon," she complained
that "my fingers are so split I can hardly write."

side-saddle, with youth and good looks thrown in, is well worth 100 dols. (£20) there to-day." But though Montana produced splendid animals with "hardy constitutions" due to the unlimited free grazing on the "wonderfully nutritious" grass and the "exceptional dryness of the climate," they were generally trained for cattle work, which, in his view, made them "very far from the pony of civilization."

The gist of the whole matter is that importing Montana ponies *unbroken to polo* will never pay. If they have not been thoroughly trained to polo in Montana, the speculation is not worth undertaking, even if the ponies could be had for nothing. . . . It is irritating to know that roaming over Montana prairies there are thousands of excellent ponies purchasable at from £5 to £15 each, good enough to play in Champion Cups, and worth Champion Cup prices when properly broken, yet unavailable simply because the ranch men have not learned how to make them suitable for the English market.

The Camerons had learned the lessons outlined in Drybrough's book all too well. Exporting polo ponies from Montana simply did not pay. The last days of 1897 marked the end of Ewen's career as a breeder and exporter of polo ponies.

Before leaving England, he had to try to salvage what he could from the wreckage. Settling his affairs took much longer than expected, and, now accustomed to Montana's dry climate, he had to endure a "horrible" siege of soggy English weather. "It has done nothing but rain, & they have snow in Scotland," he complained in a letter to Evelyn. To make matters worse, he fell ill. Writing to Effie Dowson, Major Dowson's wife, at the end of October, Evelyn reported that "[Ewen] has been suffering from chills, & as they generally settle on his larynx they are often quite serious; but now he has gone up to Scotland where I hope the air and strong exercise will set him up again." In the same letter she mentioned that she expected Ewen home by the end of November. But Thanksgiving Day came and went, and he still had not returned to Montana.

Evelyn meanwhile had to run the ranch alone—and face the growing number of restive creditors. The Camerons were indebted to shopkeepers as well as to ranchers who had sold ponies to Ewen for export. A series of notes came due at the bank, one for $550. Though she sold photographs and even slaughtered a cow and sold the meat to earn money, there was no way Evelyn could cover the payment. Ewen had always been in charge of their finances, but after their banker, H. B. Wiley, wrote saying that "he had heard nothing from Ewen in regard to the loan," she realized that "Ewen has forgotten all his business here & let it slide."

Over a month later Wiley, increasingly impatient, wrote again to find out when Ewen was expected back. On the same day Evelyn received a cable from Ewen. She opened it eagerly, hoping "it was announcing his arrival in New York!"; instead he wrote frantically from London for money. He would be unable to leave for Montana until her annuity was paid directly into his English bank account.

So, no Ewen for Christmas, nor even a festive goose for the occasion. Evelyn wrote sadly on December 22:

I could not send for a goose because Ewen owes the butcher in Miles $9 & as I cannot pay it how could I order a turkey or goose—worse luck. I asked Alec which he preferred for Xmas day leg of mutton or chicken. He chose leg of mutton.

Evelyn was hardly in a holiday mood and confessed in her diary a few days before Christmas to being "rather blue getting letters & presents from everybody." Despite her low spirits, she spent all of Christmas Day preparing a feast for herself and Alec. Her diary entry on Christmas Day, 1897, reads:

Cooked all day. Made pudding [&] mincemeat. Sup 7.
Lovely. Mild. No wind. Became little overcast. Arose 7:20.
Milked. Breakfast 9:30 cream biscuits. Fed chickens.

44

Washed up. Alec helped, wiped. Out. Got the leg of mutton from store house. Made the [plum] pudding—2 cups (1 pint cup) flour, 1 cup suet (mutton!), 1 cup stoned raisins, 2 cups currants, citron ½, small cup mollasses, allspice, nutmeg & cinnamon stirred up, put in a tin & steamed from 1 o'clock till 7:30. Fire on at 12. Chopped up 1½ lb. citron, 2 cups stoned raisins, 3 cups currants, about 2½ cups suet, sugar, spices for mincemeat. Took from 2 till 3:30 to stone the raisins for mincemeat. Alec helped. At 3:30 I fed chickens & hayed mangers. In finished making mincemeat. Washed up utensils. Milked 5. Cauliflower on, tatoes done round meat. Wrote diary. Washed changed. Did hair top o' head.

By mid-January Ewen still had not arrived, and on the 18th Evelyn was shocked to see her husband's name on the "delinquent tax list" in the *Yellowstone Journal* (Miles City's newspaper)—"nuissance, $27 odd I can't pay." The taxes had to be paid before February 7, and Evelyn had no idea how she would come up with the money.

The very next day, however, there was a glimmer of hope. Ewen cabled from Liverpool to say that he was sailing at last on the steamer *Germania*. "Oh dear I hope Ewen will arrive tomorrow," she wrote on January 31, the eve of his anticipated return. "I am looking forward so dreadfully to seeing him again. I feel quite excited already."

Eagerly she headed off to Terry in a light snowstorm to meet him, but Ewen was nowhere to be found. Instead, at the post office were

3 letters from Ewen written on steamer train & [from the] Merchants Hotel, St. Paul. Is there [in St. Paul] with no funds to proceed! Wants me to borrow from Alec $30 if possible, Alec only had $3.50, I $1.50. Got Stith [a storekeeper] to lend me $10, thus send him $15 registered envelope. Sent 40 cent telegram "Mailed fifteen dollars."

Having traveled thousands of miles en route home, Ewen was now stranded in a city twenty-four hours away. Taxes had to be paid in less than a week and he could not even afford the $26 second-class fare from St. Paul to Terry.

To add to Evelyn's woes, the Camerons' valuable hunting dogs had been stricken with some kind of deadly lung inflammation. She had already shot one of the animals to put him out of his misery, and was frantically nursing another, plying him with homemade remedies of turpentine and water and whiskey.

By February 4 she herself was feeling ill:

Afraid [I] have got inflammation [of the] lungs beginning.... Arose 7:05. Didn't sleep at all last night, felt as if my lungs were being pressed by something & kept awake in consequence. Glad when light came. Pork pie perhaps caused indigestion & yet the pressure is over the lungs. Caught it perhaps from Foxey [the sick dog] although I don't think that possible. I lit fire. Milked 3 cows. Breakfast 9. Alec very concerned [about me]. Washed up & swept.... I emptied little dress trunk & filled it with things for Miles City in case I got worse & had to go there. Lunch of 3 pieces of oatcake, one piece of toast for breakfast. Drank sage tea. Afternoon & evening I wished Ewen would come so.... Felt horrid lonesome feeling.

The next day, Saturday, she went to Terry for news of Ewen's whereabouts and found a telegram from him: "Joy! it read 'arrive ... Saturday.'" Evelyn met the westbound train, and to her delight, "Ewen got off very end. Oh so glad to see him." It had been nearly six months since she had laid eyes on her husband. And he came bearing gifts, including a Cameron tartan rug, an Austrian blanket and an Italian raw-silk blanket, and six pairs of flannel combis (one-piece undergarments).

Evelyn never explained how Ewen had scrounged up the fare to Terry. His return was all that mattered. Somehow he was also able to pay their back taxes, but the heady days of breeding polo ponies were over. The Camerons sold out their horses and bought a small herd of cattle. As usual, Ewen's timing was impeccable. No sooner had he invested in beef

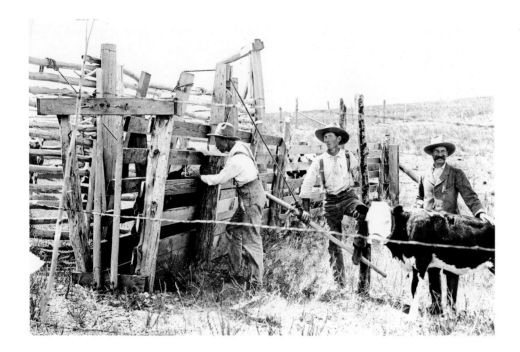

Ed Bright reaches through a fence to vaccinate one of the Camerons' cows against blackleg disease on July 27, 1899.

than blackleg disease began spreading through—and devastating—the local herds, while the horse market, which had stagnated through most of the 1890s, was just about to explode. With the outbreak of hostilities between the English and the Boers in South Africa in 1899, the demand—and the prices—for Montana horses soared. Unfortunately, the up-turn was too late for the Camerons. Their only legacy from their horse-breeding days was a leather-bound first edition of T. B. Drybrough's book, *Polo*, inscribed:

To Mr. and Mrs. Cameron
with the Author's kindest regards
July 1898.

The collapse of their dreams of wealth had no noticeable effect on Evelyn's naturally buoyant spirit. Despite occasional misery, her chronicle of her days is no tale of desperation, but one of perseverance, belief in the virtues and rewards of independence and hard work, almost unbelievable physical endurance, and more than a little adventure.

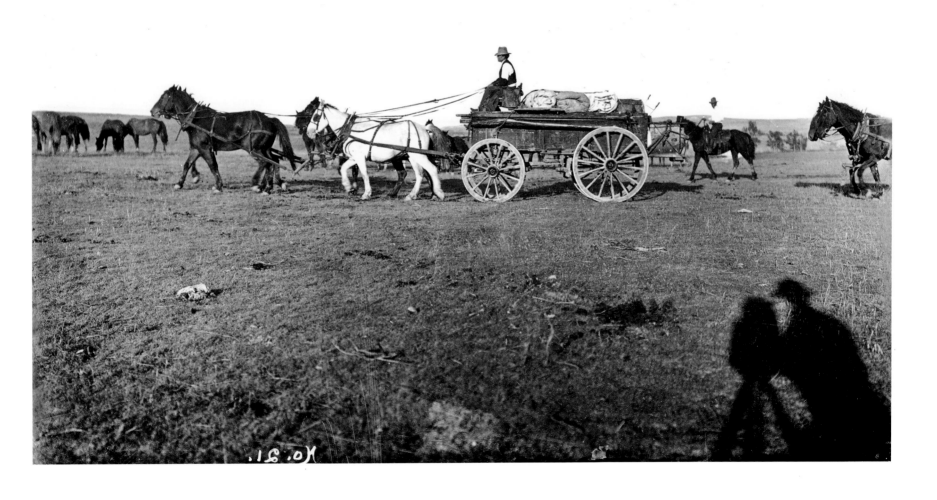

Late on a September afternoon in 1910 Evelyn photographed a roundup wagon, packed with bedrolls and supplies, on the move across the prairie. Cattlemen held two roundups a year, one in the spring to gather the herds and brand calves and one in the fall to trail the mature cattle to market.

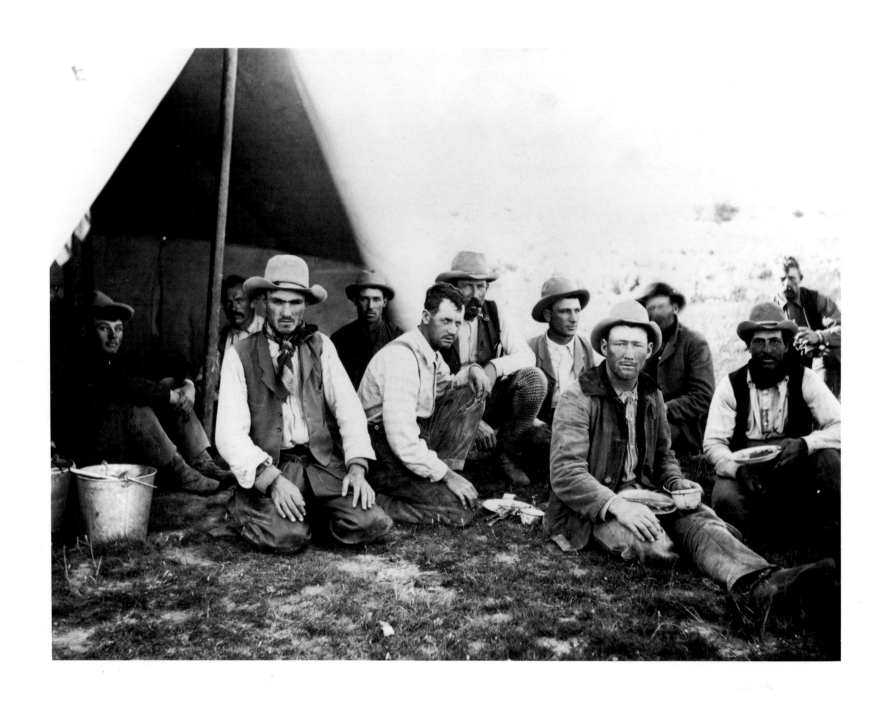

Roundups were visited by "reps," the representatives of distant ranches, who kept an eye out for any of their outfit's cattle that had strayed from the home range. On the western social scale, reps were a notch above cowboys. Evelyn photographed this group in June 1904.

Charlie Clement, a former XIT *cowboy who had trailed horses from the Texas panhandle to Montana, came to the Cameron ranch and asked to be photographed with his pack of deer hounds. The* XIT *cowboys kept hunting dogs at their home ranch on the North Side of the Yellowstone to protect their herds from wolves and coyotes.*

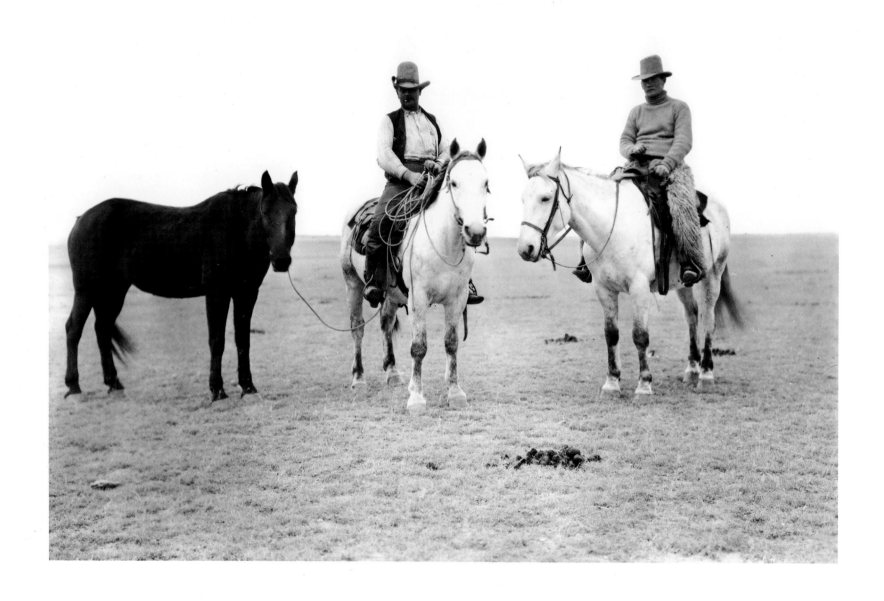

XIT *cowboys on the Montana range. Work was hard and luxuries few—though the cowpuncher on the right probably spent nearly half a month's wages on his fluffy angora wool chaps.*

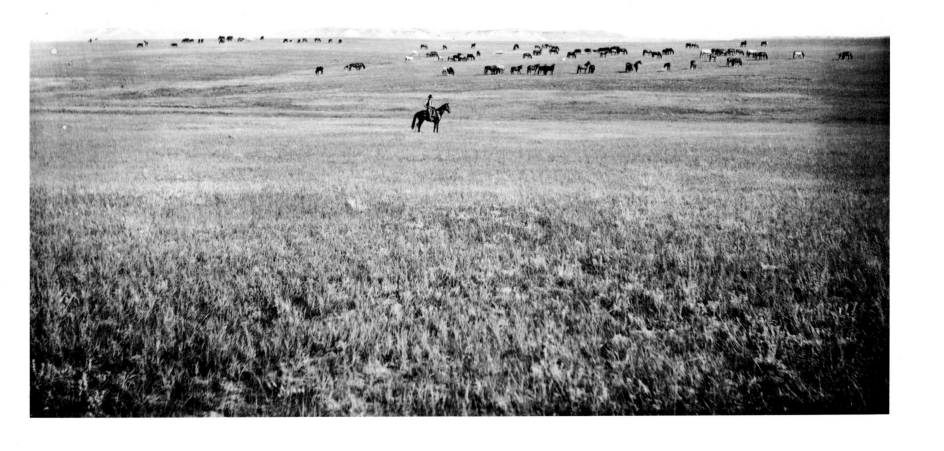

June 1904.

SPRINGDALE PUBLIC LIBRARY
405 South Pleasant
Springdale, Arkansas 72764

*Ewen, J. H. Price, Janet Williams, and her sister Mabel, at Price's
horse ranch near Knowlton in October 1909.*

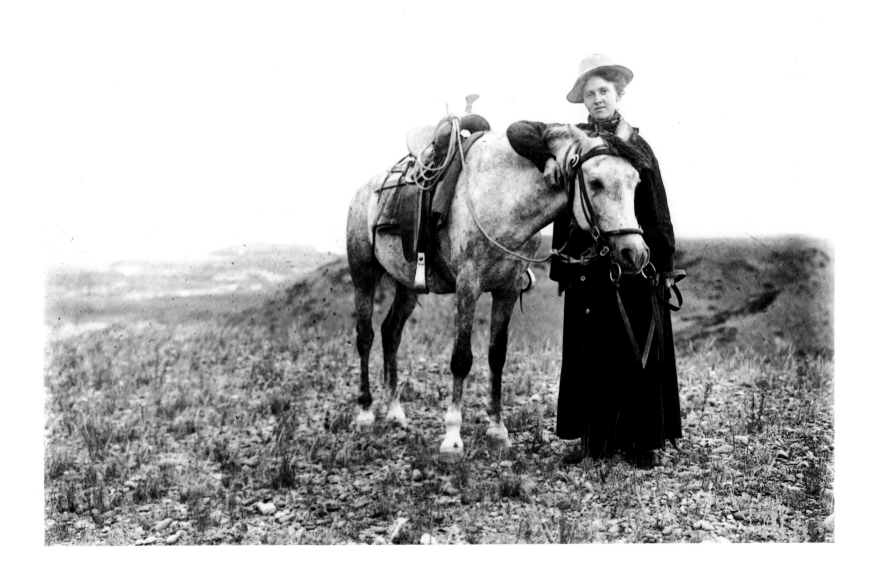

Janet Williams and Zip, her favorite horse, in the hills overlooking the
Yellowstone River, July 1911.

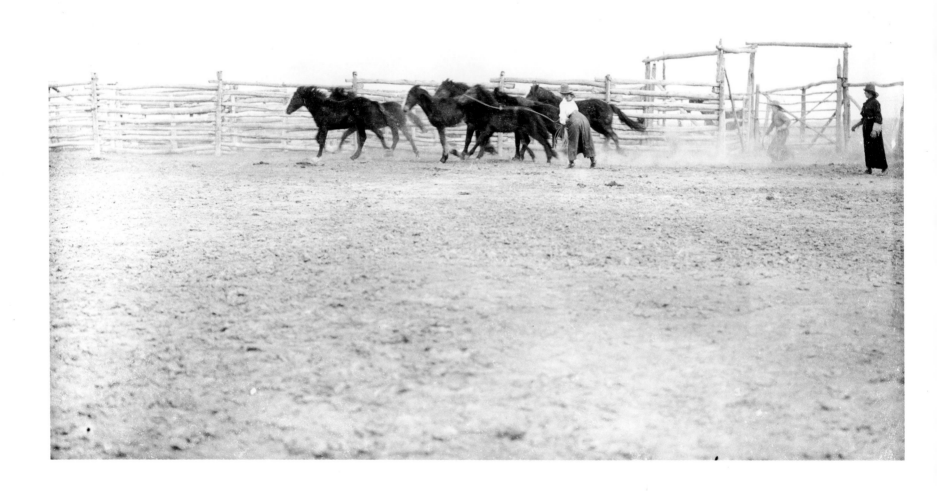

The three Buckley sisters, Mabel, May, and Myrtle, in their corral. The Buckleys,
renowned for their skills as horse and cattle handlers, ran a ranch with their mother;
their father was away a good part of the year on roundups and other ranch business.
Carnival managers tried to hire the sisters, and they were invited to perform
for Theodore Roosevelt, but they declined.

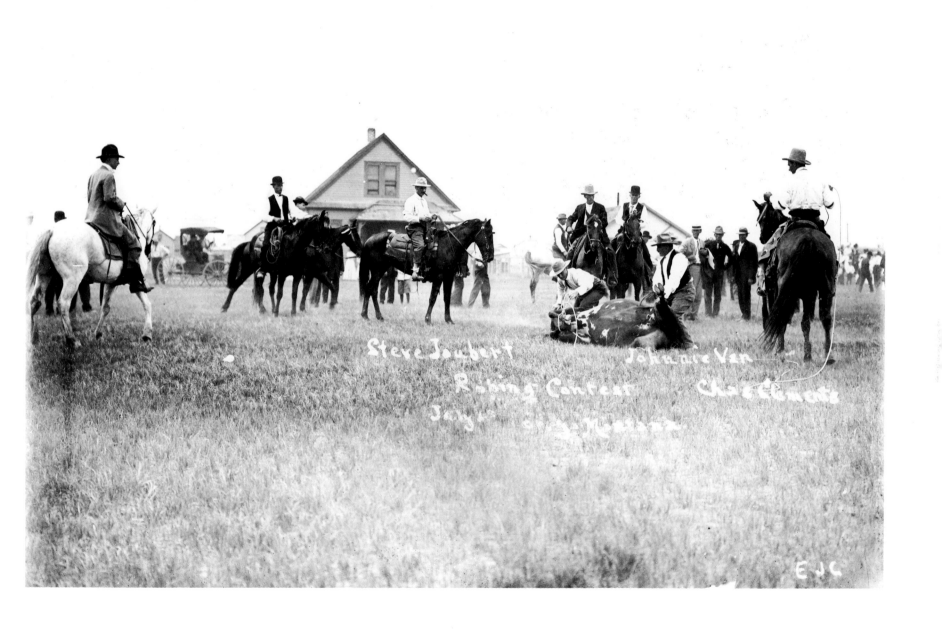

*A steer-roping contest in Terry on the Fourth of July, 1910. Charlie Clement, on the horse
at right, won the contest with a time of 32 seconds and pocketed the prize of $65.*

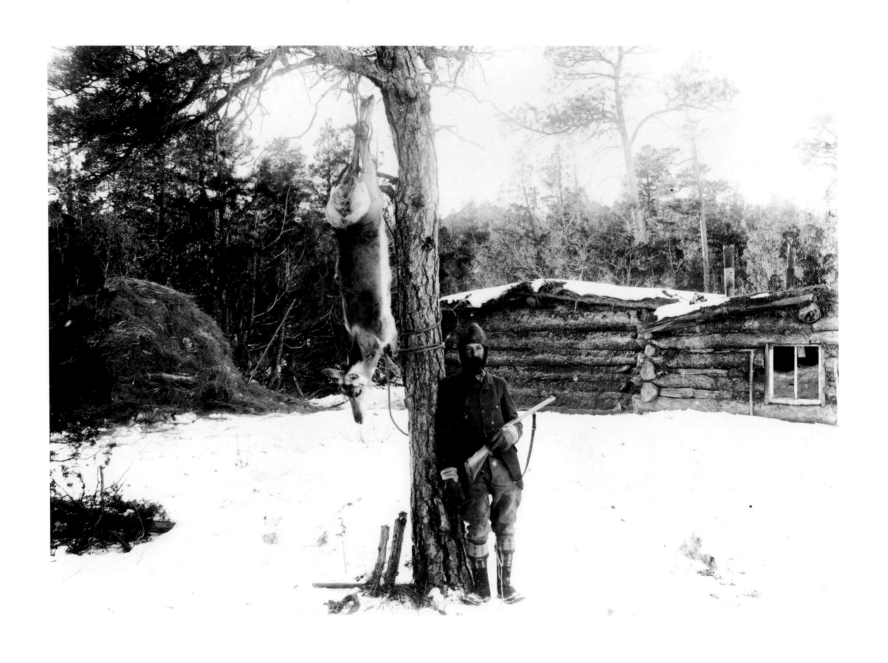

Ewen poses with a pronghorn antelope he shot on one of the Camerons' hunting trips some time in the 1890s. They probably took shelter in the log house in the background.

Hunting

ONE OF THE main reasons the Camerons had settled in eastern Montana was the prospect of unlimited hunting. Each year until 1900, they left their ranch in late fall to hunt in the outback, living as long as two to three months at a time in a tent, shack, or primitive dugout. They stalked antelope, mule deer, and mountain sheep, and generally returned home with a winter's supply of meat. Food was not their only goal, however; Ewen's research was equally important, and he meticulously observed and recorded details about Montana animals and birds in their natural habitat. While stalking bear in the spring of 1890, for example, he did not fail to note that "On April 7 the migration of wild-fowl was at its height, and I have never since seen the Anatidae so numerous as when camped near the Big Dry River at that date."

Evelyn, for her part, often photographed the animals they came upon in the badlands. For example, explaining the delay in the day's deer hunting on October 20, 1895, she wrote:

After breakfast Ewen saw a Prairie Falcon perched on the cliff of the creek above us about 30 feet. Mr. Price [a hunting companion] just broke the pinion feathers [with a rifle shot], the poor bird came down with a screech. I got camera & photographed it on a rock in the creek twice, side & full views. It seemed particularly irate with Mr. Jones [another companion] whom he clawed.

As part of their nature studies, the Camerons also skinned interesting wildlife specimens—and on one occasion, Evelyn brought them back live. After firing the decisive shot and fatally wounding a mother grizzly bear, she insisted on bringing the two orphaned cubs back to camp on horseback— despite the fact that night was falling and that "the scent of a bear," as Evelyn put it, "is often enough to throw [horses] into a panic."

Years later, in an article she wrote for the English journal *Country Life*, Evelyn recounted that twelve-mile journey in the dark.

With the side-saddle the cub could be supported in my lap, but had I been riding man-fashion, I doubt if I could have held the struggling and shrieking creature for so long a time. Although my horse protested vigorously at first, I coaxed him to endure the cub, and after a time he paid no attention to it.

Having successfully transported the animals back to camp, Evelyn immediately took charge of their care.

Among our supplies we had a case of condensed milk. My first act on reaching camp was to prepare some of this & feed it to the cubs. Strange to say, they took to this un-natural food from the first and thrived on it. . . . When we got back to Miles City they were in the pink of condition on their condensed milk diet.

Having reached a point of comparative civilization I decided that it would be a kind and wise thing to put my young charges on a diet of cow's milk. But this experiment failed miserably. The cubs nearly died in consequence of it and I had to return to condensed milk in order to save their lives.

The Camerons packed off their prizes by steamer to England, where they were presented to the London Zoological Gardens, which had lost its last grizzly bear about six months before.

Apart from the research possibilities and food that their long hunts provided, Evelyn and Ewen both enjoyed the sport. And Evelyn was particularly enthusiastic about the camaraderie of the trail. In an article entitled "A Woman's Big Game Hunting" that appeared in the New York *Sun* in 1906, she was quoted as saying:

For the woman with outdoor propensities and a taste for roughing it there is no life more congenial than that of the saddle and rifle, as it may still be lived in parts of the Western States. . . . Where the wife shows any liking at all for life in the open I consider a hunting expedition one of the most desirable ways for a couple to spend a holiday. It

is wonderful what comradeship is developed between them. All sorts of cobwebs get blown away in the long days together on the windswept prairies or in the gulches and trails of the Bad Lands.

Camping out—particularly in the autumn and winter—required a strong physical constitution. Even Evelyn admitted in her diary that her "bones ached" from the "rather hard ground" when she and Ewen started out on their hunting trip in October 1894, but she shrugged off the discomfort, knowing that she would "become accustomed to it after 2 or 3 nights."

Not only was camping out uncomfortable, it was dirty. Spending months at a time tramping through the wilderness and huddling around a campfire was not for the fastidious. During an extended hunt in 1894–95, Evelyn and Ewen left Alec behind at a remote campsite while they went to Terry for supplies. When they returned to the camp, she noted in her diary, the usually well-groomed Alec "looked like a wild man, long hair & very torn, black with smoke clothes . . . hands & face same colour."

Opportunities to bathe on hunting expeditions were rare, and Evelyn took advantage of them—regardless of the cold. She described one such occasion on November 19, 1899:

Down to the [Yellowstone] river, washed beef for stew. Looked so inviting for a bath, altho' I knew the river was awfully cold, but it surpassed my expectations when later I undressed & had a bath. The water was intensely cold. I hurriedly soaped myself but the horrid soap "White Lily" floats & I had to keep grabbing at it to prevent the stream taking it off. Shook clothes before dressing, so dusty.

On most of the Camerons' wilderness expeditions, finding decent water was a critical problem. Particularly in the bad-lands, springs and creeks were scarce, and they were often dry—or virtual swamps, their water barely drinkable—after a hot summer. While camping in a desolate stretch of country in the fall of 1895, Evelyn wrote that the hunting party

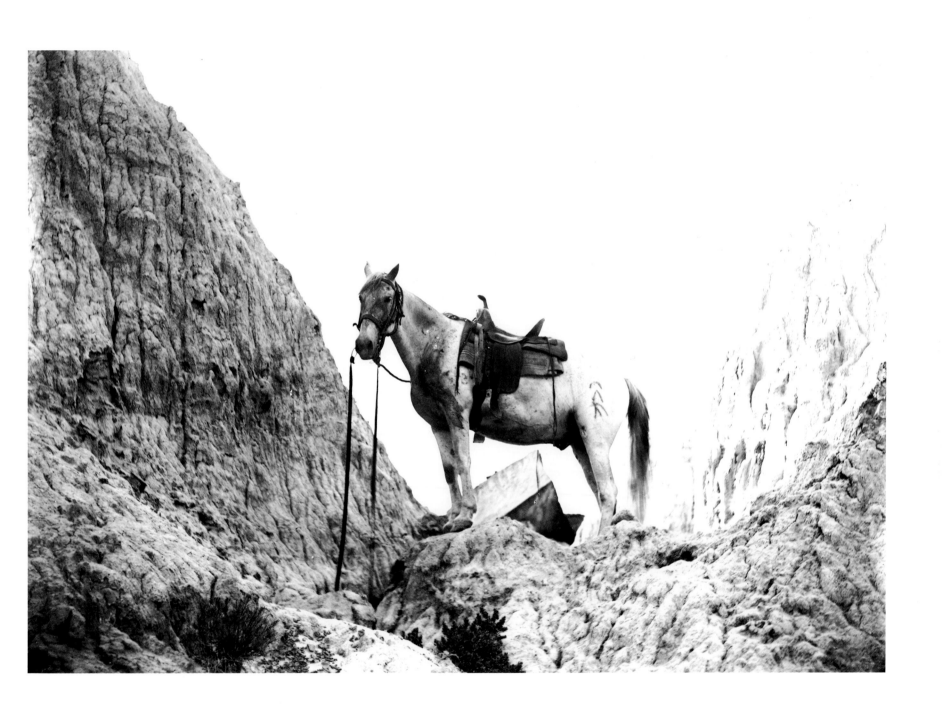

During hunts, Evelyn, who complained about the monotony of the work, took care of the horses while Ewen would stalk the game.

"dug where [a] spring was, but it ran so slowly [we] had to get coffee water out of a pool frequented by stock all summer. Water was simply essence of cattle." But the "essence of cattle" was not the only problem. Water sources in the hinterlands were often thickened with gumbo mud and almost always tainted with alkali salts, which gave the water an unpleasant, acrid taste and, even worse, had a laxative effect. The result was that the hunting parties often suffered from diarrhea, which was especially difficult for Evelyn who was almost always the only woman among a group of men.

As the lone woman on these expeditions Evelyn had no privacy, nor was she treated with any special deference. She was expected to pull her share of the weight, if not more. It was inevitably assumed that she would take charge of the general upkeep of the camp, the cleaning, mending, and packing and unpacking whenever the campsite was moved. She gathered the fuel—whether it was dried cattle dung, sagebrush, or wood—and made sure that there was an ample supply of water on hand.

Her duties extended to the field as well. When she and Ewen rode out from their camp to a hunting ground, he often expected her to tend the horses while he went off on foot stalking game. For hours at a time she would be left sitting in the middle of nowhere in the company of a string of horses. Evelyn found this a particularly boring—and irksome—task, and she made her feelings about it known to her husband. Nevertheless, she reluctantly did it—and when the game was shot, she trailed Ewen to the site and helped strap whatever he had killed onto the back of a recalcitrant horse, no easy task.

When they brought carcasses back to camp it fell to Evelyn to clean and skin the animals (saving the entrails for use as bait in the traps that she set nearby), and cook the meat for the hunting party and the pack of dogs they brought along. If the hunting was good, there was no lack of meat at the campsite. Without cows, however, there was no fresh milk in the wilderness. The ever resourceful Evelyn came up with a solution during one of their hunts: "Snow & condensed milk very good substitute for cream."

Evelyn was generally stuck with most of the cooking during long hunts, even when the hunting party included a hired hand. The one exception was the fall hunt in 1895 on which the Camerons were accompanied by three other men: Colley, their wealthy boarder; an Oxford professor–turned–Montana horse rancher named J. H. Price; and Madoc Jones, an alcoholic English attorney who had forsaken law to work as a cowhand on Price's ranch. Jones had been hired on as a cook for the trip, and his work in the wilderness was fine; a problem arose, however, when the hunting party got too close to civilization. En route home the party camped within three miles of a "road ranch," and the temptation proved too much for Jones. Evelyn had to take over the cooking. She wrote:

> Mr. Jones incapable, too much whiskey aboard. Mr. Jones confided in me that all his mother's family drank away their property [in the] North of Wales & their lives also. He has 2 brothers alive who are temperate. A brother in 3rd Dragoon Guards was intemperate, died from pneumonia.

Jones's binge was understandable (Evelyn certainly did not hold his lapse against him): it had been a long and difficult hunt in the Missouri Brakes, a rugged tract of land that, Ewen wrote, "borders the Missouri River between the mouths of the Big Dry and Mussellshell, extends to 65 miles long by 10 wide, or thereabouts, and is almost entirely composed of gumbo clay." It is one of the most inhospitable tracts of badlands in the United States, country "so rough only a bird could cross it," as a local cowboy put it.

The 1895 hunt penetrated into the heart of this trackless wilderness on the North Side of the Yellowstone. The first problem was getting there. The hunting party set out from the Cameron ranch and rode the 48 miles to Miles City. After buying last-minute provisions (200 pounds of flour, 600 pounds of oats, and 50 pounds of meat) at W. B. Jordan's store, they were ready to set out.

There were no bridges across the Yellowstone, so the group had to use one of the handful of ferries operated by entrepreneurs along the river. The ferry outside Miles City was being run by two women, a Mrs. Curry and her friend, Miss Hamilton. Ewen, Price, and Colley took the two heavily laden wagons across; Evelyn and Mr. Jones were in charge of over a dozen horses. At first, they tried to swim their bunch across but, as Evelyn noted, "Further than girth deep they refused to budge, sore throats we got in our efforts to make them swim." Finally, she and Jones led the frightened horses up the slippery wooden incline into the raft; for his efforts, Jones "got a kick in amongst them."

After reaching the North Side of the river, the hunting party headed off into the desolate wilderness. "It was estimated as 132 [miles] to our destination from Miles City by the round up roads we would have to use," Ewen wrote in a piece entitled "Sport in the Badlands of Montana U.S.A." He went on:

For the first half of the journey we travelled in company with the LU cattle outfit which having made their last shipment were returning to the ranch on the Little Dry for the winter with 2 waggons and 73 horses. This was advantageous, as it saved us the trouble of looking out camping grounds on a treeless and waterless plain we passed over abandoned to sage grouse and antelope.

From Evelyn's perspective as a woman, however, there were drawbacks to traveling with the LU cowboys. She noted the day's events in her diary entry for October 8:

We drove horses ahead of LU outfit wagons . . . which crawled along as they are taking out their winter supplies to the ranch, one wagon being loaded with 4,000 lbs. A half drunken cowpuncher, brother of the absent foreman named Case (Bill Case, foreman), bothered us the whole day. Kept galloping up & lolling all over his horse, he became *very offensive*. Mr. Jones at intervals tried to get him

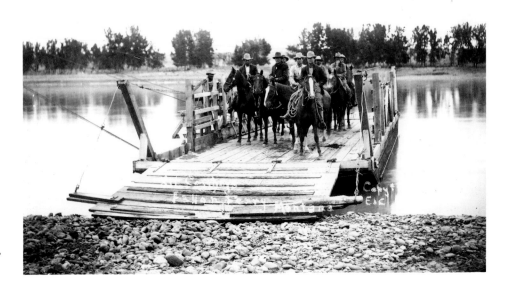

A group of XIT *cowboys crossing the Yellowstone on the Fallon ferry during the fall roundup on September 10, 1904. That day they had driven 482 head of cattle across the river.*

behind. A race I started between Mr. Jones and Case resulted in the whiskey bottle falling out of Case's pocket at the crowhopping of his horse.

They camped that night 100 yards away from the LU outfit. Evelyn was fortunately not bothered by the drunken cowpoke the next day: the hung-over Case did not turn up, and another cowboy took over for him, "owing to Case's indisposition."

All that day and the next the hunting party traveled through "woodless . . . & waterless" wastes, using dried cattle droppings fuel for their campfires. Finally, at about 5:00 p.m. on October 10, the Camerons and company arrived at the home ranch of the LU outfit, where they were welcomed by the "good looking" cowpuncher Henry Tunis and the cook Fred Smith.

Hospitality was the rule on Montana ranches. Company was an infrequent and welcome diversion, especially during the winter; after the cattle had been rounded up in the fall and the livestock ready for market shipped off by railroad, most of the cowboys were let go, so the winter months were lonely, with only a few hands retained by the ranch owners to man the home ranch, break horses, and patrol the range. While at the LU Ranch, the Camerons were given the prime sleeping quarters—a rough-hewn log house that was the "Bosses' sanctum." (In an area completely bereft of trees, the log cabin was unusual; the bunk room for the cowpunchers and the kitchen were built of stone.) The cowboys told Evelyn that she was the "second woman that has been to this ranch & the first woman to sleep here."

The hunting party laid over at the ranch for two nights to rest their horses and to bake bread for the trip. For Evelyn, as always, there was other work to be done. During the stopover she mended clothes, skinned out a small horned owl, cut Ewen's hair and beard, and caught up on her diary. She also photographed the ranch with the LU cowboys standing in front of it. The cowboys, in turn, entertained their visitors with "cowpuncher tales . . . of men being frequently frozen to

death trying to get to Miles etc. in this country in winter."

Henry Tunis gave them "an account of the country," in particular the problems the cowpunchers faced from bands of Indians that roamed south from Canada. Although organized Indian resistance in Montana had ended in 1878, there were some Indians who had refused to submit to grim reservation life in the United States and had fled to Canada. With the extermination of the buffalo herds, these renegades survived by poaching on reservation lands, rustling from Montana stockmen, or indiscriminately slaughtering game for their skins. Evelyn wrote in her diary:

> Indians, the Crees [who] come across the line (from Canada) are now hunting in our country on Lame Foot Creek. They hunt for hides, these they change for "chuck." They are not good shots but there being so many they surround them in the brush along the Missouri [River], getting sometimes 30 in a drive! If somebody would represent this slaughter to [the] Governor it might be stopt.

The Camerons and their companions left the LU Ranch and set off even deeper into the wilderness. Nearly two months were to elapse before the hunting party returned to civilization. They almost didn't make it. By the time they had retraced their steps to the banks of the Yellowstone, the ferry boat that they were counting on to transport themselves and their gear was frozen solid in the river. Evelyn described what happened, as well as Ewen's exceptional marksmanship, which made him something of a local celebrity, in a letter to her mother-in-law in January 1896:

> *My dear Mrs. Cameron,*
> We only returned on Dec 7th from a hunting trip on the North side of the Yellowstone accompanied by Mr. Colley, Mr. Price & a Mr. Jones an English lawyer. . . . All the party were anxious to shoot mountain sheep which, as you know, are considered the most difficult game animals to circumvent on this continent. Ewen was the only one who got any, & he managed one day to kill five with six shots, a

feat which the papers said broke all records for N. America. Indeed one enterprising editor, in Miles City, applied for our portraits on this account but we refused to give them to him. In spite of this extraordinary haul of mountain sheep, I was very disappointed because I could not be satisfied with anything less than a bear & we never even saw the track of one. The crossing [of] the Yellowstone river was even for us quite an adventure. It looked almost a superhuman task to get 2 heavy waggons & 15 horses across to the Miles City side with no other means except a little skiff. The waggons had to be taken all to pieces & ferried across in bits, the heavy parts being towed behind. The horses swam across beautifully. Nobody in Miles City thought we could get across, but Ewen was determined to go & where there is a will there is a way. All our difficulties arose from the fact that the big ferryboat was frozen in the ice & could not be extricated.

Dusty and weary from the long hunt, the Camerons checked into the Macqueen House, the most famous hostelry in Miles City; the chambermaid lent Evelyn a skirt so that she might socialize freely among the other guests. Evidently her hunting adventures caused quite a stir in the genteel sitting room of the hotel. She noted with amusement in her diary:

A lady Mrs. Malone introduced me to in [the] sitting room said it was like talking to some character out of a book to talk to me!! The hunting trip seems to make them think the woman who hunts a wonder.

It was rare for a woman to go on an extended hunt in the wilds—and even rarer for a woman to enjoy it. "Lying out on the snow and the watersoaked ground in defiance of sciatica, neuralgia, rheumatism, bronchitis, and pneumonia," as Evelyn described it, was not many women's idea of fun. In fact, the majority of them would probably have agreed with the woman Evelyn met at the Terry post office who "expressed her dislike very strongly to camping out."

The Camerons went on only one lengthy hunt with another woman in the party. The experiment was not a success. In the late autumn of 1898 Effie Dowson accompanied them on a hunt in the badlands north of the Yellowstone River near Terry. Mrs. Dowson was not the roughing-it type. In a letter to her mother-in-law in 1896, Evelyn described her as the wife of a "rich English brewer . . . [who] comes out nearly every summer & likes the life very much, although she is more of a society dame than a woman of the backwoods." She employed a maid at the Cross S Ranch, and for the hunting trip she brought along a "guide" named Jesse.

Neither Jesse, whom Evelyn described as a "very untidy boy, [leaving] everything in a pickle," nor Mrs. Dowson was of much help during the hunt. Effie arrived at the Eve Ranch several days before the trip began and at once interfered with preparations. "Longing to make list out properly for trip & to sew, but Effie wanted me to hold [the dog] Jan for her to paint in water colours," Evelyn wrote. She had no time for such idle pursuits. Preparing for a hunt, with all of its attendant packing and cooking, was exhausting work. (Just before the start of their 1894–95 hunt, Evelyn had written wearily in her diary: "Packed the waggons. Tiring day. I cooked hard evening. . . . Very tired on legs. I can appreciate the feelings of a cab horse, 'when down can't get him up.'")

At the ranch Evelyn was up at six-thirty and had already lit the fire, fed the chickens, and milked the cows before her guest stirred. The day began gently for Mrs. Dowson, who was served breakfast in bed. In addition to bringing Effie her morning coffee, buttered toast and watercress, Evelyn had to "put [an] oil can of water on for Mrs. Dowson's bath."

This royal treatment did not stop in the wilderness. Mornings during the hunt Evelyn would serve Effie breakfast "au lit," taking her "boiling water [in a] china saucer & cup in which a 'tea tabloid' was dissolved." The idea of hunting in the wilds was apparently more romantic to Mrs. Dowson than the reality of it. She arrived with such necessities as a deck chair, a fur collar, and a bangle with a "lucky stone" that she promptly lost.

Evelyn's diary for 1893 includes this meticulous record of the amount of food she packed to feed three people on a nineteen-day hunting trip in November of that year and the amount of each item that she brought back. By consulting this list the following year, she could see what rations could be reduced. Loathe to waste anything, she went to the trouble of carrying back even trifling amounts of leftovers, such as a half cup of grated cheese and one tablespoon of coffee.

Though she managed to last for nearly a month living in a rough shack in the outback, Effie never ventured very far from camp. Most days Evelyn and Ewen went off hunting alone, because Effie was not feeling up to it. She suffered from headaches and from the laxative effects of "concentrated alkali water"; and she had none of Evelyn's hardy spirit and curious nature. On a cold November 24 she opted to stay in camp to rest and bathe in the snow water that her guide Jesse was heating for her. Evelyn and Ewen, however, despite a chilling west wind and snow showers, hunted on foot in the badlands, where they were fascinated by the geological curiosities:

> Ate lunch amongst curious sandrock formations. Returned on our track up onto the main divide. Saw no game. Kept along the top peering over into the depth below which revealed merely a cottontail now & then. Such beautiful coloured scoria stones lie over these divide butes, various *shades of red, peacock blue, blue, mauve, green, grey & browns.* I would like to make a collection of them. Ewen amused me very much with the account of poor Effie's fears yesterday evening on their campward tramp.

Lack of curiosity and a preference for staying close to the fire where she could happily gossip about the British in Montana, and tell stories about "her sister Bella who died mad in New Zealand when her 'change of life' period arrived," were not Effie's only faults. One day while the Camerons were out packing up an antelope Ewen had shot, she carelessly let the hunting dogs out of the dugout in which they were being kept and failed to supervise them. They naturally went immediately to the food stores and devoured the cheese, butter, and twenty-one pounds of bacon. Though she had only herself to blame, Effie was "very put out about [the] missing provisions," Evelyn wrote, and feared that it might cut short the hunting expedition. It was not so much that she was enjoying the trip, but she was desperate to bring home a trophy. "She is so anxious to get a deer," Evelyn noted. "Not till then will Effie be content to 'quit.'"

Hunting, however, was not her forte. On the afternoon of November 16 the party went in search of game on horseback "thro' some rough country. . . . Effie went up a very narrow ravine & left [her horse] Pilot in it." Evelyn then had to rescue poor Pilot. When Mrs. Dowson finally did stumble upon game, she fared no better. She and Jesse unexpectedly

64

came upon a herd of twenty-eight antelope, but "her hammer fell in the act of being put on full cock which of course started the bunch who were staring 150 yards off!"

Several days after frightening off the antelope, Effie contented herself with painting a watercolor of a four-point buck that Ewen had shot and hung in a tree. Even that had its risks. The next day she stayed in bed until 4:00 p.m., having "caught a chill painting yesterday." Since it was apparent that Mrs. Dowson was never going to succeed as a hunter, Ewen finally gave her the hide and head of the buck he had killed and Evelyn had skinned. Proudly, Effie packed the trophy off to a taxidermist and departed herself with Jesse, on December 6.

Relieved to be free of them, Evelyn went to check on traps that Jesse had set, only to find that he had foolishly placed them "above [the] snow!" Throughout the trip, Jesse's incompetence had been matched only by his laziness and moodiness. When asked to fetch more water for gravy, he grew "rather silent & wouldn't eat much in consequence," and he did "his chopping & everything else in a shiftless manner, enough for the moment & no more." With him gone, Evelyn was at last able to restore order to camp. "I always keep the kettles well filled up with snow so we do not lack plenty of water as we did under Jesse's regime," she wrote the day after he left.

The Camerons had equally bad luck with their own hired help on other hunting trips. Their November 1893 hunt had barely begun when disaster struck. Returning home at dark after a day of stalking game, they were greeted by their twenty-three-year-old hand, Lester Braley, who blurted out the news that

he had "awful bad luck," the tent [a brand-new 9¹/₂' × 12' tent] got afire. He was just going to get Stockings [a horse], happened to look back & saw tent afire. He got water & threw over it. All left side burnt, saved every thing within 'cept Ewen's stocks—they burnt [&] little towl burnt up.

This made for a most unpleasant evening.

Sup outside. Coyottes howled very much quite close. Wrote diary by big fire. Braley put wagon sheet over burnt side of tent. Nearly everything damp . . . from fire extinguishing water. Fire must have started on the dry grass around sibley stove.

Sleeping in a damp tent, half open to the wind, on a chill November night was a miserable experience. Evelyn's diary entry for the following day reads:

Fearfully strong & cold West wind. Rose 7:20. O' so wretchedly uncomfortable. The East side [of tent] . . . was all burnt out except one strip. Braley had put wagon sheet over this [& it] had blown down & the wind blew thro' everywhere. Ewen called Braley who had overslept. Braley & I got breakfast under difficulties. They hauled wagon up to windward [side] of fire [&] put wagon sheet over [it]. Fire, ashes & smoke blew every way, [the wagon was] not much shelter. Went over to [empty ranch] shacks to see if . . . one could be fixed up. Braley got to work to clean it out, [it was] full of manure of cattle & a dead steer. I packed up stores & bag. Took everything in two loads. Put sibley [stove] up in shack [&] I put up a shelf. . . . Braley cut up lot of stove wood & got water. He broke handle of the ax & spent most of evening getting the head of handle in eye out. Sup 6:30 'bout, venison curry, mutton curry, rice, Appricots, coffee. Our shack seems so luxurious after last night & this morn.

Even though it had been cleaned of the cow manure and the rotting steer, this "luxurious" shack must have had an incredible stench. But it was at least dry, and relatively warm, after Evelyn put what remained of their charred tent over the doorway to keep out the biting winds.

The Camerons were hunting in the heart of sheep country around Cabin Creek, so the hut, part of the "old PH" ranch, was presumably one of a string of tiny one-room shacks or dugouts in the wilderness used by sheepherders during the

winter. Evelyn described these primitive shelters in an article that she wrote and illustrated with her photographs for *The Breeder's Gazette*, a "Weekly Journal for the American Stock Farm" published in Chicago:

> [Ranchers would] establish dugouts with haystacks at different points, from which the shepherd emerges at daylight to drive his woolly charges to graze amidst the sage brush. . . . Often when hunting antelope we have happened upon these forlorn places which are merely holes about 12 feet square roofed over in a bank. The furniture consists of a stove, bunk, table and the inevitable dry-goods box. The single herder sees nobody for weeks, excepting when his employer brings him provisions, and has nothing but his dog to enliven his solitude, apart from the ever-prowling howling coyotes, the antelope skimming over the plain, and the rough-legged hawk sailing in the blue.

Cattle ranchers employed the same system of single-room cabins—called "line camps"—for use by the cowboys who patrolled the range during the winter. Cowboys riding herd between the fall and spring roundups tried to keep the cattle from drifting too far off their accustomed range, and to protect their charges from the ever-present menace of coyotes and wolves. Since they usually had hundreds of miles of "line" to cover, the sight of the infrequent camp was comforting. Bob Fudge, a long-time cowboy for the XIT Ranch in Montana, recalled these frontier accommodations fondly in his memoirs:

> A line camp was not a luxurious home, but I have spent many happy winters in them. The house where we cooked, and slept, was generally a dugout or square hole dug in a bank, covered with logs and dirt, and maybe three sides would be built of logs. These dugouts had one door and one window . . . [and] always just the one room.

According to the unwritten rule of the range, no permission was needed to use line camps and sheep shacks (or for that matter, any unattended ranch house), and on their winter hunts the Camerons frequently stayed in these shelters, leaving for a new campsite if the cowboys or sheepmen turned up. No payment was ever expected, but pioneer hospitality required that you leave the place in good shape. Evelyn was always careful to make the way straight for the next tenant. On November 21, 1893, the day they left the old PH shack, she noted in her diary:

> Carried into house petticoat fulls of small wood from pile I cut the other day. Dragged up lot of wood, made a big pile by fire. Filled pails with ice from creek. Nailed up pictures from Winchester cartridge box on the shack wall. Wrote name & date on ridge pole.

Messages left behind at such remote outposts were common—and sometimes humorous. During their 1894–95 hunt, the Camerons came upon the deserted Hog's Eye Ranch. Though the windows and doors had disappeared, there was a stern notice inscribed on the wall:

> 'I forbid anyone disturbing this ranch,'
> James Drummond
> <u>LX</u>

Under it someone had written:

> Stay with it Jim

On another occasion, while returning from an extended foray into the Missouri Brakes, the Cameron hunting party came upon a "deserted shingle-roofed ranch . . . built in [a] bank." Inside, hung up, was a skinned antelope carcass. On the wall beside it was the message:

> Took 1 ham, F.A. Smith Nov 20th

As primitive as these remote cabins might be, they were still a refuge from the bitter wind and the unforgiving ground. On moving into a deserted sheep shack while hunting in 1894, Evelyn wrote that there were "2 bunks in this shack. We slept on one none too large. . . . Made our bed on

wooden bunk, [put] hay, tent on top o' that, then our [tar]paulin & blankets. . . . Very comfortable bed it was, after the hard ground."

Another feature of such campsites was not so comfortable. Evelyn added: "Mountain rats had a gay time in the shack at night." Five days later, she wrote, "Mountain rat carried away up into the logs 103 raisins (not seedless), a slice of cake & pieces of bread," and after that, in red ink, "Must kill the wretch."

Besides the mountain rats, the Camerons sometimes had to share their quarters with mice and their own hunting dogs. The night of October 26, 1898, was "horrid. . . . Dogs messed & smelt to such a degree & the mice kept up a racket. Had to get up & clean dog's place out 1 a.m."

Members of the animal kingdom were not the only disturbers of the nighttime peace. Sharing a one-room shack with the hired help—or the other members of the hunting party—was often a bit too cozy. For privacy's sake, in 1893 the Camerons hung a wagon sheet as a partition and had the hired hand, Lester Braley, sleep on the other side. It did not do much good, unfortunately, because Braley was suffering from the "horrid complaint" caused by the alkali water. The next day Evelyn noted wearily:

Braley couldn't sleep last night, his complaints gave him pain. It kept me awake from his suppressed grunts & groans, & lighting matches to see how time went, poor lad.

There was no room for even a wagon sheet during the 1894–95 hunt, when Evelyn and Ewen shared a muddy 15 by 19-foot shack with Alec, Mr. Colley, and a local man named Hamlin whom they had hired to help set up camp. The room was so crowded that there was only an "alleyway" between the Camerons' bunk and that shared by Alec and Colley, and Alec, as he was apt to do, made the situation worse. "We are all reading except Alec who is breathing audibly," Evelyn wrote on December 17.

This was the first—and last—time Alec accompanied the Camerons on a hunt. He was a dreadful hunter, who could be counted on to do the wrong thing. On December 29, he managed to ruin Evelyn's sport:

Doe & fawn 250 yards [away]. I got good aim sitting when Alec called 'Evy, Evy!!' . . . Doe & fawn at the sound of his voice bounced off. Alec only wanted me to wait till he got behind a tree about 15 yards off. He was very contrite but I was a little vexed.

Even worse than Alec's hunting etiquette, however, was his troublesome camp manner. On a bitter January 26, there was a quarrel:

Stayed in camp all day. Stormy without & within.
During breakfast Ewen told Mr. Colley that big wolves were not to be caught by dead steer carcasses. Alec, senza voce, said to Mr. Colley "don't believe him." Ewen read his lips, Ewen was naturally furious. Alec denied having said so. Mr. Colley, when asked, said he never paid attention to what Alec said. We then explained to Alec he was insulting. "I don't care," "all the better," were his replies. His conduct this trip was all raked up & put before him. He has made 3 previous rows & we both agree he must go home to his family, that we cannot put up with his weak minded & unprincipled conduct any longer. Alec replies he hates America, will marry a rich wife & be "independent." We pointed out to him it will be difficult for him to procure a rich wife with his education & income. . . . [Later] Alec went & apologized to Ewen humbly, but Ewen told him he forgave him but he must go home at the first opportunity . . . 10 degrees below averaged today.

Colley, for his part, was no prize hunting companion either. On a lovely October day, he did not want to go out because of "rheumatics in the back." The Camerons went off alone, Evelyn noting that "Having these kind of young men to take out spoils all our pleasure. Mr. Colley is terribly green & too fond of his ease to care about hunting much."

They were forced to endure Colley's presence, however. Desperately hoping he would put money into the Eve Ranch,

they wanted to show off the Montana wilderness and impress him with its beauty and bounty. Alec's petty quarreling on the trip did not help the cause, however, and the considerable cost of food, supplies, and help made his uncooperative behavior all the more infuriating. Ewen was still fuming about Alec's conduct after they returned to the Eve Ranch:

> Ewen pointed out how ungrateful Alec always was. We had taken him on the hunt, with everything calculated has cost £300, & Alec behaved so piggishly. . . . [But] how can one expect Alec who can neither read nor write properly to behave otherwise.

In late December 1896, Evelyn and Ewen set off without Alec on a winter hunt in the pine and cedar thickets along Cedar Creek, happy to get away and have some time alone together. They had built a rough shack there and hired two men to build a stable and do some odd jobs. One of the carpenters was Lester Braley, the same man who had accidentally burned down their tent on an earlier trip. He and his co-worker shared living quarters with the Camerons until they finished their work. At their departure Evelyn wrote gleefully: "Ewen & I danced around together after they had gone."

It was so rare for the Camerons to have any privacy that time alone was treasured, and moments of intimacy between them crop up in Evelyn's diary entries during their solitary hunts, when they were free of Alec and the other boarders. On January 7, 1897, they were disappointed after a fruitless day of stalking game; nonetheless they went back to camp "arm in arm." On a hunt they took by themselves in January 1900, they "talked much on the subject of having a child. It is my desire to have one some day," Evelyn added.

Being alone also allowed them to indulge more easily in the luxury of reading. On a trip to the North Side of the Yellowstone River that they took by themselves in 1899–1900, Ewen read poetry aloud to his wife one evening. On that same expedition Evelyn eagerly devoured several books on Australia and noted in her diary entry for December 1:

"We read with energy all day. . . . We are so glad to be able to get a good read, it is such a treat."

It was rare for them to stay in camp, however. Generally they stalked game, regardless of the weather. Even on a frigid January day in 1897 they braved the elements.

> *Coldest day I have ever felt . . .*
> *7 a.m. 30° below. 20° below all day on shack out of the wind . . .*
> Started [hunting] 10:20. I put on comforter woolen jacket & jacket knickers, combi, sealskin cap. But my! after trudging thro' calf deep snow for about 3 miles, I only got colder & colder instead of warmer. Ewen said he felt warm. . . . I felt too cold to go on & with reluctance I walked back to camp. My thighs even became biting cold & my feet were getting cold. . . . In camp at 1:15 it was 20 below on shack wall. Lit sibley [stove], warmed up slowly. I think one of my cheeks (right one) will blister (-*Note* both cheeks blistered-). Ate lunch. Warmed couldn't get enough heat. . . . I had been worrying about Ewen & wondering if I hadn't better take the horses to meet him when the old boy came back wretchedly cold. I made up sibley & he recounted his adventures. His mustache & imperial were stuck together by ice. He came on more deer & could have had 2 standing & 2 running shots at close quarters but when he had pulled his glove off his hand got so bitterly cold he had no power to aim. After more tracking, the cold being too intense, he trudged wisely back to camp. We sat & roasted ourselves. 3 of Ewen's fingers are rather badly frosted. . . . *Ewen & I agree that this was the coldest day we have* FELT.

The weather in Montana, always a critical matter, could be particularly dangerous on a hunt, for the temperature might plummet without warning and a blizzard suddenly strike while the hunter, far from camp, was dressed for a mild day; the prudent prepared for any eventuality. Evelyn described one such experience on January 6, 1895:

> Lovely spring-like morning. Afternoon blizzardish. . . . Got up amongst the big butes, no tracks except 2 coyotes &

A large buck shot by Ewen from 150 yards away during a hunting trip in late November 1899. The Camerons' dogs devoured most of the innards; when Ewen hoisted the carcass up onto a dead tree for safekeeping, the tree toppled over.

one big wolf, otherwise virgin snow. . . . Got into horrible country to get through, [my horse] Skip fell up to his chest into a hole. . . . Finally, tired of deep snow & holes, [I] left for the flat where antelope [I] hoped to see. I was obliged to take off gloves [it was] so very warm, but in 10 minutes up got the wind veering to the North. Blew snow along the crust of snow beneath at 50 miles an hour. Ate our lunches in discomfort near Whipples' Capped Bute. . . . Fine sight to see the [snow] being whirled off of the Capped Bute, like sea spray over prairie it blew, making big drifts. Wind in our faces was biting. Kept getting off [my horse] & running to keep warm. . . . 3:30 snow came down hard, could hardly see our way, [it] was blinding.

Another constant danger—especially when out hunting alone—was getting stranded in the trackless wilderness as darkness fell. This happened to Ewen in November 1894 during the hunting trip with Alec and Colley.

Ewen off . . . to hunt up antelope he shot at yesterday & wounded. . . . It got quite dark (a 1 quarter moon), Ewen never came. Got Hamlin to put up a pole and swing lantern on it on our highest hill above camp. He also fired 4 shots. We had a good joke on Alec. After asking me what sort of star it was up there (I feigning ignorance), he got his glasses [binoculars]. . . . Made himself and Mr. Colley more puzzled than ever. It did look very curious thro' glasses, like a sun. I had to tell him [that it was not a star but a lantern]. He thought it an awfully good joke & we laughed tremendously, even though I felt so anxious about Ewen. After sup I went onto the hill & swung [the] lantern back and forth for about $1/2$ hour. During this time . . . [I] conceived [the] idea of wiring out a flour sack and putting lantern in it. This Hamlin and I carried out successfully. [I] cleaned globe & put in fresh oil. . . . It looked like a big Chinese lantern. To make a fire would be dangerous, [as] feed so thick & dry all around. . . .

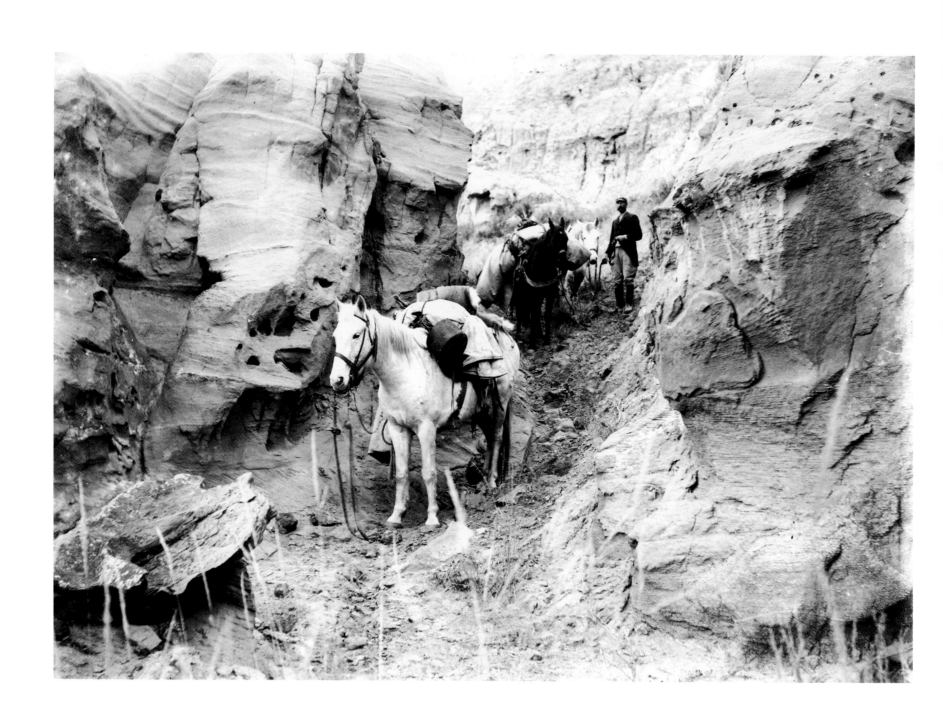

Ewen on a hunting trip through the badlands, November 1899.

Think Ewen must have got into some ranch over Beaver Creek way when it came on dusk for fear of being left out in the dark. Hope so. Hills surround us on every side, furthest being perhaps 3 miles [off], so that I think he can see the lantern as we have fixed it as well as he could see a fire. . . .

Evelyn fretted all night about Ewen's safety and whereabouts. The next morning he turned up, tired but all right.

Just finished dressing when all the dogs began to bark. Rushed out & there was Ewen coming down the bank on [the horse] Joe. Joe ran away when Ewen was looking for his wounded antelope. Something must have scared him. Ewen ran after him but his efforts proved futile. He walked many miles, striking a lot of round-up camp timber. He lit a fire with 1 of 3 matches (which Miss Wills happened to have given him), the first one lit the fire. When first streak of dawn broke he found himself on the divide near where we packed yesterday's buck. Ewen found Joe with three loose saddle horses & after a great deal of bother, caught him & rode in. . . . I sewed at Ewen's clothes, put salve on his poor blistered feet, cut his beard. . . . Ewen slept. I read religious book, made me feel better.

Evelyn's fearlessness was remarkable. She had no qualms about spending long days alone tending the horses in the wilderness; in her diary entry of November 17, 1894, she described quite matter-of-factly being surrounded by wolves:

Ewen went on stalk, I sat on ground waiting with horses. Suddenly big greys began to howl so low & deep . . . an old one off by himself replied. About 12 were howling. They came closer & closer till they must have been about 100 yards off, then turned . . . away & howled in the distance.

During a hunt in the winter of 1899–1900, Ewen left her alone for two nights while he returned to Terry for more supplies. They were camping in the rugged badlands north of the Yellowstone River not far from the site of

. . . a barbarous tragedy enacted nearly 20 years before, when 2 Swedes, engaged in "getting out" pine logs, which they pitched over the Yellowstone bank to steamers then navigating the river, were both treacherously murdered by Indians—the remains of their shack, the Indian teepees, together with the scraper, which the unfortunate men used in grading, being still there.

These artifacts were chilling reminders of the random violence not uncommon in the wilderness, so Evelyn's nerve was tested when a grizzled stranger unexpectedly arrived at her shack as night was falling, the day after Ewen had left for Terry:

Just got back to shack when I heard sound of horses hoofs in distance & soon a man leading a horse appeared on the bank. He came down. It was nearly dark, I lit lamp. Man asked if he could stay night. I said my husband was away [&] I [was] here alone & I asked if there wasn't any other place he could go. Nothing nearer than the Hatchet [Ranch] 20 miles off, so I said he could stop. Made him clean stable out for him to sleep in & put hay down. Chatted on wolfing. He is employed by a sort of association to kill wolves & coyotes. Has 6 dogs at the Hatchet. Wolfer Reade killed about 60 coyotes, 7 or 8 wolves this summer. He has been poisoning. . . . Gave him blankets & wagon sheet which he took to stable.

The next morning Evelyn cooked a generous breakfast of "bacon, hot biscuits, fried tatoes, fruit, coffee" for the rough trapper. In return, before heading off to the Hatchet Ranch, Reade gave her practical tips on how to pack four deer on a bare-backed horse.

Evelyn's stoic reaction to being by herself in the middle of the badlands during winter was hardly a typical response. When Ewen returned from town he reported that "the women in Terry thought it dreadful that I could be left here alone."

Over and over again Evelyn proved her resourcefulness in

the face of adversity, and her unfailing courage. Accidents and sickness on the trail could be life-threatening, but she always remained self-possessed—even when it was she who was injured. During the 1898–99 hunt on the North Side of the Yellowstone, she cut herself badly while trying to pack up a two-year-old deer Ewen had shot:

> In cutting the skin inside the hock to put rope through, the knife slipped & made a stab near thumb of left hand & the blood spurted out like a small bubbling spring. Ewen very distressed but tied it up tight & round the wrist. . . . My hand bled pretty badly, we thought a vein was cut. . . .

The accident did not prevent her from doing the usual round of cooking and other chores, though the wound bled on and off for two more days. She tended to it with remedies that were easily at hand:

> Bathed my hand in cold water & got off the bloody silk handkerchief, put salt on the cut. . . . Allowed salt to remain on an hour, washed & put clean dish cloth bandage round with little bacon fat to prevent sticking.

Being on the North Side of the Yellowstone posed special problems in the event of an emergency, because the closest towns, Terry and Fallon, were on the other side of the river and by late autumn the ferries had been taken out of the freezing water. Without the ferry it was necessary to wait until the ice was solid enough to hold men, wagons, and horses, and since the current in the river was quite strong, it took an extended period of frigid weather before this happened.

Usually in the course of the bitter Montana winter there is a temporary thaw, the result of a warm, dry wind called a chinook, which blows at intervals down the eastern slopes of the Rocky Mountains. Such thaws made the Yellowstone River uncrossable, and it was during one of them that Ewen got deathly ill on their 1899–1900 North Side hunt. He had been sick for weeks with headaches and terrible stomach pains, and was getting progressively weaker. The thaw left the Camerons stranded in a dugout with their food supply rapidly dwindling.

Desperate for food, Evelyn went in search of a sheep trail. She found one and followed it until she came upon a band of sheep tended by a sheepherder named Squires, who agreed to sell her a lamb that he would catch, kill, and dress for her. She went to pick it up the next day, a bitterly cold and windy day that "looked like a blizzard coming." Ewen was frail with illness, but Evelyn had no choice but to leave him.

> Left Ewen with sibley burning & lots of wood. Hated leaving but obliged to get some nutritious food for him. . . . Went right in the teeth of the wind & it was very cold. Glad to tie up Rocket in shelter of sheep sheds in which sheep were and tap at the herder's dugout door.

While Squires butchered the lamb for her, Evelyn waited with his collie sheep dog inside the sheepherder's winter home—basically a cave dug out of the side of a bank, without even a window; light came in only if the door was left ajar. For his trouble Evelyn promised Squires a box of cigars.

As soon as she got the lamb, she rushed back to her sick husband and found him lying in bed. That night he was in agony:

> Poor Ewen had a terrible night, such spasms of pains, flushes and sweats. Turning gave great pain; and he tried lying on his back for a long time but could bear it no longer. After turning [he] dropped asleep for half an hour. I rubbed his stomac and bowels which gave only temporary relief, he preferred rubbing to compresses.

Anxious to get back to the ranch, she was elated when a passing sheepman brought word that the Yellowstone had frozen over again at last: "Ice 2 ft. thick & quite safe. Hurrah!"

Ewen's health, however, was broken—he was ill for months following the hunt. Since there was no doctor in Terry or its environs, Evelyn had to write to one in Miles City

This unusual close-up of a coyote in its lair is one of Evelyn's few instances of photographic fakery— she placed a dead coyote in a wolf's den. The bony remnants of the wolf's prey strewn about the mouth of the den were actually there.

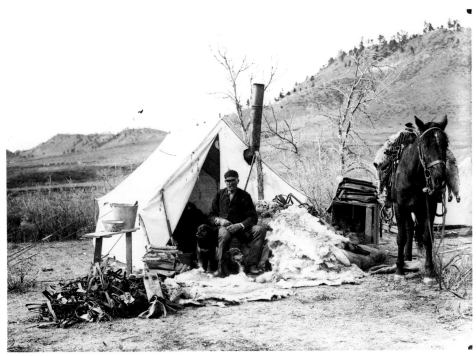

The solitary camp of a wolfer who earned his living trapping coyotes and wolves. Dick Brown sits next to a stack of hides and a pile of traps.

A hunting trophy, probably at the Camerons' ranch. Evelyn generally skinned the carcasses of their prey and sometimes sent them to a taxidermist in Mandan, North Dakota.

and ask him to come to the ranch. He arrived on February 9, 1900. Evelyn's diary entry reads:

Ewen had a wretched night of pain. . . . [He] washed his furred tongue & mouth out with warm tea thus giving relief. [He] ate nothing from 1:30 yesterday till 5 p.m. to-day, then only a few sips of malt milk. [I] swept out room & dustied. Put fomentations on Ewen. Put table cloth on & made cakelettes, hot tea & coffee going. Dressed [in] blue Jessie gown. . . . At last 3 [p.m.] Dr. arrived. Very smart, clean little man. He examined Ewen's stomac etc. & found a place (right ventricle) where he said he could feel a lump, but I couldn't, & pronounced the complaint as appendicitis at once. He said as soon as well enough Ewen ought to go to Brainhead Hospital [in] Minnesota & have an operation [to have] the appendix cut out. Told several stories of men with the complaint, he having performed the operation in Miles, & [he] came prepared to do it here if absolutely necessary. He said Ewen had made a turn for the better & if very very careful about diet would recover, but might at any time have a severe relapse. Left opium tablets "Codeina."

Ewen never did go to Minnesota and have his appendix removed. Instead, that summer the Camerons returned to London where he was attended by another physician who said his problem was certainly not appendicitis, but could offer no satisfactory diagnosis.

The 1899–1900 hunt turned out to be the last extended wilderness trip for the Camerons. Ewen could no longer endure the rigors of months of camping out, and besides, the hunting grounds would soon be taken over by incoming ranchers and farmers. In the fall of 1906 Evelyn told a reporter for the New York *Sun:* "The great hunting days are over in Custer County and the ranchman and granger will see to it that they never return. About all that is left to the sportswoman to-day is to hunt with the camera"—which is precisely what she was doing.

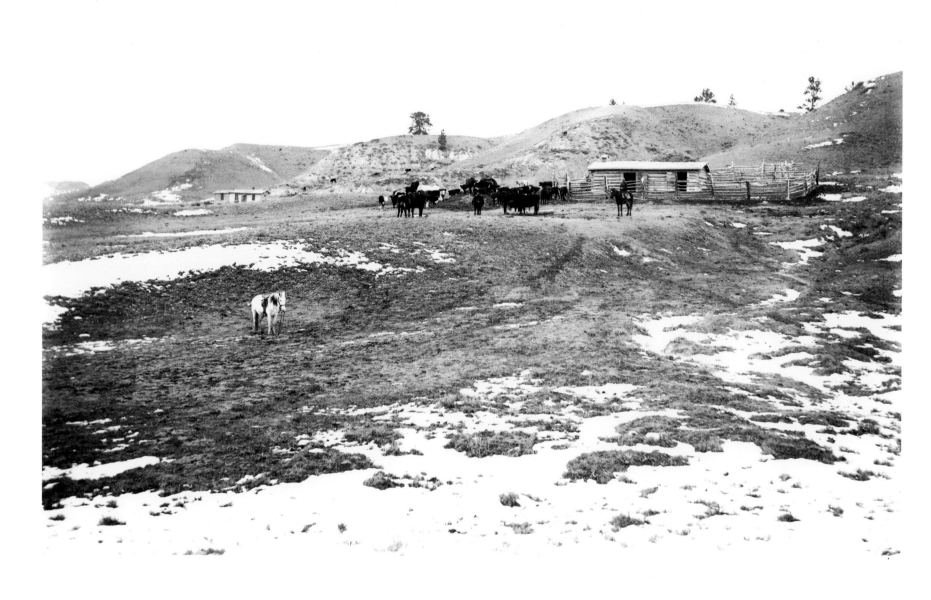

The second Eve Ranch, built in 1902, at a remote location on the North Side of the Yellowstone, fourteen miles from Terry. During construction the Camerons camped out in tents; they moved into the house by Christmas, before the gaps in the logs had been sealed. The house, on the far left, is not much more elaborate than the barn, at right.

Life on Eve Ranch

Throughout four decades in eastern Montana, Evelyn kept her diary faithfully. Late at night, no matter how tired she was, she huddled over her small, leather-bound book and recorded the day's events. It was the one part of the long day that was hers alone—the darkness was total save for the oil lamp that cast light on her pages, and the ranch was blanketed in a deep silence, broken only by the piercing howl of a lone coyote or the far-off whistle of a train. She also took her diary with her on her travels—scribbling in it next to a roaring fire while camping in the Montana outback or on the deck of a steamship crossing the Atlantic, bundled up against the cold. Though she never articulated her reasons for being such a faithful diarist, the act of inscribing the concrete details of each day within the confines of a page obviously gave her a sense of satisfaction and comfort. It was a way of giving a shape and meaning to days that might otherwise have run together in a jumble of chores; and if at some future time she wanted to find out on what date she had branded the calves, or planted the beans, she would have a record of it.

During their life in Montana, the Camerons owned three different ranches, all of them called the Eve Ranch, after Evelyn (the first three letters of her name also yielded a handsome, distinctive brand \forall for their livestock). They occupied the first Eve Ranch, six miles south of Terry, from 1893 to 1900. In July of that year they left for Great Britain because of Ewen's poor health, the pleas of his mother in England for care and company, and an epidemic of blackleg disease that was threatening the local cattle herds, including their own. They planned to spend at least two years in Britain, but Evelyn could not bear the slow pace of Old World life, nor could she abide Ewen's mother. (She wrote that she would not be content living in the Cameron house until she was old and feeble.) At Evelyn's insistence they returned to Montana in September 1901.

In 1902, just as the area was beginning to attract a number of settlers, they opted to take a step backward in time. They built a ranch on the desolate North Side of the Yellowstone River where the population was negligible and the amenities of town life were nonexistent, but where much of the range

was still open and free (though even that was beginning to change), and the wildlife was more plentiful than it was on the South Side of the river. In November of 1902, as the ranch house was being constructed, Evelyn wrote optimistically to her mother:

Dearest Mum
. . . .We have been just one year negociating for 2¼ sections of railroad land (1,400 acres) situated on the north side of the Yellowstone river opposite the mouth of Fallon Creek. . . . This fall we were able to conclude the purchase for 1 dollar an acre & I am extremely glad because it is a beautiful spot facing due south & [it has an] abundance of feed, shelter, water & wood. The river is our southern boundary & will supply us with plenty of good fish. At present we are camped in tents on the building site near a spring in the hills. I am cooking for the men who are building for us. I rise at 5 a.m. & enjoy it. There is nothing like work to make one contented, is there? The buildings are being built of pine logs which grow close in deep & romantic gulches. . . . I cook three hot meals a day & peel logs, plaster between logs etc. in my spare time, in fact there is no lack of employment at any time in this Western life. . . . We have had a glorious fall but our usual November storm started yesterday by blowing great guns—wind is especially disagreeable in a tent—& this evening heralds our first fall of snow. . . . You ask after my health & I am glad to say I am just as well as ever & as young. . . . Goodbye dearest Mum. Much love to yourself & the boys from
 Your loving daughter
 Evelyn J. Cameron

Eight months later she wrote this note to her sister:

Sweetest Sister
. . . We are now on a new ranch having bought the land . . . from the Northern Pacific R.R. Co. In order to get our mail or supplies of any kind we have to ride or drive 28 miles &

cross the Yellowstone by a ferry boat in summer & on ice in winter. We were the first people to come to this part of the country & thought we should have it all to ourselves, but other ranchers are now coming in here & land has doubled in value. . . . We have unlimited free range N.E. & West. I like the place very much but it is very isolated being shut in on two sides by the river & badlands. . . . I feel that although we have built a ranch in the wilds it is a sort of thing we could never attempt again. You can realise what a labour & bother it has been when everything down to the smallest tin tack has had to be hauled from Terry (14 miles), taken across a rapid river (1050 feet wide), the latter part of the way without any road. As the 3 work men were bound to leave before Xmas we moved into the house before it was plastered between the logs or the roof finished, but we have made it habitable now by our own exertions. . . . Best love to Frank yourself & the three nieces.

 Ever your loving sister etc.

Always preferring the joys of untrammeled nature (and its attendant hardships) to the bustle and ease of town life, the Camerons ranched happily in this inaccessible spot until 1907. For Ewen, especially, the place proved a wonderful laboratory for his bird studies; in a July 1907 article in *The Auk*, he painted an idyllic picture:

The house is situated below some springs surrounded by pines and cedars where I have placed three water-troughs. All species of birds inhabiting the pine hills of eastern Montana visit them to bathe and drink. It is indeed a charming sight in summer to watch the flocks of Crossbills, Piñon Jays, and Goldfinches descend to the water, while in winter such numbers of Rosy Finches come, that the sound of their wings resembles the wind in the pines. Even mule deer from adjacent badlands drink regularly here, passing in early dawn within thirty-five yards of the house. This shows what may be accomplished where the peace of nature is never disturbed.

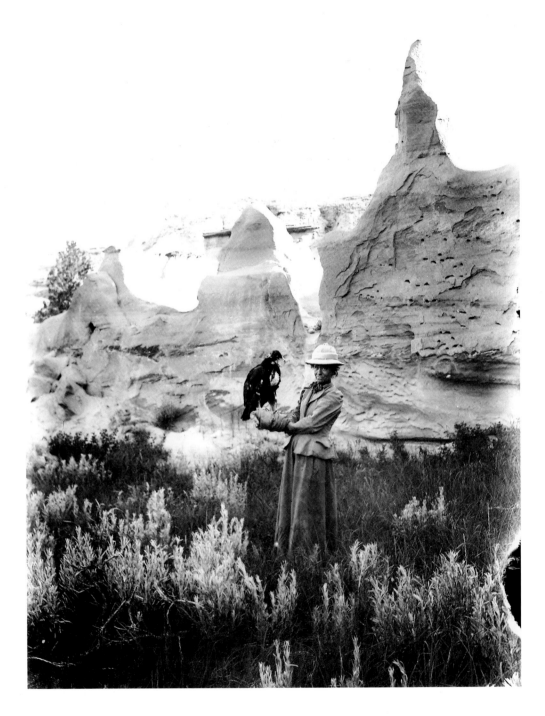

Evelyn with a young golden eagle against a backdrop of badlands buttes. The eagle's eyrie was located atop a pillar not far from the Camerons' North Side ranch, and the wild bird became accustomed to Evelyn and her camera. Evelyn's arm is wrapped in a sack to protect her from the eagle's talons.

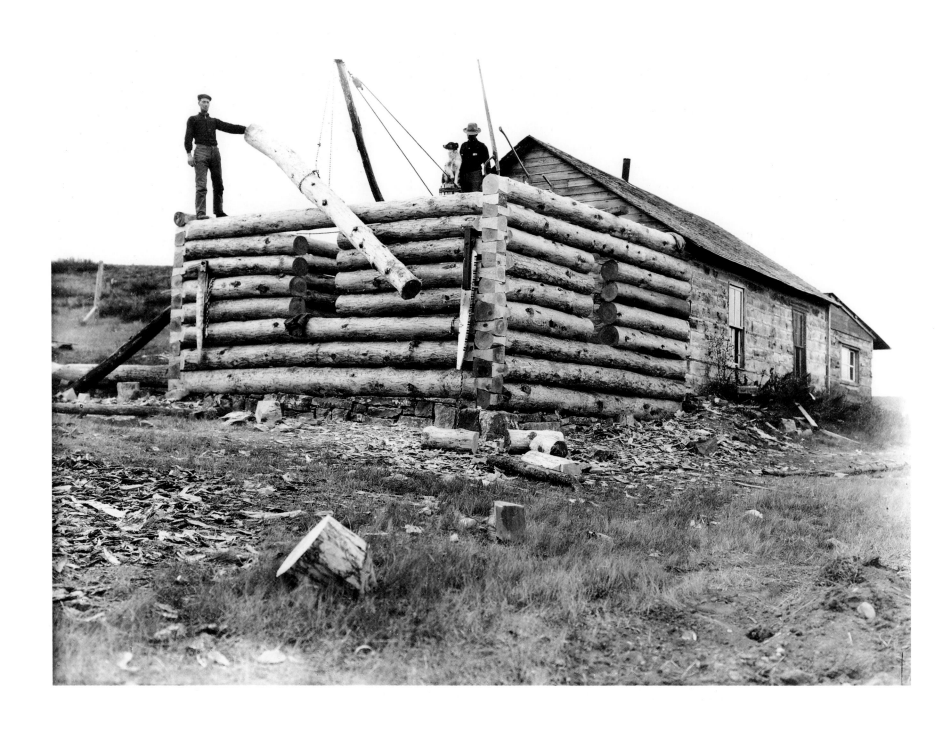

*Workmen hoisting the final pine log for a new room in the ranch house in November 1908,
a year after the Camerons had moved into the third and last Eve Ranch.*

Their persistent financial problems, however, led the Camerons once again to consider leaving for England. Then, suddenly, there was an influx of homesteaders, brought to the region when eastern Montana's second rail line was built by the Chicago, Milwaukee, St. Paul & Pacific Railroad; with the settlers came an unexpected prosperity. "This country is experiencing a sort of boom and the curious sight may be seen at Terry of two railroads running parallel with each other," Evelyn explained to her sister on December 28, 1907. She went on:

> We changed our plans as we thought it a pity to go home and not derive some advantage from the boom, more especially as it is very hard to live in Great Britain and keep up appearances on a small income.

In September 1907 the Camerons had moved to the South Side of the river, purchasing a ranch near "Fallon Flat," a large expanse of level prairie where homesteaders were beginning to settle in large numbers to grow wheat. Evelyn described the ranch in a letter to her sister:

> This ranch has wonderful facilities . . . as the Northern Pacific Railroad runs through one end of it and there is a little station where the trains can be flagged a mile and a half from the house. We have a splendid kitchen garden and four acres besides under cultivation, which can be irrigated from a reservoir fed by four springs. On this sheet of water, migrating ducks come and swim.

Within sight of the house was the Yellowstone River. "The house stands very high and we have charming views of the winding river fringed with cottonwoods," she wrote to her mother. "I think a big river is the next best thing to the sea." This is the ranch where Evelyn would live for the rest of her life.

At all three Eve Ranches the Camerons raised horses and cattle (in numbers that varied from year to year), chickens, and vegetables. After the dispiriting failure of their polo pony enterprise in 1897, they undertook no other large-scale business ventures. At all three, despite their modest means, Ewen conducted himself as a man of leisure, pursuing nature studies and leaving the ranch work largely to Evelyn. The passage of time, the invention of labor-saving devices, and the influx of the homesteaders onto the prairies after the turn of the century did little to alter what Evelyn did in a given day—or how she did it. In the late 1920s she was still living the life of a pioneer of the early 1890s. The coming of electricity, telephones, airplanes, and automobiles—all had virtually no impact on her way of life.

The overwhelming impression one is left with throughout Evelyn Cameron's diaries is the sheer physical and emotional strength that life in frontier Montana demanded. Work was never-ending and backbreaking and there were few distractions. At the first two Eve Ranches, especially, days, weeks, even months might elapse before Evelyn would go into town. The isolation was such that the Camerons depended on the distant whistle of the train to set their clocks. When Ewen was setting off to England with the polo ponies, Evelyn, seeing him off at the railroad depot, prepared for his absence by bringing along her clock "to get the right time." Confusion over what time it was—or even what day it was—was common on the prairie. When Mrs. Collins, an eccentric pioneer who ranched by herself some distance from the Camerons, arrived unannounced at the Eve Ranch one weekend in May 1893, Evelyn wrote with amusement in her diary that "she had walked all the way from her ranch near [the] Yellowstone. She thought it was Sunday & Laundre [another rancher] told her it was Friday." In fact, it was Saturday. Evelyn's diary was one way to fight this disorientation; unlike Mrs. Collins or Mr. Laundre, Evelyn always knew what day it was.

Appropriately, Evelyn began all of her diary entries with a brief summary of the day's weather. The comments were as various as the erratic Montana weather: "bullets of hard snow fell morning"; "110 degrees in the shade"; "no wind, smoke ascended straight"; "a hurricane blew from 3 to 5"; "an Egyptian morning so bright"; "cloudy soft day, regular

Scotch neat"; "outrageous sleet & rain continuous"; "dust storms, inky clouds but they lacked esential rain." Hail is described variously as being the size of half-ounce letter weights, baseballs, and pigeon eggs.

This was not idle scribbling on Evelyn's part, for the weather was probably the single most influential factor in day-to-day life in Montana. Blizzards that swept unobstructed across the Northern Plains could bring everything to a standstill—even the trains that linked eastern Montana to the rest of the world. "No train from the east," Evelyn noted on March 22, 1894. "Dakota blizzard stopt train, snow & wind too much for the engine."

Summer storms could be no less violent—or freakish. On June 4, 1902, Evelyn reported in her diary:

Sunday late afternoon a tornado killed one man, rendered another unconscious & killed three horses somewhere on Tusler Creek, North Side. They were taken up in the air, wagon also, & carried some distance.

Even being safely tucked in bed did not guarantee protection from the extremes of Montana's weather, as Evelyn discovered when she was roused from sleep during the night of May 15, 1894:

Cyclonic storm. *Continuous lightning* with a TERRIFIC East wind. Small stones pattered against the window, this lasted ³/₄ of an hour. About then it came down in a deluge & thro' our roof nearly at the same rate. I up & mopped up water 2 or 3 times. I was rather scared during the cyclonic storm that the house might get blown down but fortunately it did not increase in strength enough for that.

The place remained soggy all the next day:

Poured all day. . . . Felt very tired after last night's exertions. Our bed even at last got its share of drips. Put waggon sheet over our bed. . . . Our walls are streaked with water marks, shall not re-white wash until July

though. . . . [By evening] roofs have ceased to drip. Moved our mattress & clothes into this kitchen where we slept on floor, too damp in our room.

On a different occasion it was the kitchen that leaked: "I scoured all the knives & forks, rain thro' roof had rustied them yesterday."

Lightning on the open prairie was another hazard, as Evelyn reported in June 1898:

A cowpuncher & horse [were] struck by lightning & a companion with him had his horse fall & get up again from the shock. Three cow outfits lost horses by being struck. E.2 Ranch lost one.

Evelyn herself barely escaped a close encounter with lightning. "My hair was singed by lightening, heard it burn quite plainly," she wrote matter-of-factly in her diary on May 18, 1893.

One of the most terrifying consequences of lightning (or of a stray spark from the railroad), particularly in times of drought, was the prairie fire. In her daily summaries of the weather, Evelyn frequently remarked on a morning haze that was actually the smoke from such fires. On September 23, 1899, for example, she noted that there was a red sunrise and a thick "blue mist." She went on: "Mist so thick & it is rather cloudy. On closer inspection the fog proved to be a smoke fog from fires."

Fires threatened disaster for ranchers dependent on an ample supply of prairie grass to nourish their livestock, and the Camerons fought their share of blazes, including one that roared across the prairie on March 28, 1895:

Out to catch a coyote but instead fought prairie fire . . .
Up onto flat, saw smoke from [a] large fire. . . . Fire had started near Monty's hay corral. . . . We 3 [Evelyn, Ewen, and their boarder, Colley] rode to Monty's corral. . . . I had picked up small cedar post & beat fire with this. Ewen & Mr. Colley had 2 gunny sacks . . . these they wetted in snow water pools. . . . Finally Ewen used my [saddle]

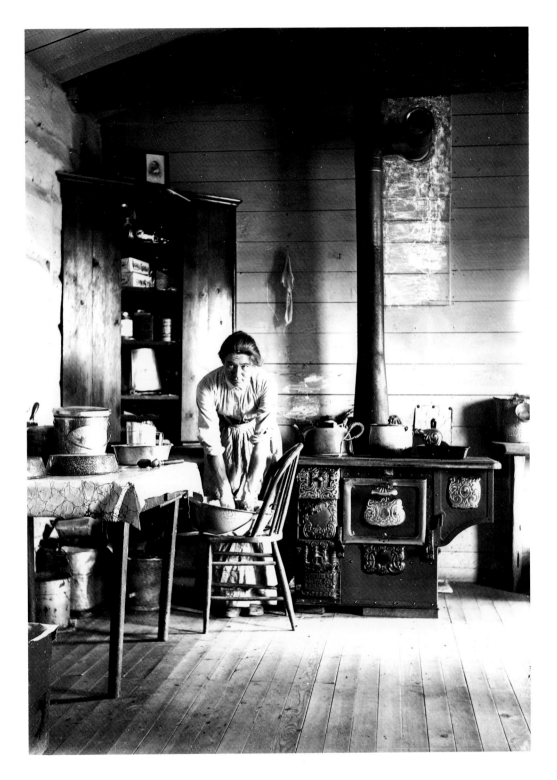

Evelyn kneading a panful of dough in her kitchen, August 1904. Anxious to give her nieces in England a glimpse of the day-to-day life she led in Montana, she made up an album of photographs including several portraits of herself at work.

blanket, tore it in halves. Very hot & tiring work. Wind fortunately not strong, but on southwest side it blew along a wall of flame. We found it easy to put it out [on] our side. . . . Saw the fire raging toward Ten Mile [Creek] & Powder [River]. Impossible to tackle such a roaring blaze, besides it would not endanger our pastures. The side we had fought was just coming straight for us. . . . We were very grimy faced on return. . . . [Later] Henry Tusler came over, [the fire] had somehow caught again & come our way. He was afraid we would have to fight it outside the pastures tonight, but the much required rain fell & quieted our fears.

It was not only the Camerons' safety and comfort that were imperiled by the extremes of Montana's weather; their herds of cattle and horses could be devastated either by the prolonged bitter cold or the searing heat for which eastern Montana was justly famous. Summer droughts could wreak havoc with Evelyn's vegetable harvest; and the weather virtually dictated what chores could be done on a given day—and how difficult it would be to accomplish those that had to be done in any case. Regardless of the "unprecedented" blizzard that was raging on March 5, 1898, for the third consecutive day, Evelyn had to milk the cows: "To get over the enormous drifts I went on all fours, in this manner I kept on top instead of sinking in & with the pail of milk it was the only safe mode of progress."

Relatives in England had no conception of the fury of a Montana winter; as Evelyn wrote to a niece one bitter January day: "We have the troubles of Arctic explorers out here but none of the credit." Even the simplest daily chores, such as baking bread, were jeopardized by frigid weather. Evelyn kept on hand a batch of starter dough—yeast, which she grew on cooked potatoes, mixed with flour and water— a concoction she referred to as her "sponge." Yeast cells die if they get too cold, so one night during the bitter winter of 1893, Evelyn took her starter dough with her to bed.

Had my sponge . . . along side of me under first 2 rugs all night to keep it warm as I was afraid it would freeze otherwise & I didn't feel inclined to get up & keep fire going in night.

Ewen spent a good deal of that winter of 1893 shuttling back and forth to Miles City on business, leaving Evelyn at the ranch. Although Alec was on hand for company, his help with the chores was negligible, and it was Evelyn who shouldered the responsibility for the ranch and the livestock as temperatures dipped to 40 and 50 degrees below zero—and stayed there. "Coldest day [we] have had," Evelyn scribbled on February 3:

The kitchen is like a cage, wind blows in everywhere. It is impossible to keep warm, the stove's small heat is quite insufficient to make the temperature bearable. . . . Anything left in the kitchen for 15 minutes will be frozen hard, the room is the worst in the house.

Rather than insulating the porous walls of the ranch house for her own comfort, Evelyn's first concern was for the livestock, and she scurried to the stable in the biting cold to fill in the cracks of the stable's walls, concocting an undoubtedly fragrant mixture to accomplish the task: "Made a plaster of horse manure & flour in a disused dutch oven, dressed, took it up to the stable & daubed up a lot of apertures, tho' nothing like all of 'em." For several days she worked by herself at this daunting task. "My hands," she wrote, "got so fearfully cold daubing on the outside, [they] ached like fury [with] returning circulation." But her industry paid off: the Camerons' livestock survived the winter without major losses.

Other ranchers did not fare as well; starving cattle wandered through the countryside and by mid-February it was estimated that 25 percent of the area's cattle had already perished in the cold. In her pasture Evelyn found the carcass of a stray yearling, half eaten by a bobcat. Evelyn, who did the butchering at the ranch and who never let anything go to

Cattle strung single file along the badlands hills after a 42-hour blizzard. When Evelyn came upon this scene in March 1904, she rushed back to the ranch house to get her camera. During winter storms cattle could wander for up to a hundred miles unless stopped by a river, a fence, or a patrolling cowboy.

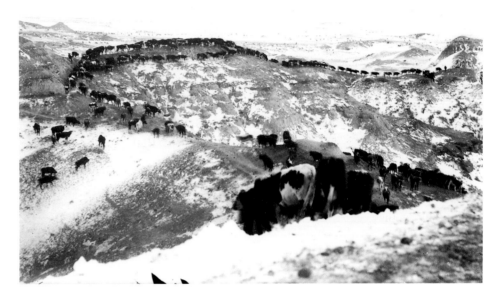

waste, was quick to salvage what she could. She skinned the animal, boiled the meat to feed the hunting dogs and chickens, and saved the entrails, which "smelt dreadfully," for use in the traps she set for coyotes and wolves. "[With] saw, hatchet & hammer cut up, after a deal o' toil, the yearling's head," she wrote. "It was dreadfully hard, the bone chipped a big piece out of the hatchet."

Another mundane task that became more difficult in winter was washing, a job Evelyn dreaded under the best of circumstances; she confessed in her diary that she "felt like a child having to go to its lessons when ready to begin washing." On a wash day in February 1902 the temperature was −17; as a result, "The kitchen was so full of steam when the boiler boiled that I couldn't see the opposite walls. The steam frosted on everything. Clothes froze to the pan."

Frozen or dripping-wet laundry then had to be hung on ropes near the stove in Evelyn's room or on a clothesline outside in the bitter cold. Retrieving it became the next painful ordeal, especially on days that saw the mercury plummet to a bone-chilling 25 or 30 degrees below zero. "Out & got clothes in, off with the pegs," she wrote on January 25, 1893. "Oh how fearfully cold it made my hands but I was determined to get them all in at one go."

The one good thing about washing in winter was the availability of "soft" snow water, with a lower mineral content than her "hard" spring water. The day before a wash was to be done, Evelyn would collect a boiler full of snow and let it melt. On one such occasion she reported:

[Washed] 2 flannel nightgowns (a caution to snakes), 1 flannel shirt [of] Alec's, 1 knitted vest, 1 pair combis flannel, 1 woollen helmet, 3 pillow cases, 4 hand towls, 2

sacks, 1 pudding cloth, 1 apron. The nightgowns took an hour each. Washed in snow water mostly, when dried they were all soft as silk.

Frigid weather also meant keeping up a steady supply of wood and coal to heat the house. The pioneers used the soft coal that underlay the badlands for fuel, referring to it as "day-and-night coal" because it burned so quickly that the fire had to be replenished around the clock. Thus keeping an ample supply on hand was no small task—and it was usually up to Evelyn to dig it out and haul it. In her pragmatic fashion, she figured out exactly how much coal was needed to heat the house in 1906, and noted it on the inside cover of that year's diary:

> We use about 100 lbs. Coal a day.
> This is 3,000 lbs. a month of 30 days.
> This is 9 ton in Six months.
> *Largest coal hod full weighs 40 lbs.*
> *Granite water pail full weighs 22 lbs.*

The badland hills near the ranch on the North Side of the Yellowstone River had veins of soft coal running through them, but, as Evelyn wrote, "So much top earth has to be moved before the coal is reached that the game is hardly worth the candle." There was a much easier spot to mine coal on the other side of the river, but since there was no bridge, in winter the ice had to be sufficiently thick to bear the weight of coal-laden wagons. The year 1904 posed a peculiar problem: the winter was unusually warm, with the result that the North Side residents were cut off from town life, from news of the outside world (for six weeks the Camerons were unable to collect their mail), and from their source of coal. When the Yellowstone did finally freeze over, Evelyn and Ewen seized the opportunity to cross the river and dig out a supply of fuel. En route back to the ranch, however, the mercury took a sudden turn upward and left them in a precarious position. Evelyn described the near disaster in a letter to her sister Hilda dated January 21, 1904:

Changes of temperature here are very remarkable & today the thermometer made a jump upwards of 16 degrees one hour. Owing to this we got into a rather bad predicament the other day. We have been hauling our coal—it takes 8 loads to last us a year—& have to get it when the river is frozen as the coalmine is at the mouth of the Fallon Creek which runs into the river exactly opposite our place 3 miles off. . . . Once there we can get a load in an hour. The snow enabled us to use horses that were not shod, but on the last day it melted so quickly that the ice had an inch of water on it. The horses could barely stand—in fact, one of them fell down & we had to unhitch to get him up again. We were anxious not to abandon our coal but it looked as if we could not get home with it & as a further complication we did not know whether the river ice was still good. However, by sanding the worst places, which was hard work, we arrived finally on the land at the north side.

Wood was also used for fuel; and after one January morning in 1893 spent turning the trunk of a big box elder into a useful pile of logs, Evelyn boasted in her diary: "Don't feel in the least tired after sawing, it is good exercise." As much as she enjoyed it, however, sometimes she got fed up with doing the heavy work. On one occasion when Ewen, Alec, and a local sheepman were all at the Eve Ranch and it was still left to Evelyn to chop the wood, she noted angrily: "Chopped up pile of wood (3 men & not one to chop for me!)"

Most of the tasks that fell to Evelyn would have been considered "man's work" elsewhere. Leaving the wood gathering to Evelyn flew in the face of frontier etiquette, according to a report on the American West published in 1894 by a Britisher named J. Turner Turner, who concluded that with the amount of domestic work demanded of pioneer women it was "not much to ask of a man to supply wood & water in return for a good dinner." Evelyn shared his sentiments; she pasted Turner's article in her diary for 1894.

The Camerons ran all the Eve Ranches without any full-time help. Although the reason may have been largely finan-

Each August, prairie hay was cut and stacked for winter feed by haying outfits that went from ranch to ranch. Haying time was one of the least pleasant seasons for Evelyn because she had to cook for the haying crew, who invariably took longer than planned to finish the job.

cial, Evelyn actually preferred it this way and dreaded those times when, for special building projects or heavy seasonal work, they did hire a man or two, for it meant that she had to spend hours looking after them. As soon as the breakfast dishes were cleared away she would start right in on the large midday meal. On May 11, 1899, she had to cook dinner for five men and herself. She had an old hen on to boil by eight-thirty in the morning and dinner on the table by 1:00 p.m.:

> Boiled chicken & rice, small roast chicken, thick gravy, celerac, mashed tato, Chocolate blanc mange, latter turned out nicely. Big wash up. Alec calls these occasions "Hotel Cecil."

Evelyn could stand the "Hotel Cecil" for only so long, and she was always anxious for the hired help to finish their work as quickly as possible. One occasion that tried her patience was the haying in August of 1894, when she and Ewen contracted with "old Braley" to mow and stack the hay in the meadow for winter feed. Work began on August 6; four days later Braley and his crew were nowhere near finished. "I shall be so glad when they are thro'," Evelyn wrote, "it is such a continual scramble with them to feed. Braley is so awfully slow he will take a week stacking I expect!" Her estimate was almost exactly right—Braley did not finish the job until Thursday August 16.

Cooking for hired hands was bad enough, but it was even worse when the help had to stay overnight. Such was the case in January 1893, when John Selby, a young man around Evelyn's age, was hired to help the Camerons settle into the ranch south of Terry. He did odd jobs for them—putting up shelves in the bedroom and in the kitchen, repairing the cellar door, and hauling enough wood and coal to last the winter. Though his work was competent, his company was excruciating. "Selby is an awful man to have," Evelyn wrote. "He cannot read, hurts his eyes at night, & [he] just sits & [I] have to talk to him all while." When he finally left on January 9, Evelyn was thrilled to see him go: "He off, rather a relief.

He has no idea how to pass the time evenings. I do dislike having strangers in the house."

With no permanent hired help on the ranch, Evelyn worked from dawn to dusk doing the rough, dirty work of a ranch hand. She roped and branded cattle; dehorned calves using only lye and a penknife; and broke wild horses. She was especially proud of the latter skill. "I am just going to begin halter breaking & stable breaking 8 Arab yearlings," she wrote in an 1898 letter to a friend in Miles City. "It is very fascinating work. The little wild brute [becomes] so gentle & confiding." In her usual modest fashion, Evelyn neglected to mention how very difficult it was to subdue willful ponies. It was a task that required enormous amounts of patience— and brute strength.

To Evelyn's horror, the local cowboys often resorted to cruel methods to achieve the goal quickly, as she noted with revulsion on July 3, 1894: "Saw Drew breaking broncs [at the Tusler ranch] in the most brutal manner, scaring them into wire & tumbling on their heads—sickening." Her own methods were gentler. On March 26, 1895, she wrote:

> Took the foals down to water. They were frightened of the clothes on the washing line blowing in the wind, therefore I made them go round & round the length of the line. Little grey [foal] was awfully willful, threw itself down & skinned my fingers so I tied them up, put gloves on & broke one at a time. Had hard battle with Figs (iron grey) to get her to go under the line, but got both finally so that they let the clothes flap all round them.

Evelyn took her share of hard knocks while trying to train unruly horses, on one occasion getting a "bump as big as a chestnut" on the bone of her left arm. Nor was the day-to-day care of the cattle and horses without its dangers. Several times Evelyn was the target of a stray kick while milking her cows, and on one occasion she was attacked by a steer while making a routine inspection of her cattle. "I had a little accident," she wrote to Kathleen Lindsay on September 21, 1897,

. . . about a week ago when on one of my periodical pasture rounds. In the pasture where you beat me racing so shamefully were 2 strange steers, so I proceeded to turn them onto the range. The brutes insisted on going in opposite directions. Finally just as I got up to the biggest, a 4 year old, to turn him, he made a rush at [my horse] Buttermilk digging him in the ribs with his horns & tearing my skirt. Buttermilk of course whipped round like lightening & I fell like a thunderbolt right under the horse . . . for I saw all his legs over me. I jumped up with one thought only—catch Buttermilk for I feared that steer on foot. Luckily the beast stood gazing & then turned & fled after its mate, much to my relief. I then caught the terrified Buttermilk & turned the steers out. In the meantime blood was streaming down my face from a slight cut on the head done by one of the horse's hoofs, & my ankle was slightly sprained. Otherwise I felt none the worse, [though] the crown of my hat was ripped off.

In addition to carefully tending the cattle and horses, Evelyn also raised chickens for both food and income. By 1908 she was writing proudly to an English relative:

I have at present 66 Plymouth Rocks & they have laid wonderfully well all the winter—January 406, February 561 eggs, & now they lay 25 to 28 eggs a day although the weather is pretty cold. . . . In the towns eggs are worth from 35 to 40 cents. . . a dozen.

The money from selling eggs and chickens helped keep the Eve Ranch afloat, but like everything else on the place, Evelyn's flock required her constant attention. It was she who cleaned the chicken house, gathered the eggs, and protected her charges from predators, as she did the night of September 29, 1899:

At about 2 a.m. I heard 2 chickens running down to [the] brush making their scream of fright. So up I jumped, pitched on some clothes, [took an] axe & lantern to [the]

chicken house where I saw a large skunk. It ran & dodged so fast I couldn't get a good hit with axe under perches. Got the 16 bore & shot it, pulled [it] out into open. [It] had killed 5 chicks largish & small, & hurt 2. [I] chopped the 5 heads off & hung [them] up. Put skunk in the pit behind hay stack. To bed. Ewen very tempered, said I smelt of skunk.

Feeding the chickens was not much easier than protecting them, because Evelyn made her own feed, into which she mixed a healthy dose of chopped bone. The bonemeal was a good source of calcium, and she was convinced that it helped make her chickens healthier and more productive. Midwinter in 1911, she wrote to one of her nieces: "I beat everyone round here in the daily number of eggs, & attribute it to the fact that I pound up so much bone for the birds. . . ." The bonemeal diet, however, required an extraordinary amount of additional work for Evelyn—she had to seek out dead carcasses, salvage the skeletons, and then mash the bone. On January 13, 1898, on a dull day that threatened snow, she hit the bone jackpot:

Went a' bone gathering. . . . [Found] 5 horse 2 steer skeletons. . . . [Went] to a dead horse [that has] lain there for 3 or 4 years but the hide was terribly tough to separate from the bones. I hacked them apart with a hatchet. Got all into waggon, the hide also for hens to pick over. Down near lower gate & hunted for an old steer. Could find skull & few bones covered by a hillock & snow. . . . To a dead horse outside Henry's pasture. . . . I got 3 more horse skeletons & bits of 2 steers.

The gritty work of feeding and caring for the animals on the Eve Ranch had other unpleasant aspects. Evelyn cleaned not only the chicken house but the stables and corrals as well, recycling quantities of the manure as fertilizer. She described an entire day she spent carting the smelly stuff to her garden on May 1, 1897:

*Finished manuring & cleaning corral. [In] 8 hours took 26¹/₂
loads. . . . Have [now] put 65¹/₂ loads on the garden in dump
cart.*

Bright. Southerly breeze. Did not notice temperature.
Very warm.

Arose at 6:50. Fire on. Milked. Breakfast 8:15 & fini
both breakfasts at 9. Swept. Washed up. Took setting
hen off [eggs] etc. Watered 3 foals. . . . Carted manure
from old corral, took down 6 loads before lunch at 2:15.
To work 3. I have discovered that it all depends on the
sort of manure as to the amount of loads hauled in a day.
Corral manure, ¹/₂ of it was thick & damp . . . [&] on a
fork could be handled thus quickly & easily loaded. East
side of the corral & all the outside manure was dry,
scattered & thin—[it took] more time to load such stuff
& less solidity when loaded. Worked till 7:45. . . . I
watered foals & had difficulty in getting two into the
stable, it was rather dark. Light bay "fit like a bar" fell
back & refell, but I got it in. . . . Under the corral
manure there ran an inch layer of snow, [I] hauled it all
away. Sup 8:45. Thin beaten steak, mince, poached
eggs, rice, tomatoes, coffee, pears. Washed up. Wrote
diary. Ewen was rather put out about the late hour.

Ewen was annoyed, even though *he* had not worked late,
because his dinner had been delayed by Evelyn's corral-
cleaning. There was never a break from her domestic duties.
Once, while in Terry with Ewen, she thought wistfully of
how nice it would be to stop at the local hotel for dinner:
"Heard Mrs. Jordan's sup bell, wished it was possible for us
to go & eat there but those nuissances (the boarders) give me
no peace."

On March 5, 1895, she expressed her frustration—and
exhaustion—in a rhyming diary entry:

From repose arose, none the worse for my dose. In worn &
tattered raiment sallied forth to do the chores, & then
returned to cook for those everlasting bores.

Especially irksome to Evelyn was the leisurely manner in
which the other members of the household began the day.
Usually Evelyn had lit the fires, milked the cows, made the
breakfast, and done myriad chores before anyone else even
stirred. Any variation in this routine was noteworthy: "Ewen
actually arose 2 or 3 minutes before me!!" she wrote sar-
castically on June 10, 1899.

Even if Ewen did wake up at a reasonable hour, Evelyn
generally had to hold breakfast for him, because he was
extremely fastidious and deliberate about his morning ablu-
tions. The pace at which Ewen moved in the morning drove
Evelyn crazy, and she noted with exasperation one day:
"Ewen shaved—this operation took longer than getting
breakfast." And when he finally did sit down to breakfast, he
was not always pleased—and not always civil. Evelyn was
inured to Ewen's prickly temperament, but on the morning
of September 19, 1893, his behavior pushed her too far. As
usual, breakfast was ready long before Ewen made his ap-
pearance; yet no sooner had he sat down than he made his
displeasure known:

Ewen took a fly out of [the] cream & threw it on the
boards. I told him I didn't like cream thrown on boards
[&] he became mad with rage & flew into the other room.
Later I went to try & appease his wrath, [this] made him
worse & [he] cursed me 4 times as I went down the
verandah steps 'cause I cried. I felt mighty bad & in . . .
solitude poured forth my heartache. To be cursed by
him—! Finished washing up. I had no breakfast, too big a
lump in my throat to swallow.

(Ewen, for his part, ignored Evelyn and spent the rest of the
day writing up his ornithological notes.)

Even holidays did not do much to soften Ewen's cranky
disposition. On Christmas morning in 1899, during one of
their annual hunts, Evelyn prepared breakfast in a tiny shack
in the wilderness while a "shinook [was] blowing strong"
outside. She made "pancakes of graham meal," but Ewen
announced that he was "very disgusted with them, he wished

for ones like [the] Scotts [make] at the Hotel." Because of his delicate health Ewen insisted on a bland diet; her boarders, however, had more exotic tastes, and Evelyn had to cater to them as well. One cold December morning in 1897 she prepared a special breakfast treat for her brother: "Pig trotters cold in their jelly for Alec, one [of] his favourite dishes."

Evelyn cooked a wide range of hearty foods—from a humble hare stew ("cut up ½ the hare which I fried, put it into pot of boiling water, fried 3 onions brown, put this with hare & let it stew on a gentle coal fire all afternoon") to a beef soup that Alec said "reminded him of Clarige's Hotel soup." Memories of Britain were mixed with the smells that emanated from Evelyn's kitchen. Pork pie, scones, bubble & squeak, shepherd's pie, haggis, and mulligatawney soup were all part of her culinary repertoire. But there was no mistaking the influence of the Montana wilderness either. Dinner, after all, was dependent on what was in the larder—and that might range from porcupine (which Evelyn made into tasty porcupine croquettes) to antelope. Indeed, she was

not averse to trying any local recipe no matter how awful it sounded. The day after she had her calf Willie castrated, in June 1915, Evelyn indulged in a cowboy delicacy: "I got wild spinach on to boil & Willie's testicles. Heard they were very good, boys eat them on roundup. They were good fried in butter."

There was one local source of food the Camerons resisted using: though the pasture and brush near all their ranch houses were alive with birds, some of them quite tasty, the Camerons seldom hunted them. During the financial Panic of 1893, however, they had no alternative. "No bacon, no nothing, shot grouse to make up the deficiency," Evelyn wrote across the top of her diary entry for August 19, 1893. Other local treats depended on seasonal migration patterns. On an October day in 1898, she jotted in her diary: "Sandhill cranes are so numerous now everywhere & are splendid eating."

With the bounty from their fall hunts the Camerons generally had a good supply of meat in winter. Summer

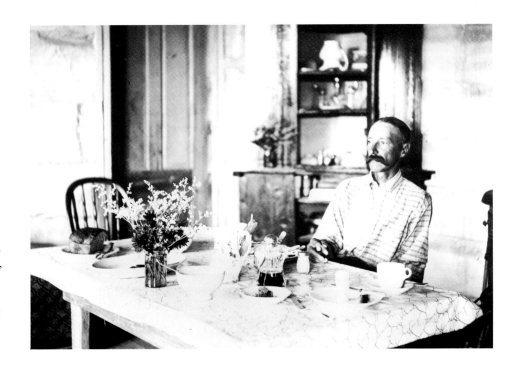

Ewen after breakfast, on August 4, 1903. Breakfast might include scones, porridge, mince, bacon, poached eggs, buttered toast, fresh cream, coffee, and tea. Ewen was particular about his food; he once flung a cup of cream to the floor because there was a fly in it—Evelyn burst into tears, having gotten up early to milk the cow to get the cream.

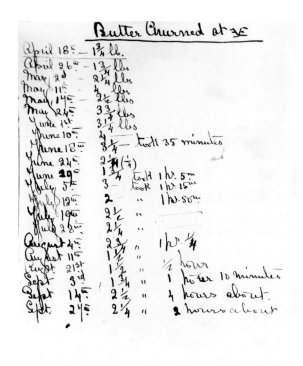

Evelyn's log of her butter production for 1894. One entry shows that she had to churn a troublesome batch for four hours—40 minutes was the norm. She often read as she churned.

was another matter. Without adequate refrigeration, meat quickly grew rancid; to preserve it as long as possible Evelyn smoked or pickled meat when the warm weather arrived. Her recipe for pickling was inscribed in her diary entry for May 30, 1896:

> 3¹/₄ lb. salt, 1 lb. sugar, 2 oz. saltpetre, ¹/₂ cup mollasses, 2 gals. water. . . . I washed 19 lb. meat & poured this over it, have to leave it 2 weeks (in spring).

In both winter and summer, Evelyn also butchered domesticated fowl for the dinner table. "Killed 2 ducks à la Lady Jane Grey," she noted, for example, on September 19, 1893.

Her technique on December 5, 1904, was not quite so efficient:

> Killed a rooster—chopped ¹/₂ its head off & on returning from milking found it standing up. Had quite a tussle to keep it from getting away before its head was entirely severed, poor beast.

Year round, Evelyn's morning ritual included milking the cows ("I whistle whilst milking as it induces her to let down her milk," she wrote of one reluctant cow); later, she would skim the cream that rose to the top of the milk and churn it into butter in a dasher churn. On June 22, 1895, this churning went well:

> Arose at 6:05. Dressed. Churned from exactly 6:30 to 7:10, the precise time for good butter "to come"—viz: 40 minutes. I was relieved when it came as [there would have been] none for breakfast if I hadn't. . . . 2¹/₄ lbs. butter I churned.

The butter making did not always "come" so readily, however. On Christmas Eve of 1897, Evelyn noted: "Felt blue, 3 days spent of my precious time churning, result—nil." Two days later she was still grappling with the same recalcitrant cream:

> I churned & read "Pear's Annual" at the same time, so one can do two things at once. . . . Butter still refuses to come, shall scald the cream & when cold shall use the surface fat for shortening.

Working cream into butter always proved more difficult in cold weather; likewise hens were reluctant to lay when the temperature dropped. "Have to peel tatoes every morning to help out lack of eggs," Evelyn remarked during one winter. As a substitute for eggs in cooking she had another idea, which she mentioned in an 1896 letter to her mother-in-law:

> Have you ever tried Bird's Baking powder in your household [as] a substitute for eggs. I tried to get it in Miles City,

Ewen probably snapped this August 15, 1904, picture—after Evelyn set the exposure—of Evelyn milking, a chore that Ewen never undertook. In her diary Evelyn noted that if she whistled when she milked one reluctant cow it seemed to make the milk flow.

Evelyn poses in her vegetable garden with an array of squash. To make extra money she sold vegetables to other ranchers, cowboys, and railroad workers. Evelyn's records for 1895 (opposite page) show that she packed more than half a ton of potatoes and cleared $41.20 from food sales after deducting payment to her brother Alec.

but it has never been heard of there. In the winter when eggs are dear & hens refuse to lay, I have thought that such a substitute would be useful on a ranch.

As soon as the spring thaw set in—and sometimes even before it—Evelyn had to begin the cultivation of her garden: she sowed seeds in starter boxes in March, on at least one occasion using a pickax to "mine" the frozen earth to fill them.

Once established, the garden required constant vigilance against the ravages of drought, weeds, and insects, and the diaries are filled with references to these blights. On a June day in 1900 Evelyn yearned for rain to revive her parched plantings:

Just a breeze, only suppose it will rise to a hurricane. Bright. Oh, if only it would rain—everything out of the valley *is so dry*. . . . I irrigated & put ashes on cabbages but the jumping flea has eaten them all nearly.

Evelyn spent hours removing the "nastiest weeds that ever grew to pull"; wrapping the stems of her cabbage plants in horseradish leaves to prevent cutworms from killing them; and plucking potato bugs one by one from her plants and dropping them into kerosene for an instant death. There were also larger predators, as on the evening of August 31, 1898, when Evelyn went in search of a garden thief:

Sup 8. Fried chicken, boiled tato, fried squash. When I got squashes I found lots eaten by porcupine. Milked. Washed up. Alec & I down to garden. I took axe, went to squashes & there was Mr. Porcupine eating a fresh vegetable marrow. I let him hurry off the marrows then I brained it. Alec & I took it up. Alec called it coon hunting by moonlight. [It] weighed 24 pounds. Hung it up on meat tree to be skinned for dogs.

Like a squirrel preparing for the dark days ahead, Evelyn spent each late summer and early fall harvesting the last of

JANUARY, 1895.
Paid.

March 3rd Sacked 692 lbs large size potatoes
" " 303 " medium size "
" " 246 " Miscellaneous "
" Boxed & Greathe, 361,400# for cows
" Thrown away about 200# Spoilt by frost.

Total of potatoes 1241. lbs.

My share of Garden produce
netted $41.20 for this
Year.

Total £ _____

her garden's fruits and vegetables, pickling and preserving for winter use whatever she did not sell. She also collected wild fruits and berries, making jams, tarts, and other confections from chokecherries, wild currants, and bulberries. In August 1898 she spent long hours gathering chokecherries in 10-pound lard pails, and then squeezing the fruit through "mosquito barring" over a frame to extract the juice while separating out the stones and pulp. On a stifling 90-degree day that same month she "stewed sugar into cherry juice for wine . . . giving $1\frac{1}{2}$ lb. sugar per gallon" of fruit juice (she also cut up and cooked half a sheep that day). She made sixty-five bottles of wine that August, mixing in the previous year's plum wine to make what she judged to be an especially tasty and fragrant drink, despite the fact that a few weeks later the wine had to be strained to remove the "flies & moths [that] had got into the bottles."

Come September it was time to gather wild plums: "Went to the plum trees & picked one pail & a lard pail by shaking the trees." On September 13, 1899, she spent a "lovely" day "pluming," but had an annoying mishap en route home:

Got ready & off on Steel. Jan & Smiler [the dogs] came too. Went to furthest plum patch east side [of] creek & [got] $3\frac{1}{2}$ pails (10 lb lard) & $\frac{1}{2}$ more on way home. Going home got to near wire fence & the barbs tore the sack open letting down most of the plums all in rose brush & on the sandy trail. I got off & gathered up all again. . . . Cleaned trough out & washed all the plums in it, made the sticky sand all come off.

Days thereafter were spent stoning and boiling the plums for jam. On Saturday, September 16, she wrote:

Put plum jam on to boil again & finished it up. 21 lbs. sugar to 19 lbs. fruit. Put chair on Arbuckle [coffee] box, this made a good height to sit on to stir. Could read also. At 2 quit & put it in a 4 gal. jar, 3 pint bottles & an 8 oz. bottle.

Evelyn's work was well worth the effort. A fellow pioneer declared the result "the best jelly she had ever tasted in her life!" And she herself noted in a letter: "I have been very busy making jams & pickles. It is horrid work but has got to be done for we appreciate these things in the winter."

With the threat of frost in the air as early as mid-September, Evelyn had to scurry about harvesting what summer crops remained. She collected the herbs that she cultivated all summer, tied them in bunches, and hung them to dry. She made ketchup from the last of the tomatoes, melon preserve from the remaining water melons and musk melons, and piccalilli from a potpourri of vegetables. On September 14, 1897, she wrote in her diary:

Gathered small beans, onions, few more cucumbers & cauliflowers (4) cut these up & snipped bean ends off. Cut up cauliflower this took me till 1:30. Put 1 gal. of vinegar in the pan, spices, mustard etc. & let it all boil. Took the pickles off at 5 as the vegetables seemed to be boiling too much, put the pickle into 12 gal. pickle keg, 2 old pickle bottles, 1 Chutney bottle, $\frac{1}{2}$ a tobacco bottle.

This was also the time to begin bringing in the cornucopia of autumn vegetables, including a wide assortment of squashes, cabbages, and potatoes.

Harvesting the potatoes—digging, sacking, hauling, and storing them for the winter—was particularly dirty, strenuous work, and as usual it was Evelyn who did most of it. She charted each year's harvest carefully, weighing the produce on her "tripod weighing stand." The size of her potato crop was prodigious: 1,395 pounds in 1898, for example, and 2,000 pounds in 1899. Evelyn described a typical day of "tato" harvesting in October 1898:

Got sacks, weighing machine, bushel basket & trudged to North patch of potatoes with misgivings as I feared the frost might have hurt some—the ground [was] damp but tatoes untouched. Slaved away by self for an hour with spade then Alec came & he picked up [the potatoes]. I dug & picked [using] 2 receptacles, one for small other for large tatoes. Lunch down there [on] biscuits, buns, pudding plum, water melons. After this I used potato fork & Alec the digging fork, thus we both were able to dig up & get along quicker. Put tatoes (tho' rather damp) into sacks. Gathered tomato & tato vines & covered the sacks with this, 1st putting sacks then [tar]paulin.

On October 27, 1899, she persuaded a reluctant Ewen to help: "Ewen very averse to hauling up tatoes but we did do it in 2 loads & like last year at the same job he was boiling. He changed his clothes cause [he] sweated."

During such periods of heavy seasonal work Evelyn was not freed from other responsibilities. On the contrary, all of the domestic duties (and more) still fell on her shoulders. In fact, the morning after she and Ewen had laboriously hauled in the 2,000-pound crop of potatoes, she had to make frantic preparations for the wilderness hunt on which they planned to leave the next day, preparations that included ensuring there was an adequate supply of food for Alec, who would stay behind. Still, in her diary entry for October 28, 1899, it is impossible to detect the exhaustion she must have felt:

Very busy. Packed. Cooking going all day. Big Baking. Churned 1 lb 5 oz.
Beautiful very mild & calm.
Arose 6:10. . . . Bright Pink rosey hue to North. Breakfast on. Fed chicks. Milked. Breakfast 8:45. Washed up. Wiped. Swept. Got 8 chickens on to boil . . . cut them up into joints. Alec made a new oil can into a pail & I put a ham to boil in it. Packed stores. Left a lot of everything fresh for Alec. Baked another (2nd) batch. Lunch on the move. . . . My bag packed. Fed chicks. . . . Milked. Sup 7:20. Boiled chick rice, parsnip, baked tato. Made 3 pies for Alec, 2 apricots, one pear. Greased wagon & ground Ax [in the] morn. Alec put up vegetables for trip. Washed up. . . . Churned 1 lb. 5 oz. Bath. *Bed 11.*

Alec also created extra work in the sewing and mending department, to Evelyn's dismay. "I sewed at my Scott Adie skirt & at a pair of Alec's worn out oversocks—his rotten old things keep one busy," she wrote disgustedly on February 16, 1893. On April Fool's Day in 1900 she finally extracted a measure of revenge: "I sewed up Alec's nightshirt near wrists for fun [on] April Fool." (Evelyn noted in her diary that her brother had also been the butt of a practical joke in 1894 when "Drew & Henry [Tusler] . . . stuffed up Alec's stove pipe & made the room full of smoke as an April fool. . . . All sorts of tricks are played today everywhere in America especially stopping up chimneys.")

Whenever she had a spare moment Evelyn took up needle and thread, for there seemed to be no end to the mending that needed to be done. Long skirts were not very practical for rough outdoor work, and to prevent the bottoms from fraying she sewed leather around the edges. Though she generally bought her clothing from local dressmakers or, in later years, from the Montgomery Ward catalogue, on one occasion she salvaged some of her British woolens to make a rugged "chore skirt":

I put old Shetland herringbone homespun back onto front of Irish homespun back, this making an apparently new

skirt. Patching, darning & leather . . . [on] bottom [of] skirt to be done yet.

Evelyn's mending extended beyond clothes to items such as Ewen's binocular case, which she repaired during a wilderness hunt with sinew from their slaughtered game. She also learned how to tan hides from her neighbor Mrs. Kemp-

A dead bittern, October 1902 at the Crown W Ranch.

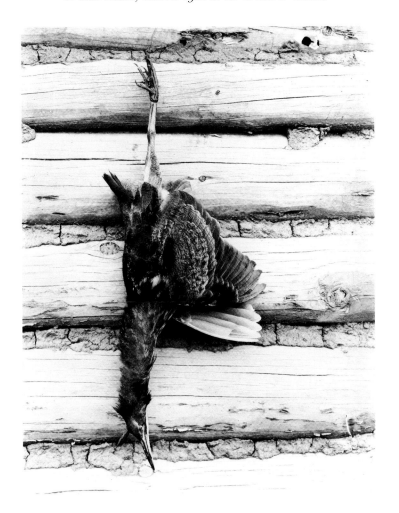

ton, a physically imposing half-Indian pioneer rancher, inscribing the method in her diary on May 28, 1894:

> Mrs. Kempton . . . had been making gloves from her own tanned hides, beautifully tanned. . . . She soaks the skin in the creek till soft then scrapes all the hair off. . . . 2nd, 2 table spoonfulls of lard or suet melted [she] rubs in the hide, [&] leaves it for few days, 3rdly, [she] washes the grease out in lukewarm soap sudded water, [the skin is] then pulled & rubbed dry by 2 people. Not at all difficult to do she says, certainly the result is worthy of some labour.

In March 1895, after killing a coyote "to get the $3 bounty which the new bill provides for," Evelyn was determined to tan the hide. On an overcast day when the temperature dropped to 14 degrees below zero, she began:

> I got coyote skin [which was] frozen, hung it up in our room to thaw out. . . . Skinned out coyotte's head, & pulled bone out of its tail. Took skin & washed horrid smelling dirt off of coyotte's tail in stream.

The next day, she continued the process:

> After work [morning chores] thro' went to fowl house where [I had] fixed graining block yesterday, got horse curry comb & scrapped away at the skin. It was toilsome work. . . . I had skinned it off hurriedly leaving lots of grain on it. Ewen called me at 2 to put out lunch. Glad to put feet in hot water, they got damp & cold standing from 11:30 till 2 graining. . . . [Later] took off flesh from scalp [of] caiyute.

The Camerons often saved the skins of Montana wildlife, sending them to a taxidermist named Allen in Mandan, North Dakota, for preservation and stuffing. Evelyn, as a rule, was the one who got stuck with the messy job of skinning the animals first. She spent the entire afternoon of January 19, 1893, for example, skinning out the heads of a bobcat and a coyote for her Irish boarder Adams, as well as a rough-legged buzzard that Alec had inadvertently trapped.

The skins were then hung up in the kitchen to thaw out before being sent off to the taxidermist. Adams and Alec had the creatures stuffed as trophies of life in the Montana outback; for Ewen, however, the skins were of professional interest, and he dispatched specimens not only to his brother in Scotland (who was also a naturalist) but to institutions in London. "Did up . . . 2 pine marten skins for British museum," Evelyn noted on September 1, 1898.

It is evident from Evelyn's diaries that Ewen spent most of his days absorbed in observing and writing about Montana wildlife, especially the birds. Evelyn was an invaluable partner in his work: she accompanied him on many an "ornithological ramble"; she helped him amass an extensive collection of eggshells by carefully blowing out their contents; and she artfully photographed the creatures he was studying. She not only skinned animals and birds for him, she helped him make precise identifications, as on April 11, 1893:

> Ewen concentrated his whole attention to discovery of the two owls shot yesterday. My suggestion of their being *young Great horned owls* proved correct after an exhaustive search in Cone's & Baird's. At 12 I began [skinning the owl], didn't finish until 4:30. Lunch in between when I read cookery books to find Swiss Roll which weren't to be found under any name applicable to them. . . . Washed up mess I made in the bird cleaning.

The next day, "Ewen read out directions for ascertaining sex of a bird. We dissected the owl & satisfied ourselves that it was a male."

Ewen's scholarship, however, was achieved with a single-mindedness that precluded his getting too involved in the day-to-day management of the ranch. Evelyn did that. The day after dissecting the owl for Ewen she was back at more prosaic tasks: "Scrubbed kitchen floor out. I put down on it a lot of sand, the better to scour, but. . . such a nuissance getting the sand out again." Keeping the ranch house clean was a never-ending struggle, and scouring with sand was

only one of the techniques Evelyn experimented with. On another occasion, following a recommendation by her friend Mrs. Collins, she washed the floors with whey. To add a high polish she rubbed them with bacon fat.

Periodically the walls and ceilings of the ranch house were thoroughly cleaned, then brightened with a lime-based whitewash; the arduous task of applying the caustic solution fell to Evelyn. "The lime to-day made my left hand fingers fearfully sore, burnt skin off in 3 places to the flesh & fingers are dried & swollen," she noted on October 25, 1893. She again set to work at whitewashing in June 1895, when she tackled the walls and ceiling of the combined sitting room and bedroom:

> White washed our room, finished it myself. . . . Cleared the room of everything—[put] furniture & trunks on the porch; books, garments etc. in kitchen. [Had] only one brush, other quite worn out. Alec made up some mortar & plastered up a few places in our room. Put down sacks close to wall on which [I] white washed to keep floor cleaner, it is (wash) such horrid stuff to get off again. Did East wall & ceiling first. Lunch 1:45. Mr. Colley came to see the work. Set at it again, kept on till 4 when lit fire, washed salted meat & got sup going generally. . . . [While whitewashing] wore snow spectacles, they kept the lime out of my eyes.

She finished the job the next day:

> Began at our room again. Lots of places the wash had been too thin (white wash didn't slack yesterday morn, consequently it settled very quickly & had to be stirred frequently) . . . so I made a round of the room again with brush & tin. Then when thro' with that I washed the ridge poles, the white wash having dribbled down them & I don't like them [white]washed. I like to see the yellow pine logs across. . . . I swept thoroughly. Scrubbed floor [with] lye & boiling water, had it on all morn. Took lots of work [removing whitewash stains], knife got spots off mostly. When thro' got Alec to come up from garden to help put room to straights, he dustied books & put them up. I

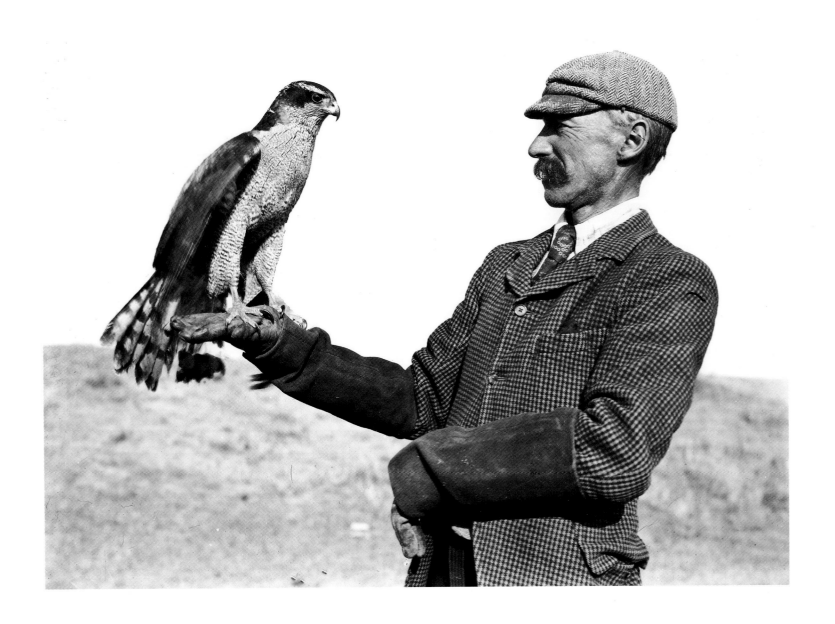

A goshawk that Ewen winged in the fall of 1906 became a long-term guest. Here it perches contentedly on Ewen's hand in April 1907. When the Camerons moved from one ranch to another that winter, it rode alongside the cat on their wagon. At the new ranch they tried to keep the bird in the house with them, but in the evenings it flew around the kitchen, prompting Ewen to exile it to an empty chicken coop.

did boots, bottles, eggs, my books, scrubbed middle of room. . . . Our room looks very much better.

The whitewashing not only improved the room's appearance; it was also the first line of defense against bedbugs. When the very English Effie Dowson, appalled to discover that she shared her quarters at the Cross S Ranch with these insidious creatures, wrote to Evelyn about the problem, she received this advice, in a letter dated September 21, 1897:

> Corrosive sublimate in the white wash is the best exterminator for bugs & that insect powder Savage sells with a little puffing instrument to apply the powder is also effective for bedsteads & furniture in general. I am sorry you are troubled with the little horrors. They will be hard to get rid of unless the calico [covering the walls] is taken down & the remedies applied to the logs.

Despite Evelyn's meticulous housekeeping, however, the Eve Ranch was not free of the "little horrors." On July 8, 1899, she wrote, "Bugs troublesome near our bed. I puffed powder & killed about 50 that came out of cracks."

Bedbugs were not the only pests endemic to ranch life. After a day spent rounding up forty-seven of their calves in the spring of 1904, Evelyn reported with disgust: "Found cattle lice on my dress & cap! horrid!" Until she was able to rid her cattle of these pests with her "patent dip" of kerosene, water, boiled linseed oil, and sulphur, she had to change her clothes before doing housework to avoid infesting the house. Fleas posed a similar problem. After thoroughly cleaning out the barn on June 23, 1904, she noted, "I was so thickly *covered with fleas* I undressed out of doors & put . . . clothes in hot oven. The fleas just crumpled up, such a number [of them]."

While working her garden or tending the livestock, Evelyn was also apt to run into snakes, and she would calmly dispose of them. Midway through her diary entry for July 13, 1899, she casually mentions that

> at chicken feeding time I killed a house snake near [the] store house. It nearly ceased to wriggle but when I put it in

the stove . . . it then made a most terrific wriggling before it let up. It couldn't possibly feel though [as its] head [was] smashed to pieces.

Neither afraid of the creatures nor repelled by them, Evelyn rather took a scientific interest in them. "Killed a very small snake with a big frog in its inside," she wrote on July 22, 1894. "How it could have swallowed it I don't know." On another occasion the dissection of a rattlesnake revealed a "newly eaten sparrow, full grown, [that] looked far too large for the snake's mouth."

Rattlesnakes, of course, were an ever-present danger. Just how prevalent they were is apparent from an encounter Evelyn had while she "hunted up badger holes" with a polo stick on a beautiful July day in 1894. She ran into a "big Bismarkian German sheepherder" who reported that he had killed sixty rattlesnakes in the area during the previous year. Bitten by one of the snakes, he had cut and drawn out the venom himself, and "felt none the worse" for it.

Evelyn had a healthy respect for the treacherous rattlesnake—and her horse shared her sentiments. Riding in the badlands one evening, Evelyn's horse came to a sudden stop. He had detected a rattlesnake and refused to move another inch. If Evelyn dared to dismount, the snake would undoubtedly strike her, so she and her horse remained motionless in the dark for a seeming eternity until the rattler slithered away.

Evelyn had many encounters with rattlesnakes, amassing a large collection of rattles from those she had killed. While she was out riding with her boarder Mr. Adams on May 22, 1894, a rattlesnake began to "tune up" just beneath her horse. She saw it coiled in some sagebrush, and luckily Adams was able to kill it with his quirt. On one occasion she had the temerity to tease a rattler to try to make it "go on the fight" before she "shot its body to smithereens"; on another she successfully photographed one of the deadly creatures at close range while it was coiled and ready to strike.

Just in case her boldness backfired, Evelyn had a recipe for

counteracting the rattlesnake's deadly venom, one she had gotten from a local rancher; she passed the tip on to a compatriot who was also ranching in the Montana wilds, in a letter dated September 21, 1897:

> I must give you this Freer's prescription for rattle snake bites. Please tell all the men on your ranch it is—cut a cactus in two & apply one half to the wound like a poultice when it will draw out the poison. The spikes have 1st to be cut off or got rid of in some way. . . . I think this is a good thing to know.

This letter is typical. The Camerons often exchanged medical hints—both for their own health and for that of their livestock—with their neighbors. The nearest doctor was almost 50 miles away, in Miles City, and he was called only in the direst emergency. For anything less, the local pioneers concocted their own remedies. Trial-and-error was the rule, and if a recipe proved effective—no matter how strange its ingredients—it was passed on to others.

For a persistent facial rash that Evelyn was troubled with, Mrs. Kempton suggested applying one tablespoon of sheep dip (the brew used to rid sheep of lice, ticks, and other assorted parasites) diluted in eight ounces of water. And when Ewen's severe stomach pains were (incorrectly) diagnosed as appendicitis, the Kemptons immediately recommended a steady diet of sardines and cornbread. For days thereafter poor Ewen was force-fed sardines, with no salutary effect.

The Kemptons were also the source of a rather curious remedy for frostbite, which Evelyn described in the back pages of her diary for 1896:

> Mr. Kempton once had his feet so severely frost bitten that 3 doctors said he would die if they were not cut off. Mr. Kempton was determined not to have them amputated. An old "darkie" woman happened to call for his mother's washing. She saw his feet & at once said they could be saved. Her receipt being *baked common white turnips*, the

inside (pulp) of the rhind applied quite hot as a poltice to the frozen parts. . . . For the first 5 days the poltice had to be renewed 3 or 4 times, the very wet pulp being entirely absorbed by the feet. At the end of 5 days the moisture no longer became absorbed but remained in the poltice. In about 18 days the skin of the foot came off entirely like a mocassin. "Darkie" then advised very tight slippers or boots to prevent feet spreading. After the skin came off, the feet were a bright puffy red colour & when stood upon felt as if they would burst. [The] feet cracked down soles but finally became as well as ever through this treatment. *Related March 8th '96 by Mr. Kempton*

Another home remedy, for diphtheria, was detailed in Evelyn's diary entry for July 7, 1896:

> Mrs. Braley told me of an infalable receipt for diphtheria, she has given it severe trial. Saltpetre, Alum, Chloride of potash, & tanin equal parts of each mixed in water, [do] *not* mix them dry first as they might explode but mix in the water gradually & separately. Keep bowls [bowels] open with castor oil. Gargle the saltpetre etc. every $^1/_2$ hour during day.

To reduce throat inflammation caused by diphtheria, Mrs. Braley suggested a mixture of bacon fat and black pepper.

Accidents and emergencies were a part of ranch life. After a spring day of spreading manure over her garden, Evelyn was left with a "nasty grit in my right iris . . . I found after supper it had stuck in tight but after some vain attempts I got it out with the eye end of a needle." On another occasion, while leveling a water trough in June 1904, she accidentally hit the right side of her mouth with her pickax; she sewed up the "jagged cut" herself, with five stitches. When tormented by an aching tooth in September 1896, she again took matters into her own hands:

> *Pulled a double tooth out . . .*
> Arose at 7:40. Had a bad night, tooth ached [& I] got up several times to put tooth ach solution into it. Milked,

turned cows out etc. Got small glass & wire pliers, [went] into store house & ran wire round [tooth]. . . . Hung by [wire] from rafter but it broke. Put stronger wire round the tooth, joined ends again to rope which [I] threw over rafter. Stood on trunk [&] let self down easy. This pulled the tooth out. [A] piece of the jaw held the crown (roots out), got this loose, ran in with the tooth nel mano, [&] told Ewen. Bled a good deal but it didn't hurt getting it out. Breakfast [I] got merrily.

Dentists were as scarce as—if not scarcer than—doctors on the Northern Plains. For a brief time in 1894 an itinerant practitioner named Dr. Adams treated patients at the Terry railroad depot. He could not have chosen a busier or a less sanitary place to set up business.

The railroad depot was one of the few gathering spots for the area's scattered ranchers. Men and women in from the country would pick up the local gossip at the depot while loading onto their wagons the supplies they had ordered from mail-order houses back east, or delicacies such as fresh salmon that Terry's railroad operator had arranged to have delivered from the west coast. Sides of beef, eggs, and other foodstuffs were also picked up at the railroad depot. It was in the midst of this chaos that Dr. Adams set up shop.

On a lovely May day in 1894, Evelyn, accompanied by Mrs. Drew from the neighboring Tusler ranch, went down to the depot to have the dentist attend to their neglected teeth. Evelyn had a glass of beer after her painful appointment, and later noted in her diary how expensive her agony had been:

Cost me $7 to have 3 teeth stopped. Mrs. Drew had a $10 job. Hurt me awfully & not sure it would not ulcerate & have to be pulled or nerve killed.

Dr. Adams apparently did his work quickly, collected payment just as fast, and left on the next train. No need to tarry and have his competence—or his prices—questioned. It is possible, however, that he lingered too long in Miles City. While Evelyn was having dinner in the cook tent at the spring roundup the next month, she learned from a local rancher that "if Adams the dentist hadn't run away from Miles City he would have been lynched, he was a scoundrel."

In addition to being her own dentist and doctor when necessary, Evelyn, like other ranchers, had to be her own veterinarian—diagnosing the illnesses of her animals with the assistance of some general medical textbooks; devising home remedies; and even performing surgery. If her treatments failed, she would perform an autopsy. Unable to relieve the suffering of a sick hen, Evelyn mercifully killed her on February 8, 1899. "Think chopped bone ailed her," she wrote. "Will post mortenuse her."

Evelyn's autopsies did not always discover the cause of an animal's mortal illness. On the same January day in 1898 that she had to kill a sick buckskin mare that was not responding to her ministrations, she also had to shoot one of her favorite hunting dogs:

Went to let Petrarch out, [he's] very weak, tottered walking. Tried him with warm milk [but he] wouldn't look at it, also beef collops [he] wouldn't touch. Hopeless. Breathed in quick short breaths. . . . I felt wretched, oh so wretched. . . . Petrarch too weak to stand, breathing very difficult. It howled for a while. When Alec came in between us we carried him out & I shot him to put him out of his misery. His gums & on his stomac the skin had begun to turn colour. I opened him [& found] bile & a little milk curd in his stomac, his lungs had dark spots over them & a few white spots on an organ that . . . resembled [the] liver, but wasn't liver or kidney. Otherwise his inside seemed quite normal. Put Petrarch in a sack & put him in the brush in meadow by lane till [frozen] ground in condition to bury him.

Evelyn was perplexed by the inconclusive findings of the postmortem on Petrarch, especially when another of her hunting dogs came down with the same symptoms. All along she had assumed that Petrarch was suffering from a dose of poison, a common problem in the region because some pio-

Effie and Major Philip S. Dowson sit with Evelyn next to a cedar grove, where Effie had wandered to paint, May 1903. With Evelyn are her hunting dogs Brinny and Blue.

neers and professional trappers indiscriminately set out poisoned bait for coyotes and wolves. On a previous occasion she had been able to save a poisoned hunting dog by concocting an effective home remedy, described in her diary entry for April 10, 1893:

Bruin came limping towards us all of a tremble—poisoned! I rushed in got warm water [with a] tablespoon of mustard therein (he wouldn't drink milk). Ewen held his mouth open & we poured it down. He had fits & lay as tho' dying, recovering & running about in a tremble we gave him also a cigar end steeped in warm water . . . our emetics had an effect.

Even more destructive to the Camerons' animals were the wily coyotes and wolves. A newborn calf was "eaten to [the] ribs by coyotes" in February 1899 before its birth was even discovered—that was how closely the threat of death hovered over life in the Montana wilds. Often Evelyn's role as ranch veterinarian extended to midwifery. On successive days in April 1904, for example, she literally pulled calves out of their mothers. In one case the calf was dead, but in the other, her efforts saved the life of the newborn:

To barn, found Starlight . . . [with] her calf's head and fore feet appearing. I pulled and pulled. Ewen *had* to help & we got it out only attached by umbellical cord. It would have suffocated if we hadn't drawn it out, the vagina compressed its lungs so.

Newborn calves frequently needed help. Inscribed in red ink at the top of Evelyn's diary page for March 24, 1893, is the legend *Daisy got a calf;* in the main body of the entry she wrote:

I followed & found poor old Daisy in a sheltered part of the brush with a little calf just born, I picked it up & carried it some way, very heavy. Fetched Alec & we took it up together, put her in [the horse] Nancy's stall & Nancy in [with the] cows. . . . If I had not found Daisy her calf

would surely have died, night so cold. . . . [After dinner] up with lantern to look at calf & horses. Daisy was moaning for her calf which had strayed into Nancy's stall. I put the teat into its mouth & the little bugger drank a whole lot. Pulled out a lot of afterbirth from Daisy, thought another calf was coming!

Daisy's calving provided an unexpected benefit when the Irish boarder Mr. Adams shared with Evelyn his cook's recipe for pancakes made with the milk of cows that had just calved. The recipe proved such a success that thereafter pancakes "à la Adams" appeared on the Eve Ranch menu whenever the opportunity arose.

Evelyn would spend days or weeks trying to save a sickly newborn, and she grew extremely fond of her patients. She named one weak calf "Sicklamen," and another, discovered on a "terribly windy" May day in 1899, "Touch & Go."

I started out to get up cows, dogs with me. . . . Up to big pasture looking at steers [when] Sally ran about like one demented. Saw her go to some sparse buck brush & following I found wee wee calf (about 12 pounds weight) very chilled & lain out. At first I thought it dead but wasn't. Wrapped my coat around it & hurried back to the ranch, never stopped once it was so small & light. Put it in blankets by stove in our room.

She nursed the "wee calf" in her room for nearly two weeks, tending it night and day, though the chance of success was slim: her neighbor Henry Tusler told her "he had never seen such a small calf before." (Ewen, who did not share Evelyn's devotion to "Touch & Go," moved into another room to sleep in peace.) She soaked flannels in hot water to make compresses and put them on the calf's belly, changing them every three or four minutes. She also tried a variety of recipes to ease its "violent colic spasms," including several potions—"whiskey & an egg beat up"; "2 small teaspoons of choke cherry wine (18 month old wine)"; and what proved to be the most effective recipe, "tablespoon about [of] whiskey,

ginger & warm milk"; one day she "put vaseline on its stomac & rubbed, [in a] circular motion . . . for quite ¹/₂ hour." She fretted about the calf because it "hardly ever slept," but she was faring no better herself. "I feel rather worn out," she wrote, "like the calf only not so much so."

Despite Evelyn's ministrations, on May 27, the calf developed paralysis and then quietly died:

When I came in to put hot water compresses on . . . oh there was the poor little thing dead. I had got so fond of it & felt so awfully bad about it. . . . At 12:30 with spade & poor calfie I went & dug a deep grave on the hill where Adam's bird trap is, [it is a] pretty view & high. Put the remains of poor old Petrarch [who had died during the winter] in first, cover with earth & then calfie. I felt so wretched. I made a pile of stones on top of the grave.

Similar episodes, when Evelyn worked patiently for days or weeks in a vain attempt to save a dying creature, are found again and again in her diaries. On one occasion she grew quite attached to a cow that had become stuck in a bog, a common occurrence in the spring, as Theodore Roosevelt explained in his memoir of ranch life on the Northern Plains:

During the early spring months, before the round-up begins, the chief work is in hauling out mired cows and steers; and if we did not keep a sharp lookout the losses at this season would be very serious. As long as everything is frozen solid there is, of course, no danger from miring; but when the thaw comes, along towards the beginning of March, a period of new danger to the cattle sets in. When the ice breaks up, the streams are left with an edging of deep bog, while the quicksand is at its worst. As the frost goes out of the soil, the ground round every little alkali-spring changes into a trembling quagmire, and deep holes of slimy, tenacious mud form in the bottom of all the gullies. The cattle, which have had to live on snow for three or four months, are very eager for water, and are weak and in poor condition. They rush heedlessly into any pool and stand there, drinking gallons of the icy water and sinking steadily into the mud. When they try to get out they are already too deep down, and are too weak to make a prolonged struggle. After one or two fits of desperate floundering they resign themselves to their fate with dumb apathy and are lost, unless some one of us riding about discovers and hauls them out.

On May 8, 1893, Ewen discovered just such a creature mired in the mud not far from the Eve Ranch pasture. Evelyn wrote:

She had evidently been bogged for 3 days, dead calf just born close to her. She took an awful lot of work to get out, mired over her middle, but at last they dragged her by aid of [the horses] Joe & old Dick. She is pretty far gone, but will eat, [& she] drank two pails of water.

For the next four days, while juggling her gardening and other duties, Evelyn nursed the cow. She lovingly bathed it, fed it a warm mash of oatmeal, cut grass for it, and made a pillow of hay for its head. It was not enough. After feeding the chickens on May 12, she

found the cow in very weak state, refused to touch her warm mash, also grass. She cared for nothing but to lie flat her head resting on my bank that I made for her. Obliged to leave at 7:20 with an aching heart. Breakfast at 8:30. Milked at 7:45. Washed up. Filled 3 sacks chock full of hay to prop cow up with. . . . I arrived found her lying motionless, felt very inclined to weep but kept from doing so.

Ranch life afforded no time to mourn. The very next sentence in her diary reads:

Went back . . . [& got] 2 knives, saw, whetstone, rope. . . . We took the hide off inside out, cut it up. . . . Took 3 loads to take the whole [cow] in.

Still, Evelyn's devotion to her animals is evident on almost every page of her diaries, and their normally matter-of-fact tone is transformed with emotion when she is dealing with

sick or maimed animals. On one occasion she even expressed a reservation about hunting after hearing that a doe's leg had been broken by a bullet. "That is the worst of hunting, wounding the game," she wrote, "they must suffer terribly."

Evelyn's deep affection for her pets and livestock, especially during the early years, is understandable. On the first Eve Ranch her human contacts were primarily with rough, ill-bred men of the range—or even worse, her whining and demanding British boarders. No wonder then that her animals were her closest companions, and her diary entries concerning them make this clear. "Kindlings kept mewing after me," she wrote of her cat on April 29, 1895.

> I finally concluded she was suffering the pains of labour, her tum very enlarged & soothingly rubbed seemed to suit her complaint. . . . Put her in a box with paper & gunny sacks, in this she was content to lie. . . . Since writing Kindle has given birth to a kitten, she purrs loud & continuously the whole time.

At all of the Eve Ranches there was an assortment of pets, including at various times a lamb, an antelope, hawks, and a pair of wolf cubs described in a letter to a niece in England:

> The sister was named "Tussa" & the brother "Weecharpee." Tussa was the name of a tame wolf in Lloyd's "Field Sports of the North" & Weecharpee is the Sioux Indian for Starlight. . . . I would go in the evening to the creek & sometimes when called they would plunge into the water & swim across to me so full of delight. At other times they refused to come to call & I would then howl like a wolf which never failed to bring them to me & they would try to lick me all over in their sympathy & howl themselves in concert.

The Camerons had acquired the wolves in 1907 from a professional hunter, or "wolfer," when they were a month old. Ewen later described them and their antics in an article he wrote about Montana wolves:

They were covered with a smoke coloured wool, interspersed with harsh black hairs, the latter absent from the head. The legs and feet were fawn colour, and traces of the same tint appeared in the face. . . . When introduced into the house they walked up and down by the walls like caged beasts, and for the first ten days they were fed upon oatmeal mush and milk and rice and milk with an occasional raw egg. On April 20th, when they were believed to be about six weeks old, we started them on a diet of minced beef, and from that time on they refused all food except milk and meat either raw or cooked. Wolves like greyhounds require an abundance of fresh meat and exercise, and could not be reared successfully otherwise. Our youngsters had the run of a ranch, and an unfailing supply of horse, veal, and lumpy-jaw beef, in consequence of which they were always in superb health, and grew apace. . . .

They were unquestionably the most playful animals which I have ever seen, romping boisterously with each

In April 1907 the Camerons bought two wolf cubs, several weeks old, for $10 from the wolfer Dick Brown.

other until tired, or indulging in a grand game with any acceptable plaything such as a glove. They had soft mouths like a well trained retriever, and one of their favourite amusements was to carry about a kitten of their own age. At first my wife would rescue from their jaws the wet, slimy, mewing cat, fearing it might be hurt—more especially when both wolves had hold of it together. Such interference, however, was decidedly futile, for the kitten, as soon as it could escape, invariably returned to its waiting playfellows to be conveyed about as before. The male wolf also caught and carried about a tame goshawk without injury to the bird.

The cubs were also fond of chasing cattle, "entirely in the spirit of play," Evelyn told her niece:

The wolves were never in the least afraid of the cattle & it was amusing to see them play with the gentle cows' tails. The recumbent cows would be switching at the flies & the wolves making little jumps at her tail. These cows were not the least afraid of the wolves but took them for puppy dogs.

The cubs' response to inanimate objects, and to strangers, was quite a different matter. Ewen's article goes on:

For inanimate objects, on the other hand, the puppies showed no such tender consideration, and proved even more unmanageable than the greyhound pups to which we were accustomed. They chewed up everything, in fact, they could lay their paws on—heading their game list with a sack of flour and a joint of prime veal. . . . The moving rope of a picketed horse . . . was at once recognized as inanimate, and the mischievous pups would sever it with their teeth, permitting the animal to rejoin its companions. . . .

No stranger . . . could take a liberty with either wolf. When two months old, their gambols and innocent appearance constantly tempted lady visitors to try and caress them, but the ungracious reception accorded to these over-

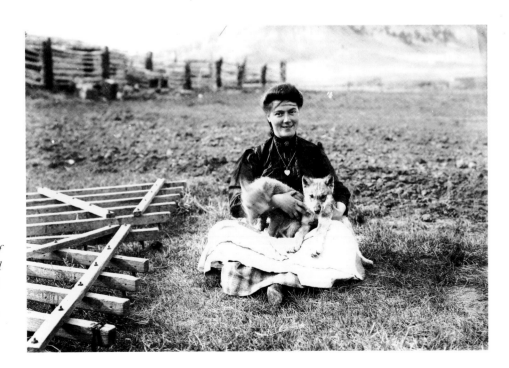

Jetta Gray, a Scottish woman who lived near one of the Camerons' ranches, struggles to hold Tussa and Weecharpee. It was remarkable that they would sit with Jetta at all: the cubs were frightened of strangers and whenever one approached, they either attacked or ran for cover in the root cellar, "as it resembled their badland cave."

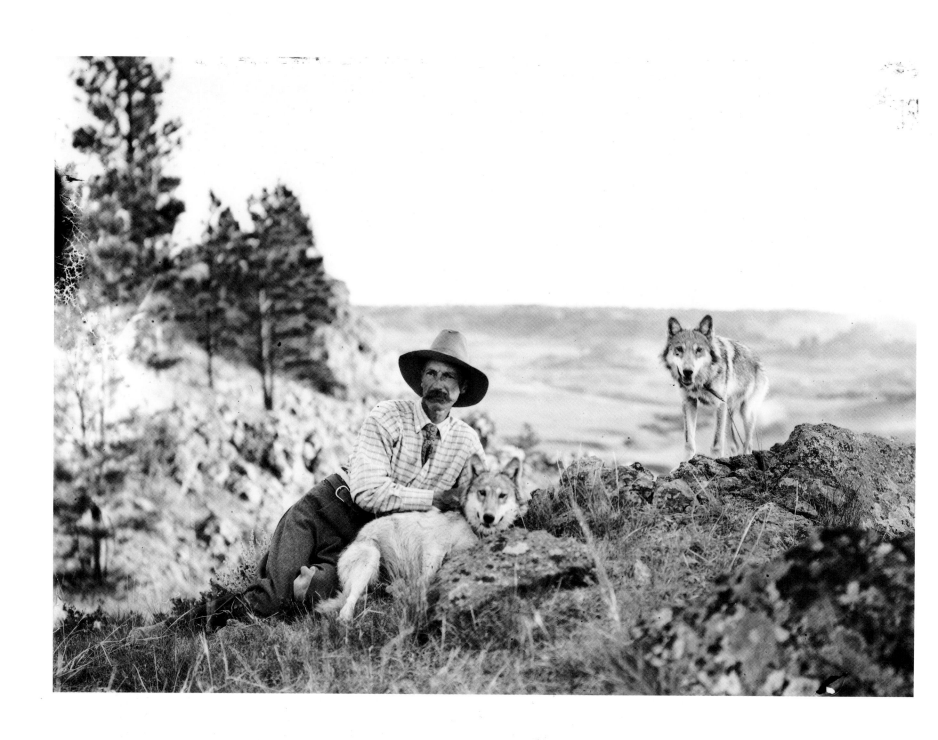

Ewen wanted to train their wolves but gave up on the idea because Evelyn was "too daring" with them, and he worried she would be hurt. He sent them to a zoo at Coney Island.

tures soon repelled the most enthusiastic lover of animals. . . . With advancing age the wolves grew more shy as well as more fierce, so that curious visitors (of whom there were many) found it advisable to send notice in advance in order that we might call up our pets and chain them to posts. . . . It was affirmed by the "wolfer" that an exception would be made in his favour, both on account of his strong odor of wolves, and his claim to be a "passé maître" in the art of handling them. To his disgust, and equally to our amusement the reception accorded him by the pair was unusually hostile, and could hardly have been more vindictive had they been aware that he was the cause of their capture and orphanage.

Eventually the growing size and strength of the rambunctious animals—and Evelyn's fearlessness in dealing with them—led Ewen to banish them:

Prudence constrained me to part with them on account of the too great daring of my wife. Both pups were devoted to her, the female especially displaying as much affection as any dog could do; but the male . . . was not good-tempered like his sister and especially resented being chained up. When five months old he often emitted horrible snarls and seized my wife's hand threateningly—albeit restraining himself from biting hard. She, nevertheless, persisted in playing with him without gloves, and always treating him precisely like a pet dog, and it was clear that any day he might lose his self-control so far as to inflict a dangerous bite with his permanent teeth.

The decision was made to pack their pets off to a zoo. Evelyn described their departure:

Their journey to Terry in a waggon took two days which made them both very cross but especially Weecharpee. To lift him in & out of the waggon thick gloves were necessary. We kept the wolves at a livery barn in Terry for a few days before shipping them to Bostock's Menagerie, Coney Island, New York. After an absence of two days we returned to Terry & a little boy in the street said "Mrs. Cameron, one of your wolves slipped its collar & got away this morning." It proved to be Tussa & a woman friend who had seen her pass, but was afraid to catch her, drove two miles into Terry to tell me. We rode in the direction indicated calling her by name and about 3 miles from town she came bounding out of a thick plum patch & nearly tore us to pieces with delight. Alas! She was led back & so ended her last run on her beloved prairie.

Coney Island was a glittering paradise at the height of its fame in 1907, and Bostock's Menagerie was just one of the delights to be savored in "Dreamland," its newest and most extravagant amusement park. Sprawling at the edge of the Atlantic Ocean, "Dreamland" was emblazoned by a million electric lights and, according to the contemporary American critic James Huneker, stood as a "dazzling apparition for men on ships and steamers out at sea. Everything is fretted with fire. Fire delicately etches some fairy structure; fire outlines an Oriental gateway; fire runs like a musical scale through many octaves."

Fire was to be its undoing. A few years after the Camerons' wolves were dispatched to Bostock's Menagerie, the vaunted electric lights of "Dreamland" exploded and the entire fantasy land was reduced to rubble. Many of the caged animals—including perhaps Tussa and Weecharpee—fell victim to the conflagration.

It was not a common practice to keep wolves as pets on the prairie, where wolves and coyotes were regarded with loathing because of the threat they posed to livestock. Professional wolfers tracked down the predators for bounties offered by the state and by syndicates of ranchers. The British ranchers, however, turned the necessity of hunting coyote into a sport resembling as closely as possible the fox hunting they had enjoyed in Britain. The Camerons kept packs of pure-bred hunting dogs for the purpose, and Ewen did his best to keep up the tribal rituals of his homeland. He had brought with him to Montana the full regalia of the sporting English

gentleman, including an elegant scarlet hunting jacket and a hunting horn. On March 1, 1893, Evelyn noted in her diary what must have been a startling sight on the Montana prairie—Ewen with a coyote on the run:

> Ewen rushed down & tally hoed the hounds on. Of course, Monsieur Coyote flew up the pasture hill & disappeared with hounds after it. . . . Ewen got horn, blew thereon not quite orthodox notes.

Coyote was a favorite quarry of Evelyn's as well. She described one of her own chases, an impromptu affair, in a letter to an expatriate friend dated October 24, 1897:

> I had a little cub hunting the other morning. When on my way to drive up the saddle bunch I started a coyote & soon had [the hunting dog] Petrarch after it. After an exciting chase he pulled it down & got it by the throat. I jumped off [my horse] & between us it was soon hors de combat.

She recorded the outcome of her combat in her diary: "At last . . . [Petrarch] held it well by throat while I thumped it over the heart with the heel of my boot & it thus died."

Coyotes were not the only challenge. On a chilly May day in 1895 there was an exhilarating chase after a jackrabbit:

> A good day on Terry flat with the greyhounds. . . . Last one gave us a phenomenal run. 1st [it went] straight towards the railway line along which the west bound train was spinning, turned [&] went through Terry. Everyone rushed out & shouted & waved [his] hat in direction taken by hounds. . . . Mr. Jack got into a hole & so saved his hide [after] about a 3 mile run.

Coursing the hounds over the Montana prairies and badlands was one of the Camerons' main amusements, and Evelyn was quick to rebuke Alec in May 1895 when he complained about the greyhounds:

> Gave Alec a jawing for always saying "too many dogs, other people do not have" [&] explained if we took our

pleasure as the common herd do here we should be drinking & playing cards in a saloon instead of coursing.

But although the Camerons did not frequent saloons, card playing was, in fact, among their few diversions in the early years; during the winter of 1895, poker was the game of choice. On the 1894–95 wilderness hunt, Evelyn, Ewen, Alec, and the boarder Mr. Colley had learned the game from two ranchers, the Nesbit brothers, who had delivered hay for the horses to the camp. The Nesbits had stayed for a dinner of baked fawn haunch with all the trimmings and then, Evelyn noted,

> [they] tried to teach us "Poker," [a] great saloon game. I caught on but boys didn't—just as well too. I retired at 10. They played Batchelor [probably the equivalent of a game of "Old Maid"], this elicited roars of laughter.

Evelyn carefully wrote down the rules for "American Poker" in the front of her 1895 diary, and though the "boys" were a bit slow at first in picking up the game, they soon became avid players; with winter beans as chips, poker became a regular activity at the Eve Ranch. Unfortunately, by June of that year Evelyn was noting in her diary that she had told Alec

> he must not play cards in daytime with Mr. Colley. He [Alec] is getting [to be] a regular gambler & Mr. Colley I spoke to also about it. He doesn't like playing, only does so to please Alec. Alec wants sometimes to play up to a dollar but Mr. Colley limits it to 15¢. Every spare hour & till 12 o'clock at night Alec has been inducing Mr. Colley to play!

Alec's gambling was not limited to poker and other card games. He engaged Evelyn in a series of wagers on the outcome of almost anything: on a roping contest with Evelyn, which she won handily; on the amount of butter that Evelyn would churn on a given day; on the sex of a newborn calf; on the arrival time of an expected guest; and on the outcome of a prizefight between Fitzsimmons and Sharkey in

Stand take to talking / If you throw my.

WHAT HAVE I LENT?

WHEN LENT.	ARTICLE OR BOOK.	TO WHOM	WHEN RETURNED
	American	Poker	

Fouraces — highest
Flush — 5 of a suit — needn't follow suit
Fullhouse — 3 of a kind with another pair with them
Threes — 3 of any kind
Two pair
One pair
Highest in the hand

Five cards are dealt (any number of players). Discard those not required, dealer then redeals to those who have discarded to make up their hands to 5 cards again. The one ahead of the dealer "antees" viz: puts 1 counter into the pool. Every one bets according to the value of the cards. Those who have bad hands can "pass" or "bluff". Should 2 betting players' hands prove alike it is then decided by the next highest card viz: her who has the next highest card wins.

During a hunting trip in January 1895, the Camerons learned how to play poker. Evelyn wrote the rules in her diary.

San Francisco in 1896, when Evelyn had put her 25 cents on Sharkey while Alec liked Fitzsimmons's chances. The outcome, however, was by no means clear, as Evelyn reported:

Fitzsimmons knocked Sharkey out 8th round. Sharkey's supporters carried him out insensible & claimed that Fitzsimmons hit him with his knee in the groin. This foul was upheld by the referee . . . but Fitzsimmons claims it is all a swindle, that he never hit him with his knee.

Alec continued to follow Fitzsimmons's career closely, and during dinner on March 15, 1897, he animatedly discussed the upcoming Fitzsimmons-Corbett prizefight to be held "at an obscure town called Carson," Nevada. Evelyn, hoping to curb her brother's betting mania and channel his energies into a more productive use of his free time, and concerned that he could not even read or write properly, had offered to read with him every night. Now, after dinner, she "Read an hour with Alec. We began Conan Doyle's 'Exploits of B. Gerade.'" Alec, unfortunately, could not muster the same enthusiasm for reading that he had exhibited while discussing the Fitzsimmons-Corbett bout, and a note of exasperation crept into Evelyn's diary entry: "Alec has no *ambition* to read or advance in mental culture, he has got a terror of what he calls 'bother.'"

For Evelyn, reading was one of life's great pleasures. She and Ewen read poetry aloud to each other and, during every free moment (and even during some that were not so free—for instance, while churning butter or toning photographs) she devoured whatever books, magazines, or papers were available, including the standard pulp fiction of the day, though she sometimes thought it quite "stupid" or at least not very believable. After finishing a book entitled *For Faith or Freedom*, she reported in her diary: "I think it is a splendid book but where in real life is a heroine as Alice to be found." On the other hand, she considered Sherlock Holmes "a very wonderful man," and she loved reading about exotic locales, about hunting rhinos in Africa, for example, or the tragic story of Sir Arthur Gates, the "lost Baronet in the Klondyke." She was also fascinated by Darwin's *Voyage Round the World* and Sir Randolph Churchill's book on Africa. On December 20, 1907, she wrote to thank her mother for sending a fantasy called *The Boater Chaperone*, which she enjoyed so much that she named two calves after characters in the book, though she found the ending to be contrived: "when the old chaperone suddenly transformed herself into a young and lovely damsel [it] rather jars upon the reader." She asked for something more substantial the next time:

When you feel inclined to send me another book from England, I would like "The Man-eaters of Tsavo," price £7. 6 by Lt. Col. Patterson. Both the Field and Country Life make this out to be the most thrilling work on African sport ever published.

Evelyn read not only for enjoyment but also with practical goals in mind. While working on her photographs she scoured the *Cyclopedia of Photography* for tips, and she studied texts on irrigation that would prove useful in her gardening. Her curiosity about the world around her led her to read a history of the United States and a book on geology that she pronounced "very interesting."

She closely followed U.S. and world events in *The Chicago Record*, and, for sheer amusement, once took part in a contest that the paper sponsored. A first prize of $1,000 was offered to anyone who could figure out the final chapter of a novel full of twists and turns that had been serialized in the newspaper, and Evelyn spent days trying to make sense of the convoluted plot, then happily posted her manuscript to the *Record*.

Prize Mystery Story editor, The Chicago Record, 181 Madison Street, Chicago. Ill. Dated April 28th '96.
Dear Sir,

I cannot send in my "guess" without first thanking you for the great pleasure you have given me by the publication of that most charming story "Sons and Fathers."

As you truly say, like virtue, it is its own reward but I may as well take my chance at solving the mystery with the rest since you have inaugurated such an amusing competition.

I find it no easy task to disentangle the different threads, weave them together, and finish them off neatly; but I enclose my best endeavour without any hope of approaching the denoument of the gifted author.

Very faithfully yours,

(Mrs.) Evelyn J. Cameron

She eagerly awaited the outcome of the competition but was not surprised to discover that she was "away off" in figuring out the conclusion of the story.

Once they had finished with their newspapers, magazines, and books, the Camerons often passed them along to friends and neighbors. This was part of the code of conduct on the frontier, where there were no bookstores or libraries. "I feel I must read & improve intellectually," Evelyn noted once, "but there are so few books on the ranch to read."

Always on the prowl for intellectual stimulation, she sometimes found it in the most unlikely places. During a hunting trip in the winter of 1894, the Camerons stumbled upon an isolated sheep ranch where they were invited to spend the night. The place was manned by a Canadian named Errington who had left his native country as a boy of eleven; a

Evelyn kept a list in her diary of books read in 1897.

112

sheepman from the Duchy of Luxembourg who had, according to Evelyn, "French sympathies but [a] strong German accent"; and a sheep dog named Cap who seemed none the worse for his broken hip. Immured in the Montana outback the sheepmen were undoubtedly thrilled to hear the latest news of the outside world, and over dinner they discussed the war raging between China and Japan. In turn, before the Camerons left the next day, Errington lent Evelyn a novel.

Visits to isolated sheep ranches provided other cultural surprises as well. While traveling to and from their campsite during a winter hunt that began in December 1896, the Camerons spent several nights at the home ranch on Cabin Creek of the German-born Renn brothers—a place that at its peak boasted six thousand sheep in addition to some cattle and horses. The three brothers—Paul, Carl, and Ed (short for Edolphe)—loved music and played a variety of instru-

ments (they performed at the local dances in Fallon and Terry), and they were eager for any excuse to pull out their instruments.

They got such a chance when Evelyn and Ewen arrived for the night of December 19. After serving a dinner that was noteworthy for including milk and butter ("quite a luxury" in midwinter, according to Evelyn), Ed Renn played several tunes on the zither for them. A month and a half later the Camerons stopped for the night again, and this time they were entertained by the three brothers playing ensemble on two violins and a bass. Evelyn enjoyed the impromptu concert but was immediately returned to reality when she headed off to bed in the guest shack and discovered that the "blankets smelt rather strong."

Music had always been an integral part of Evelyn's life—the melodies written by her mother, a composer, had filled

The Heywood Daly Ranch.

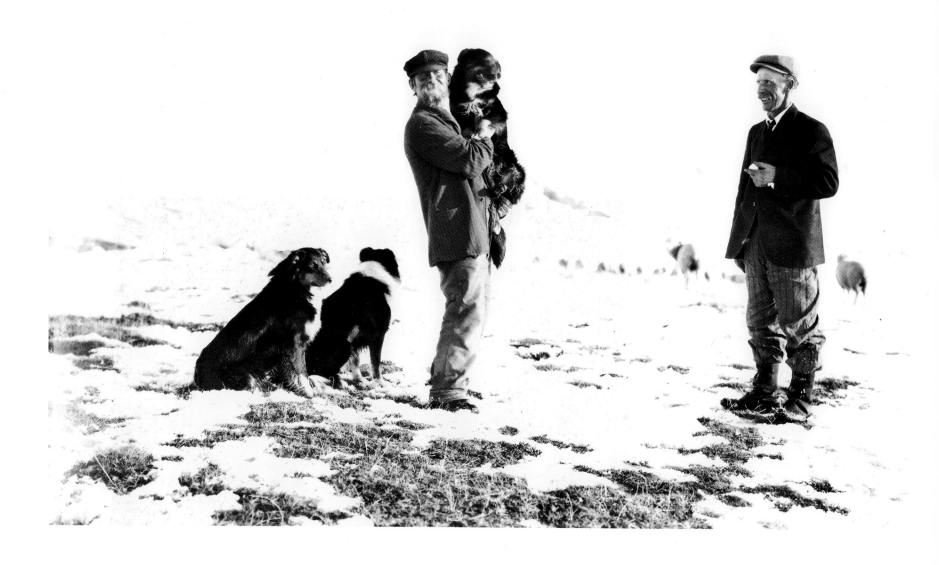

Paul Renn, Sr. (right), checks on one of his family's bands of sheep after a snowstorm. During one blizzard the Renn brothers lost 150 sheep that had wandered away and were killed by a pair of wolves. A few years later the Renns put a large wolf "frozen in a lifelike attitude" on their roof as a trophy—and as a warning to other predators.

the elegant drawing rooms of her youth in England—and she missed it sorely in Montana. In 1896 she had her violin sent to her from home, though ranch chores did not leave much time for playing. She did take advantage of some free time on a Sunday afternoon in May when a cyclone with hail and driving rain hit the area. While her neighbor's barn roof was being blown off, Evelyn calmly "fixed my violin which had broken & played God Save the Queen à la Hamlin [a local fiddler]."

One of the high points of Evelyn's visits to the Cross S Ranch was the music that usually followed dinner in the evening. Kathleen Lindsay sang and played the piano—even on occasion playing music composed by Evelyn's mother. "Mrs. Lindsay played—so lovely to sit & listen, reminds me of the old days so," Evelyn wrote on August 17, 1897.

On another evening during the same visit, Kathleen sang to the accompaniment of a banjo and Evelyn concluded that she "really must get [a banjo] & try to learn some songs." Upon returning to the Eve Ranch she did just that, borrowing $20 from Alec and ordering the instrument from a store in Chicago. When the banjo arrived, Evelyn pronounced it a "beauty" and wrote to Effie Dowson: "I have invested in a Washburn banjo which I intend learning this winter. It will be a source of great amusement on long winter evenings."

Unfortunately, the banjo became a source of aggravation rather than amusement, for it proved defective. On January 24, 1898, she wrote angrily to Lyons & Healy, the firm from which she had bought it:

Dear Sirs,

Your letter of Jan. 20th is most unsatisfactory. You advise me to "Give your instrument into the hands of someone who understands repairing."

I live on a Montana horse ranch miles from any person experienced in such matters & it would be unsafe to trust the banjo to anyone in a small western town. I was recommended to write to your firm for a banjo by my friend Mr. W. G. Comstock & he gave me your address saying all your goods were thoroughly reliable. What has been the result—I could not even practice on the instrument you sent me—No. 1025 Washburn banjo ordered Oct. 1st, '97—owing to a faulty tail piece causing the strings to snap whenever tuned to the proper pitch. On writing & complaining you forward me another tail piece which I cannot adjust with the means at my command. I again write and advise you of this fact when I receive the above answer.

If the banjo must be sent to an experienced hand, in view of the above explanations, your firm should most certainly undertake the repairs free of cost & also pay the transportation expenses both ways. This I trust in your next communication you will propose doing if it is impossible for me to make the repairs on the ranch. . . . Hoping to hear from you soon. Believe me etc.

Evelyn pretty much abandoned her banjo. With her rigorous daily regimen, she had no time to struggle with a defective instrument—nor did she have any time for idle distractions.

Even on Sundays the same chores had to be done, the same meals had to be cooked—most Sundays at the Eve Ranch were indistinguishable from any other day. Evelyn would undoubtedly have preferred to abstain from work and observe the Sabbath properly, but it was just not possible, and in the spring of 1894 she blamed this for her garden's failure: "My watermelon, cantaloupe, sweet corn seed that I sowed May 6th has never come up, suppose because sown on Sabbath."

The spiritual needs of the far-flung ranchers in the environs of Terry were met by traveling ministers with varying degrees of ability. The local citizenry was thrilled to attract any wandering missionary, regardless of his denomination or qualification, and the earliest church services were held at Terry's railroad depot. One day in August 1898 Evelyn rode into Terry with a bouquet of nasturtium and sweet peas, along with a load of fresh garden produce for a Mrs. Bowden who was gravely ill. While in town she heard an earful about

the most recent wandering divine, who was having trouble leaving Terry:

> The minister has been very funny, going to leave [on] every train & doesn't leave. Walks about at night. General opinion is that he has the opium habit & has a tape worm! His appetite [is the] talk of the place.

Evelyn and Ewen never took part in the early church services, nor in the enthusiastic (but for many years, unsuccessful) efforts by the townspeople to recruit a minister. On one occasion Evelyn was surprised at home by a preacher who was making the rounds of the scattered ranches by bicycle. She was curious to discover that he originally hailed from Pennsylvania and that his family could be traced back to William Penn's time, but she exhibited little or no interest in his brand of organized religion. Though she had been a regular communicant in England, only when she was visiting the Lindsays' Cross S Ranch did she attend anything approaching a formal service. On July 11, 1897, for example,

> Mr. Lindsay read prayers, collect, epistle. We sang hymns. Mrs. Lindsay played the accompaniment on her piano, servants all joined. While we were singing a hymn the herder brought in the herd of mares, they looked so pretty coming down the drive.

The truth of the matter was that Evelyn had no time for organized religion—nor any desire to get involved in community affairs. She read her Bible frequently and filled her diary pages with inspirational and religious quotations, but the day-to-day struggle to keep the Eve Ranch afloat, as well as her extremely independent nature, precluded her attending religious services or taking part in later efforts to build a church. Evelyn's religious beliefs were expressed more eloquently by her charity than by her Sunday behavior. She invariably fed and gave shelter to vagrants who made their way to her ranch; she often took time out of her busy schedule to visit the sick; and she never was a party to the malicious gossip of small-town life. Her credo was based on a down-to-

earth honesty and generosity toward others, and people in trouble were invariably drawn to her kindness. Fannie McElrath, a young American governess in Miles City who had spent some time with Evelyn the preceding summer at the Cross S Ranch, was teetering on the edge of a nervous breakdown in December 1897. In her hour of need she thought of Evelyn and wrote plaintively to her:

> *Dear Mrs. Cameron,*
>
> I often think of you & lately I have wished so much to be with you a little while—I have felt so out-of-sorts with the world and your strong gentleness seems the spirit of rest. That is God's sweetest gift, is it not—a heart naturally and truly broad and loving & at peace.—
>
> Forgive me for writing you a little love letter but I feel it very sincerely.—

Evelyn immediately sensed her friend's desperation, and even though it was the worst possible time for her to have a guest (she was running the ranch virtually by herself while Ewen was in England), she resolved to invite Fannie to the Eve Ranch. The next day she had second thoughts: "It strikes me I shall be obliged to ask the 2 Avery boys as well, she having them in her charge! Do not want them they are so mischievous." But her concern for her friend outweighed any other consideration, and she wrote graciously on the 30th of December:

> *My dear Miss McElrath,*
>
> Come & stay with me & bring the nephews. Of course you have completely run yourself down by overwork. Change of scene, rest & quiet are the only remedies. At this time of the year I have so many stock chores to do that I do not feel in a position to entertain a guest—but I know you won't mind that & you can help me pitch hay, feed chickens etc.!
>
> These are the tonics that will make you feel the world is not such a bad place after all. . . .
>
> With much love—best wishes for the New Year & hop-

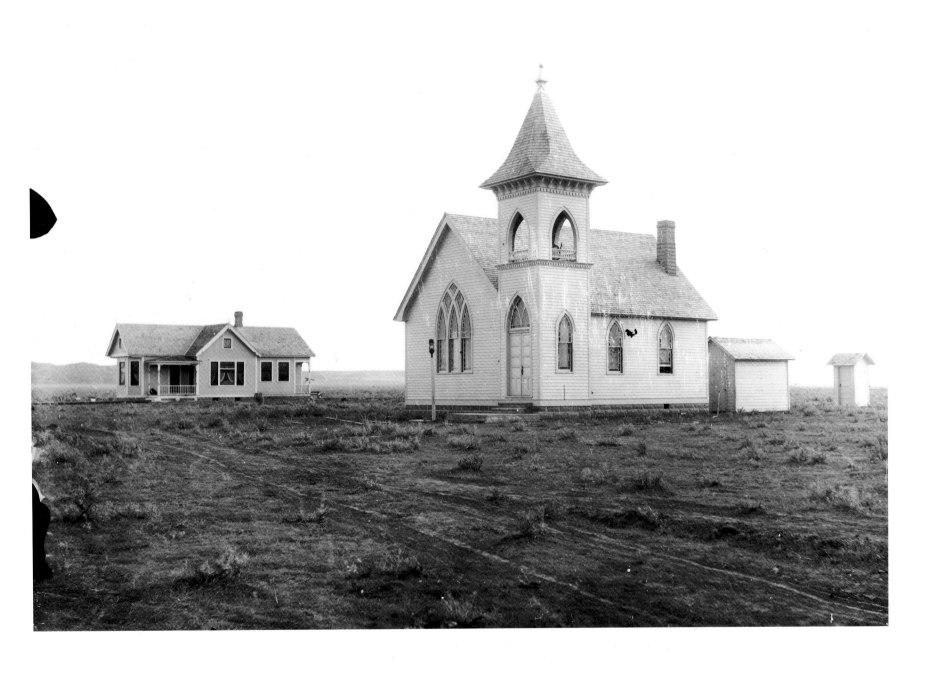

*The Union Church, the town of Terry's first permanent house of worship, built in 1906. For
a time, services had been held in a wool storage building, and the congregation sat on sacks
of wool. The builders added an outhouse in the back.*

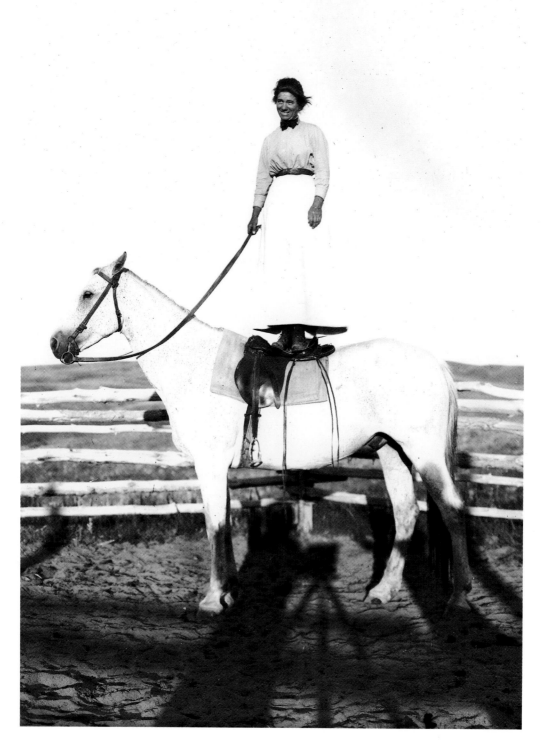

In 1912 Evelyn attributed her robust health to "the open air life—riding on horseback, digging in the garden, etc. etc."

ing to see you soon. Believe me dear Miss McElrath, yours affectionately,

Evelyn J. Cameron

Evelyn had a firm belief in the efficacy of hard work and in the healing powers of Montana's invigorating climate. She was certain that ranch life would revive the city dweller's spirits, and when Fannie had to decline the invitation, Evelyn immediately wrote back:

My dear Miss McElrath,

I was so disappointed after reading your letter saying you could not come & pay me a visit. . . . I feel sure the change would have done you a world of good. Dear Miss McElrath I am afraid your nerves are overstrung & if I was with you I should insist on you going for a 3 or 4 mile walk with me every day & I would not allow you to wear yourself out for others—as I am quite positive you are doing—the whole day long.

What lovely pure exhilarating air this is in Montana, it would cure many nervous & other ills if it was only given the chance.

I am sure I wish I could be with you for a while also, but we are both in the same boat—only my ties are of the stock order & yours are human. . . .

Very very best love from yours Affectionately,

Evelyn J. Cameron

It is apparent from Evelyn's correspondence with Fannie McElrath that she did not look upon herself as a victim of the harsh Montana climate or the grind of her daily regimen. On the contrary, she reveled in the rough outdoor life—every day of it was, to her, worth putting onto paper. And when she took up photography, she did not use it as a way to escape. Instead, with her camera she examined ever more closely the fabric of her workaday life, and ranged farther and farther through a rugged world, where the very air was exhilarating.

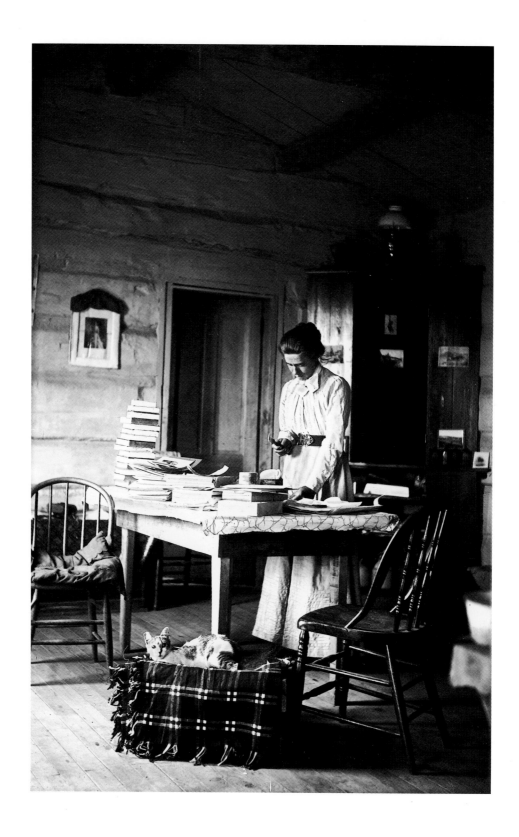

Evelyn mounts prints on cardboard in the kitchen of her ranch house. Stacked on a corner of the table are the boxes in which glass plates and photographic paper were shipped to her.

Photography

IN HER DIARIES Evelyn once referred to herself and Ewen as "the 2 explorers," and in essence that is what they were—Ewen with his pen, and Evelyn with a camera.

Evelyn began to teach herself photography in 1894, taking it up with the blend of energy and inventiveness that characterized her whole life. She first mentions the subject in her diaries in 1893, when, beset by mounting financial difficulties, she and Ewen considered leaving Montana and moving to the remote Orkney Islands off the northern coast of Scotland. The idea was that Ewen would write a book on the local fauna which Evelyn would illustrate with photographs. When, thanks to Evelyn's determination to make a go of it in the West, the Camerons abandoned the scheme, Evelyn turned for her subjects to the wildlife, eerie landscape, and colorful personalities of frontier Montana.

Evelyn's impulse to chronicle her surroundings was not an uncommon one at the time—educated British men and women were traveling around the globe and photographing exotic locales. The English in Montana were no exception. Virtually all of Evelyn's compatriots occasionally pulled out a camera to satisfy curious relatives and friends back home. Effie Dowson brought to Montana a camera given to her by Lord Kitchener's brother; another expatriate by the name of Gilliat also came equipped with a camera, and on one occasion he was nearly trampled while trying to snap an enraged bronco with his Kodak.

At the time the Kodak was the camera of choice in Montana, and throughout the world. Introduced in 1888—"you press the button, and we do the rest," the advertisements exclaimed—it had been an overnight success and had revolutionized photography: small and lightweight, it used a roll of flexible film; once exposed, the film (for the earliest model, the entire camera) was sent back to the Eastman factory in Rochester, New York, where it was developed into circular images about two and a half inches in diameter. There was no need to lug around heavy, and fragile, glass plates; no need to learn the messy and time-consuming art of developing and printing negatives. With the introduction of Kodak cameras, the ranks of the amateur photographer soared; the age of the snapshot had begun.

Yet in 1894, when Evelyn ordered her first camera by mail, she decided to wrestle with the intricacies of dry-plate glass photography. There is no record of the camera model in her extant diaries or letters, but before making the choice she undoubtedly sought the advice of her boarder, Mr. Adams. An accomplished magician who had performed in public, Adams was also an amateur photographer familiar with glass-plate procedures who had, unfortunately, neglected to bring his own camera to Montana. Eager for some distraction from the tedium of frontier life, he was only too happy to encourage Evelyn's interest in photography, teach her the basic techniques—and experiment with her new camera himself. It was Adams who went off to the Terry railroad depot on August 13, 1894, to fetch it. The next night, Evelyn wrote, "Mr. Adams showed me how to change plates in his room. Great business to exclude all the light, moon in full blast."

She attempted her first photograph—a scenic view looking down the creek near the ranch house—on August 16; it was "an utter failure." Undeterred, she retreated to the hammock that afternoon and read her handbook on photography. A gust of wind, she decided, had jarred the camera.

The prairie winds were not the only variable to contend with; the intense Montana sunlight also had to be taken into account. Evelyn quickly discovered that mornings and late afternoons were the best times to photograph. When the sun was directly overhead, the harsh light defeated efforts to capture details and subtle tones, even on a day when prairie fires created a thick haze.

> Arose 5:30. Breakfast 7. Nice & dull for photography early but by the time vegetables were gathered & brought up to the buggy, sun shone brightly as the smokey haze would permit—too strongly for the camera.

Evelyn's camera did not have an adjustable shutter (or if it did, it did not work properly), so she had to expose the negative manually, that is, remove the lens cap when she was ready, count the number of seconds (or fractions thereof) she wanted, and then replace the lens cap. Any fumbling could mean overexposing the negative and ruining the image. And as she ticked off the seconds aloud, she ran the risk of counting too quickly or too slowly.

No sooner had the camera arrived than Evelyn's neighbors began clamoring to have their pictures taken, and she and Adams photographed several families at the Tusler ranch. After developing the negatives that night, Evelyn pronounced them all good except one in which the subjects had moved—prompting Adams to return his half of the money they had received: "Hamlin & Lester Braley's photo not good enough to keep the $2 for, so Mr. Adams returned his $1."

There was much to learn and Adams's tenure as teacher proved short; it was less than two weeks after the arrival of the camera when he packed up and returned to Ireland. Before he left, however, he not only collaborated with Evelyn on some of her earliest photographs, but he also helped her develop the glass-plate negatives at night and then print from them during daylight hours. He printed some of his own Montana photos on his "English 'Ilford' paper" to take back with him, among them individual portraits of Evelyn and Ewen on horseback. Long-exposure plates were used for these equestrian shots, and to keep the horses at attention for the duration Alec was commissioned to blow on a hunting horn. During another photo session, Evelyn drove a mare within sight of Ewen's stallion to make the animal prick up his ears. On May 15, 1895, she described to her mother-in-law what she had been up to:

> I have lately taken up photography & work at it occasionally after the house hold has retired to rest. It is very fascinating work but requires a lot of practice. A boarder we had here—Mr. Adams—was a first class hand. The photo which Ewen sent you of himself on a white horse was a specimen of his work. That photograph, which you did not like because Ewen had a beard, took "very highly commended" at a London photographic competition, which was equivalent to fourth prize. We will send you another one mounted on a card with a companion one of

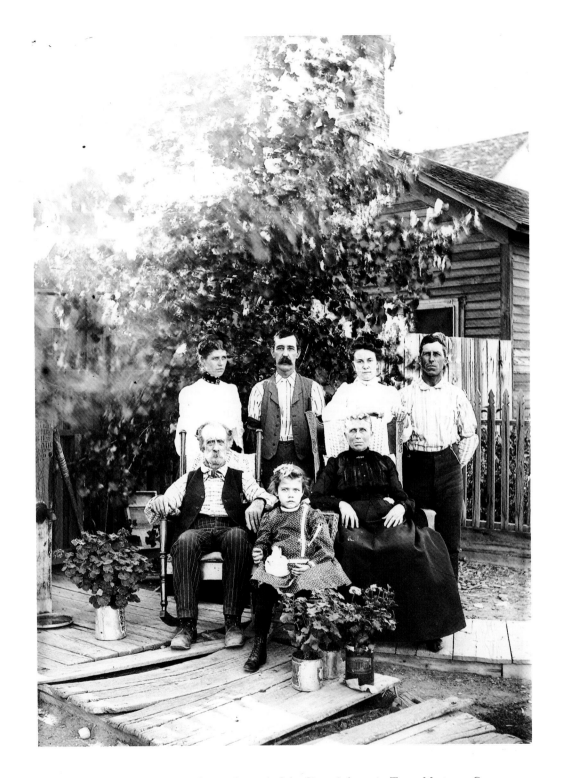

The Scott and Gipson families in the yard of the Gipson's house in Terry, Montana. George Gipson (second from left, back row), formerly a cowboy on the cattle trail from Texas to Montana, ran a general store in Terry. He had married Minnie Scott (back row, left); their daughter, Nellie, sits with a chicken in her lap (front row, middle), flanked by her mother's parents. The other couple in the back row are Cady Scott and his wife.

myself. I think it is such a good photograph of Ewen, just what he looks like now.

Mr. Colley, the boarder who followed on the heels of Adams, was also a camera enthusiast. He and Evelyn collaborated on a series of photographic experiments, including staging a photograph of a man swinging from a noose. To Evelyn's surprise, her brother Alec agreed to pose as the lynching victim. The scene must have horrified their genteel relatives back home; it certainly amused the perpetrators of the hoax. (Though this was not a sample of genuine frontier justice, there was a certain measure of poetic justice for Evelyn in seeing her pain-in-the-neck brother dangling from the end of a rope.) She and Colley also jointly photographed some of the local ranches and settlers, made portraits of each other, and developed and printed the exposed negatives.

Colley had brought with him to Montana a Kodak that could take "40 photos without changing" the film, and he took snapshots of the Camerons. Though they could not compare in quality with the portraits Adams had made from glass-plate negatives, Evelyn nonetheless sent them off to her mother-in-law, with the disclaimer that they were "taken by Mr. Colley with a very small Kodak for fun—not as specimens of what we can do."

Ewen was impressed with the convenience of Colley's small Kodak camera, and for his wildlife studies he decided that they should "get a Kodak which is all done automatically." Evelyn, however, preferred the tonal quality and clarity of photographs made from larger negatives, and her aesthetic judgment prevailed. In June 1895 they ordered a No. 5 Kodet designed for $5'' \times 7''$ plates or film. A month later the camera arrived, along with a tripod that disassembled into four pieces and a Watkins exposure meter, a primitive mechanical aid to determine camera settings. Manufactured by the Eastman Kodak Company, the No. 5 Kodet was a moderately priced folding camera, fitted with a Bausch & Lomb shutter that Evelyn pronounced "a great success." The Kodet was designed for use in the field atop a tripod or,

rarely, to be held by hand. Although the camera was much heavier and much more complicated to use than Kodak's snapshot model, Evelyn expressed no misgivings when she got her hands on it.

The Kodet was a leather-covered box with a mahogany interior and polished brass fittings. When the hinged front panel, or "bed," of the camera was dropped, a bellows bearing the lens and shutter was pulled forward into operating position. In size and weight it was like a large, heavy lunch box—made even heavier when a $5'' \times 7''$ glass plate in its holder was set into the camera. It was not absolutely necessary, however, to use heavy and fragile glass plates with this model camera. The No. 5 Kodet included an optional holder to accommodate rolls of five-inch-wide flexible film. As soon as the camera arrived, Evelyn wanted to experiment with this purported advantage. "Mr. Colley in & we had quite a time putting roll holder into camera. I read up [on it] in little book." After struggling to get the holder in place, her initiation into using roll film was not very promising. She described her inaugural attempt on July 20, 1895:

Tried our Kodet. Spent all morning & afternoon over 1 photo! Ewen & I put up blanket & 4 deer heads on it but . . . Ewen split [one] trying to put a nail in it. Caused a long delay as I lit fire & glued it together again. Put it up on blanket, wind blew strongly & down it came, breaking 2nd time. I spent time trying to mend it with wire, finally put it up resting on nails. . . Sun by then had gone off antlers . . . Ewen & I took a photo of the heads on west wall of store house, but in winding [the camera] I waited to hear the click that never came & so wound off 5 films. I ought to have watched the register. Made me feel very sore.

Evelyn never did take to roll film, and she used it rarely. Instead, she preferred heavy glass-plate negatives; if she wanted the convenience of lightweight film, she generally opted for individual $5'' \times 7''$ sheets of cut film in plate holders. Because roll film was made of thin celluloid and was wound on a spool, it always curled. This was a problem, particularly

in printing, when the negative had to lay perfectly flat. Cut film, in contrast, was made of a much thicker celluloid that was easier to handle and less prone to curling.

Roll film had another disadvantage: Evelyn had to finish an entire roll of film before she could process her images. She might make only one or two exposures in a given day, and she was usually anxious to process them as soon as possible to see the results. Having to wait to develop her images—or worse, to waste unexposed film in order to hasten the process—neither suited Evelyn's character nor the nature of her photography. Her subjects were often elusive, and she had to capture them when the opportunity arose.

The Camerons, who had once planned to write and illustrate a book about the birds of the Orkney Islands, instead focused upon the birds of their new homeland. Ewen set about compiling the first comprehensive list of all the birds known to occur in that section of eastern Montana, and he contributed many articles to ornithological journals and sporting magazines in both England and the United States. Evelyn's images illustrated Ewen's published articles, although she was not often credited for her work. She thoroughly enjoyed their collaboration, and later wrote that "our ornithological rambles were our greatest pleasure in life."

By a combination of daring, patience, and a knack for dealing with animals, Evelyn was able to take extraordinary close-ups of eagles, hawks, and other wild birds—images that are among the earliest photographs ever made of western American birds in their native habitat.

Calmly dangling from the edge of a steep badland cliff, she photographed the five-foot-wide nest of a golden eagle with two eggs in it, then returned to the site repeatedly over the course of three months to chronicle the growth of the eaglets. Ewen described the dramatic setting in an article he wrote and Evelyn illustrated for the April 1905 issue of *The Auk:*

The eagle's eyrie was situated near the top of a scoriacious rock in the badlands, a crimson pillar which crowned a

high butte sloping abruptly to deep washouts. . . . It was possible to climb to a north ledge of the rock, immediately over and about a yard above the eyrie, but the whole pillar behind was seamed with a gaping fissure which threatened immediate collapse, while a sheer precipice yawned to the front or west. From this precarious position the accompanying photographs, were nevertheless, obtained.

Evelyn's excitement over documenting the maturation of the eaglets outweighed any fear she might have had for her own physical safety. But courage had to be combined with great patience. Wild birds were, first of all, difficult to track down in the vast wilderness, although the Camerons had some help. Word spread throughout the area about their professional interest in the local wildlife, so neighboring ranchers brought them skins of unusual specimens and reported sighting any interesting birds or nests. Once tipped off about their location, Evelyn and Ewen set off in search of their subjects; naturally, the birds were not always around when the Camerons arrived. (On an April day in 1913, Evelyn was able to read *The Merchant of Venice* in its entirety while she lay with her camera awaiting the return of some swans.) When a bird finally appeared, she might then have to spend hours waiting for it to get into the precise position that she wanted. She had no telephoto lens, and had to rely entirely on stealth and absolute quiet to make photographs of birds at close range.

The eaglets that Evelyn photographed from birth became so accustomed to her calm and continuing presence that they paid little attention to her, or to Ewen, who was busily scribbling notes about their plumage and habits. One problem she did encounter in photographing them, however, was their decided preference for the shade. Ewen noted in a July 1908 article in *The Auk* that young eagles have a low tolerance for heat, and "collapse panting, with wide open mouths and drooping wings, at 100° in the shade," which presents "an undignified appearance much at variance with their ordinary noble aspect." Not only do eaglets naturally make for

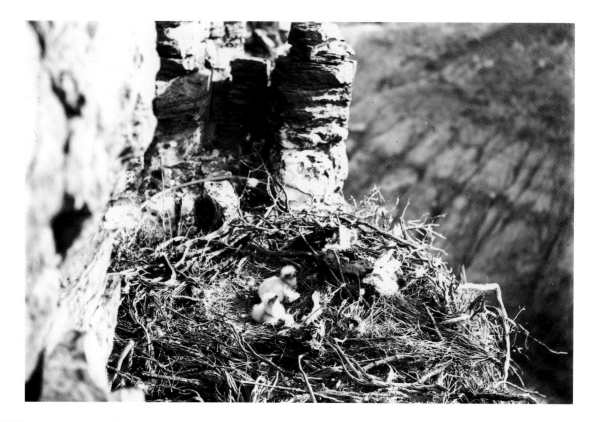

the shade, "if forced to stay in the sun they turn their backs upon it," a propensity which made them extremely difficult to photograph.

Evelyn, nonetheless, persisted, and having won the eaglets' confidence, was able to take great liberties with them, at times prodding them mercilessly until they got into the position she wanted or assumed an appropriately photogenic expression. "Had to poke them about with my tripod. With a stone I made one nearly have a fit," she wrote on May 21, 1904. The regal birds eventually permitted her to pick them up with her bare hands and pose them. Among the images she made of them is a self-portrait with one of the birds perched on her outstretched arm.

The majestic hawks and falcons that soared over the badlands were another favorite subject, and Evelyn seized any opportunity to photograph one at close range. A raging

A golden eagle's nest atop a badlands butte. Evelyn photographically recorded the maturation of the birds from helpless nestlings into young eaglets, as shown opposite. To do this, she had to climb to the edge of a precipice with her unwieldy equipment. She would hover over the wild birds for hours at a time waiting for the proper moment to make an exposure. The parents of the youngsters never attacked Evelyn, though she had to withstand the father's "cruel gaze, characteristic of his tribe," as well as the "putrid remains" of grouse, jackrabbits, rats, and snakes that littered the nest.

snowstorm in April 1899 unexpectedly delivered a frightened sparrow hawk to the Eve Ranch, and she immediately went into action:

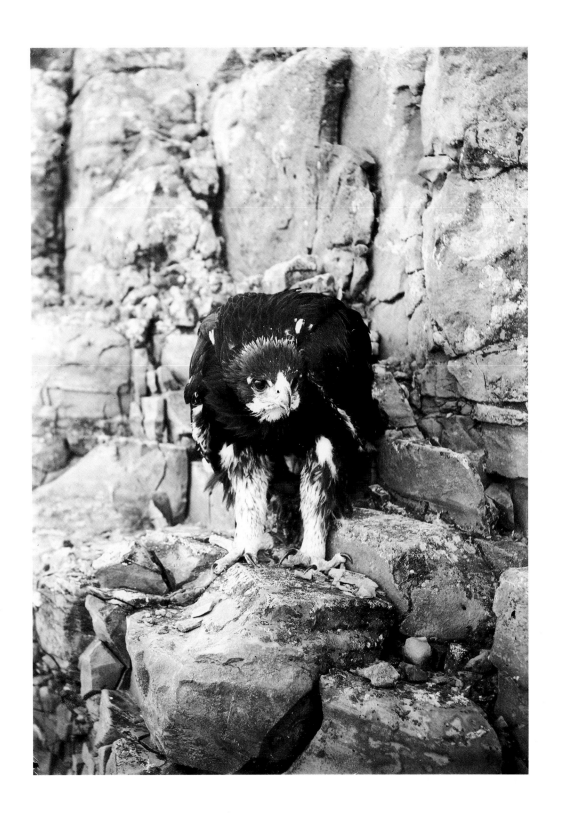

At 2 a sparrow hawk got imprisoned on the verandah. Alec caught it with gloves on. We tied its leg to his bed post & let it stand on back of a chair & I took 2 exposures, 1 second & 2 seconds, diaphram 16. Let it go. I handled it without gloves & it never attempted to hurt.

Over the years the Camerons also captured and tamed a series of wild birds—including a variety of hawks—for research and photography purposes. In many cases this was to protect their subjects from the assaults of the local population. The noble birds of prey that Evelyn and Ewen sought out were the same creatures that gave jitters to most ranchers, who would rather reach for their shotguns than risk any loss of livestock.

The Camerons had to become diplomatic advocates for the birds, convincing reluctant neighbors to spare them. In 1903 Ewen leaped to the defense of a pair of golden eagles that had nested near the North Side ranch. Their eyrie had been discovered by an enraged sheepherder, who had watched in horror as one of his lambs was carried off by an eagle, then tracked the bird to its nest, where there were two fully fledged eaglets. One of the young eagles was dispatched on the spot; the other made its escape. When Ewen got word of the discovery of the nest he was certain that the surviving eagles would return to the same eyrie, and he was able to extract a promise from the local ranchers and their hired herders to protect the birds—even if it meant losing a few lambs. Their forbearance allowed Evelyn and Ewen to photograph and observe the golden eagles over a three-year period from 1903 to 1905. All went well until one sheepherder was driven too far. Ewen explained what happened in *The Auk* in July 1907:

[The sheepherder] narrated how from some distance away he saw an eagle stoop [sic] at one of the dogs, and hang above it as raptorial birds are wont to do when attacking ground game. The dog, not paralyzed like a hare at the proximity of the great bird, ran towards its master, when the hovering and expectant eagle fixed one foot on each

side of the collie's throat and endeavored to bear aloft the shrieking animal. The shepherd described how during the few minutes that he was running toward the struggling pair and trying, incidentally, to find a stick, the eagle made frantic efforts to carry away the dog, which seemed unable, when clutched in this manner, to make any attempt to free itself. According to the story, the bird was flying all the time, in any case flapping its wings, and, although prevented from rising by the weight of the quarry, it was able to drag the hapless dog to and fro. The eagle had, in fact, too good a hold for her own safety and was ignominiously killed by blows on the head with a stick.

Hungry, wandering sheepherders also had an annoying habit of swiping and eating the eggs in nests that the Camerons were studying. Worse, ranchers and hunters set traps and laid out carcasses laced with strychnine to kill wolves and coyotes, and many eagles, hawks, and other animals were either killed in the traps trying to take the bait or died from eating the poisoned meat. The eagle was almost exterminated in eastern Montana by this indiscriminate trapping, poisoning, and theft of eggs, and the population of other birds of prey was so reduced that, in order to study them at close quarters, the Camerons at times removed fledglings from their nests and housed them in the safety of a barn at the Eve Ranch. In short order they would become quite tame— so tame, in fact, that when the Camerons were preparing to leave for England in the summer of 1900 and Ewen tried to free their two captive hawks, he met stiff resistance. The birds had grown quite accustomed to the cozy confines of the ranch, and were not about to leave without a struggle.

Evelyn made some wonderful portraits of captured birds, including an arresting self-portrait in which she is feeding a grasshopper to a sparrow hawk. Feeding voracious wild birds turned out to be more difficult than photographing them. A Swainson's hawk the Camerons captured in 1909 required a steady supply of grasshoppers, beef, mice, rattlesnakes, and small birds. The creature's preference, how-

Evelyn feeding a grasshopper to one of the many wild birds which she and Ewen tamed.
The one pictured here is an American kestrel, a small falcon, often referred to as a sparrow hawk.

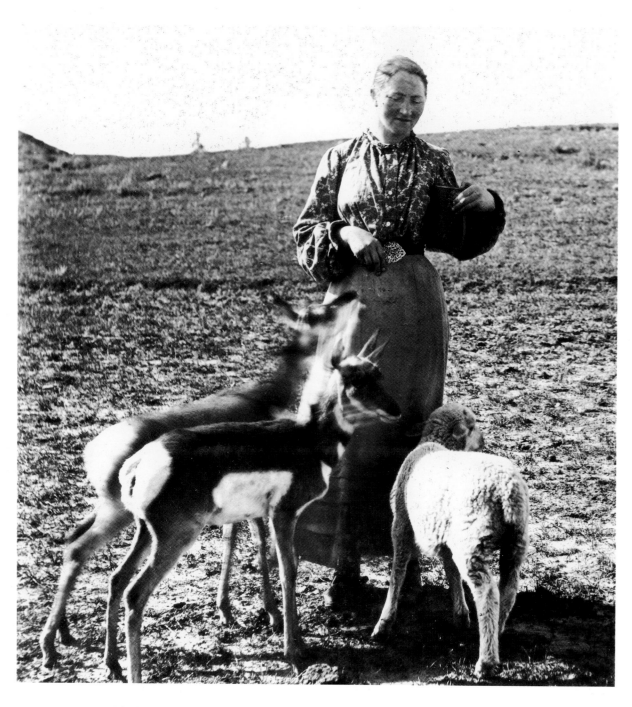

Ida Archdale feeds her "sweet but not very tame" pronghorn antelopes, favorite pets of Montana ranch women. Though timid in the wild, these animals became ferocious when kept as pets—as Evelyn discovered when she was knocked down while trying to photograph one.

ever, was for frogs; he would consume six large ones at a meal and, according to Evelyn, "was often compelled to disgorge those which he had swallowed whole to avoid being choked." In 1902 the Camerons reared sage grouse in captivity from eggs (a feat that Ewen believed had never been accomplished before), and discovered that the birds' "insatiable" appetite made them the most troublesome animals they had ever raised. "Their staple food was ants' eggs," Ewen complained in his field notes on sage grouse, "and so much of my time was spent procuring them that it became a joke among the neighbours."

Birds were not the only wild creatures that Evelyn tamed and photographed. She skillfully photographed the pet wolves that she and Ewen raised and eventually sent off to Coney Island. Some of the wolf photos were published in *Country Life;* Evelyn proudly reported the reaction in a letter to her mother dated December 20, 1907:

> I do not know if you saw my photographs of wolves illustrating an article in *Country Life* of September 14th. I was much amused by people asking me how I happened to get so close. Of course these were tame wolves which I brought up from the time they were a month old. . . . Allan Cameron was invited to a lunch given by the editor of *Country Life* & there met the photographic superintendent Mr. Hassan. He spoke in very flattering terms about my photos & he reported their remarks to me which was of course very flattering.

Domesticated animals were not necessarily more docile subjects than wild ones, as Evelyn discovered while photographing an "inconveniently aggressive" pronghorn antelope that was the pet of a local ranch woman. In an article that she wrote and illustrated for the January 16, 1909, issue of *Country Life,* Evelyn described the photo session:

> An attempt to photograph the beast . . . nearly proved fatal to the camera, as the antelope charged full at the tripod. In a courageous effort to save the instrument the lady photographer behind it caught her foot in her skirt and fell backwards, and the triumphant antelope was upon her in a moment. Fortunately the buck's strength does not equal its pugnacity, and the recumbent photographer with great dexterity managed to hold the tripod in one hand, while firmly grasping her assailant's horn with the other until released from this awkward position.

Except for the occasional itinerant cowboy or passing rancher who stopped by the Eve Ranch and asked to be photographed, Evelyn always went to her subjects, often traveling for hours—or even days—through the trackless wilderness to reach a remote ranch or an eagle's eyrie. Ingenuity and a strong constitution were required, for she went on horseback, and had to devise a system for safely carrying her bulky and fragile equipment. During one of the Camerons' long hunts, in January 1897, she went off in search of unusual badland formations to photograph and spent the whole day on horseback with her camera tied around her waist and her disassembled tripod in a gun scabbard. "My hip is bruised from the camera's pressure," she admitted in her diary after she got back to camp. "[The horse] Pilot's rough jog [was] tiring."

Though her camera was heavy and awkward, it did not stop her from exploring every inaccessible nook and cranny. In December 1912, in a letter to one of her nieces in England, she described climbing 5,000 feet up a mountain near Great Falls, Montana, weighed down with "my 9 pound camera & a heavy tripod" in order to photograph a hawk's nest. The heavy load did not prevent her from marveling at the scenery as she made her ascent:

> The steep slope is covered with spruce, pine & rock of wierd, fantastic shapes called hoodoos formed by . . . ancient volcanic irruptions. This rock much resembles English grey granite. Geologists call this butte a laccolith & there are very few in existence.

Geological oddities fascinated Evelyn, and she went to great lengths to photograph other unusual formations she

found in the far reaches of the badlands. While hunting in the winter of 1899, she stumbled across an enormous petrified tree that lay across the head of a washout, forming a "very curious natural bridge." Evelyn's first reaction was that she "must photograph it directly," and she did so the next day.

She was apparently not satisfied with the results, for during the following year's hunt she returned to the same site with her "heavy tripod, camera plates & ax." The ax was necessary because the tops of cedar trees obstructed the view of the petrified tree "bridge" from below, and Evelyn was soon at work chopping down the trees.

Ten days later she brought Ewen to the bridge to get precise measurements of the stone tree; her diary indicates that he was unnerved by her fearlessness:

> Arrived at the Petrified tree bridge. I stuck an end of the rope into the ground with an iron tent pin [&] dropped rest [of the rope] into the gulch. [I went] down to gulch, took up the rope & climbed up onto the East butt of the tree where it enters the bank. Ewen very old nurseyfied— thought I would fall! I found cut on the sandstone of the tree A. BACKSELL 6/7/1883 & again T. PERROT 83, evidently 2 cowboys. I cut E. J. CAMERON ⋎ 21/1/1900. . . . Measured the rope to where I had knotted it, which made the bridge from bank to bank 72 FT. ACROSS & 15 FT. 6 IN., 1/2 THE CIRCUMFERENCE at East base.

On another day she made several striking portraits of herself perched on the curious formation while reading *The Bystander,* a British publication that offered prizes for photographs showing the magazine being read in bizarre places. She set up the camera on a bank looking down on the bridge from above, an angle that heightened the sense of danger, and the photograph shows her dangling her legs precariously over the abyss. Clad in worn boots, dusty corduroy jacket and divided skirt, shirt and tie, pith helmet and pongee, with a half smile on her face, she serenely holds up *The Bystander*— the epitome of the intrepid explorer.

Evelyn was fascinated by what she referred to as the "New World type," the colorful frontier characters who were drawn to the remote area, and by the how-to of life in the West—how to "thrash" a field of wheat; how to shear a sheep; how to drive a herd of cattle across the Yellowstone River. She did on-the-scene documentary photography of them all, from the lowly sheepherders to the proud wheat farmers in their fields.

Among her favorite subjects were cowboys roping and branding cattle on the open prairie. She captured the legendary XIT cowboys, who had driven cattle from Texas to eastern Montana, eating dinner on the roundup, and, on September 10, 1904, swimming a herd across the Yellowstone River to reach the Fallon stockyards. This last operation began in the pre-dawn hours because cattle are frightened by their own reflection in the water and might have refused to swim altogether if the sun was too high, but although the dim light was "abominable" for photographing, she made a series of images of the cattle—482 head— strung out across the river. She worked to the soothing refrain of a cowboy who was trying to hold the herd by saying over and over again, "Whoa dogies, Whoa dogies."

Cowboys were natural subjects for Evelyn's photography, but she also sought out the more elusive men of the range, including wolfers, the solitary hunters who roamed the rattlesnake-infested outback tracking wolves and coyotes for bounties, and the sheepherders, with the primitive wagons in which they lived while tending a band of sheep.

Sheepherding was considered the humblest form of employment on the Northern Plains (so much so that one man who worked only briefly as a sheepherder admitted years later that he was deeply embarrassed that Evelyn had photographed him while herding a band of sheep). For months at a time the sheepherder's only companions were his sheep dog and his wooly charges. His job was to graze a herd of sheep that might number 2,500 in the winter and expand to 3,000 to 4,000 in the summer, and protect it from the ravages of nature. Blizzards could be deadly, and bloody raids by

Evelyn on a petrified tree in the badlands displaying a copy of The Bystander *magazine, which was conducting a contest for photographs of the magazine being read in the most unusual locations. She clambered out "as far as I dared," across the 72-foot-long natural bridge, hampered by her skirt, which kept snagging on the rock. The photograph was published in the British magazine.*

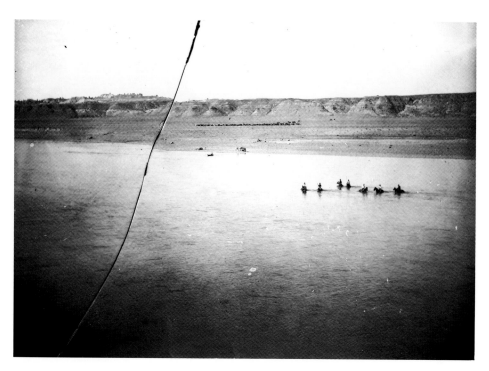

Evelyn took this series of photographs in September 1904. Cowboys on horseback and in rowboats prodded the cattle to swim across the Yellowstone River through the strong current.

mountain lions, wolves, and coyotes were a constant menace. The herder's isolation was almost total, save for infrequent— but memorable—forays into town. In a 1911 letter to one of her nieces, Evelyn described a seventy-two-year-old Siberian sheepherder whose behavior was fairly typical:

> He is a curious old character but a conscientious herder for 5 or 6 months, after which he goes to town & indulges too freely in whiskey until all his wages are gone. Returning to the ranch, he takes another spell at work & collects some more money which is again squandered in the craving for "Mountain dew."

Evelyn was intrigued by these unsung heroes of the range, and she sought out and photographed them in the fall, protecting their bands of sheep on the snow-covered prairie, and in the spring, when the herders led their charges to lambing camps, where the sheep ranchers and hired help assembled to assist at the birth of new lambs. In 1904 she photographed the lambing camp operated on the North Side

of the Yellowstone River by Sam and Nels Undem, brothers who had emigrated from Stavanger, Norway, and her remarkable images portray vividly the joyful, but anxious, lambing season. Ewes that have just given birth often will not recognize and nurture their own lambs, and must be dragged forcibly to their offspring by means of a crook; the long, curved hook became an evocative element in Evelyn's lambing scenes. Similarly, the tools of the sheepshearer—long shearing scissors and, on one occasion, mechanical clippers—were prominent in many of Evelyn's shearing images.

Shearing took place not long after lambing season, and was done by itinerant sheepshearers, a notoriously tough bunch; some were reported to consume a quart of whiskey a day and smoke marijuana cigarettes while at work. They were paid by the number of fleeces they clipped, and a good shearer was expected to wrestle with at least one hundred sheep a day. It was a rough, filthy job, prompting sheepmen to remark that "A shearer is a herder with his brains knocked out." The shearers' reputation, however, did not deter

Herd
crossing
Yellowstone
River Cory'

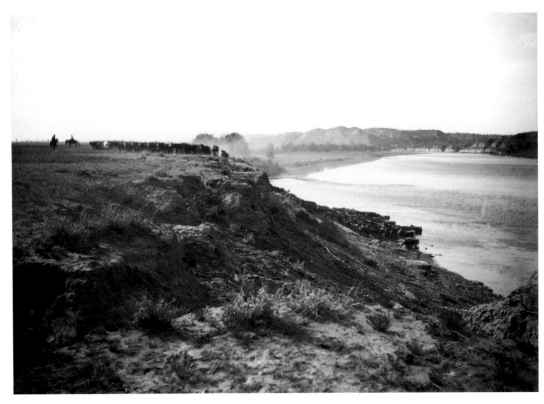

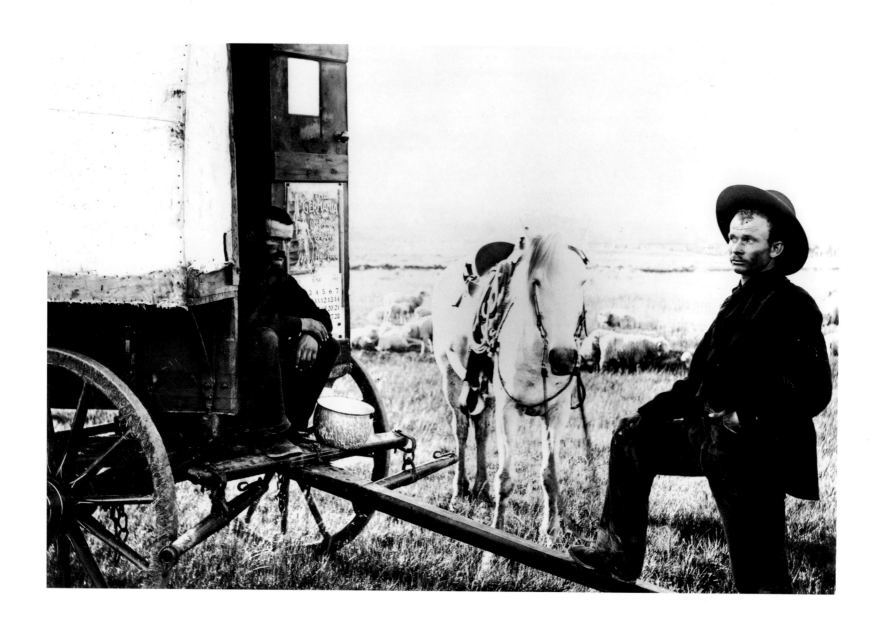

*Reno Walters (right) had previously arranged for Evelyn to come and take
photographs of him and his brother with their band of sheep on Sunday, June 8, 1902.
His brother Leopold (seated on the doorstep of the sheep wagon) came from
the saloon in Terry for the photo session.*

Evelyn from photographing them—unwashed, unshaven, wearing torn and filthy undershirts, with cigarettes dangling from their lips. She captured them at work astride the squirming sheep, and she made group portraits, often using the crude structure of the shearing shed—an open-air pen with a makeshift roof of branches and leaves to protect the shearers from the blazing June sun—to frame the image.

There were shearing sheds set up in Terry next to the Northern Pacific Railroad tracks so that the bags of shorn wool could be easily loaded onto railroad cars. The town came alive during shearing season, as sheep from throughout the area were trailed in on foot with hordes of shearers and other sheepmen close behind. Local business boomed. "Both Hotels had their suppers in full swing, sheep men everywhere," Evelyn reported at the height of one season. "Shearing in full blast."

With her photographic equipment in tow, Evelyn headed for Terry's shearing sheds on June 24, 1899, to catch the men in action. After photographing them, she carefully noted their names and addresses and the number of prints each one wanted. Two days later she returned with the photographs in hand.

> I got most of the men to pay me. Others promised to leave [money] at post office, not having any at pens. They made jokes about man on wool sack, Malone—called him a frog. Lester said Hare was trying to rock his sheep asleep because they both moved!

Sheepshearing operations were not limited to the pens in town; shearing camps operated by individual ranchers were also scattered about the range. In 1904, Evelyn rode 26 miles alone on horseback carrying "folding tripod, camera & 12 plates, 18 mounted prints & 1 . . . [photo] album" to reach a shearing camp run by state legislator George Washington Burt and his brother-in-law Lon Fluss, where she stayed for several days recording the proceedings.

Shearing season, and the arrival of the spirited work crews, signaled a welcome break from the tedium and iso-

To Evelyn there was "no sweeter music" than the bleating of lambs, a sure sign of spring. Armed with crooks to corral delinquent mothers who abandoned their young, the owners, Nels and Sam Undem, and their four hired men were able to shepherd most of the new flock through the risky lambing season.

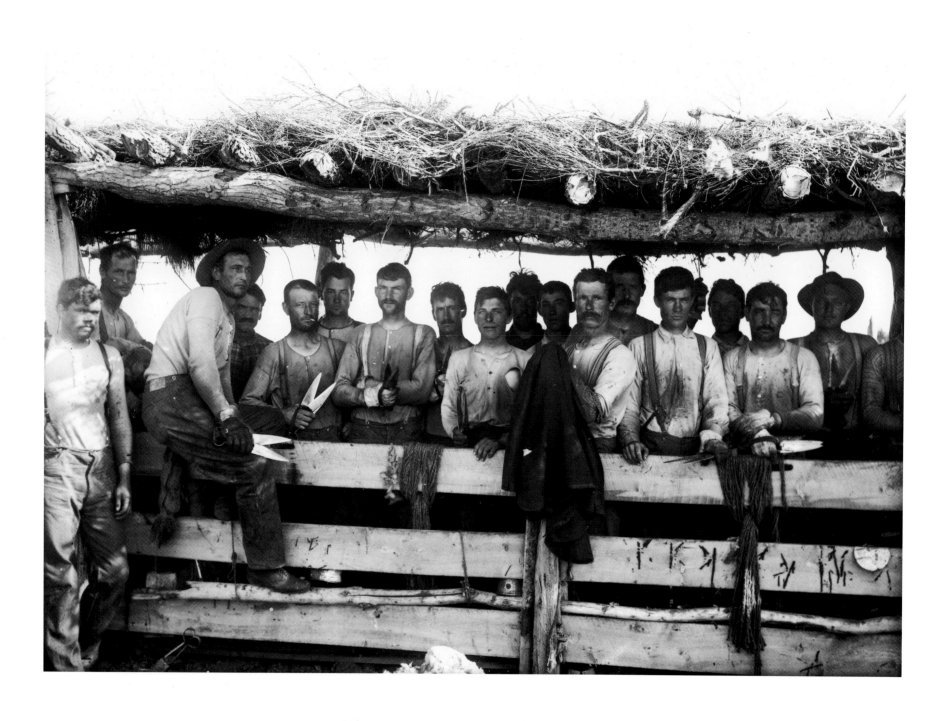

Caked with dirt and sweat, this group of sheepshearers was photographed inside the pens where they had been fleecing scores of sheep. Although known for being hard-drinking and tough, sheepshearers cooperated with Evelyn—and were then eager buyers of her photographs.

George Burt, one of eastern Montana's most prominent sheepmen, was an aficionado of transportation in all its modes. For his children, Lucille and Paul, shown here, he provided the first bicycle in Terry and a goat-drawn wagon.

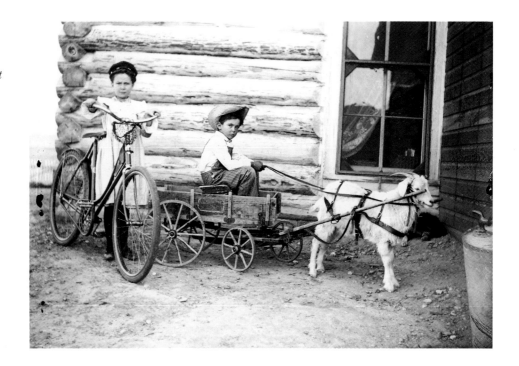

lation of sheep ranching. Evelyn arrived at the Burt camp on the evening of May 29, when the shearing was just beginning, and to celebrate the occasion the assembled sheepherders and shearers danced a little "2 step" to the accompaniment of an accordion.

George Burt's shearing operation was of great interest to Evelyn because it was unlike any other she had previously photographed. The shearing was done inside an enclosed shed with steam-driven mechanical clippers, technology that had been introduced to the area by Burt, one of eastern Montana's most prominent and innovative citizens. Trained as an engineer in Ann Arbor, Michigan, Burt liked to keep up to date. For his wife and daughter, he imported from Chicago the first bicycles in Terry. When his children were presented with a pet goat by a local rancher, he ordered from Montgomery Ward a red harness and wagon, and then hired Evelyn to photograph his son and daughter with their fancy new bicycle and goat-powered wagon.

Burt also invested in a red wagon of his own—a red 1903

Ford that he used to visit the seven permanent sheep camps that were scattered across his 25 miles of land. This was the first automobile in the area, and it must have been a wonderful sight to see the dashing Mr. Burt motoring across the prairie in his open car; however, when Evelyn ran into him and his machine on the way to his camp her horse was "scared . . . into fits" until the automobile stopped. Evelyn later photographed the elegant Mr. Burt and his young son Paul (both in broad-rimmed hats) in the showy red Ford. The technological marvel stands on the scrub grass in front of the primitive log cook house at the shearing camp—the old and the new in vivid counterpoint.

Although she remained loyal to her horse, Evelyn did permit Mr. Burt to take her for a spin. "Went fine, just wizzed on good pieces [of] road," was her report. Still, the expression on her face is slightly suspicious in a photograph of herself inside the car with Mrs. Burt and the Burts' ten-year-old daughter, Lucille.

Intent on adapting the newest technology in order to

For traveling to his distant sheep camps, George
Burt purchased the first automobile in the area.
While overseeing his shearing operation in 1904,
Burt posed with Lucille in his red late-model Ford.

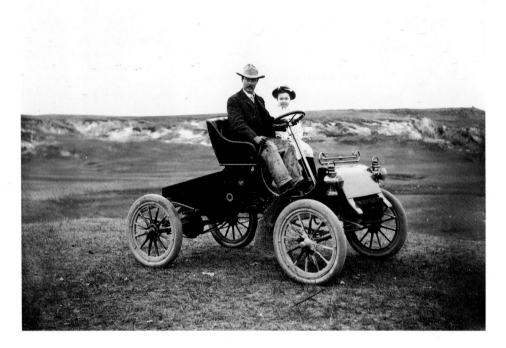

modernize the sheep business, George Burt introduced other innovations to the region besides steam-driven clippers. For the sheepherders who tended his flocks he purchased sheep wagons that were compact homes on wheels, each with a bed and stove inside a canvas-covered wagon. The wagons were a great improvement over tents and bedrolls; other local sheepmen quickly followed Burt's lead, and the sheep wagon became the standard home for eastern Montana sheepherders in the field. (Burt was so taken with its design that he built a model of a sheep wagon with cigar boxes and pins. And when Burt's family and assorted relatives made a six-week trip to Yellowstone National Park in 1901, a sheep wagon served as sleeping quarters for his children.) Burt also used modern technology to reduce the time required to haul the wool from his distant shearing camps to the railroad. Horse-drawn wagons piled high with sacks of wool were the usual mode of transport. But not so for George Burt. He ordered a steam-powered traction engine, powerful enough to drag five wagon loads of wool at a time, from the local

hardware merchant, J.W. Stith. Evelyn photographed this wonderful contraption as it chugged across the range.

She also took her camera inside Burt's mechanized shearing sheds, where she made a ten-second exposure of the shearers at work, with George and his son standing proudly in their midst. The wooden floor of the machine shop was covered with wool and the air was undoubtedly redolent of sheep—facts that did not prevent Burt from putting his shearing sheds to other uses; during the school year he hired a teacher and set up a classroom for his children on the second floor of the shearing shed at his home ranch.

Evelyn did more than snap photographs of sheep and their handlers. She also learned the ins and outs of the business, and she was understandably impressed with George Burt's up-to-date methods. Nevertheless, she was aware of one serious drawback to his modern shearing technology, and she pointed it out in an article on sheep in Montana that she wrote and illustrated for *The Breeder's Gazette* in 1905. Old-time sheepmen maintained that mechanical clippers sheared

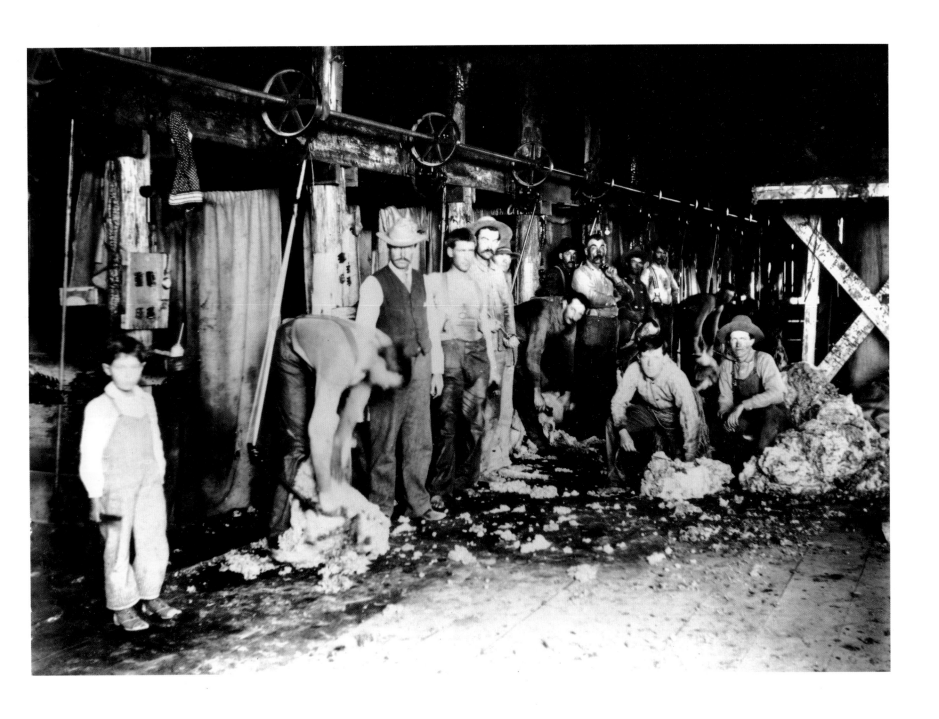

George Burt, and his young son Paul (left), stand amidst wool clipped with steam-driven
mechanical shears, a technology which Burt pioneered in eastern Montana.
Machine shearing yielded about a pound more per fleece, but some sheepmen contended
that it left the sheep more susceptible to cold.

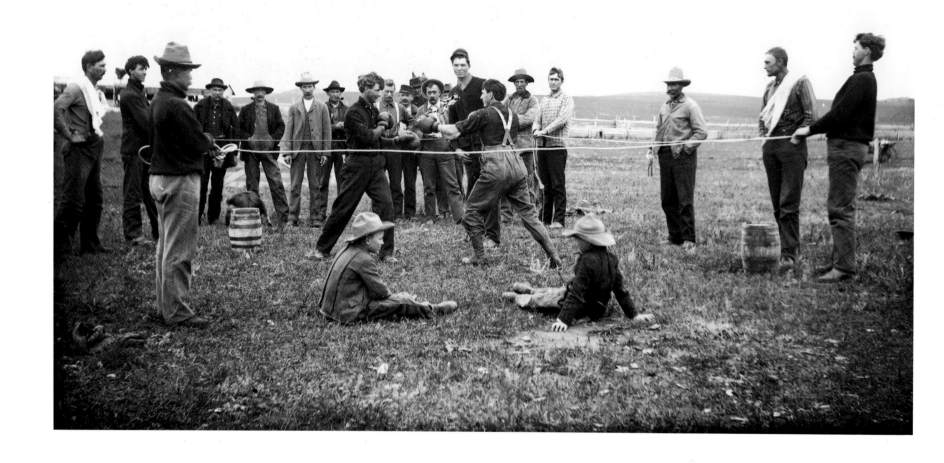

*An impromptu boxing match in early summer, 1905, at State Senator Kenneth McLean's
sheep camp. The corners of the ring were held taut by four of the herders and shearers
(wooden posts were hard to come by in the treeless area).*

The log shack where the cooks and children worked and slept for weeks during shearing season. The owner's wife, Della Burt, gave Evelyn a leg of mutton to take home and a month later bought a large selection of photographs.

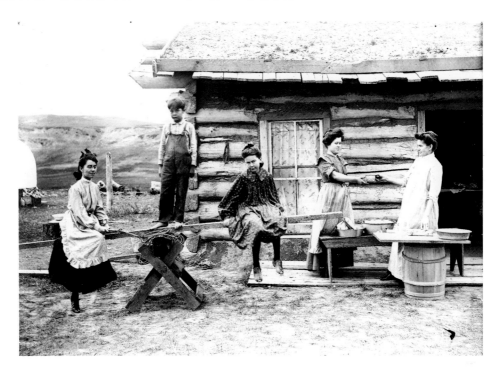

so closely that they scraped the hide of the sheep and left the animal much more vulnerable to cold. Even a rainstorm could then prove fatal, as it did to 400 local sheep that were soaked and chilled after being mechanically shorn in 1902; another flock shorn with hand clippers only a mile away experienced the same downpour without any losses.

During the course of their work, the gang of shearers slept in tents or on bedrolls on the floor of the shearing sheds. The shearing might go on for several weeks or even for a month or more, depending on the size of the flock to be shorn, the skill of the shearers, and the weather; wet weather brought a halt to the operation because of the danger to the sheep and the difficulty of shearing a soggy fleece. (During one such rain delay at a shearing camp, Evelyn photographed the shearers and herders at play—two men engaged in a boxing match inside a makeshift ring.)

Throughout all of this time the hired cooks—usually women—scurried about to keep the hungry hordes fed. At the 1904 Burt camp the cooks were Mrs. Della Burt and Mrs.

Irva Fluss, the wives of the owners, plus Miss Geneva Plummer. At night the three women, along with the Burts' two young children, all bedded down in the cook house, a crude log shack with a dirt-covered roof. Evelyn joined them in this cabin, and was generally pleased with the accommodations. In her diary she praised the dinners of mutton, vegetables, and pie as "very good fare," and reported that she had a "nice cot" to sleep on, even if it had no sheets.

As was her custom, Evelyn immediately threw herself into camp life. Although she was busy with her duties as photographer, she assisted the cooks as they served nearly twenty sheepmen at mealtimes, and she helped tend the needs of the Burt children, which turned out to be considerable. No sooner had she arrived than ten-year-old Lucille came down with the measles. Evelyn was dispatched to Terry (a 24-mile round trip on horseback) to fetch some lozenges and pine tar for the child. Then it was eight-year-old Paul's turn. Feverish and cranky, he kept his mother up one entire night. The next morning poor Mrs. Burt, who was still expected to keep food

on the table for the work crews, was thoroughly exhausted, and Evelyn generously stepped in to read to the boy until he fell asleep. With all the women and children living in such close quarters, it probably came as no surprise when one of the cooks, Irva Fluss, also contracted the measles, a serious case that required sending for a doctor.

Evelyn escaped the virus, and before illness waylaid the camp's cooking operation, she vividly captured in her photographs the domestic side of sheepshearing. She photographed the cooks standing in front of their log cabin with sunbonnets in hand and a shy lamb rubbing at their skirts; huddled around the kitchen stove with Irva Fluss holding a huge slab of meat with a hook; serving the shearers at the long dining table inside the cookhouse; and rolling dough on a makeshift table set up outside, right next to a teeter-totter on which the children were solemnly balanced.

In 1904, George Burt, at the age of thirty-six, was at the height of his ranching success. His innovations had taken hold and, in partnership with his brother-in-law, he was successfully raising some 30,000 sheep that had to be tended by ten full-time herders. He had built a showplace in Terry, a two-story log house that was the town's first with running water and heat. Evelyn thought the latter convenience was a mixed blessing, writing to her mother on January 8:

> There is a rich sheepman's wife in Terry who keeps her house so warm that they never have blankets on the beds in winter! It is a thick walled 8 roomed house, but how injurious to health it must be to keep up such a warm atmosphere!

Burt's confidence in himself is apparent in Evelyn's images of him. But a year later he suffered a debilitating stroke that forced him to curtail his ranch work. However, income from the sale of his lands allowed him to purchase a 100-foot sternwheeler for a therapeutic trip down the Mississippi and across the Gulf of Mexico to Florida.

Ranchers did not send for Evelyn and her camera only to record their workaday lives; they also frequently wanted photographs of their children. On occasion, she bartered for her services, agreeing to photograph one man's child in 1896 in return for a load of wood. She found squalling babies and rambunctious children difficult subjects, though she photographed them exceptionally well. "Over to Bright's, her little (2 or 3 month) baby is the ugliest little creature I ever saw," she wrote on December 6, 1897—surely sentiments not shared with her clients.

Family portraits were also in demand, and the subjects often insisted on including in the image their favorite possessions—even if it meant borrowing them. On June 13, 1900, Evelyn went to the Smith residence in Terry to photograph mother and daughter. "Miss Effie & Madame in gorgeous array," she wrote. "Took them at harmonium, Madame with a borrowed mandolin which she cannot play!!"

Evelyn met with a much more improbable "borrowing" when she photographed Mrs. Collins, the feisty woman pioneer from "old Oireland" who had been one of the early settlers in the area. A thoroughly independent and resourceful character, Mrs. Collins had left her abusive husband in 1870 because she feared for her life. She ran a ranch by herself along the Yellowstone River, and, at roundup time, when cattle and horses were being loaded onto railroad cars for shipment east, she lived in a tent near the stockyards in Fallon and operated a thriving business cooking dinner for the cowboys. (Other businesses also flourished when the cowboys were in town. While Mrs. Collins was slinging hash nearby, a prostitute was killed by a cowboy at "Donelly's indecent shacks.") Although Mrs. Collins was a noted tippler when she "got into the blues," she was always on the prowl for new adventure. In 1897, when word spread about the discovery of gold in the Klondike, she was all set to join the rush, asking Evelyn to be her partner in a hotel venture. Evelyn, of course, declined, but she liked the eccentric Mrs. Collins, finding her a constant source of amusement. On March 20, 1900, she photographed her in Terry:

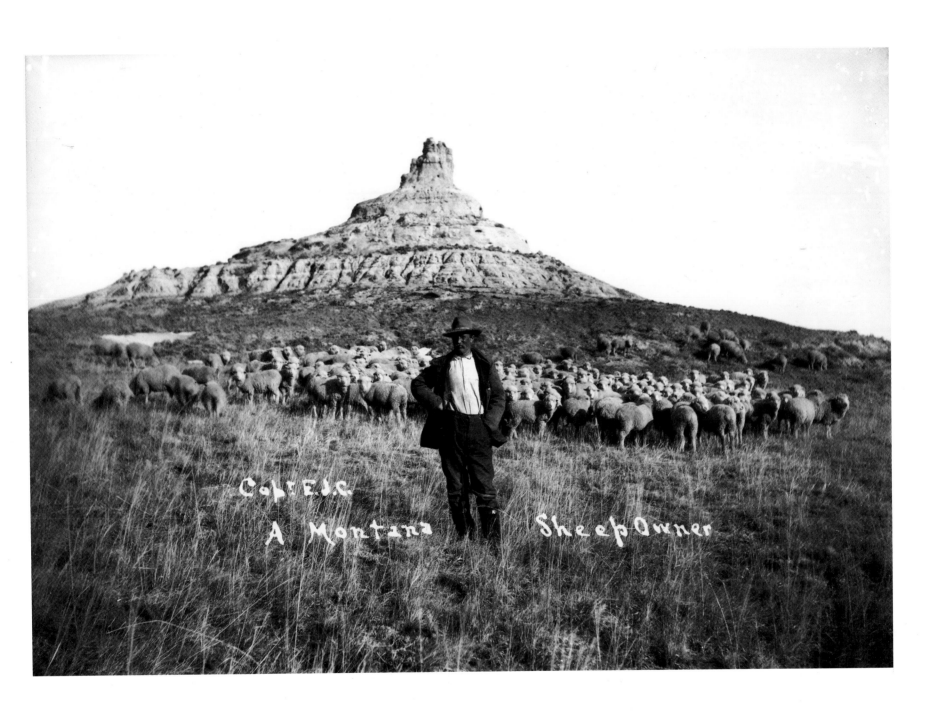

Nels Undem with his flock of sheep at the foot of what Evelyn called a "curious butte,"
February 1905. A month later Nels and his brother Sam purchased the photo as part of a
complicated barter deal in which the Undems gave Evelyn a 39-pound sheep and 25 cents in
exchange for photographs, some eggs, and a subscription to The Breeder's Gazette.

Alfred Wright (right) visits his herder and wether band of 3,000 sheep after an early morning snowfall, October 1905. Wright, originally from Hertfordshire, England, had arrived in Terry with $5; he became one of the area's most prosperous sheepmen and the first mayor of Terry.

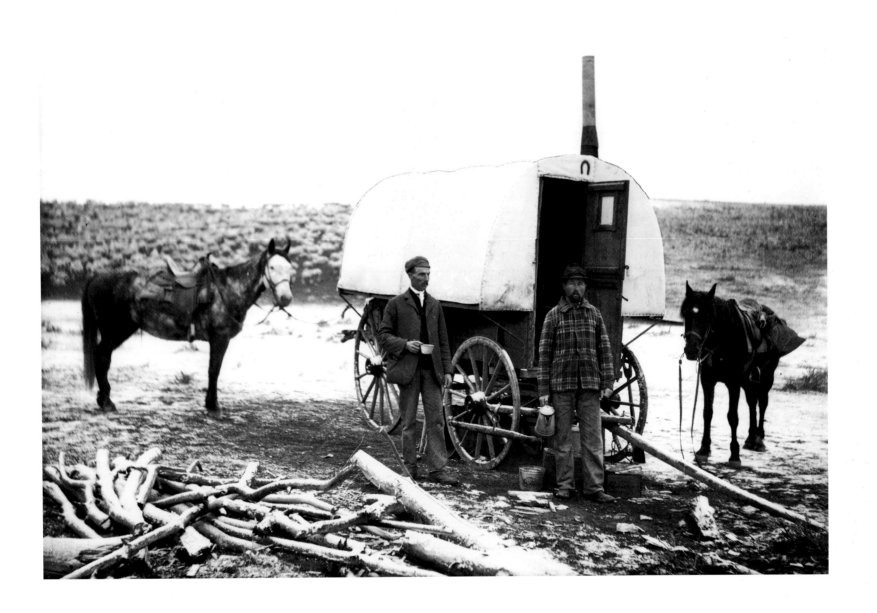

Wright had invited Evelyn to stay overnight to photograph his ranch and livestock. She photographed as well the small sheep wagon where the herder lived in the fall and spring months. The herder, holding the coffeepot, was alone for weeks or months at a time except for the companionship of sheep dogs.

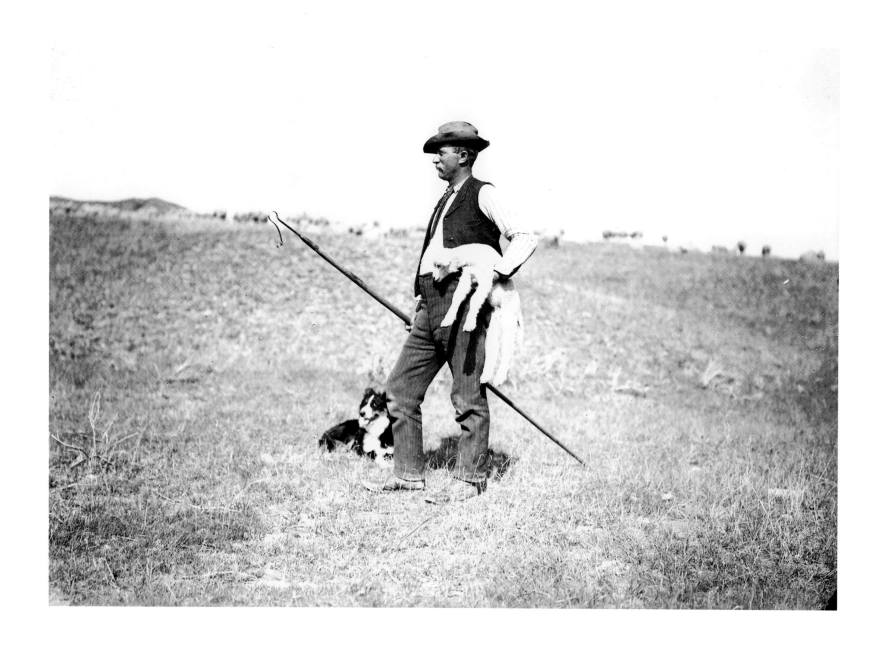

Nels Undem at his lambing camp in May 1904 is shown in profile with the tools of his trade—a sheep dog and a staff to protect newborn lambs.

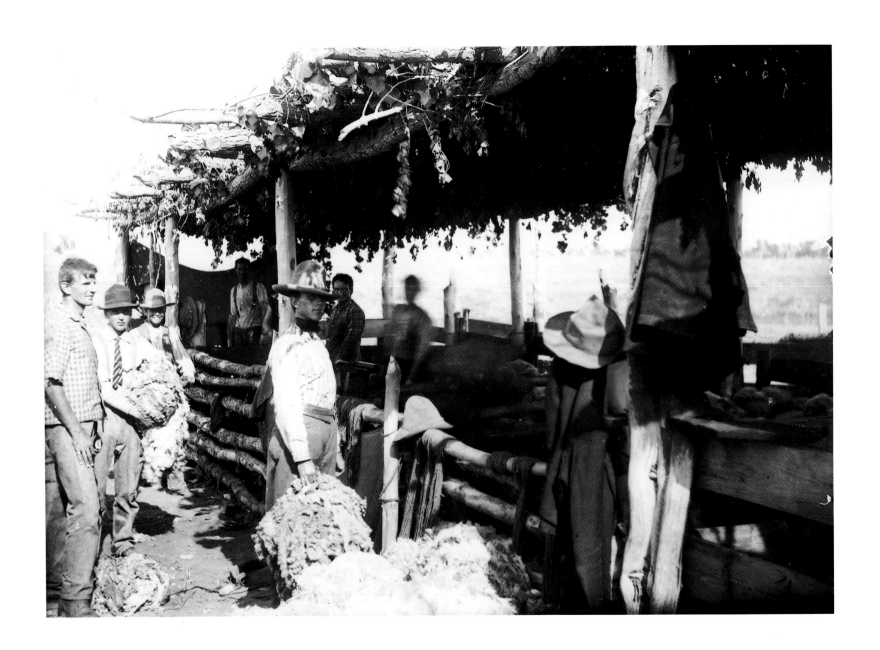

The annual shearing at Powder Bridge, July 1905. Most of the shearers were itinerants,
traveling from camp to camp during the summer and working under makeshift shelters.

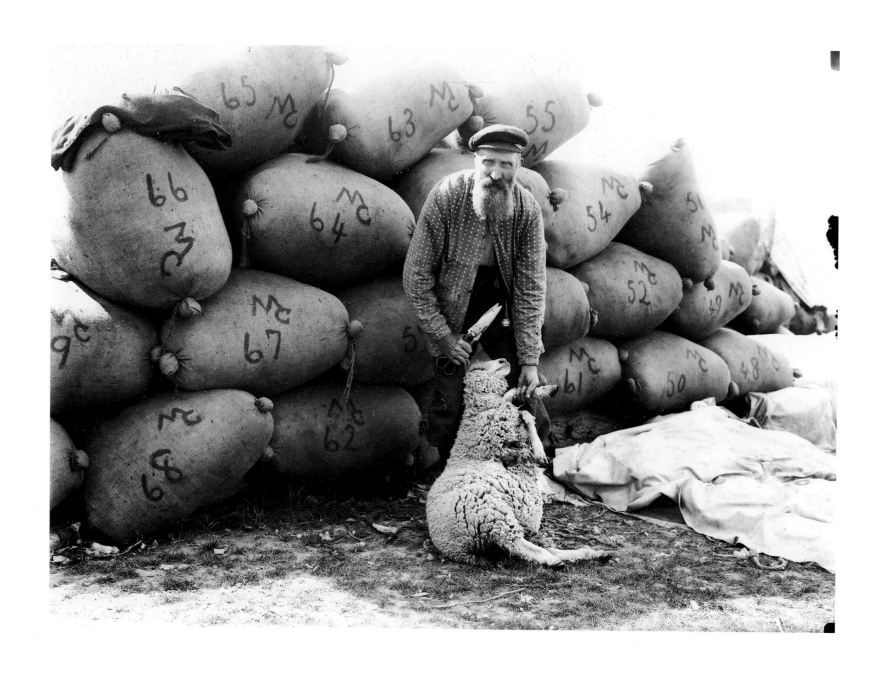

This shearer hunches over a sheep in front of sacks of wool, numbered and painted with the owner's brand. Terry, Montana, was an important wool-producing center; almost a million pounds of wool were shipped from the town in 1901.

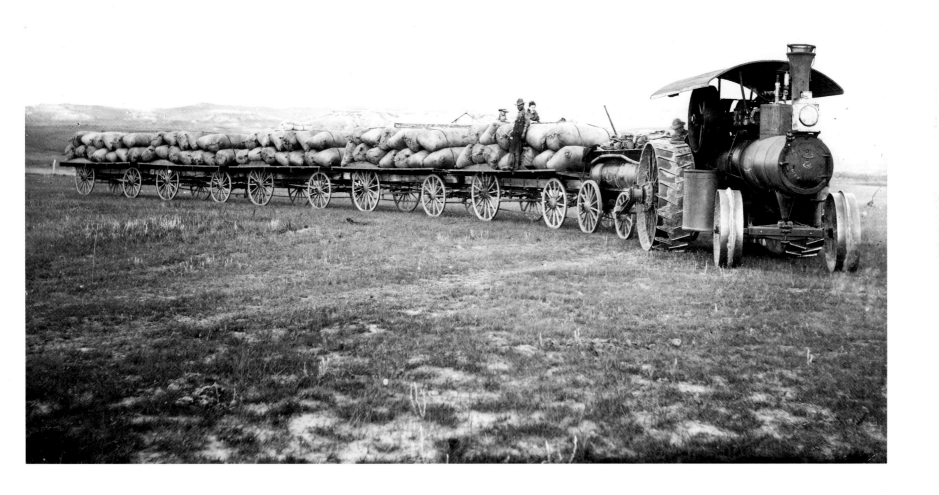

A steam-driven traction engine drags sixty-five sacks of newly shorn wool, weighing 25,000 pounds, from George Burt's shearing camp to the Northern Pacific Railroad depot in Terry. For Evelyn's photograph Burt's children hopped aboard the wool wagon.

Mrs. Collins had great time getting herself & room ready. She couldn't find her gown & lost her false teeth, she thought her dog had gone off with them. Finally she wished me to go & borrow Mrs. Van Horn's [teeth] which I did. She had to take them out & wash them first!!

At the other end of the spectrum, Evelyn documented the refined British horse breeders who tried to maintain at least some semblance of their Old World manners in rough-hewn Montana. In July 1897, for example, she photographed a tea party on the crude wooden verandah of the Lindsay-Dowson Cross S Ranch house and included herself in the scene. One of the servants snapped the shutter, capturing a moment of elegant repose: a group of well-dressed young men and women assembled around a table in the open air. The handsome tea service is silver, the table linens are impeccably laundered, and there is an unmistakable aura of aristocrats at their ease.

The expatriate ranchers brought along with them the trappings—and often the preoccupations—of their class. The interior of the Cross S (in Evelyn's estimation, the "dustiest ranch" she had ever visited) was filled with a cozy jumble of Victorian bric-a-brac bearing the stamp of the far-flung British Empire. Evelyn photographed a corner of the sitting room crammed with such items as an elephant's foot, exotic stuffed water birds, and, in the foreground, a Ping-Pong table.

While the Camerons were visiting at the Cross S in 1896, Walter Lindsay "discoursed on [the] hereditary talents of people & horses," and he had Evelyn photograph him in his "new suit of racing colours—red & blue stripes, blue cap," an outfit that he had gotten just in time for the fall horse races in Miles City. During another visit to the Cross S, she photographed the stately Kathleen Lindsay seated sidesaddle on her Montana horse, as well as Effie Dowson stretched out on a wicker chaise on the verandah, darning stockings. The well-dressed expatriates are invariably easy to pick out among the rough cowhands. J. H. Price, sporting his mono-cle and bow tie, cannot be missed in a photograph of a group of ranch hands clustered around a roped horse at his Crown W Ranch.

After visiting at the expatriate ranches, Evelyn would return to the Eve Ranch to develop and print her negatives, producing sample prints which she sent back to her subjects. She then awaited their orders. On September 21, 1897, she wrote to Kathleen Lindsay:

At last I am sending you the photograph proofs, they are untoned therefore will darken by degrees in the light. If you want to look at them thoroughly it would be best to do so by lamp light, which does not effect the paper. The prints that you wish duplicates of please return with the number required written on the back & I will tone you them as soon as possible. I am sorry the Ranch is out of focus & the one of the horse portraits & the bedroom are covered with spots, dust must have got inside the plate holders before they were exposed. It is a great pity.

The finished prints—and on occasion an entire "souvenir" album of western scenes—were then dispatched. "I am so much obliged to you for the album of lovely photographs which arrived safely," J. H. Price wrote after receiving one of her photo albums in 1904. "I am charmed with it—& in my old age I shall be able to look through it & recall incidents of my Montana life. . . ."

Evelyn also assembled albums of photographs as gifts for her relatives in England to show them something of the life she was leading in Montana. Among them was one for her three young nieces, made up in 1904. She described it in a letter to one of them on September 14:

You will see photos of coyotes (prairie wolves) in the album. For some time we kept hounds to hunt the prairie wolves but the best hounds were killed by eating poisoned baits put out to kill the wolves by cattle owners. . . . The soap weed [seen in the album] grows all over the hills in great profusion; in July it all blossoms out like those in the photo. The Indians use the roots instead of soap. I have

washed my hair with the root & found it made my hair clean & so soft. . . . The photos I mention in this letter are in a little album I am sending you. I thought perhaps they might amuse you. Aunty took them herself. Goodbye sweet one. Much love to you, Joan & Nancy. . . .
Ever Your loving Auntie *Evelyn*

For her nieces' benefit she also included several portraits of herself doing her ranch chores. (Evelyn would compose the image, set up the camera, and then let Ewen snap the photo.) The images include one of her milking a cow in a wooden corral with the badland hills in the distance, and another of her in her kitchen, kneading a panful of dough.

Nearly eighty years after the arrival of the photo album, Evelyn's niece Nancy Edwards still recalled the awe in which she held her "Aunt Evie." She had met her only once, during the course of the Camerons' year-long stay in Britain in 1900–01, when Evelyn joined her sister and nieces for several happy days at the seaside at Bognor. Nancy was only seven years old at the time, but the event made a lasting impression on her, to the extent that at sixteen she begged her parents to allow her to go to Montana to live. (The romance of the Camerons' western adventure also captivated Ewen's Scottish nephews, who as boys played "Uncle Ewen going to America.") The trip never came off, but Evelyn did not forget her nieces, and when Nancy married she surprised the bride with a magnificent book of photographs.

Among those bitten by the photography bug was Evelyn's half-brother Lord Battersea, several of whose travel photographs of Athens and Carthage were published in *Windsor Magazine* in 1900, while Evelyn and Ewen were in England. The article's subject was the way amateur photography had taken hold among the "leisured" class, and the author had this to say about Evelyn's celebrated relative:

To find Lord Battersea an expert at photography is not likely to provoke surprise, for he is proficient in so many branches of science and is a lover of art in all its forms. The once Mr. Cyril Flower, M.P. . . . has travelled seldom of late without a kodak. His collection of snapshots, enlargements of some of which have won him prizes and diplomas in London and Vienna, is one of the best I had the pleasure of examining.

Lord Battersea was renowned for the photographs he made of his upper-crust friends at Aston-Clinton. There he photographed a veritable who's who of late Victorian and Edwardian England: Prime Minister William Gladstone, the Anglophile novelist Henry James, and members of the elite English intellectual and social set dubbed the "Souls," to name a few.

He also photographed various members of the Flower family; one of his images, a photograph of Evelyn's beautiful half-sister Clara, created a small sensation among some visiting cowboys at the Eve Ranch. Evelyn treasured all of her family photographs, and she admired Cyril's skill with a camera. When she received word in December 1907 that he had died of pneumonia, she immediately wrote a letter of sympathy to his widow:

Dear Constance,

I cannot resist the impulse to write & tell you how sorry I was to read of the death of Cyril in the papers. It must have been a terrible blow to you & I deeply sympathize with you in your great trouble. In former days I had always looked upon Cyril as the ideal of health & strength & that he should be thus suddenly taken seems to me indeed sad. I can only hope that he did not suffer at the last.

I venture to ask you whether you could let me have photographs of him and yourself as I should value them exceedingly. I have photographs of all my other relations but none of you or Cyril.

Again expressing my deep sympathy with you in your grievous affliction. Believe me,
Yours affectionately,
Evelyn J. Cameron
née Flower

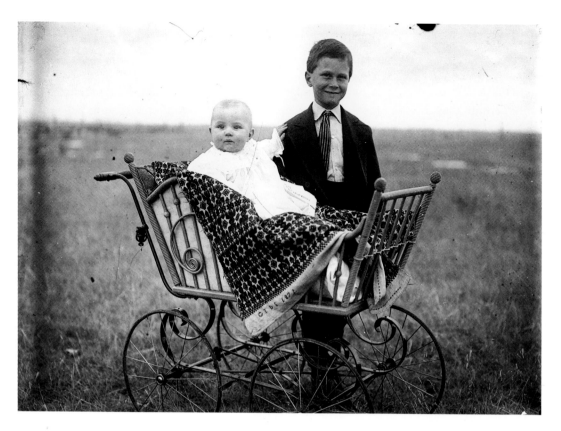

*A baby rests its hand on a smiling big brother.
The infant sits in a fine wicker carriage on a
coverlet made in 1872.*

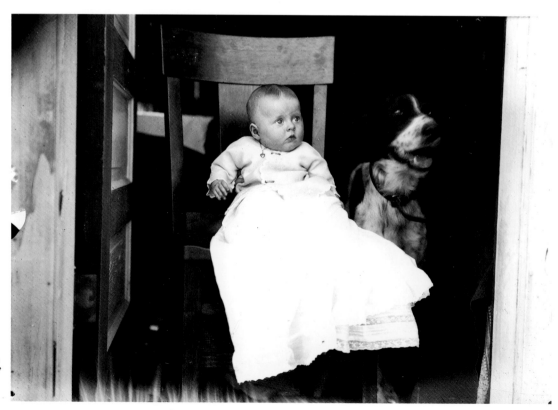

*An infant, its thin patch of hair carefully parted,
and the family dog. The mother is just visible
behind the chair, supporting her baby.*

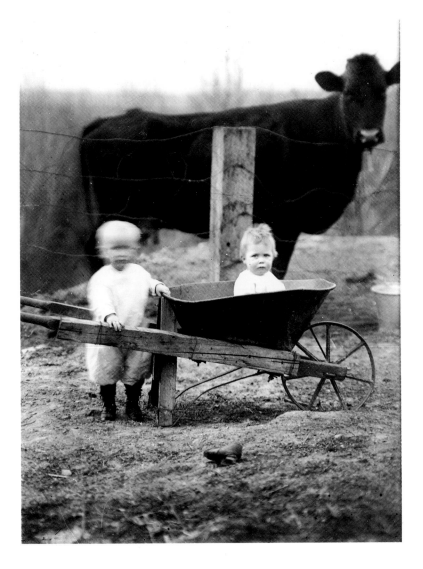

Photographing babies and children was an important part of
Evelyn's business, though not one that she always enjoyed.
Restive children were "so bothersome," she wrote. She was
paid only for acceptable pictures, and not for negatives that
were wasted because a child moved, as in the portrait above, which
also includes, perhaps at the customer's request, the family cow.

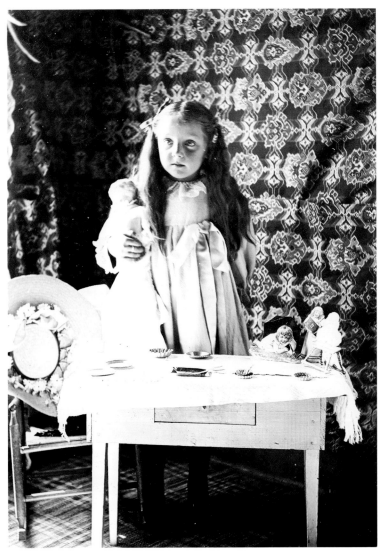

Several months later Ewen went to town to fetch the mail and returned lugging a large, six-pound package from England. Inside the box were individual portraits of Lord and Lady Battersea made by the British photographer Lafayette. Cyril, dressed impeccably in a Norfolk jacket, was portrayed reading a book, while his wife Constance was photographed with a "string of pearls around her neck as large as marrowfat peas." Evelyn was thrilled to receive the photographs—in her diary she pronounced them "too too, quite scrumptious!"—and she wrote gratefully to Constance:

> I cannot tell you how surprised & delighted I was to receive the two magnificent photographs which you sent me. I think they are both excellent but that the one of yourself is the finest example of the photographer's art I have ever seen. They will always be among my most treasured possessions. I am very sorry not to have acknowledged them sooner but the fact is I expected small photos to come thro' the post & no inquiry was made at the railway station until the New York brokers letters were received. I was quite unprepared for such a present: even the station agent was under the impression that the package contained oil paintings. As you can well believe such photos are rare in this part of the world. I must mention that the photos in their portfolio were beautifully packed & arrived in perfect condition.

The elegant portraits of Lord and Lady Battersea thereafter graced the crude walls of the Cameron ranch house.

On her visit to England, Evelyn had brought with her a box of glass negatives from Montana. Because of a luggage mixup they were left behind when she returned to America, and for years thereafter Evelyn paid a £6 annual fee to have them professionally stored in Tunbridge Wells where Ewen's mother lived. As the years went by, and the homesteaders transformed eastern Montana, she realized how valuable these early negatives were. In 1917 she asked her sister Hilda to take care of them, explaining: "The negatives are precious to me, including many western scenes never to be duplicated in the days when the desert has blossomed as the rose." She then authorized the company that had been storing them to send them to Hilda. Nine months later, when they had not arrived, she wrote angrily to the company:

> The photographic negatives are of great value & I would not accept £20 a piece for most of them, for they represent western scenes in the USA which can never be duplicated now that the prairies have been turned over by the plough.

Alas, the negatives never did surface, and Evelyn sadly concluded, in another letter to Hilda, that some of her earliest negatives of pioneer Montana had probably been lost "owing to the dislocation of domestic traffic occasioned by the war."

Well aware that her images were a precious record of a unique time and place, Evelyn sent albums and individual photographs to her friends and relatives as gifts. Most of her photography, however, was done for money to help keep the Eve Ranch in business, sometimes with publication in mind (illustrating Ewen's and her own articles), but more often at the behest of the local settlers. She was not paid any kind of a flat fee for the time she spent traveling to and from distant ranches (sometimes an overnight stay was required) or for the hours spent taking pictures; she was paid only by the number of prints her subjects wanted. When they didn't like their photographs, she had to go back and keep going back until the results pleased them—at considerable cost in photographic materials as well as time. It is no wonder that she didn't begin making money right away. "Ewen posted photographic accounts & makes me $4.92 in the hole yet. Made $31. Spent 35.92," she wrote on August 4, 1899.

By the late 1890s, the log-cabin post office in Terry had become the nerve center of Evelyn's photography business. Sooner or later, everyone in the area stopped in to see the postmistress, Mrs. Snow (known locally as "Aunt Susie"), to pick up both their mail and the latest gossip. Evelyn sent off bundles of finished prints at the post office and, while there, collected the messages that had been left for her by ranchers or townspeople who wanted some photography done. Before

Postmistress Susie Snow and her husband in front of their combination log house and post office in the summer of 1899. She sold Evelyn's photos at the post office for a 10 percent commission.

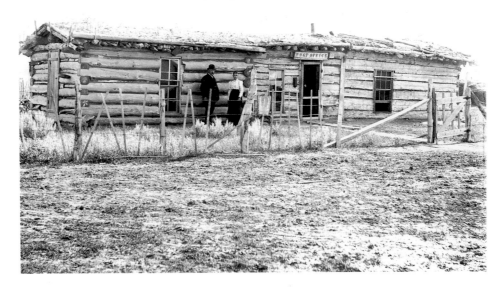

First business day in Terry but got no customers!

long the postmistress had begun selling Cameron prints, hanging a poster Evelyn made up with six sample prints and a price list:

MRS. CAMERON PHOTOGRAPHER.
$3.00 Per Dozen
—1.75 per half Dozen, 25¢ Each not exceeding four—
Please leave orders at Post Office.

Business seemed so promising that Mrs. Scott, who ran the local hotel, suggested that Evelyn come into Terry on a regular basis to photograph, and with Ewen's blessing, she rented a room at the hotel and put up notices around town (and also in Fallon) announcing that her services would be available "every Wednesday in Terry" from 12:00 to 4:00 p.m.

July 26, 1899, was Evelyn's first official day of work. She arose at 4:40 and rushed about doing all of her chores before setting off to Terry. At day's end she wrote across the top of her diary entry:

Evelyn's career as a photographer in Terry lasted a mere six weeks. In part, this was because Ewen was "very irrate at my continuing to take photos because he says I must rest till [my] back is quite well." (For years Evelyn slaved on the ranch with a sore back, and it never seemed to concern Ewen. It's more likely that he was grumpy because her absence every Wednesday afternoon might delay his evening meal and even force him to get more involved in ranch work.) In truth, the arrangement in Terry had not been very successful. Since people did not flock to her at the hotel, she ended up spending her Wednesday afternoons going around to the local townspeople trying to drum up business. And it seemed that whenever she had made plans to photograph a family in town, some problem arose—usually illness. Four Wednesdays in a row the Bracketts and their two children could not be photographed because at least one of them was sick (the boy, Tam, Evelyn wrote, "nearly had typhoid").

157

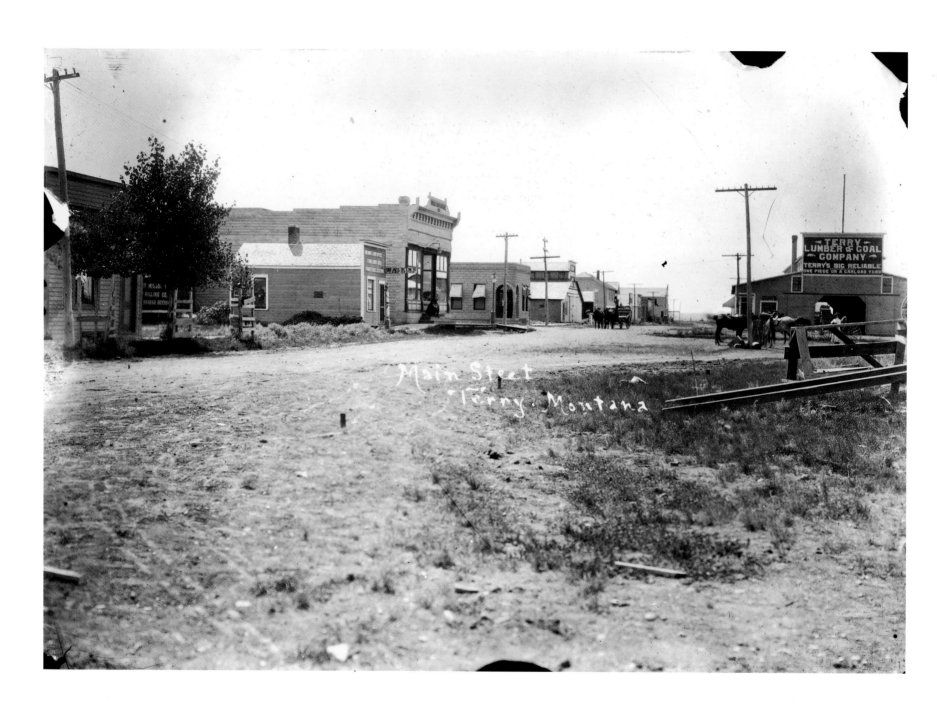

Terry's Main Street, photographed about 1910, when the town was booming from an influx of farmers brought in by the Chicago, Milwaukee, St. Paul & Pacific Railroad. Among the businesses along the street, which paralleled the rail line, were a bank, a large lumber establishment, and Mackin's Land Office, which helped newcomers locate homesteads.

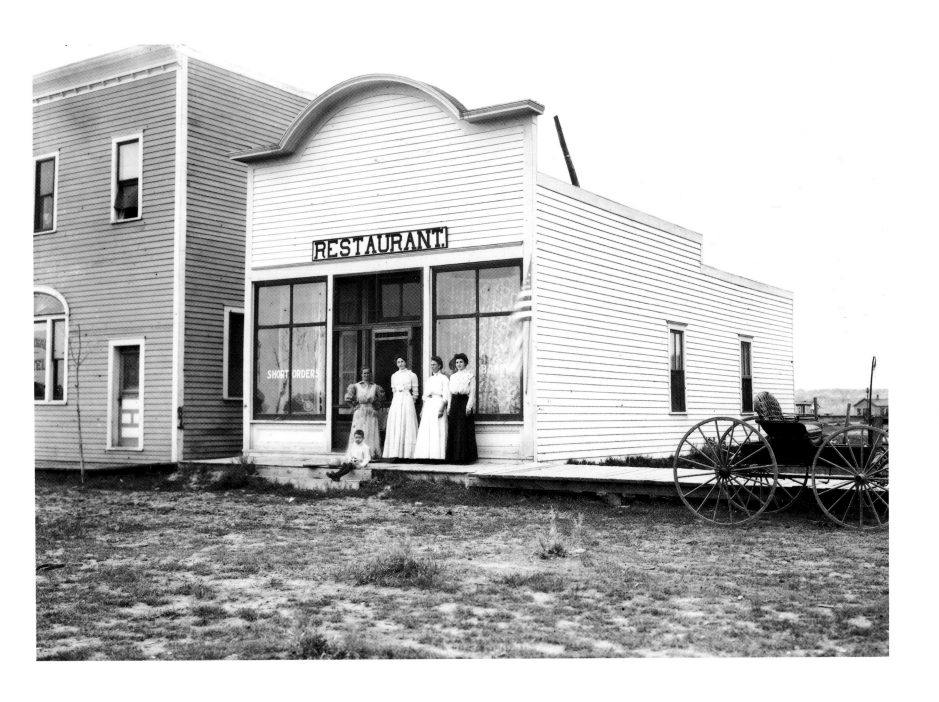

Other enterprises in town also began to prosper, including the Central Cafe, which had such trappings of civilization as lace curtains in the windows.

Evelyn did, however, make some notable portraits during her brief tenure in Terry—particularly her photographs of Mr. and Mrs. Snow in front of their wonderfully ramshackle log home, which also served as Terry's post office. When Evelyn delivered the finished prints to Mr. Snow the following Wednesday, he declared them to be "perfection." A traveling minister who was also at the post office agreed with Snow's assessment, and on the spot ordered two photographs of the cabin.

The post office remained a convenient marketplace for Evelyn's photographs, especially after the Camerons moved to their North Side ranch in 1902. "I do not get orders as I used to when living nearer Terry," she wrote to Hilda on January 21, 1904.

> The Post Masters at Fallon & Terry sell photos for me & I make up albums with 2 dozen in each which sell for $5 a piece. "I guess I will buy one of them to send back east to my folks" is fortunately a frequent remark in the above mentioned towns. My mounted photos sell for 25¢ each.

Evelyn paid the postmaster (or postmistress) a 10 percent commission for selling her work in town. She also sold prints and albums herself, while visiting and photographing at distant ranches. On occasion, someone would ferret out Evelyn at the Eve Ranch to order photographs. She had an enormous black leather photo album filled with hundreds of images, dated and described; potential customers would look through it and decide which ones they wanted to include in their personal albums. Two days before Christmas in 1903 Evelyn was surprised by a stranger:

> To Reservoir, lit fire & heated irons to shove up pipe so as to thaw out ice. Was just in full swing when a man on grey horse rode up [&] asked if it was Cameron's Ranch & if I was "the lady that took pictures." He put his horse in barn. I changed, got dinner on. Ewen annoyed, [he had] just got nicely to work on his birds. Dinner 1. Biscuits, stewed &

minced meat, boiled tatoes, ginger cake, jam. Showed all photos, he bought 4 dozen to be put in 2 little flexible books [for] $2.50 each, as Mrs. Drummond had sold him the old one for that sum, & I stupidly said I would take [the old album] back as he said there were many [photos] he did not want in it! Made a list [of] ones he wanted. . . . Stuck 2 dozen in a little book by very bad lamplight. Wrote under photos their description.

As her diary shows, Evelyn did not exactly come out ahead on her transaction with this particular visitor. Not only did she "stupidly" agree to make up his albums for half the usual price, but she also had to feed and house him for the night.

As the years went by, Evelyn captured not only the ranching and cowboy culture she first encountered in Montana, she was also a first-hand witness to the revolution the railroad wrought as it opened up vast stretches of Montana prairie to the plow. She photographed the work crews who built and maintained the tracks and the homesteaders who followed them.

The transient railroad workers invariably heard about Evelyn's skill as a photographer, and they would leave word for her at the post office or make the trek to the Eve Ranch and ask her to photograph them. The summer of 1904 proved to be an especially busy season for her, when a crew of Italian workers on the Northern Pacific sought her out repeatedly. In a letter to a niece written four years later she recalled her encounters with the men, who were routinely referred to as "dagos":

> Most of these Italians come from Genoa & Naples; they are looked down upon by the American working man, who says one "white" man can do more work in the day than 6 dagos. . . . Four summers ago I made a little pot of money photographing a gang of dagos. I used to photograph them on Sundays when they would dress up regardless. It was very amusing when certain cliques were taken together (probably 4 or 5 in a group) for if an outsider wished to

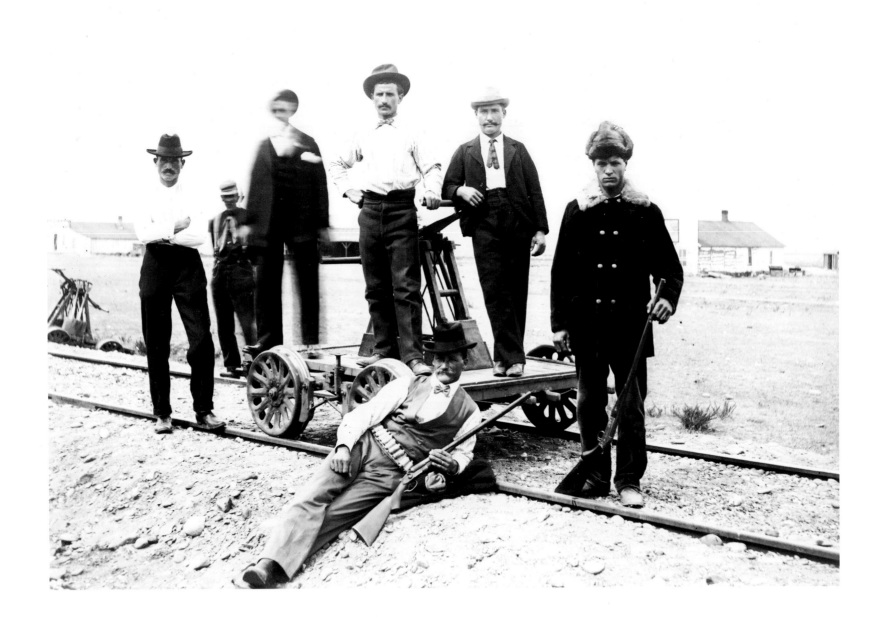

Railroad workers with a handcar they used to transport themselves up and down the line. Many of the workers were recent immigrants, and included Greeks, Italians, Poles, and Bulgarians.

Two Italian railroad workers pose for their portrait. In October 1907 some fifty workers were living in a dozen boxcars parked in Terry. The newspaper reported that in the evenings, "with the cars well lighted up, a violin in one section, a singer in another and an excellent gramophone going most of the time . . . the picture is a lively one." Evelyn sold many photographs to the Italians.

join the group it would create quite a wordy warfare with unrefined language—fortunately in Italian.

The Italians, at first, were blissfully unaware that Evelyn spoke and understood Italian. During one photo session, in September of 1904, to which she had brought a young woman named Miss Sherry, a handsome Italian named "Michiavelli or 'Mike,'" evidently smitten, turned to a companion to say, "E una Bella donna sa." Afterwards, Evelyn amused the young woman by relaying the compliment to her.

The itinerant Italians were not trusted by the permanent residents of Terry and its environs because of a reputation they had earned as garden thieves and poachers (the Camerons too felt the sting of their light-fingered ways). Evelyn was probably one of the few local settlers who had regular dealings with them, and she treated them with respect. She returned again and again to the railroad cars to photograph them at their request, and when they moved away to work further down the line, she corresponded with them in Italian. On several pages of a pocket-size journal in which she made random notes on her photography, she listed the Italian workers to whom she owed photographs. The names included the butcher Macellaio, Serpente Sonaglio, Matteo Giamfrancesco, Salvatore Monaco, and Nicola Santarelli, who ordered a half dozen of the photograph "con cigaro." (Not all of the railroad workers were Italian. Further on in the journal Evelyn inscribed the surnames of another crew she photographed, all of whom were Greek.)

The Chicago, Milwaukee, St. Paul & Pacific Railroad began laying track across eastern Montana in 1908 to extend its service from the Midwest across the west to Puget Sound, at the same time launching an aggressive advertising campaign to lure homesteaders to the area. George B. Haynes, the Immigration Agent for the railroad in Chicago, heard of Evelyn's work, and in 1908 he contacted her and requested some photographs to help sell the bounty and beauty of the prairie. She sent him a packet of twenty-seven prints to choose from, but was disappointed at his final selection:

I have supplied the agent of the Chicago, Milwaukee & St. Paul R.R. with a number of agricultural photos for their pamphlets & folders. They have selected an awful one of me with my arms full of vegetable marrows & my helmet on one side. It is to be hoped they will not use this for the cover or as a frontispiece.

In the 1880s and 1890s eastern Montana had been passed over by most farmers, largely because the region was considered impossibly dry. All that changed between 1900 and 1910. The combination of a liberalized homesteading law, new "dry-farming" techniques designed to conserve moisture, the introduction of more sophisticated farm machinery, and vigorous advertising by the Chicago, Milwaukee, St. Paul & Pacific Railroad created an unprecedented rush for the Montana prairie lands. Evelyn described the enormous changes in a 1908 letter to her brother Percy:

This part of Montana has now taken on a regular boom and it is being rapidly settled up by "dry farmers." The growth in the size of the towns has to be seen to be believed. . . . Terry, which when I first went there only included a saloon, an engine tank and a store, has now a church, a bank, 2 hotels, 2 livery barns, 4 saloons, 2 schoolhouses, what they call an opera house, a newspaper & numerous stores, with two railroads running thro' it.

Evelyn photographed the homesteaders posing proudly in front of their forlorn shacks, and recorded the significant events in their lives, from weddings to Fourth of July picnics. The area attracted a large number of German and Russian wheat-farming families, including a clannish group of German-Russians, descendants of Germans who, generations earlier, had been invited to farm on the steppes of Russia. While in Russia they had maintained their native customs and language, which they brought with them to Montana. Speaking an archaic form of German that even fellow Germans could not understand, they tended to band together socially and to marry among themselves. During

Judging by the disheveled appearance of the man at far right, the wedding celebration of a German-Russian couple, John and Christina Krenzler, had been under way for some time when Evelyn took this portrait of the wedding party, on February 22, 1912. Some thirty to forty people attended the wedding, where beer and schnappes were served.

World War I, the Germans kept a very low profile, though that did not prevent one German-Russian at the outset of the war from lecturing Evelyn on the righteousness of the German campaign against Russia and the cruelty of the Cossacks who slit the throats of children and held them aloft with their swords.

Evelyn was probably one of the few people who could always move freely from one immigrant group to another; with her camera in tow, she was a welcome—and sought-after—addition to any ethnic gathering. Some of Evelyn Cameron's finest images are the group and individual portraits she made of the homesteaders. But she was not altogether pleased. In February 1914, in a letter to her sister Hilda, she reported that although she had had a good "season" of photography, it was "not interesting like the old cowboy days as it consists of Russo-German picnics, marriages, burials, confirmations & babies!"

Far more intriguing to Evelyn was the day-to-day opera-

tion of dry farming, and she set out to photograph the cultivation of the prairies by the "honyockers"—the derogatory term for homesteaders used by the ranchers and cowboys, who despaired at seeing their range fenced up and plowed. Evelyn shared the old-timers' anguish at the transformation. In January 1911 she wrote sadly to Percy, recalling the days when he had hunted in the wilderness:

> The range country that you knew so well is about gone now and the prairie swarms with farmers who plough up the land with steam and gasoline engines. The only consolation we have is that they have not begun to plough the badlands, although someone may soon invent an effective contrivance for even this.

Despite her dismay, Evelyn now trained her camera on those cursed steam and gasoline engines. Fascinated by the ungainly mechanical creatures, she made them central characters in her images of farmers at work.

Mrs Kist's Funeral Procession Sept 4 1913

Mrs Kist's Grave Sept 1913

A line of wagons (above) proceeds across the prairie for the funeral of a settler, Mrs. Kist, in September 1913. The funeral had been delayed for two days until a Lutheran minister could be located. Accompanied by Janet Williams, Evelyn walked in the procession to the cemetery, where she took a photograph (right).

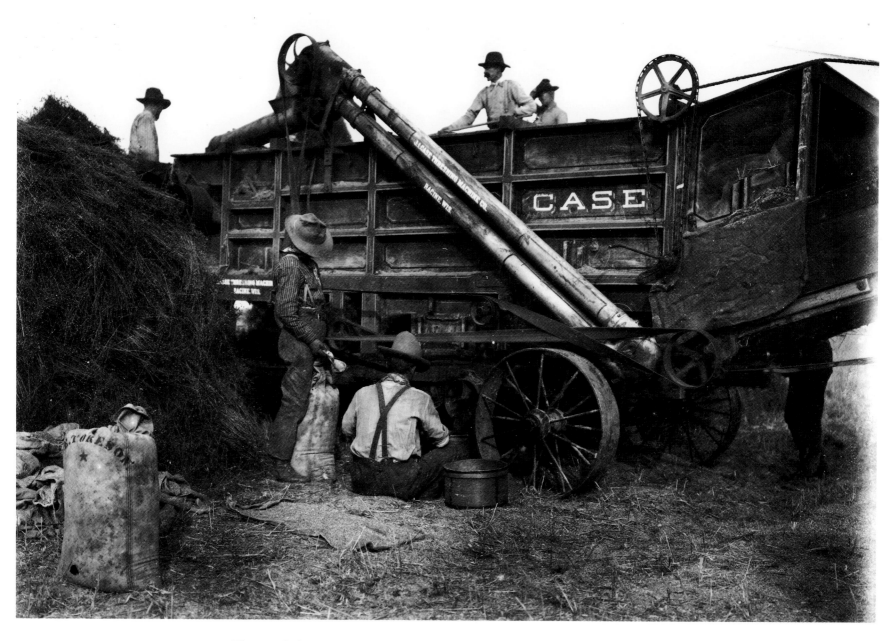

*The arrival of steam- and gasoline-powered engines on the Montana prairie helped
transform the area from a ranching to a homesteading farm culture. The open range was
doomed. Evelyn reported that a steam-driven plow broke up 46 acres of the Williams' land
in just two days. Hard, high-protein wheat was the primary crop of the new settlers, though
they also planted flax and oats. This Case threshing machine, which is separating grain
from its husk, was operated by itinerant crews who moved from farm to farm.*

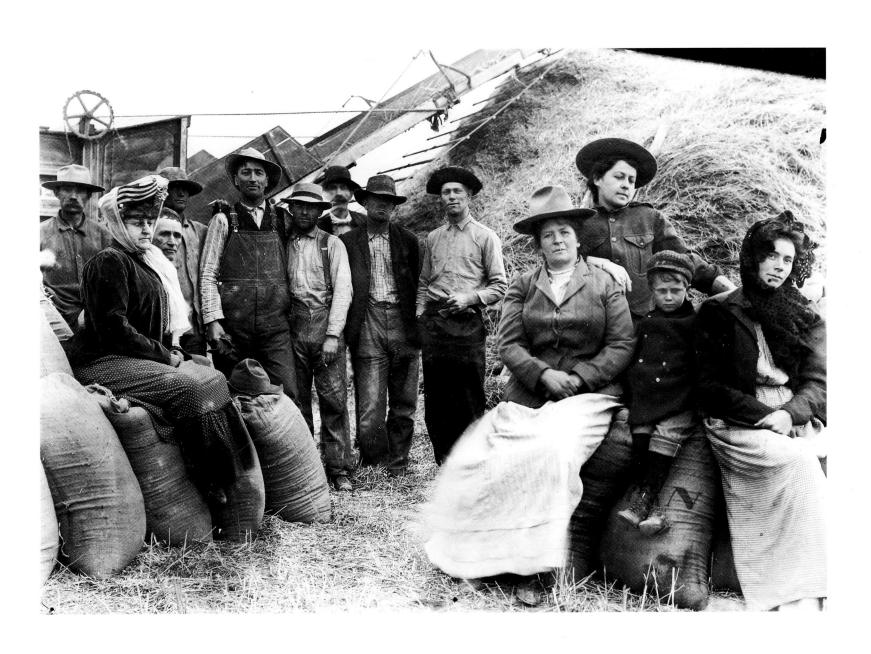

Many women seized the opportunity to lay claim to homesteads in eastern Montana. In this photograph a group has come to inspect the threshing of the Whaleys' crop by the team of men at center. The woman wearing an apron and cowboy hat is Mary Whaley, who homesteaded with her brother; the cowboy-hatted woman with her hand on Whaley's shoulder is another homesteader, Cap Barker. The woman in the fancy headgear at left is Mrs. J. D. Johnson, a neighboring rancher.

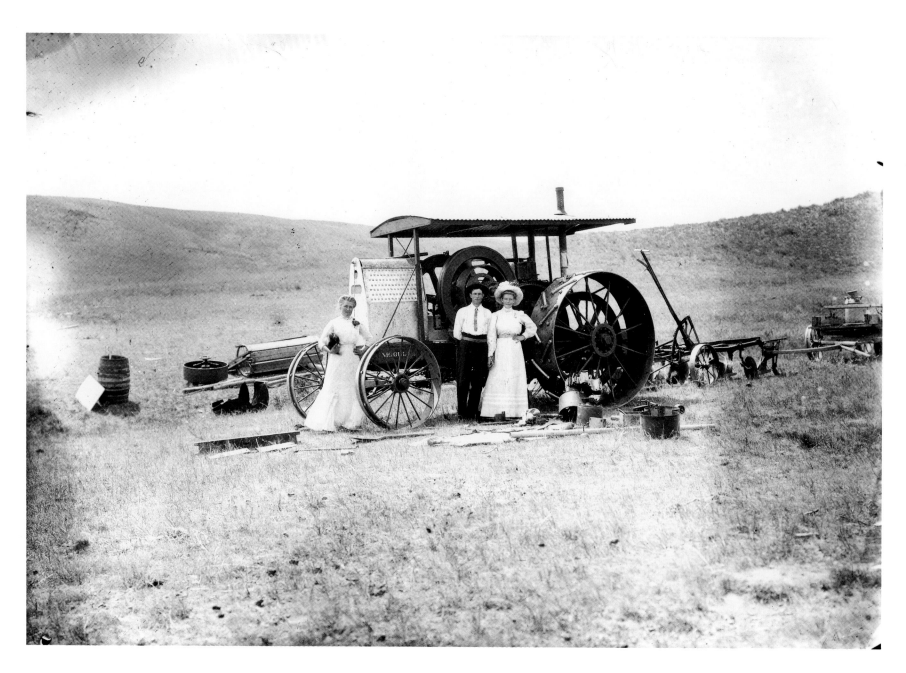

Unidentified farmers in their Sunday clothes, full of the optimism that characterized the early years of homesteading when rains fell in ample amounts in eastern Montana. In 1909, a farmer wrote that the prairies of Montana and Dakota were "destined to be the last and best grain garden of the world." The idyll did not last long. After World War I grain prices collapsed, plagues of locusts descended, and half the farmers in Montana lost their land. About 20,000 mortgages were foreclosed and 2 million acres went out of cultivation.

J. D. Johnson established a horse and cattle ranch on Spring Creek about 1896. By the time Evelyn took this picture of him in August 1913, his ranch had been completely surrounded by the homesteads of farmers, who fenced up the range. Johnson managed to coexist peacefully with his new neighbors—he hired farmers to build this barn, covered with galvanized sheeting—but gave up on Montana a few years later and moved to California.

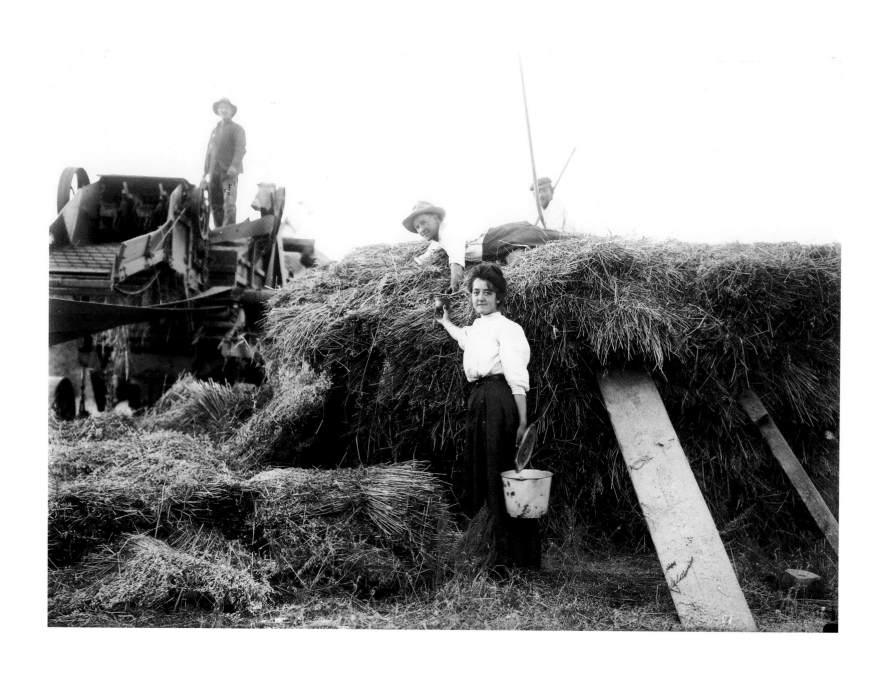

*Mabel Williams brings water to the threshing crew at work on her family's farm
in September 1909. A few years later the Williams family lost crops valued
at $2,000 in a single hailstorm.*

The tiny homestead of a farming couple. Hopeful farmers began to pour into arid eastern Montana early in the century—"their little cabins dot the prairie in every direction," as Evelyn wrote in a letter to a relative. New "dry-farming" techniques for conserving moisture were being introduced, but Evelyn held out little hope for their success: "The new settlers think that dry farming will pay but old timers shake their heads."

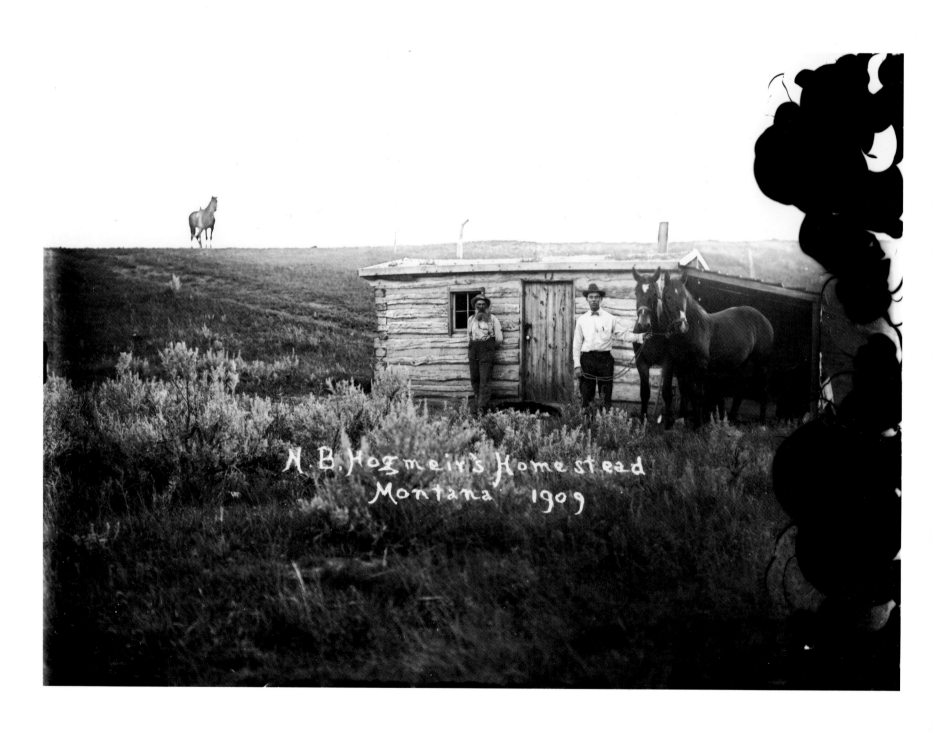

N. B. Hogmeir's Homestead
Montana 1909

Ned Hogmire holds a pair of horses as the patriarch of the family, Robert, leans against
Ned's 1909 homestead. The Hogmire clan had emigrated by train from Michigan
that year, in which the government doubled the size of homestead grants in
arid areas from 160 to 320 acres.

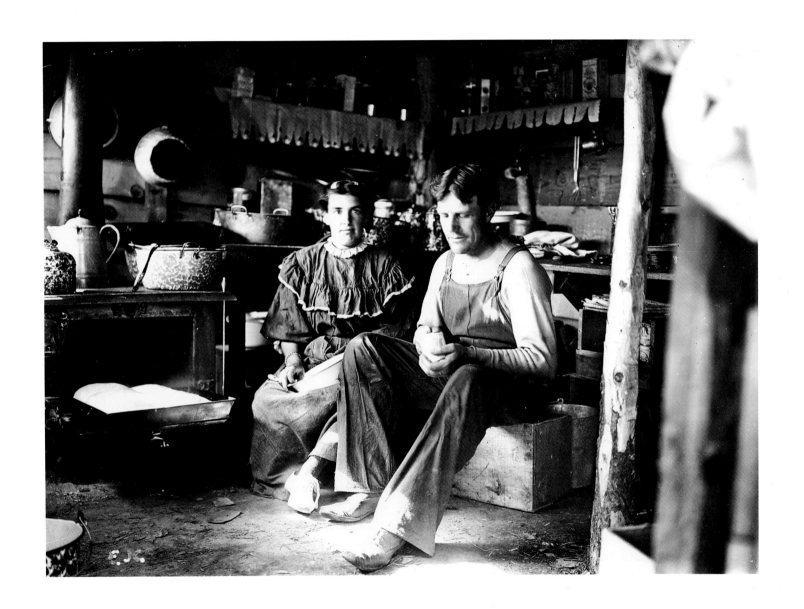

*The interior of a typical Montana homestead of the early 1900s, with a bare dirt floor and
log posts supporting the roof. A pan of bread rises in the oven.*

Another important focus of her work—one that spanned both the ranching and homesteading eras—was her fellow women pioneers, whose struggles and accomplishments were largely ignored by historians and photographers of the frontier West. In her photos women are seen riding, roping cattle, tending animals and gardens, cooking for sheep-shearers and farm crews, and working in the wheat fields—and her diaries make clear that women were not shielded from the rigors and dangers of ranching and farming. On November 22, 1914, she noted, for example, that Mrs. Ulrich was not up to being photographed because she had just lost the tops of three fingers in the threshing machine.

Evelyn took obvious pride in the robust life of the western woman, and was anxious to sing her praises. She wrote and illustrated an article for *Country Life* about Montana ranch women and their favorite pet in the 1890s, the antelope—an animal renowned for its timidity in the wilds and its ferocity in captivity. She herself had a pet antelope for a while, so she had first-hand knowledge of its nature; other ranch women kept as many as half a dozen at a time, sometimes selling them to passing travelers from the East.

The June 6, 1914, issue of *Country Life* contains another of Evelyn's articles, a tribute to the Montana cowgirl illustrated with vivid action shots of the Buckley sisters—Myrtle, May, and Mabel—roping cattle and horses. The Buckleys were just young women—the eldest was barely out of her teens—but they were known throughout the area as the "Red Yearlings" because of their manes of red-blond hair and their expertise as horsewomen. "All three sisters," Evelyn wrote, "may be said to have been born in the saddle, and are accomplished in the incidental work of branding cattle, breaking horses and throwing the lasso. . . . A book might be filled with their exploits and hair-breadth escapes when riding 'broncs.'" So famous did the Buckleys become that they were sought after by Wild West shows and asked to perform before Teddy Roosevelt, but, being shy by nature, they declined the honor.

Evelyn also provided photographs to other women who were writing about the West, among them her friend Kathleen Lindsay, who upon her return to Ireland wrote an article about Montana and asked Evelyn for illustrations. Similarly, Evelyn supplied photos to Marguerite Remington Charter, a British journalist who had visited the Eve Ranch and was inspired to write about her experiences. And she agreed to collaborate with an author of romantic fiction who had recently settled on a remote ranch in the area. The writer, Mrs. Charles McKay, had served as a music and art critic for the Boston *Advertiser* and the New York *Tribune* before arriving in Montana. Evelyn found her "very charming," and an accomplished singer and harmonium player; but she was hardly prepared for frontier life, being unaccustomed to either cooking or riding. ("She can only sit not ride!" Evelyn noted in her diary.) Nonetheless, in short order the newcomer had written a melodrama about ranch life, and on June 18, 1906, Evelyn wrote to her about illustrating it and placing it with a magazine:

> I received your story The Tragedy of -M ranch safely. Ewen & I think it is a very pretty & characteristic story of western life—in fact a breath from the plains. I will endeavour to get illustrations worthy of the theme this summer. The Terry dance I do not think would make a suitable picture as low ceilings & logs would be absent. I must depict a log house dance. . . .
>
> I am afraid it will hardly suit the paper that we wanted it for—"Country Life"—(England) on account of the extremely tragic nature of the end but of course we will do our very best with it.
>
> I will send you the photographs I think of sending with it when obtained, as you will like to see them.

By 1914, when her paean to the Buckley sisters appeared in *Country Life*, Evelyn had to admit that the role of the cowgirl on the range was being overshadowed by the hustling farm girl:

> Dry-farming . . . is developing a new phase of the woman on the ranch. The female members of the Russo-Germans

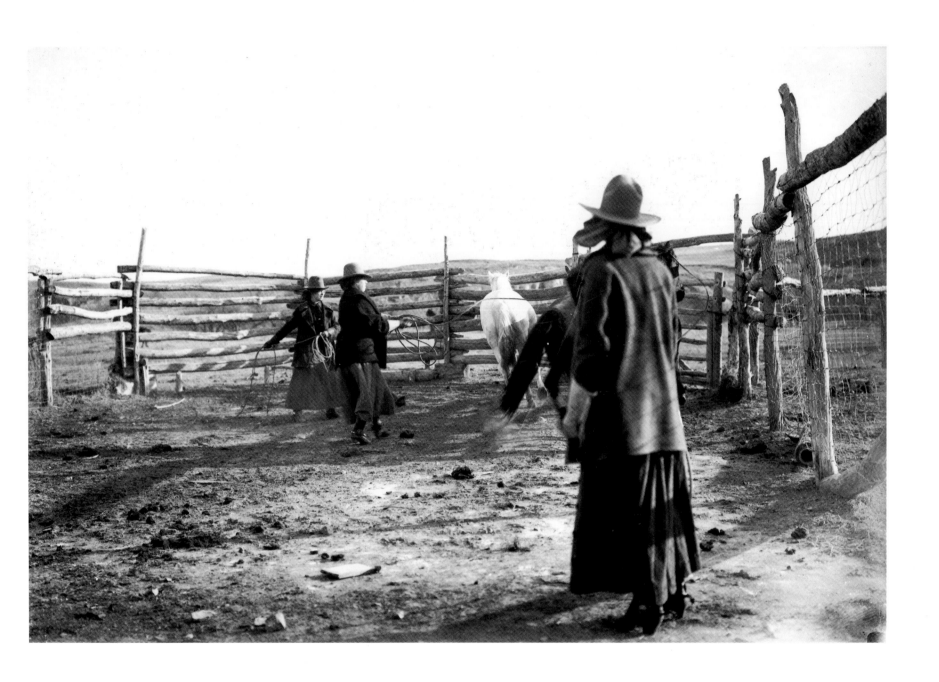

Evelyn climbed into the Buckley sisters' corral to take this photo, confident that the sisters,
experts with the lariat, could keep the horses from breaking away and trampling the camera.

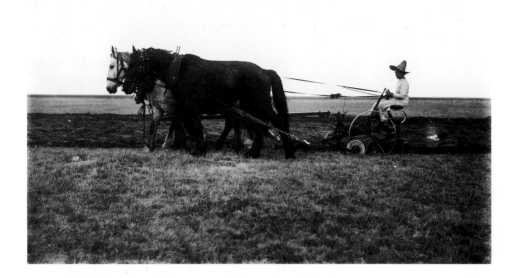

This young woman, whom Evelyn photographed plowing her field in 1912, was one of many German-Russian women who homesteaded in eastern Montana at that time. In an article for Country Life, *Evelyn said that these industrious farm women were supplanting cowgirls as the heroines of the West.*

who have swarmed over the prairie like ants take outdoor work even more seriously than the cowgirls whom they replace. Russo-German girls in their teens successfully perform every kind of farm labour, and may be seen ploughing from daylight to dark, sacking and hauling grain, haymaking, or driving up the cows on their great draught colts, ridden bareback.

Excited by this new breed of woman, she was anxious to immortalize her with her camera. "I am going to take a photo of the Reisler girl ploughing with four horses which I think will be of interest as showing how hard these Russian and German girls work," she wrote to a friend in 1912.

Evelyn could appreciate the achievements of the "Reisler girl" and others like her because she herself continued to do all her regular ranch work while taking on the additional tasks associated with professional photography. Neither the unceasing daily round of chores nor the primitive conditions

was any obstacle to her. She often worked until dawn developing her glass-plate negatives, and then picked up her other chores at daybreak, scarcely stopping for rest. Occasionally she admitted to fatigue, and it was bitterly disappointing for her to work all night developing negatives only to discover that the images were a total failure, something that often happened early in her photographic career. "Was tired from last night's employment & the result of my work is experience, nothing more," she wrote on one such occasion.

By day she printed her negatives, using the light source most readily available to the pioneer: the sun. She worked outdoors when she could. When winter arrived and it became "too snowy to print dehors," she exposed her negatives in the sunlight at the windowsill; the sun's reflection off the white snow actually speeded up the process—in her words, "made the prints hurry."

Evelyn did not have the equipment necessary to enlarge photographs so she made contact prints, the same size as the

negative, by laying the glass-plate negative over a sheet of sensitized "printing-out paper" in a wooden frame of her own construction that ensured tight, even contact. Having developed the print by leaving it in the sunlight until the image formed on the paper, she washed and "toned" it in gold chloride, which protected it from fading and gave it a beautiful hue, ranging from a warm sepia to a maroon color. She then fixed the print in a chemical solution that made the image insensitive to further exposure by light, washed it thoroughly in water, and let it dry. As a finishing touch, she burnished her prints to a high gloss and pasted them onto cardboard mounts.

The entire process, from developing the negative to producing a finished print, generally took several days to complete. (For one of her poorly exposed glass plates, she estimated that the printing alone would take twelve hours in the sun for all the photographic detail to emerge.) The total operation was difficult to master and physically taxing. "Work today made my back ache like mad, much worse than a day's washing," she complained after spending a December day in 1895 hunched over her negatives.

Montana's bitter winter weather made the printing procedure even more difficult, for the cold could interfere with the necessary chemical reactions. "Began to tone 11:50," she reported during a cold snap in 1897.

Prints refused to change the brown for the purple, thought the gold solution had lost its strength from continuous freezing. Threw it away, washed the bottle & made fresh. I put in a tremendous lot of gold S.S. altogether.

Thoroughly washing negatives and prints during frigid weather also posed a problem. Since a basin of water would freeze over, Evelyn used the outdoor pump:

At 11:30 took negatives to pump & gave them a good $^{1}/_{2}$ hour washing. Blizzard blowing tried to give 'em a wash by hand, but after 2 [negatives] my hand "like t'er froze."

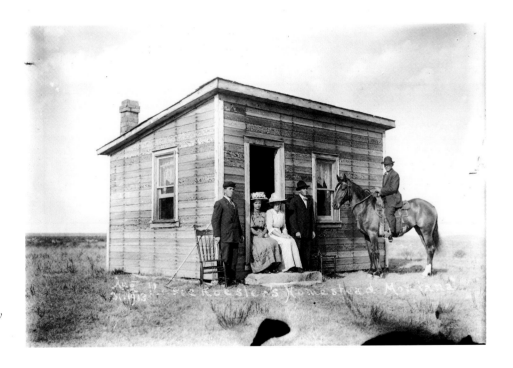

Another German-Russian woman, Rosie Roesler, built this homestead in the spring of 1912. After finishing the farm chores each day, Roesler walked six miles to the town of Marsh to earn extra money washing clothes and doing other housework.

Come warmer weather, she often used the watering trough to wash her negatives and prints, and then her work had to withstand—not always successfully—the assaults of thirsty livestock. Although she treated her exposed glass-plate negatives with great care, accidents were inevitable and some images were lost. "I have been doubly unfortunate having broken one of my ribs & also your negative—the last an irreparable fracture," she wrote apologetically to a local cowboy in 1910.

Evelyn experimented with a variety of printing papers. For exposing negatives in the sunlight, she used several different brands of "printing-out paper," including Aristotype, Karsak, and Solio. As early as 1896, she was also experimenting with "developing-out paper" that required only a few seconds of exposure to a strong artificial light source such as an oil lamp. Evelyn recorded that she worked with both Velox paper, the most popular brand of "gaslight" paper available, and bromide paper, about which she noted some reservations on June 15, 1896: "That bromide paper has to be handled so much that in consequence many abrasions appear on its surface & mars the beauty of the otherwise soft toned print." Though printing by artificial light was faster, Evelyn often found sunlight more reliable. On May 17, 1913, she was having no success with the supposedly easier "developing-out paper" and she complained in her diary: "Spoilt 8 pieces of paper as the lamp kept going down & [I] undertimed them."

On occasion Ewen helped Evelyn with the developing and printing, but they differed on the aesthetics of the photographic print. "He always likes to print his prints light," she wrote on December 21, 1895. "I like them darker. If he overprints altogether, he accuses me of being the cause."

Evelyn ordered all of her photographic paper, equipment, chemicals, glass plates, and film by mail. O. H. Peck in Minneapolis was her usual supplier, though she ordered from other sources as well, including Montgomery Ward. Throughout her career she used $5'' \times 7''$ glass plates or cut film; on rare occasions she used $3^{1}/_{4}'' \times 5^{1}/_{2}''$ plates; and she experimented briefly with $8'' \times 10''$ plates.

The glass plates Evelyn received—they arrived in boxes holding one dozen plates each—were coated at the factory and ready for use. Different types of negatives had different sensitivities to light, and therefore the length of the exposure had to be adjusted accordingly. From early on, she tried a wide range of glass plates. In the summer of 1895 she and her boarder, Colley, photographing each other outdoors, posed motionless for twenty-five seconds in the midst of swarming mosquitoes, a dramatic demonstration of the advantages of plates that required less time. She made one exterior view of the Eve Ranch with an exposure of forty seconds; she took other views of the ranch with different kinds of plates, exposing them for only two to three seconds. Because most of her photographs were made outdoors in bright sunlight, Evelyn generally used exposure times of a few seconds or fractions of a second. Her favorite brand of plates was Seed's Dry Plates from St. Louis (the company was eventually absorbed by Eastman Kodak). She also used Cramer's Dry Plates, likewise made in St. Louis (particularly the "Banner" plates they produced and advertised as being "Plates of great rapidity. Best for general use in Portrait Photography"); Lumière Dry Plates from New York; Eastman's Kodoid Plates; and Imperial Dry Plates manufactured in London.

Although she carefully maintained her Kodet camera—she oiled it, filled pinholes in the bellows with oil paint, and even fashioned a "press button" with a nail head and washer to drop the bed bearing the lens and shutter—the years of wear and tear took their toll. "I shall have to send my camera away to be renovated as it is so dilapidated from ten yrs. constant use," she wrote Hilda in 1904. "The perpetual carrying of a camera long distances on horseback is very hard on it."

Too hard up for cash at the time to buy a new camera, Evelyn was nevertheless well aware that her old one was outdated. Through magazines and her contacts with other

local photographers, she kept up with the latest developments in camera technology, and she knew, in particular, about the single-lens reflex cameras that had just been introduced. These cameras were a great leap forward: The photographer could now look down into a collapsible hood atop the camera and see the image on a ground glass. (The Kodet, in contrast, required Evelyn to focus in the rear of the camera under a dark cloth.) In addition, the new cameras had dramatically faster shutter speeds than Evelyn's earlier equipment, and she realized that added speed would be a boon to her photo sales. "When I can afford to invest in a 'Reflex' camera, something similar to Ross' twin lens camera," she told Hilda, "I shall be equipped to take bucking horses etc. & the photos would go like hot cakes. Times have been so dreadfully hard here however that I have not been able to save my earnings to buy one. I don't care to buy a cheap substitute but want to buy a good one or none."

For the time being she made do with her old model. She also experimented for a good part of 1905 with an 8″ × 10″ camera that she borrowed from a local photographer named Johnnie Breum, and she liked it well enough to inquire about prices. By late summer of 1905 when she finally bought her new camera, she opted for the Graflex, manufactured by Folmer & Schwing. The most advanced single-lens reflex camera of its day, it was the camera of choice for photojournalists. Evelyn's Graflex—which she referred to fondly in her diaries as "Lexie"—was designed for 5″ × 7″ plates or film and had a focal-plane shutter speed as fast as ¹/₁₀₀₀th of a second. Its lens was a German-made Goerz. Simple and versatile, the Graflex suited her needs perfectly, and it was her primary camera during the rest of her photographic career. Years later, when she was in the market for a camera that used smaller, postcard-sized film or plates, she considered buying a Voigtländer; instead she decided on another Graflex, this time the 3-A model that made 3¹/₄″ × 5¹/₂″ images.

Evelyn kept precise notes on the photographs she made, including the kind of plate she used, the length of the ex-

DIRECTIONS
FOR OPERATING THE
3-A GRAFLEX

FOLMER & SCHWING DIVISION
EASTMAN KODAK COMPANY
ROCHESTER, NEW YORK

The instruction booklet that came with Evelyn's 3-A Graflex camera that she bought in 1913 to make postcard-sized photographs.

posure, the aperture setting, and the light available, inscribing the information in her diaries, photo albums, and in a separate pocket-sized photo journal. In the spring of 1907, for example, she made several photographs at a one-room schoolhouse in Knowlton, Montana, and recorded the images as follows:

Two Exposures of Knowlton school children
2 ³/₄ seconds. 16 diaphram.
Seeds 26 [glass plate]. Sun in lens, shaded lens.
Fine result.

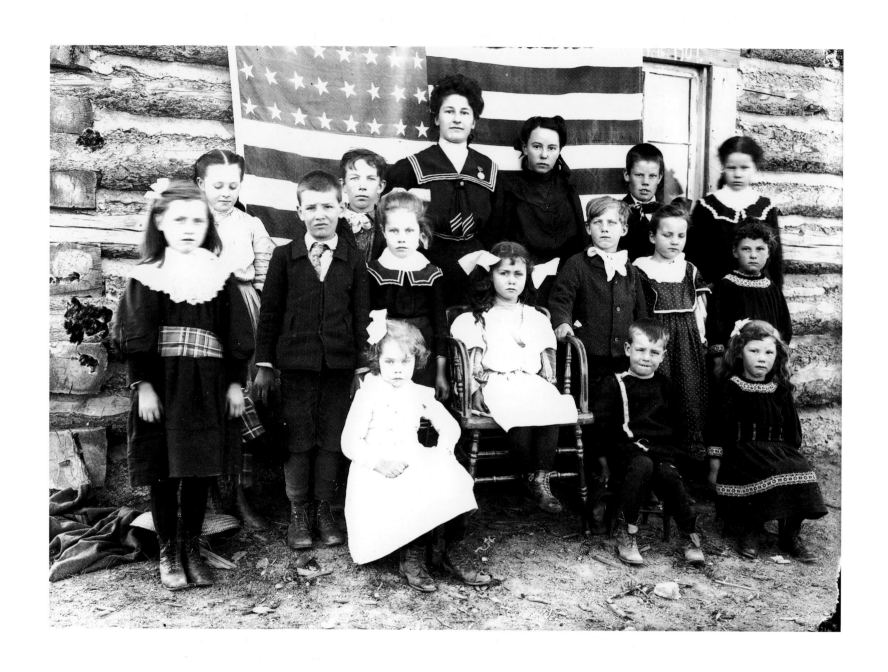

*In her diary on May 15, 1907, Evelyn reported that she had gone to photograph the
"scholars" in the very small town of Knowlton, 35 miles south of Terry. The teacher was
Clara Walters, probably the sister of Reno Walters, the sheepman and ferry operator in Terry.*

She had less success with the portrait she made of the school-teacher, Miss Walters. She posed the teacher at her desk inside the classroom and made a sixty-second exposure, which proved to be too long. The image was overexposed, she noted, adding that thirty seconds probably would have been right.

By keeping track of such details and weighing the results, Evelyn was constantly educating herself about the photographic process, and improving her images. Only after learning how to master the mechanical variables of her craft was she able to create the effects she desired. And she had definite ideas about what she wanted: her deceptively simple style belied the work that went into composing her images. For example, in a photograph made in 1905, she vividly captured the desolation and loneliness of the Northern Plains by her positioning of a band of sheep and their care-takers. The subjects are arranged in the middle of the frame with ample foreground and background to evoke the sense of endless space, and the way the sheep stretch from one side of the negative to the other reinforces the unremitting flatness of the distant horizon. Clustered in a slight dip in the land-scape where there are two small pools of water, the band of sheep appears to be the only sign of life on a frozen prairie flecked with snow. The sheep stare curiously at Evelyn. Standing forlornly behind them are the sheepherder and his dog, lonely silhouettes against the landscape. Chance played no role in the composition of this photograph; years later the sheepherder pictured, Jesse Trafton, vividly recalled how Evelyn had worked tirelessly to get the sheep in the precise arrangement she wanted.

Evelyn took many photographs of range sheep (an inher-ently boring subject) and turned them into something quite different. Some of these images seem scarcely about sheep at all, but about the shapes they create when massed together. At first glance one photograph looks like a quiet middle-distance shot of a small hillside on the prairie. Except for a few clumps of scrawny sagebrush in the foreground, the image is barren. No trees or human figures break the monot-ony of the landscape. On closer inspection, however, the hillside turns out to be teeming with sheep, giving shape—and life—to the land.

Evelyn approached many of her landscape photographs in the same way. Unlike the grand landscape artists of the American West, such as William Henry Jackson, Timothy O'Sullivan, and Carleton Watkins, who left behind an epic vision of an overpowering and awe-inspiring wilderness, she worked on a smaller, quieter scale. She wanted the viewer to grasp the unconventional beauty, even humor, of the bad-land buttes. Fascinated by the exotic shapes and textures of the gumbo hills, she sometimes focused in so tightly on the idiosyncratic formations that the images became studies of abstract forms.

One sign that Evelyn was aware of her role as a chronicler of her time and place is that she sometimes left her personal "signature" on her images. Her riderless horse is a frequent figure in the landscapes, serving as both an indication of scale and a reminder of the unseen presence of the photogra-pher. She also employed her shadow to great effect. One of her most compelling images is a side view of a roundup wagon being driven across the prairie just before sundown, with objects casting long shadows. Evelyn's own shadow—the unmistakable outline of a camera on a tripod, and the pith helmet that was her favorite headgear—falls across the lower-right foreground. She composed the image so carefully and subtly that the shadow is prominent but not intrusive; its angle reveals the photographer hovering at the very edge of the frame, knowing that she cannot step into the picture lest she ruin it, but determined to leave her mark.

Evelyn's entire life's work was only several thousand images—a total that today's professional photographer with the camera on motor drive might churn out in a single assignment—but within that relatively small body of work she was able to create a distinctive personal style. Her most successful images convey a sense of intimacy. This is espe-cially apparent in the portraits, in which she took a simple, direct approach to her subjects, capturing them in the midst

of work or play in their own milieu—on the open range or on their own ranches and farms. She strove for a natural, unposed effect, and despite the relatively long exposure time her large-format camera required, many of her photographs have a candid, spontaneous feel, and an energy and vitality not often evident in the images of other pioneer photographers.

In part because of the simplicity of her style, there is often a surprising edge to the formal portraits. Her camera is unwavering in capturing her subjects honestly. Evelyn knew them well—these were neighbors, not strangers, and her portraits of them are revealing. There is a powerful directness in her work, as well as a "modern" feeling achieved through composition and camera angle.

Evelyn took immense care in using all of the elements within the frame of a photograph to create a mood. She made many successful portraits of children, but her most startling one is of a serious-looking child of Eastern European extraction, presumably a boy, in high-buttoned leather shoes and a dark dress standing on a chair against a plain wooden wall. The child is positioned between two crude rows of nails that run vertically up and down the wall; the rough wooden planks are unpainted, and the grain of the wood gives a wonderfully tactile feel to the photograph.

The realism of the image is heightened even further by a grimy adult hand that holds the child's. Rather than the whole figure of the man—undoubtedly the child's father—Evelyn includes in her image only his arm and a sliver of his dark-suited body. By cropping the figure in this way she adds to the poignancy of the photograph, because it is then the adult's expressive hand, its fingernails caked with soil, that becomes the focus of the image; though callused and dirty, it touches gently the soft fingers of the child.

The meeting of the hands seems to tell its own moving story. The farmer's hard existence scratching a living from the recalcitrant soil and his desire to make a good life for his child are etched in his creased hand. The tenderness the rough pioneer feels for his son is apparent in the gentleness of the touch, while the child's tiny, soft-skinned hand captures his vulnerability and dependence on his father. Moreover, the viewer can almost sense that the father's difficult life will soon be inherited by his sober-faced son; it is almost possible to envision the same scene some twenty-five years hence, with the child, now grown to manhood, reaching out to touch his own child.

Evelyn's ability to generate powerful emotions in her images is also evident in her disconcerting, yet precise, photograph of an aging Ewen. It is a surreal image. One of the last photographs made of him, it serves as a kind of chilling death mask. The scene is inside their cabin, and the frame is cluttered with Ewen's most beloved possessions. The elements of the photograph are diverse and jarring, and at first glance it appears to be a montage rather than an image made from a single negative.

Ewen is in a corner of the room, where he appears to be surrounded—and overwhelmed—by his life's work. The bookshelves behind him are filled to overflowing with books, journals, and manuscripts. To his left, just above his shoulder, is a round clock, the hands frozen in time at 1:08. On the wall above the clock is a shadowy picture of railroad tracks running through a western setting. The feeling is claustrophobic: the walls seem to be closing in on Ewen, and the effect is heightened by Evelyn's decision to tilt the camera slightly up toward his face.

Directly in front of Ewen, and pinning him into his corner, is a magnificent stuffed trumpeter swan. The bird has been propped sideways on a chair that is draped in a white shroud. The swan's neck is elegantly curved and stands as erectly as Ewen behind it. Though Ewen stares directly at the camera, his eyes are as glassy and lifeless as the trumpeter swan's. He looks lined and gray, and his bushy mustache hides any expression. The collar of his shirt is loose, as if illness has caused him to lose weight; in fact, he was not well and would soon die. Evelyn would later write to his brother that it was Ewen's painstaking study of this trumpeter swan that killed him.

The Williams sisters joined Evelyn for this picture, which Evelyn used to advertise her photography business in 1910. The horse, Dolly, did not appreciate all the weight and kept turning her head to eye the three passengers.

The image is the perfect epitaph for Ewen—a somber, moody man who was hemmed in emotionally by his obsession with the birds of Montana. Using the day-to-day elements of Ewen's life in an unusual interior view, Evelyn has created a compelling psychological portrait that vividly captures her husband's melancholy, distant nature.

In her best work Evelyn combined her formidable documentary skills with a remarkable ability to create mood and capture nuances of character. Her images are fascinating: as social and historic documents of that time and place; as a visual record of the frontier as perceived by a woman and a British expatriate; and as a scientific catalogue of the birds and wildlife of eastern Montana. In addition, some of her images have a power that goes beyond the subject matter itself. The best rise into the realm of art.

Evelyn achieved neither fame nor fortune during her lifetime (nor did she seek it). However, she did receive the recognition of such pioneer photographers as Erwin Smith of Texas and L. A. Huffman of Miles City, Montana, both of whom bought her work. Huffman in particular was an admirer of her photographs. In May 1900, she received a letter from Huffman in which he said that he had been to New York "& seen many photos, professional and amateur, but none that pleased him better than mine. . . ."

What was intended to be a portrait of a child becomes an evocative portrait of father and son.

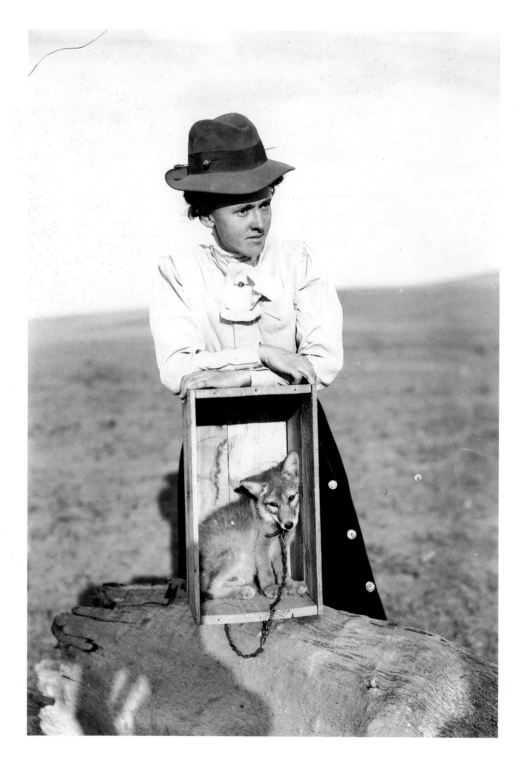

On a visit to the Hogmire farm in July 1911, Janet Williams posed with a young coyote the Hogmires had trapped. Evelyn described in her diary how the coyote "snapped & hung onto Janet's wrist." Evelyn forced the coyote to let go by pressing its lips against its teeth after gentler persuasion had failed: "blowing in ear no avail."

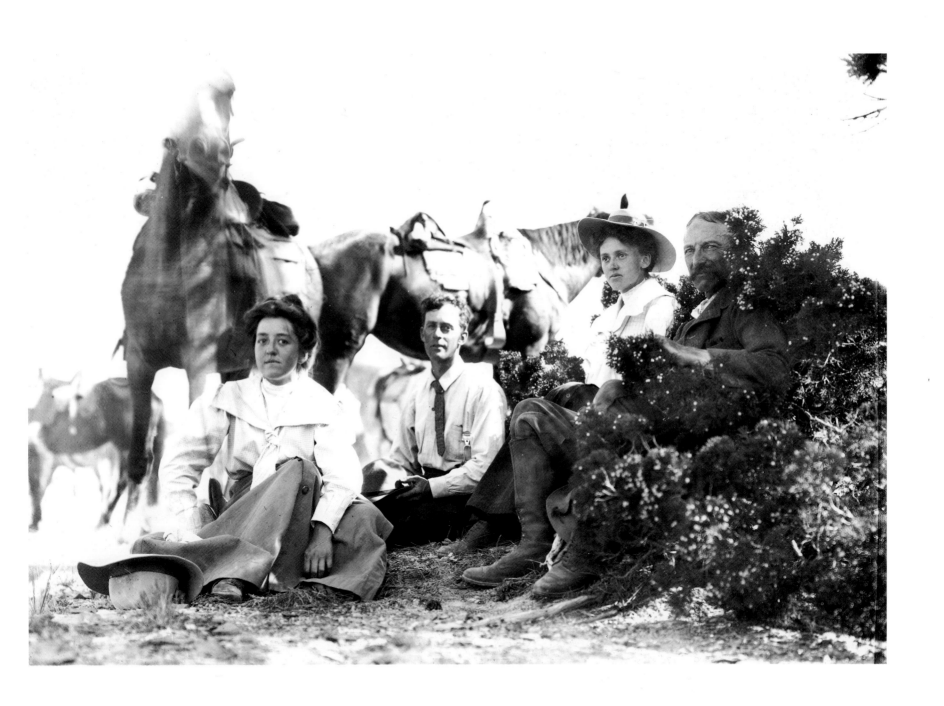

Evelyn often took portraits with her camera pointing up at a slight angle, and the results were sometimes unsettling. Here the horse looming up in the background, a ghostly blur of motion, appears to threaten the sedate group. Ewen sits on the right, accompanied by (left to right) Mabel, Roy, and Janet Williams.

On a "brilliant" July day in 1913, Evelyn rode out to a German picnic, where the entertainment consisted of sermons, hymn singing, and children reciting. The church picnic was attended by many German-Russians, ethnic Germans whose forebears had settled in Russia late in the eighteenth century at the invitation of Catherine the Great.

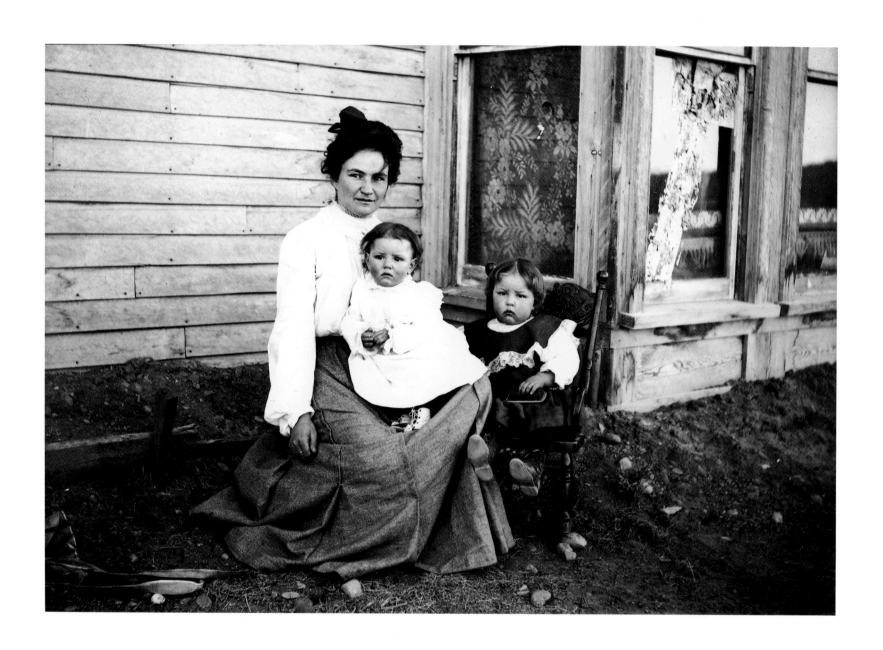

Unidentified mother and children.

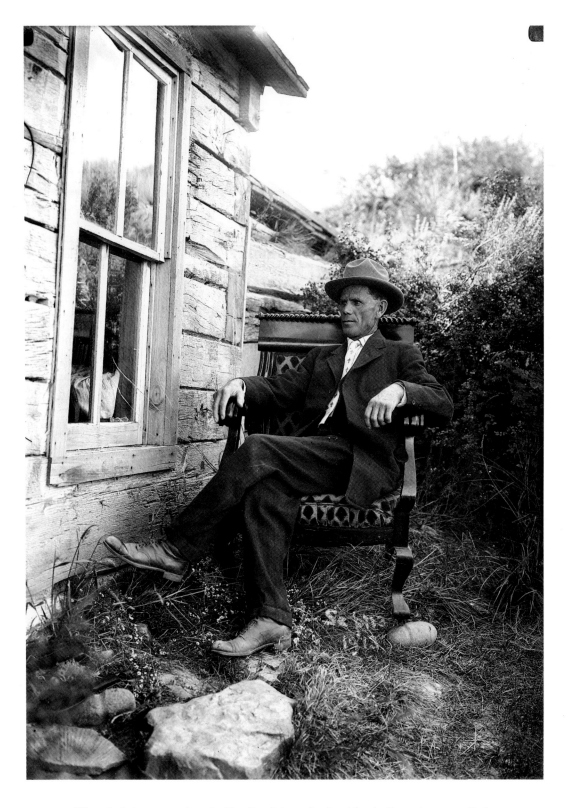

When Jack Rice arrived at the Eve Ranch just after breakfast in September 1913, Evelyn moved an armchair outside and had him turn toward the wall rather than toward her camera.

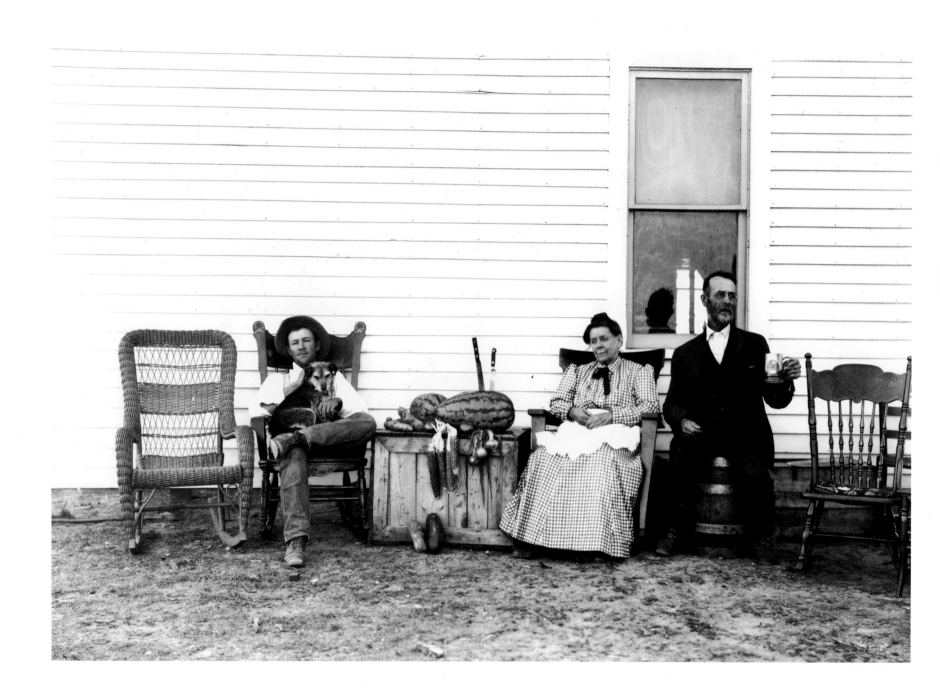

Unidentified family group.

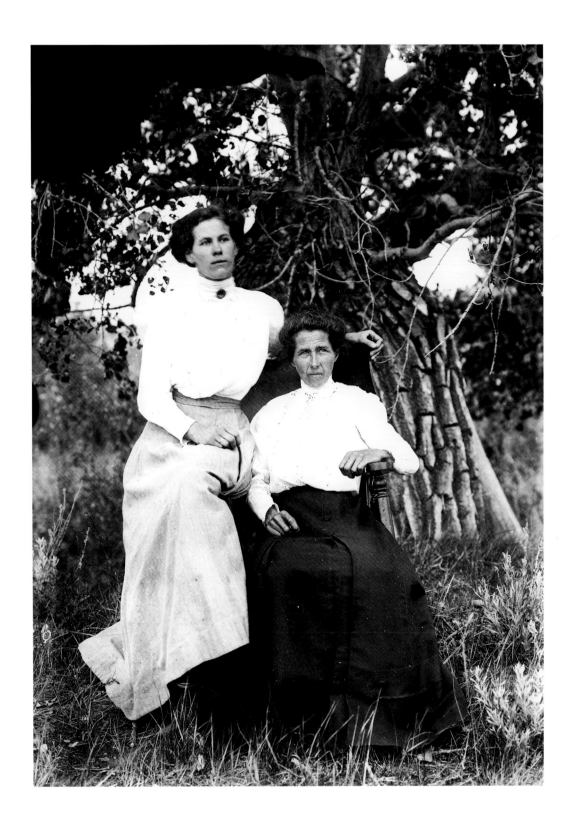

Unidentified mother and daughter.

This portrait was probably made in Terry on the Fourth of July or some
other patriotic occasion.

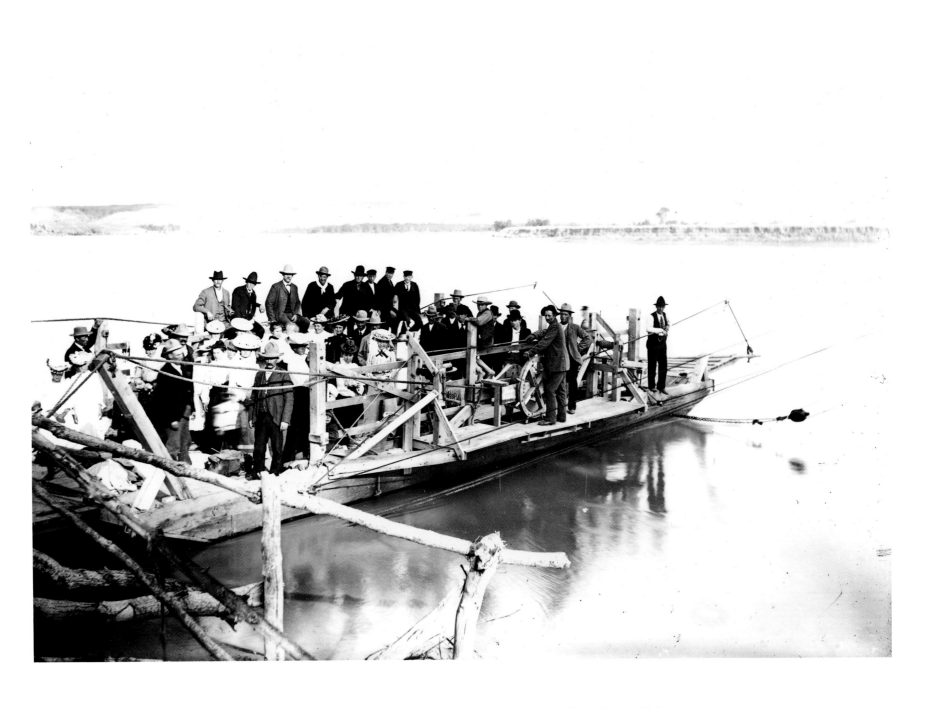

Whipple's ferry was used as a dance floor during the town of Fallon's Fourth of July celebration in 1903. That afternoon Evelyn took a friend for a ride in a rowboat, astonishing a pair of male onlookers who had declared that a woman couldn't row against the Yellowstone's stiff current.

Ewen and a mounted grey trumpeter swan taken on June 15, 1914, eleven months before
Ewen's death. These swans, which had once been common in Montana, had by 1914
become scarce. Ewen sent the results of his research about them to experts at the
Smithsonian Institution. Even mounted specimens of trumpeters were very rare—Ewen's was
one of about twenty in the world.

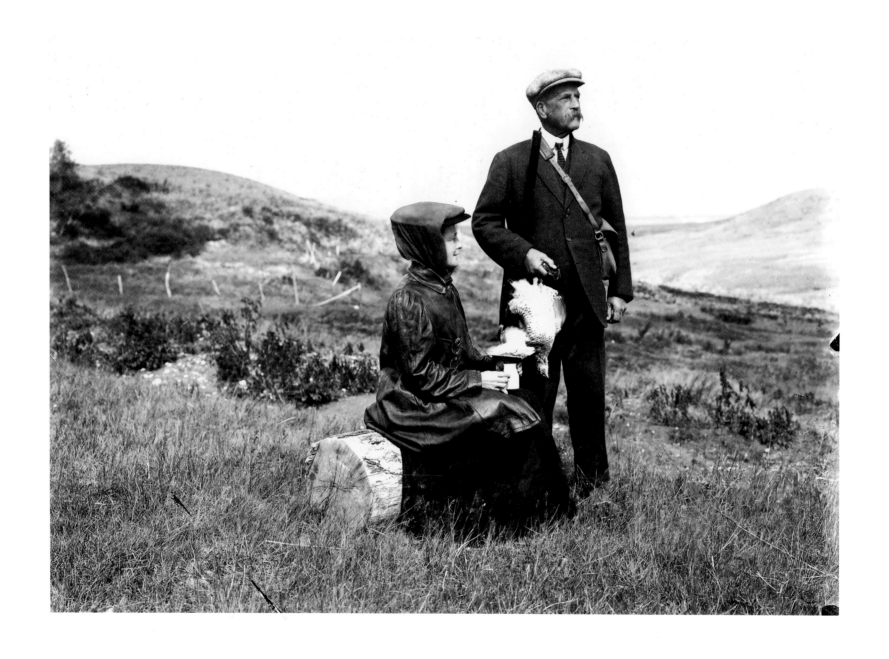

*Two of the most prominent Britons in eastern Montana were Effie and Philip Dowson,
a wealthy couple who frequently traveled to fashionable resorts. In 1904, Evelyn wrote
that Major Dowson was alone at his Montana ranch while "his wife travels about in
France and Italy painting. They meet in Italy this winter." The Dowsons had passed
a previous winter in Palm Beach, Florida.*

Miles City
and the British Colony

I N T H E L A T E nineteenth century eastern Montana was one of the odd outposts of wandering Britons. Some were fleeing troubled lives at home, some came in search of riches, and many, like the Camerons, came to hunt. Initially, the quarry was buffalo, and the most famous British hunter of them on the Northern Plains was Sir George Gore of Sligo, Ireland. In his mid-forties, with a hefty annual income, Gore launched a memorable hunting expedition from St. Louis in 1854. His retinue included over 40 employees, 112 horses, 18 oxen, 3 milk cows, 14 staghounds, 3 dozen greyhounds, 6 wagons, and 21 French carts, which were painted red. An entire wagon was required for his substantial arsenal—seventy-five rifles, about a dozen shotguns, and a large number of pistols—and his fishing gear filled two more. Among his employees were gunsmiths, a professional fishing-fly maker, and a taxidermist. "Roughing it," to Sir George, meant sleeping on a brass bedstead in a large, green-and-white striped linen tent, drinking ample quantities of wine with the magnificent meals prepared by his cooks, and after dinner reading Shakespeare aloud to his barely literate guide, the famed mountain man Jim Bridger.

Sir George and his party set up one of their camps near the present site of Miles City, Montana, where he continued his prodigious slaughter of animals. By his own estimate, on the entire hunt from the summer of 1854 to the spring of 1856, he killed "the enormous aggregate of forty grizzly bears, twenty-five hundred buffaloes, besides numerous elk, deer, antelope and other small game." While he was camped in eastern Montana, reports of his wanton slaughter of game stirred an official complaint from the local Indian agent—and attracted others to the rich hunting grounds there.

Some four decades later, the memory of Sir George lived on in local legend. And in his wake followed a small contingent of Anglo-Irish attracted by the opportunity and sport that eastern Montana offered. Among them was Walter Lindsay, a "well known gentleman steeplechase rider" whose name appeared regularly in the British sporting magazines of the day. Lindsay arrived in eastern Montana several years after the Camerons, and ran the Cross S Ranch on Mizpah Creek, about 40 miles southeast of Miles City—the same horse ranch that had been home to Captain E. Pennell

Elmhirst, the colorful expatriate who wrote *Fox-Hound, Forest, and Prairie.*

Lindsay's senior partner in the ranch was Major Philip S. Dowson, a middle-aged Englishman with a taste for adventure. He had lived and worked for nearly thirty years in Japan, running a foundry that employed one hundred men; he boasted that he had built Japan's first torpedo boat; and he spoke fluent Japanese. In the 1890s he sold out his business, returned to England, married his wife, Effie, and tried to settle into the life of a country gentleman. It was useless. Wanderlust took hold of him almost immediately, and brought him to Montana and the Cross S, which he and Lindsay turned into one of the largest horse ranches in Montana, running a herd of about 4,000.

Walter Lindsay's wife, Kathleen, who came to Montana from Britain in 1897 as a bride of twenty-one, was the compatriot of whom Evelyn was fondest. She especially admired Kathleen's nerve as a horsewoman, and wrote about it in an article for *Country Life* in 1914:

> [Kathleen] rode a great many "high strung," half-broken and nearly thoroughbred horses in the side-saddle she brought with her. Her husband . . . being a powerful man, could lift his wife right into the saddle from the ground with his arm passed through the English bridle reins, and if necessary the horse's eye was covered, as is usual here. Under her husband's careful tuition this girl showed quite remarkable ability and nerve with range horses, and upon her return was equally at home in the hunting field, as was proved by the appearance of her picture in a contemporary [magazine] among the six best lady riders of Ireland.

Evelyn must have been amused at the sight of Kathleen being gently lifted into her saddle by her husband—she herself certainly was never lifted into her saddle by Ewen (the reverse might have been more apt to happen).

Some of Evelyn's expatriate comrades did not fare as well as Kathleen Lindsay in facing the reality of frontier life. One such tormented soul was an Englishman named Gilliat.

Gilliat was an adventurer who had traveled to the remote corners of the world, but eastern Montana was the place that drove him nearly mad. He was the junior partner with J. H. Price in the Crown W horse ranch, and his duties there included being the cook. The Montana air did nothing for Gilliat's obstreperous personality or his congenital heart condition, which made him subject to "the flops"—fainting fits—that occurred "in summer or when overworked at any time."

Gilliat found neither fortune nor romance in the pine hills where the Crown W Ranch was located. Gilliat just wanted out almost as soon as he arrived. Evelyn described his plight in a letter to her mother-in-law on May 15, 1895:

> [Gilliat] is so disgusted with the life out here & for some time he has made unavailing efforts to rid himself of the half share he owns in the ranch. He invested about £5,000 but will take £3,000. He cannot get along at all well with his senior partner named Price, nor with his wife & 5 children who live in Norfolk. . . . He seems to be in a very unpleasant position, as there is not the remotest chance of anyone giving him £3,000 for his share.

In desperation Gilliat offered Ewen his share of the ranch for £200. Ewen declined, but Price eventually bought out his disgruntled partner. As for Gilliat, he announced that he was "going into holy orders" because there was "nothing else to do."

Florrie Ibbs was another British casualty of the Montana outback. She and her husband, a retired English officer who was an acquaintance of Lord Battersea, met the Camerons on the sea voyage from England to Canada in late 1901. Obviously enchanted by Evelyn and Ewen and their tales of life in the wilderness, they turned up unannounced at the Camerons' doorstep and proposed to join them in building a ranch on the North Side.

The fashion-conscious Florrie arrived with trunks full of magnificent clothing and jewelry; the Camerons were forced to hire a local woman as a maid to keep up with the ironing—

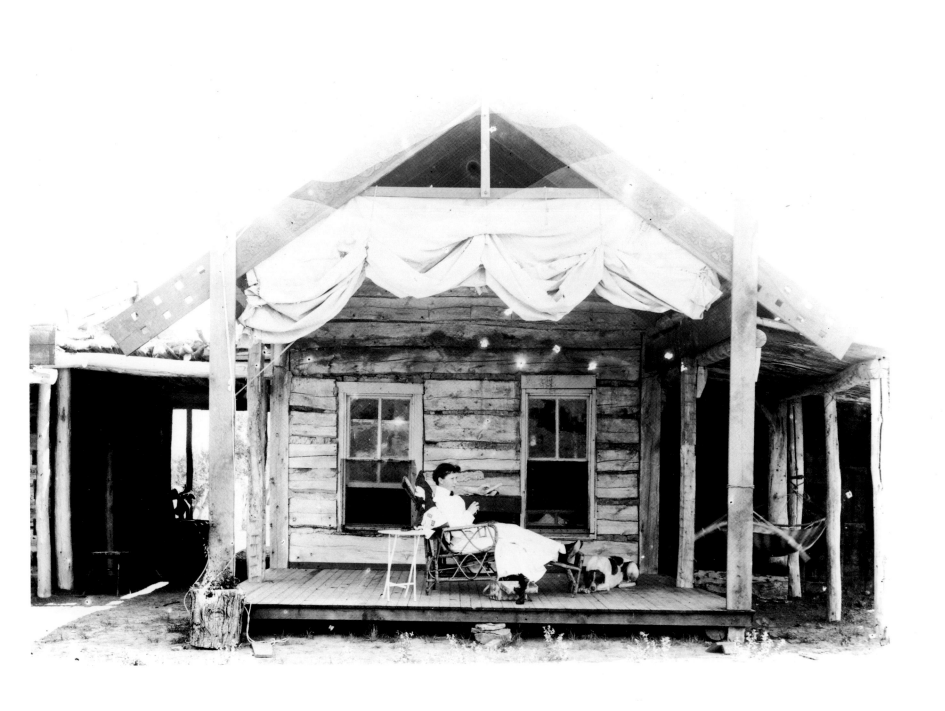

Effie Dowson at the Cross S Ranch in 1897. During Evelyn's visit Effie showed her the collection of shells she had gathered the previous year in New Zealand and Samoa.

her underwear alone took all morning to press. Word spread quickly about the newcomer's extravagant wardrobe, and one ranch woman came by anxious to try on Florrie's clothes. But if Florrie was the envy of the women in the area, she was aghast at the life they lived. Any romantic notions she might have harbored about life in Montana were put to rest on her first afternoon, when she joined Evelyn in scalding a bedstead that was teeming with bugs.

Florrie not only abhorred the dirt and privations of pioneer life, she was also horribly homesick, and although Evelyn assumed that "time will soften feelings in that quarter," her longing to return home only intensified.

> [Florrie] threatens every day . . . to leave & earn her living in London—as a barmaid! Will serve out drinks to beastly Londoners but won't cook for haymakers here!

After Florrie spent a good many days and nights weeping in her room, her husband finally relented and agreed to return to England. Dressed elegantly in black silk and cashmere with a thin gold chain ("altogether not suitable for travelling," according to Evelyn), and wrapped against the January chill in a sable cape and muff, she gleefully bid adieu to the wilderness and departed with her fifteen pieces of luggage in tow. The Ibbses had not lasted four months in Montana. In a grand understatement, Evelyn noted that Florrie was "too fond of finery for these parts."

The social center of British life in Montana was Miles City, a celebrated cowtown some 48 miles from the Camerons' first ranch, and the place where, since there was then no bank in Terry, all their business arrangements had to be made. Ewen visited the town frequently by himself in their early years, in his desperate attempt to straighten out their muddled finances. (As the years went by, their finances continued to show the workings of a perverse Fate: when the *Titanic* went down in 1912, she took to the bottom a check on its way to Ewen.)

For Evelyn, however, a trip to Miles City was a delightful if rare occasion, and she looked upon a stay there as a well-deserved vacation. "So glad to get off for a holiday," she wrote on August 7, 1895, a hot, bright morning when she and Ewen set out on horseback for the town. "Such events are not appreciated until one is hard worked." In Miles City there were no chores to be done, no meals to be cooked. If she pleased she could stay in her hotel room and read, while Ewen got "trimmed up by the barber." Or, she might buy a new hat, which she did that August when she treated herself to a confection of pink roses, black ribbons, and lace for the extravagant price of $4.50 at Miss Miner's shop. On that same visit she also indulged herself at the local saddlemaker by ordering a belt with the Eve Ranch brand () stamped on it.

Miles City provided the most up-to-date wonders and entertainments. It was at Professor Mark's saloon there that Evelyn heard a phonograph for the first time. She was transfixed for two hours. Miles City also meant being able to visit with and perhaps suffer through a "harangue on politics" from L. A. Huffman, the noted pioneer photographer who had a studio there. In 1895, Evelyn bought a photograph from him of the polo teams that had played in Miles City the previous fall; eventually Huffman would buy some of her prints and negatives.

The trip to town took nearly eleven hours on horseback, and in itself was a pleasant diversion for Evelyn, as it gave her the opportunity to visit the tiny outposts that had sprung up along the rail line. "Passed Blatchford, just section house & 2 log shacks," she reported in her diary.

> At Shirley section house stopped to get a drink. The water there is brought by the train once a week, the well being of "no account." A Swede woman [was the] only soul there, men all out at work.

It would be early evening by the time the Camerons reached town and stabled their horses at the livery operated by Charlie Brown, one of the area's most celebrated characters, who also ran a saloon. "Teddy Blue" Abbott, a cowboy

who frequented Miles City's watering holes, later recalled Charlie Brown's hospitality in his memoirs:

> There was a saloon man in Miles City named Charlie Brown. He had the Cottage Saloon and he kept a big bowl of Mulligan stew standing on the stove all the time, and he would say, "Just help yourself." If they wanted to, [cowboys] could take their blankets and bed down on the floor, and in the morning he would give them a free drink.

It was in this saloon—at a gambling table to be precise—that voting in Miles City's elections took place.

Mrs. Jordan, who ran the hotel in Terry, told Evelyn another story about Charlie Brown, or rather, about one of his pets:

> [Brown kept a] tame bear which was allowed to run about Miles City & one day it took [Mrs. Jordan's] daughter Lily out of the arms of her elder sister. The sister (Mrs. Beaugarde) got the baby back again, but the bear got it again. Then Mrs. Beaugarde screamed which attracted [the] attention of men who shot the bear to pieces.

From its inception, Miles City had never been noted as a genteel outpost of civilization. Located at the confluence of the Yellowstone and Tongue rivers, the city—originally called Milestown—had sprung up overnight in the fall of 1876 in the form of several saloons and a gambling hall near a new army post. Eventually called Fort Keough, the post was established by Colonel Nelson A. Miles in response to the stunning defeat of General George Custer at the Battle of the Little Big Horn the preceding June. In the 1880s, when the Northern Pacific Railroad reached Miles City, it became an important and colorful shipping post for livestock—a renowned "wide open" town that catered to the whims of the cowboy intent on blowing his pay and raising hell. A *New York Times* reporter described it in 1883:

> Cowboys with lariats hanging on their saddles are seen at every turn, riding on the stout little broncho ponies of the plains; rough looking men are loafing on the street corners; occasionally a "big Indian" with a squaw or two following him, stalks across the scene, and on each side of the street are innumerable places of low resort, in which the combined attraction of rum and gambling are openly advertised. These places are so numerous indeed, that they seem at first glance to constitute the chief industry of the town. At night they constitute a curious spectacle. Nearly all are large rooms opening on the street. The doors are kept wide open when the weather will permit and inside may be seen a motley crowd of men and women. On one side of the room is a long bar from which beer and whiskey are dispensed and about which there is always a crowd. Scattered about the room are three or four faro "lay-outs," with grim and intensely interested groups of players standing around them. . . . At some of the tables women act as dealers of the game and apparently they are regarded with the utmost respect by the rough men who are tempting fortune and wasting their hard earned savings.

The town swarmed with a volatile mix of rowdy soldiers, railroad workers, and lonesome sheepherders and cowboys. They were an incredibly thirsty bunch. In 1881, with a permanent population of 1,000, the town boasted 42 saloons. It was estimated that 1,000 bottles of beer were consumed a day there, and that 1,300 gallons of whiskey were sold each month.

Drink was not all that was sought after; female companionship was also a valued commodity, and the local madams made out very well. Mag Burns, who distributed engraved invitations to the formal opening of her parlor house, was remembered vividly by a Miles City bank clerk as being one of his most substantial customers; he made out a $50,000 certificate of deposit for her, the largest he ever handled.

Dance halls and brothels lined the streets of Miles City; yet when the gently bred Evelyn Cameron arrived in town in the summer of 1895, she caused quite a commotion. It is hard to believe that in such a setting Evelyn could ruffle any feathers. But she did. With typical understatement she noted

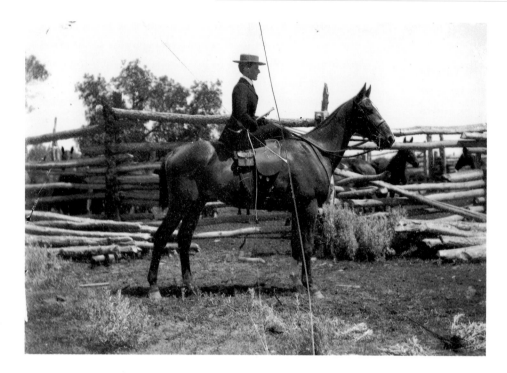

Kathleen Lindsay, an Irish expatriate and a close friend of Evelyn's, possessed "remarkable ability and nerve" as a horsewoman. Her equestrian feats were all the more remarkable considering that she insisted on riding in the conventional feminine manner on a sidesaddle.

in her diary entry for August 7: "My divided (dark blue) skirt attracted much attention." In an article she wrote some years later for *Country Life,* she recalled in more detail the "attention" she received when she rode down the street wearing the "California riding costume" that had cost her $100 from a Chicago firm.

> Although my costume was so full as to look like an ordinary walking dress when the wearer was on foot, it created a small sensation. So great at first was the prejudice against any divided garment in Montana that a warning was given me to abstain from riding on the streets of Miles City lest I might be arrested! After riding into town forty-eight miles from the ranch, I was much amused at the laughing and giggling girls who stood staring at my costume as I walked about.

Evelyn was concerned with neither fashion nor social convention. What mattered to her were practical considerations such as how best to negotiate the badland buttes that often required "mountaineering skill," how to perform her ranch chores on horseback most efficiently, and how to withstand the rigors of long rides (such as the trek to Miles City) over Montana's wild terrain. The divided skirt—or even a pair of Ewen's old trousers—served her purposes better than traditional riding attire. "I always ride stride-legged now & in a man's saddle & I am convinced it is the only safe way for a woman to ride," she wrote to her mother-in-law not long before she raised eyebrows in Miles City. "On long rides the physical exertion is so much less." As far as Evelyn was concerned, "side saddles are of little use in the West excepting on 'plumb gentle' horses," and she for one had no intention of being stuck with old "dead heads."

The other British ranch women did not all share Evelyn's disdain for convention. Kathleen Lindsay remained a devotee of the sidesaddle and full-skirted riding habits, and in 1897 she suffered the consequences. When her horse bucked her one day, Kathleen's skirt caught on the pommel of her saddle and her head was dragged down over the horse's side.

Evelyn introduced the divided skirt to Montana when it was inconceivable for a woman to wear pants and was threatened with arrest when she first wore a divided skirt in Miles City.

Fortunately she escaped serious injury; but upon learning of the mishap, Evelyn dashed off a note to her friend:

> I was so extremely sorry to hear of your accident on Dynamite, what a very narrow escape you had. What must your feelings have been when hanging onto the pommel by that fraud of a SAFETY skirt!!

Thanks to Evelyn's bold fashion initiative, the divided skirt in short order became the accepted mode of dress among Montana women—and a common sight on the streets of Miles City. At first, however, the local citizenry must have regarded her as just another of the eccentric English who lived in Miles City or flocked there from their scattered ranches. One of her fellow countrymen, the well-known Oliver Henry Wallop, who raised horses in eastern Montana and Wyoming and eventually fell heir to the title of the Earl of Portsmouth, was noted for his slovenly attire. When chided by a ranch wife for his careless manner of dressing, he stated that he was relieved to be in a country where he did not have to be as concerned about his appearance as he was in England.

Removed from the rigid mores of late Victorian England, some of the British expatriates became noted for their outlandish behavior. A group of British "remittance men" found Sam Pepper's Miles City saloon a most congenial setting. One of this group, Sidney Paget, was a great admirer of the courtesan Connie Hoffman—so much so, in fact, that she accompanied him on a visit to England. "Syd" Paget was a "genuine all-around sport" noted for his fondness for horse racing and his ability to outstrip his allowance, no matter how large it was. But though funds from home could always be counted on to bail him out of difficulties, his largesse when it came to Connie Hoffman became a source of public outrage. A woman pioneer from West Virginia, Nannie Alderson, recalled Paget's shocking behavior in her memoirs:

> There was a wealthy Englishman, among several such around Miles City at that time, whose brother later came into a title; and this man set her up in an establishment of her own with horses, carriage, everything, and was seen with her everywhere. She would even appear at the races—for the town boasted a race track in those days—dressed in his cream and scarlet colors. It was a most brazen performance, and scandalized even Miles City.

Before Connie Hoffman began her notorious liaison with Syd Paget, the striking brunette had been "kept" by a wealthy stockman at the Macqueen House in Miles City. When the courtly southerner Major Macqueen, proprietor of the hotel, discovered the unsavory occupation of his guest, however, he promptly asked Connie to leave the premises along with her provider. After all, the rambling frame Macqueen House was a respectable haven for cattlemen, not a brothel. It was, in fact, a legendary social center for the stockmen: wealthy ranch owners wintered there; cattlemen awaiting the arrival of their herds being trailed from Texas congregated at the hotel and played billiards; and the grandest social event in eastern Montana, the annual ball of the Montana Stockgrowers Association, was held there each spring.

The Montana Stockgrowers Association had been formed in Miles City in 1885, when separate groups representing the interests of eastern and western Montana cattlemen merged. It was a powerful political and economic organization, and when the cattlemen arrived for their annual meetings the Macqueen House was filled to capacity. During one of these three-day conventions even Theodore Roosevelt had to share his bed with a stranger.

The jam-packed accommodations did not dim Roosevelt's enthusiasm for Miles City, however, and he wrote breathlessly about the place in his book *Ranch Life in the Far West:*

> A true "cow town" is worth seeing,—such a one as Miles City, for instance, especially at the time of the annual meeting of the great Montana Stock-raisers' Association. Then the whole place is full to overflowing, the importance of the meeting and the fun of the attendant frolics, es-

pecially the horse-races, drawing from the surrounding ranch country many hundreds of men of every degree, from the rich stock-owner worth his millions to the ordinary cowboy who works for forty dollars a month. It would be impossible to imagine a more typically American assemblage. . . .

Despite Roosevelt's nationalistic claim, the Macqueen House was also a favorite haunt of the British, and the menu of the hotel's restaurant reflected their patronage—Christmas dinner in 1888 included loin of beef with Yorkshire pudding. Expatriate ranchers settling into the area used the hotel as a jumping-off point. The Camerons always stayed at the Macqueen House when they were in Miles City, and collected mail there. They also stored some of their belongings at the hotel for safekeeping, though it did not turn out to be the safest repository.

Miles City was subject to severe flooding every year: as the spring thaw set in, huge chunks of ice often jammed a bend in the Tongue River near the town, causing massive overflows. In the spring of 1881 rowboats were reportedly used to navigate the watery streets. The waters rose again in 1884, forcing Nannie Alderson, in town that spring awaiting the birth of her first child, to evacuate the house where she was staying and move temporarily to the Macqueen House, which stood on higher ground. In her memoirs Nannie recalled that "after the gorge broke or was blown up . . . great chunks of ice lay on Main Street for weeks."

Nannie was safe from the flood waters at the Macqueen House; ten years later the Camerons' possessions were not so fortunate. In March 1894 Ewen returned from Miles City with a soggy wagon load.

He brought 2 boxes from McQueen cellar. The McQueen cellars are flooded with water from the rising river. [I] took everything out & hung it up to dry.

For several of the Camerons' Irish and English friends, storing valuables at the Macqueen House proved to be even more disastrous. In the fall of 1897 the wooden structure went up in flames, and with it, all of Mrs. Ferdon's London gowns. Evelyn wrote to console her friend:

I was hoping when I saw your name amongst those who had lost trunks at the Macqueen House that there was nothing of value in it. What a dreadful pity it contained all your English things. I am extremely sorry, so much time & trouble lost besides the financial outlay. The Lindsays lost a trunk also. I wonder whether any of Kathleen's trousseaux was in it!

During its heyday the Macqueen was considered an oasis of civility—at least in relation to the rest of honky-tonk Miles City—and indeed Nannie Alderson thought it "homey enough in one way." But, she went on,

it was a poorly built, wooden structure; and as the only bath was off the barber shop, I had to bathe in the wash basin. . . . The walls were so thin that you could hear every sound from one end to the other, with the result that I overheard several masculine conversations which both fascinated and embarrassed me.

The flimsy walls also made for drafty rooms, and the only heat was supplied by a small stove in each room that had to be tended by the occupant. In 1893 Ewen had to make several winter trips to Miles City, which naturally meant staying at the Macqueen House, and Evelyn, left behind at the ranch, fretted about his catching a chill. She must have been little comforted when he wrote: "At time of writing 6 p.m. [January] 31st, it was 40 degrees below 0 & it is expected the spirit will drop to 50 degrees below 0."

Visits to the Macqueen House might result in a cold, but they also yielded news of the British community. In that same letter Ewen reported that Mr. Walsh's new wife "is not a woman of good repute, she was connected with Mr. Paget & others." Walsh had previously written to the Camerons announcing the nuptials and stating that "being of a roving

nature he doesn't intend that this should tie him down."

Many of the British in Montana were involved in raising fine horses, and Miles City became one of the largest and most important horse markets in the West. The Custer County Horse Sales and Fair Association was organized there in 1890 and attracted Britons interested in buying and selling horses. In part to show off their stock and to flaunt their equestrian skill—but mostly for the sheer sport of it— the expatriates also flocked to the annual fall horse races held in Miles City. By late summer they were gearing up for the September competition: in August 1896 Evelyn and Ewen spent several weeks visiting their compatriots—Mr. Price at his Crown W Ranch, and the Lindsays at the Cross S—and at both places they found race courses set up and a daily regimen of practice. In her diary Evelyn reported that at the Crown W the men were "training for hurdle races in Miles. . . . Messrs Price and Digby take their racing steeds round their course every morning before breakfast."

At the Cross S Evelyn took part in some of the practice runs herself. She summed up the day's activities for August 18 this way: "Branding. Photographing. Riding. Jumping. Racing." During their stay Evelyn and Ewen raced each other around the flat course, Evelyn beating her husband "by a neck." They also watched intently as Lindsay practiced on Avona, the horse on which he had won the two-mile steeplechase the year before in Miles City.

Evelyn and Ewen had spent a week in Miles City the previous September attending the horse races, and they had witnessed Lindsay's stirring victory. They had also won some money. Before the big race began, the British had gotten together a "Sweepsteak." For one dollar a chance, each entrant drew a slip of paper that was either blank or had the name of a horse running in the two-mile steeplechase. Ewen drew Avona and hit the jackpot. It was an "awfully close and exciting race," Evelyn wrote. After deducting his losses for the two previous days of races, Ewen cleared seventeen dollars, and he and Evelyn celebrated that evening at post-race festivities at the Macqueen House:

Had musical box up. And drinks. An inebriate named Ross played dance music. Mr. Madoc [Jones] up & sang us a song in which his memory failed him. After sup called on Mrs. Malone. Sat on balcony, drank a peppermint liquer. Danced waltz and polka.

The week's stay in Miles City was a whirl of social activities, with evenings spent visiting and singing on the verandah of the Macqueen House with their British friends. Mr. Walsh played the piano and Mr. Ferdon, Evelyn noted, was a "splendid whistler."

During the day the Camerons made the rounds of the Miles City merchants, and since they were seventeen dollars richer from the horse races, they splurged on some ranch furnishings:

Bought 2 white enamel wash basins at Ryan's, a coffee mill also. To McIntire's, got window curtain for all our windows at ranch, brass rods, slippers also—$8.90 bill.

Not all of the British were so lucky. Madoc Jones, the ex-lawyer who worked at the Crown W Ranch for Price and Gilliat, never paid his hotel bill. Evelyn noted in her diary that upon leaving the hostelry Jones had the misfortune to run right into the manager of the Macqueen House on Main Street. When confronted, "Mr. Jones had the gas to say 'Oh, Gilliat will be good for that!' Nearly every business man down Main Street has got a worthless cheque of Jones', Mr. Gilliat says." Jones's behavior was not unusual. Several of the "remittance men" who hung around Miles City were as noted for their rubber checks as for their conviviality—but, as with Paget, their improvidence could be winked at because funds from home invariably rescued them.

There were other misunderstandings between the British and the locals. Evelyn reported on one of these, as recounted to her by Walter Lindsay:

He & Mr. Walsh were watering a bunch of horses at the ditch when an old lady drove up & began vociferously to censure Mr. Lindsay, saying the ditches' bank would get

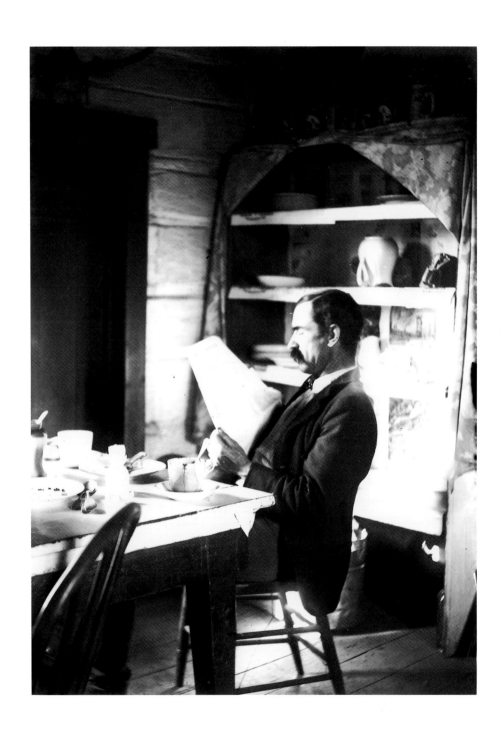

J. H. Price, a horse rancher, was one of the stalwarts of the British community then living in Montana. He organized a polo team, which Ewen was invited to join. Evelyn photographed Price in October 1902 having his breakfast of an egg and coffee (from a cracked cup). The 17-second exposure was illuminated by sunlight through a window.

trodden down. Mr. Lindsay replied "I am awfully sorry, I will get a spade & repair any damage." She roared back he wasn't a gentleman etc. & went off in a great rage. This Mr. Lindsay couldn't understand as he had been most polite. He sent Mr. Walsh after her to pacify her. She stopt & after some parlay it turned out that she thought "he had called her an old jade." She wouldn't give in but said Mr. Walsh was very polite, but not the other.

In general, however, the citizens of Miles City welcomed the colorful and well-bred British ranchers, and during the racing season the expatriates were honored guests at the homes of some of the most prominent residents. Invitations were issued at the Macqueen House, where all of the out-of-towners were staying. The day after the 1895 races ended, for example, a Mrs. W. L. Avery sent her formal calling card to Mrs. Cameron. Evelyn came out to meet her in the hotel's sitting room, and then accepted her invitation to spend the evening at her house. It was a "very pleasant evening," highlighted by a toffee pull: "We pulled sort of toffee till it became very light colour, [then] plaited it. When cold [it was] hard & crisp."

The only disappointment was that the creator of the candy, Mrs. Avery's sister, had "made herself quite ill" while cooking the confection and "couldn't come down, headache so bad." The stricken sister was well enough to see the Camerons off at the railroad depot the next day, and to give Evelyn some homemade candy for the journey home. This was Fannie McElrath, the same young woman, serving as governess to her two young nephews, who would soon be writing to Evelyn in such despairing fashion.

Fannie McElrath and her sister Bessie Avery were members of one of the founding families of Miles City. Their father, Thomson P. McElrath, had been a major in the United States Army who was posted at Fort Keogh in 1876. Weaned on the newspaper business—his father had been at one time a part owner and publisher with Horace Greeley of the New York *Tribune*—Major McElrath had served as a

correspondent for *The New York Times* covering the sensational 1879 murder trial in Miles City of a trio of Cheyenne who attacked and killed a soldier.

The trial was noteworthy on several counts. As it was deemed to be a civil rather than a military case, it was tried at the first territorial court ever held in eastern Montana. Not surprisingly, the three warriors were convicted of murder and sentenced to be executed in a month's time. However, the Indians' sense of honor dictated a different outcome. McElrath wrote about the tragic postscript to the trial in a long letter to the *Times* dated June 8, 1879:

> The jail facilities are limited at this place, and short shrift was given them, the seventh of July being appointed for their execution. Two of the condemned Cheyennes, however, rejected even this period of life, and were found dead in their cell on the following morning. They had sought death in a cool and deliberate manner, so unparalleled as to provoke the admiration of even their white foes. Although handcuffed, and chained by the ankles to a bull-ring in the floor, they had succeeded in hanging themselves by a belt strap to an iron bar in the aperture of the cell door. The same strap was used by both, one waiting until the other was dead, and then lifting down the corpse, deliberately removing the strap and adjusting it for his own hanging. [Not long thereafter the third warrior strangled himself with the cord from his moccasins.]

Major McElrath saw the potential for growth—and for money to be made—in Miles City when the Northern Pacific Railroad arrived; no sooner had he finished filing his reports to the *Times* than he launched his own newspaper, the *Yellowstone Journal*, in the summer of 1879, vowing to "record the growth and progress of the new country." It was the first newspaper in all of eastern Montana Territory, and T. P. McElrath did his best to sing the praises of Miles City and its environs. He also wrote an exhaustive guide to the region entitled *The Yellowstone Valley: A Hand-Book for Tourists and Settlers* that was published by the Pioneer Press in 1880.

The book was a masterpiece of promotion. According to McElrath, the Montana grasses provided the "best grazing country in the world"; the railroad was about to link Miles City with eastern markets and unleash an unparalleled wave of prosperity; and Miles City was an "orderly place in which riotous demonstrations are promptly and inflexibly repressed," where "even the wanton discharge of firearms in the streets is a punishable offence."

Puffing the richness of the land and the gentleness of its settlers was a common ploy to attract land seekers and thereby increase property values. McElrath had no small interest in that end, as an advertisement he ran in his own newspaper in 1880 shows:

REAL ESTATE
T. P. McElrath, Attorney
and Counsellor at Law
Miles City, Mt.
Land business a specialty
All kinds of land scrip bought & sold
Titles explained
Patents secured
Claims surveyed and mapped
Railroad lands
Particular attention given to SOLDIERS' HOMESTEADS

McElrath's two charming daughters were at the center of Miles City's social life in the mid-1890s. They lent an element of sophistication and culture to the rough-and-tumble town, and Fannie McElrath, in particular, socialized with the expatriate set. In the fall of 1896, when Walter Lindsay was building new rooms at the Cross S for himself and his bride-to-be, all of his British friends came to help him out. Evelyn worked tirelessly on the finishing touches: rubbing oil into the wooden doors, window frames, mantelpiece, and fireplace rails; scraping paint from the windows; tacking up a denim cloth wall covering; hanging pictures; and nailing flouncing around Lindsay's sofa. Fannie McElrath, who numbered herself among his close friends, pitched in as well.

She embroidered his initials onto the mattress cover of his sofa and made a curtain out of his old ties that Evelyn declared "very pretty."

The following summer Evelyn and Fannie McElrath were both guests of the Lindsays at the Cross S. Although they only spent some five days together Evelyn made an enormously favorable impression on Fannie, and they struck up a friendship. Evelyn photographed the young American woman on horseback and later sent her a print of it. Fannie, for her part, turned to Evelyn as a confidante. Not long afterward, Fannie's career as a governess came to an abrupt end when her brother-in-law was appointed U.S. consul to British Honduras and moved his family there in early 1898. She lived for a time alone in a house on the outskirts of Miles City, but eventually moved to New York and fictionalized her western experiences in a sentimental tragedy entitled *The Rustler* that was published in 1902. In it the heroine, Hazel, whose relations include members of the titled British aristocracy and who moves easily in sophisticated New York social circles, visits her cousin's cattle ranch and finds that she prefers the "forsaken-looking Montana prairie, poking about the hills on a horse, to going to Newport." Hazel decides to remain in the West, working as a governess to two children, and falls in love with a humble but heroic cowboy. Their ill-fated romance is played out against the backdrop of the eastern Montana ranching scene, where upper-crust ranchers work side by side with gritty cowhands.

Although Fannie had never ranched in Montana, her visits to the British-run ranches near Miles City undoubtedly provided the raw material for her pulp fiction. And her heroine's independent spirit and zest for the outdoor life were probably inspired by the ranch woman whom Fannie so fiercely admired: Evelyn Cameron.

The transplanted Britons were always anxious for news from home, and the mail brought them an ample supply of fresh society gossip, as well as an assortment of English magazines. The Camerons kept abreast of the British social and

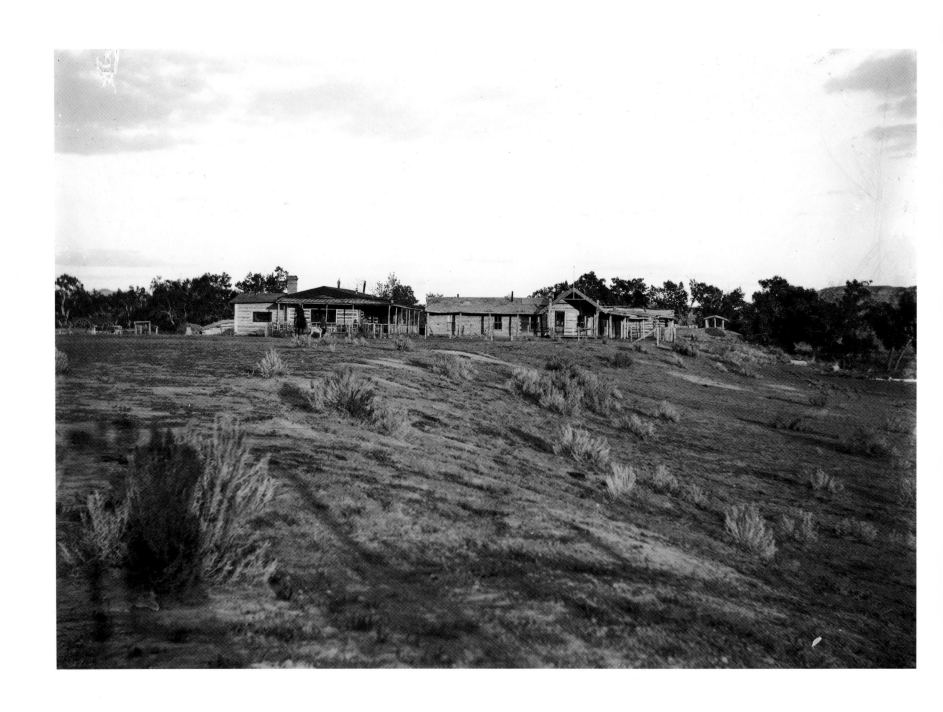

The Cross S Ranch, photographed at sunset in September 1902 with a minute-and-a-half exposure. During her visit with the Dowsons, who were then running the ranch, Evelyn had to lock up her hunting dogs to keep them away from the prized Belgian hares the Dowsons were raising.

The sitting room at the Cross S, photographed through an open window. In the foreground is the Ping-Pong table where Evelyn and Effie Dowson enjoyed a "very nice game."

sporting news—following such events as the Derby horse race and the prestigious Waterloo Cup competition for coursing hounds. Among the publications they received regularly were *The Field, Lloyd's Weekly Newspaper,* and *Country Life.* They also received—and in many cases shared with their fellow countrymen—more exotic periodicals. Alec lent his English ballet papers to Price and the grimy British ranch hands at the Crown W horse ranch. And Evelyn was anxious to share the literature she regularly received that was put out by the Imperial British-Israel Association, a group that believed the inhabitants of Britain and its scattered Empire were actually the ten lost tribes of Israel. Using scriptures to interpret world events in that light, the Association in effect legitimized late Victorian British imperialism—for if England was indeed synonymous with the House of Israel, then it was her right and destiny to unite the lost tribes by maintaining control over and adding to her colonies.

This nationalistic theory had been circulating for some time. Evelyn recalled that as a young girl her aunts enthusiastically embraced the creed. Her mother-in-law was a current devotee, and it was she who showered Evelyn with British-Israel literature; she sent *The Banner of Israel* magazine every month to the Eve Ranch, as well as the group's official handbook and other publications.

Evelyn, in turn, passed the publications along to her British friends and she also tried—with limited success—to interest some of Terry's local citizens in the theory, reporting to her mother-in-law on March 7, 1896:

> I have "sown some British Israel seed" in Terry where I hope it will germinate, but the people there are not very ambitious for enlightenment beyond their St. Paul or Chicago weekly. I lent "The Handbook" & two "Banners" to a Mrs. Brackett who will, I believe, become interested as she is fond of her Bible. In any case she seemed grateful for the loan of the litterature.

That Evelyn continued her proselytizing into the next year is revealed in her detailed accounting of the money she spent during 1897. Inscribed in the back pages of that year's diary is a list of items she purchased, ranging from 33 yards of blue-figured denims bought for $6.60 to one bottle of East Indian chutney ordered from Smith's Cash Store in San Francisco for 65 cents. On the list as well is British-Israel literature ordered from England, including one year's subscription for *The Banner of Israel,* which cost 7 shillings, three copies of *British Israel Truth,* and three pamphlets entitled *British & Jewish Fraternity.*

It seems completely out of character for Evelyn—the soul of level-headedness, with little interest in formal religion—to espouse such a crackpot theory. Yet in the waning days of the nineteenth century the whole world order seemed to be collapsing and the unsettled international situation cried out for some explanation. The Bible seemed as good a place as any to look for answers. Territorial and economic rivalries among Great Britain, Germany, France, Russia, and Austria-Hungary erupted into a series of confrontations over spheres of influence in Africa, China, and the crumbling Ottoman Empire. British-Israel theorists interpreted these crises as a sign that the stage was being set for Armageddon, when the final battle would be waged between the forces of righteousness (i.e., the British Empire and its allies) and the forces of evil. Evelyn avidly followed the end-of-the-world predictions, writing to Effie Dowson:

> Have you read up the Identity theory? From the aspect of the world things are working up to a grand climax. There is a pamphlet come out by Mr. Dimblely, the astronomer & chronologer of the British Association. He claims that he can tell the age of the world & the near close of the dispensation by the stars, chiefly the Transits of Venus & Mercury. It is called "Scientific time." Curiously enough all of his dates deducted from the planets quite agree with the dates of Daniel. It is strange that his interpretation of the Planets should coincide with the interpretation of the divines who study & explain the prophecies in the bible.

Ida Archdale in the sitting room of her ranch house, known to the locals as "Castle Archdale." Her husband, Mervyn Montgomery (Monty) Archdale, had come to Montana with his brother Lionel to join the British ranching community. They have hung a bellpull next to the door perhaps to remind them of a more civilized world where there would be a parlor maid to answer a ring.

The Archdales raised horses and cattle at their Fiddleback Ranch.

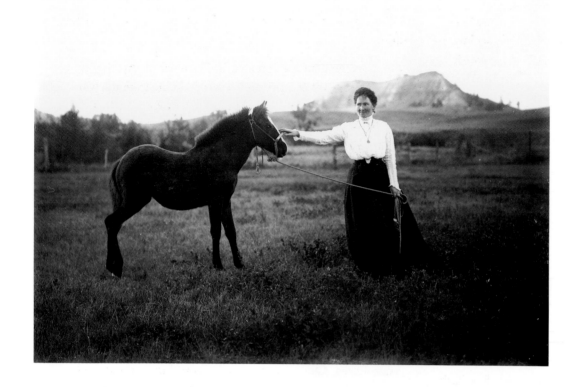

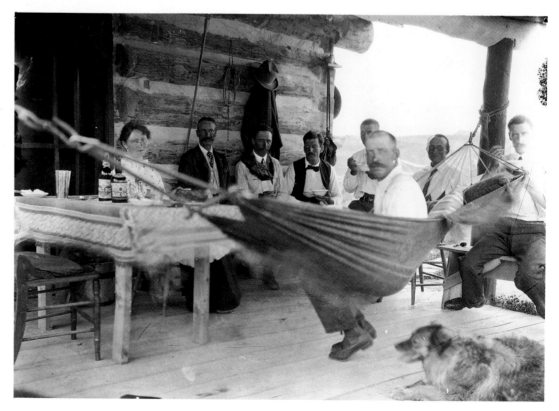

A group of British ranchers gathers on the porch of "Castle Archdale" for sloe gin and ice cream to celebrate the Fourth of July, 1907. Lionel Archdale said that upon stepping off the train in Montana, his first thought was that he was at the end of the world, and that when he arrived by buckboard at his future home at Locate Creek, he knew he was at the end of the world.

The world appeared poised on the brink of a grand cataclysm when the Boer forces in southern Africa declared war on Britain in 1899. According to Evelyn, the final day of reckoning was at hand: "War probably begun in Africa against Boers!—This will be the beginning of the great wars & the last wars."

The news from the front, however, was disquieting. The Boer forces shocked the British with an early series of impressive victories and it became immediately apparent that there would be no quick, decisive triumph of the forces of good over evil. As the war went on, many who had been eager to join the fray became increasingly reluctant. Evelyn's brother Severin Flower, for one, at the outset of the conflict had managed to get a coveted commission in the Imperial Yeomanry which was being organized to fight in Africa—a social coup—but he was unable to take it up because he could not raise the requisite £150. Even their half-brother Lord Battersea refused to help. Severin's disappointment, however, quickly turned to relief. Less than two months later he wrote to say that he had had four offers of a commission but had refused them because of the higher premiums on his life insurance that would result if he went to Africa.

The war was still raging when Evelyn and Ewen returned to Great Britain in 1900 and heard dismaying news from Africa: a friend was dying of enteric fever, troops at the front were complaining bitterly of half-rations and, according to first-hand accounts, even attacking their own officers. The latter revelations were made during what was supposed to be a patriotic celebration for soldiers returning from the battlefield. In the spring of 1901 a group of five local men returning from Africa were given a hero's welcome in Dornoch, the sleepy seaside town on the northern coast of Scotland where the Camerons were renting a house. Flags festooned the streets, a parade was held, welcoming speeches were made, and a dinner and dance were given in the soldiers' honor that lasted until the wee hours of the morning. But the festivities were marred by the stories that leaked out about the reality of the war. Evelyn described the soldiers' homecoming in a letter dated May 4, 1901, to her sister Hilda:

> Great excitement was created in Dornoch on April 30th when 1 sergeant & 4 privates returned home from the war after over 1 yrs. service in Africa. They were attached to the Sea for the Highlanders & while one of the 12 died of enteric the remainder are still in Africa. The horses were taken out of the machine ½ a mile from the town & it was drawn in by admirers, preceeded by the volunteer band. The 5 had mahogany complexions & looked wonderfully well. A service & address by the minister was given in the Cathedral square. . . [&] a dinner and dance followed. They have spread some rather undesireable stories; for instance that more officers were shot by their own men than by the Boers!(?) One unpopular officer from these parts—Brodie of Brodie—was found facing the enemy with 9 bullet holes in his back. These stories make one ask if they were not more deserving of hanging than fêting. One man asserts he would have reenlisted but that in so many instances the sergeants treated the men "worse than slaves" as soon as the officers' backs were turned & he didn't care to risk it. It is hinted that the Government will not get any more recruits around Dornoch.

The effects of the war were felt as keenly among the British in Montana as among those at home. Initially, enthusiasm was high. A chain letter was circulated among the expatriates in Montana to raise money in support of the Canadian South African contingent. Lance Irvine, a high-spirited Irishman, rushed off to join the 420 men of the Irish Hunter's Contingent. (Irvine was a well-known character, noted for his wit and his ever present smile. He was also remembered fondly for his pranks. On one occasion he jumped his horse over a street excavation in Miles City just as the mayor was in the hole inspecting pipes—a stunt that got him arrested.) He was to return to Montana in 1901 disheartened and stricken with tropical fever.

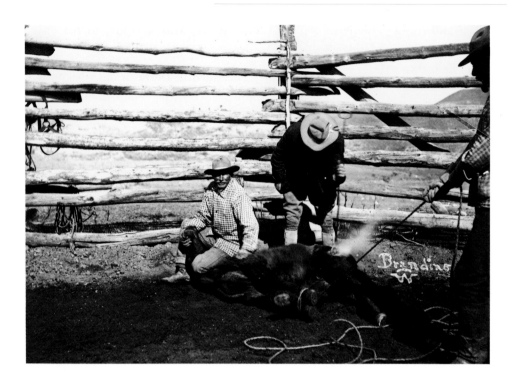

*Lance Irvine sits on a horse's neck to restrain it as
J. H. Price applies his Crown W brand.*

As the war dragged on, it became harder and harder to depict the British Army as the untainted force of righteousness, especially as dismal reports drifted back from Africa of the herding of Boer women and children into concentration camps. But though the English horse ranchers in Montana might have been disappointed in the conduct of the war, they remained loyal subjects, ready to stand by their country. As it turned out, many of them, including J. H. Price and O. H. Wallop, provided quite a lot more than moral support and in the process made a fortune. Horse prices skyrocketed with the soaring demand, and animals worth £1 to £8 in Montana were purchased for as much as £20 by the English authorities.

A little more than a decade later, the outbreak of World War I also affected the horse market in eastern Montana. Ranchers—including Evelyn on one occasion—flocked to Miles City to sell their animals to the Allied forces. And once again the expatriates were desperate for news of the fighting,

though when it arrived it was not always good. On May 7, 1916, Evelyn was distraught: "British Mesopatamia army capitulated!!! to Turks—3,000 British 6,000 Hindus. Awfull. Awfull."

Frustrated and angered by the reverses that the British Army was suffering, some of the local expatriates decided to take a more active role in the war effort. Major Dowson, for one, though over seventy years old, was anxious to get into the fray. While Effie sold flowers to raise money for the wounded, the Major returned to Britain from California, where the Dowsons were then living, to enlist. The English would not have him. Undeterred, he persisted until he found a role with the French. Dowson's age turned out to be immaterial; he was thrilled to be in the midst of the action, and his only complaint was that the roar of the cannons was so deafening that it was impossible to talk over it. Evelyn marveled at her old friend in a January 1918 letter to Hilda:

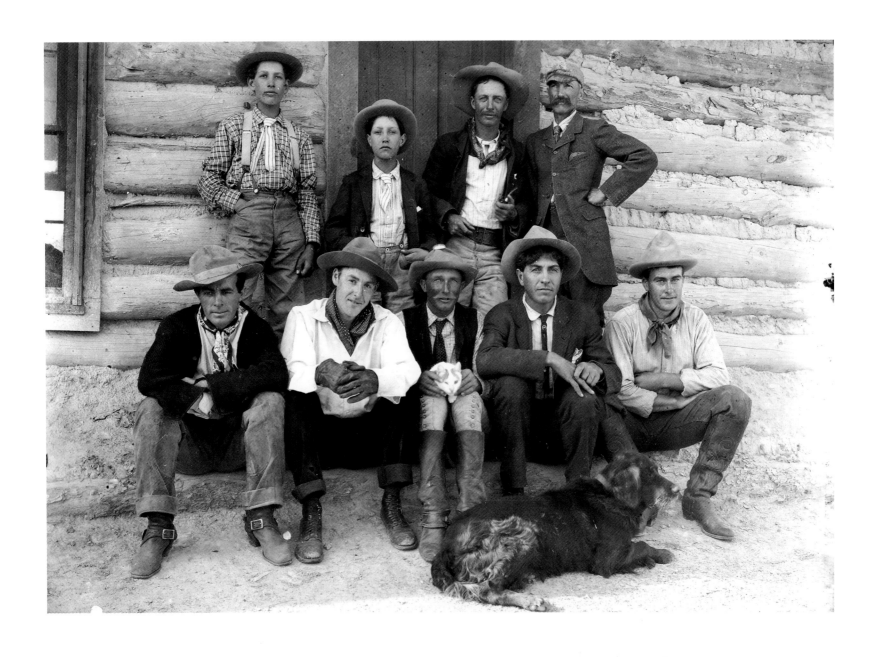

Ewen stands at far right in this group photo taken at the ranch run by Lance Irvine (seated, center) and Wesson Adams (seated, far left).

Major Dowson wrote to me the other day from France enclosing a photo of himself & his ambulance corps, in which they are being inspected. He is saluting & saying "All Present, Sir." He was 74 August 28th 1917! He couldn't get into any British corps but somehow managed to get into the French Ambulance Service & now writes "I am at last satisfied & happy." Poor old chap, he is an awfully dear kind soul.

Another expatriate friend—though considerably younger—also tried unsuccessfully to join up with the British forces. Thirty-year-old William Binnie, a native Scotsman, returned to England on his honeymoon in 1916 and tried to enlist. He was turned down, even though he was, according to Evelyn, a robust "6′2″ & correspondingly broad—a fine figure of a man."

Binnie was not part of the established circle of British ranchers who had arrived in eastern Montana in the late nineteenth century; he was among the new wave of home-steaders who had appeared around 1910. A young man on the move, he was anxious to profit from the homesteading boom, and he got involved in promoting the area—and selling real estate—both as a banker at the newly formed Fallon bank and as the editor of the local newspaper *The Fallon Forum*. The Camerons met him when he arrived one day at the Eve Ranch on his motorcycle. Ewen was thrilled to discover a fellow Scotsman who shared his interest in ornithology and who had an extensive library on birds and wildflowers, while Evelyn grew quite fond of him and followed his efforts to get into the war. Having been turned down in Britain, Binnie, who was a naturalized U.S. citizen, was off to the Presidio in San Francisco for military training almost as soon as his adopted country declared war on Germany. The boot camp on the west coast was grueling, as Evelyn described it to an English relative:

They work them unmercifully over here. Hours were from 5:30 a.m. till 9:30 p.m. with rest only on Sundays. Not only

J. H. Price, formerly a professor at Oxford, was one of the Montana ranchers who made a great deal of money selling horses to the British Army during the Boer War. His financial success was short-lived; he was forced into bankruptcy when the growing popularity of the automobile reduced the market for horses.

are their physical & mental capabilities sorely tried, but, also their tempers with a view to discipline.

Binnie returned to Montana briefly to see his pregnant wife before setting sail for the front lines. Looking handsome in his khaki uniform, he also stopped by to bid farewell to Evelyn. Less than two months later she received word that he was among the missing when the ship carrying him to France was torpedoed during the night.

Evelyn was deeply touched by Binnie's death and she wrote of it and other casualties of the war in a letter to a solicitor in Scotland:

> I heard a few days ago that a friend is amongst the missing on the Tuscania. He was a lieutenant in artillery & came to say goodbye to me on his way to France. . . . His poor wife, who has returned from the East (U.S.) to be with her family in her distress, is prostrated. They are neighbours living 3 miles from my ranch. I have 6 nephews in the war on the Flower side & 2 on the Cameron. One has had a hand amputated, another shot in the head, & has been invalided now for over a year.

Some of the sacrifices her family and fellow countrymen were making for the war effort were for the better, Evelyn thought. "It seems so curious that the 'well to do' at home are managing 'on their own' [without servants]" she wrote in her diary. "A marvellous influence for good this war is having in spite of the horrors." In a letter from home she received word that a niece, Joan Edwards, was working as a nurse at a military hospital in Norfolk. Evelyn admired Joan for tending to the wounded; nursing was, in her view, the "most trying of all professions for a woman."

Evelyn herself had been ready to rush to the front as soon as the war had erupted. She scribbled in her diary on September 21, 1914:

> Suddenly I wished to go & help nurse the wounded at the front, realizing at the same time [it] would be hell on earth work, but have a strong feeling I ought to rent place, sell household goods.

As it turned out, however, she had her own private hell to face. By the end of 1914, Ewen's health—which had never been good—was taking a sharp turn for the worse. For months Evelyn patiently nursed him as his body and mind deteriorated until, bedridden, he was reduced to singing endlessly "It's a Long Way to Tipperary."

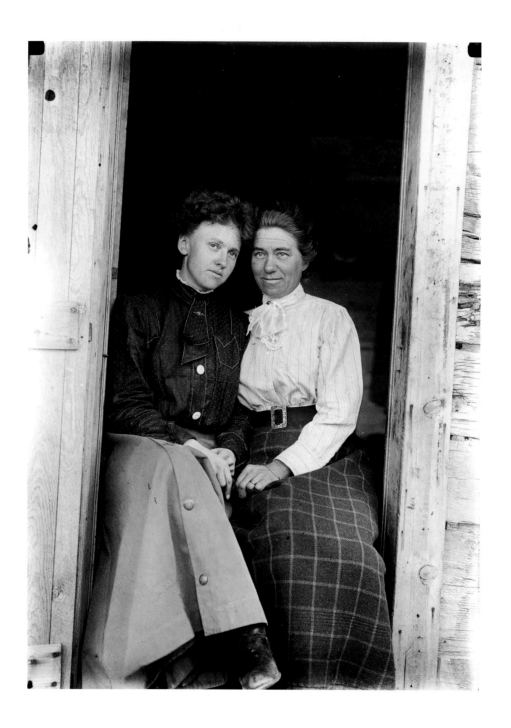

The close bond of friendship between Evelyn and Janet Williams is evident in this portrait, snapped by Ewen in March 1910. Janet was by then living at the Eve Ranch a good part of the time. She played the piano so well that the Camerons discussed paying to send her to study music in Paris, but never did so.

The Final Years

O N C H R I S T M A S D A Y , 1914, Evelyn vowed that she and the ill Ewen would not spend another winter at the Eve Ranch; on February 11 she bundled him into a sleigh filled with hot bricks to keep his feet warm and headed for the train to begin a journey west in search of warmer weather—and a cure. They stopped first at Salt Lake City, but stayed for only a week. The doctors there proved useless, as Ewen's health steadily worsened. His entire left side was now paralyzed, and he was able neither to walk nor to dress himself.

Evelyn was not about to give up hope. She loved the ocean and had a firm belief in its curative powers, so with great difficulty she managed to get Ewen and their belongings on a train heading for California. They ended up in Long Beach, where she rented a cottage for eighteen dollars per month, constructing a runway over the stairs so that she could bring Ewen to the ocean in a wheelchair. Once they had settled in, she wrote to her dear friend Janet Williams:

Dearest Janet,

I write to answer your letters of Feb 16 & 18th which we were very pleased to receive. As Ewen got weaker every day at Salt Lake City I brought him on here. I do not think Dr. Sandberg [Utah doctor] approved of this plan as he thought Ewen was too weak to bear a journey, but I acted on my own responsibility & am very glad as I have got him in a nice cottage near the sea. Ewen's condition is pitiful: he is so weak that he cannot turn over in bed without my assistance. His left side is paralysed. It is strange that both doctors, Dr. Terry here and Dr. Sandberg at Salt Lake City, should find his condition compatible with trichina (trichinosis) which comes from eating pork & ham & Ewen has never eaten either, or hookworm which is not a disease of Montana at all. The doctor here has entirely changed the treatment & dietary—having put Ewen upon milk, buttermilk, eggs, vegetables, fruit & chickens. He thinks a vegetable diet best for Ewen while the Salt Lake City man thought a meat diet the best. Ewen has had to be carried everywhere since leaving Salt Lake City but wherever this was necessary—into Pullman, taxi cab, wheeled chair, etc.—a burly volunteer stood ready to offer his ser-

vices; otherwise I do not know however I could have got him here. We changed our plans & came here because by all accounts this is by far the most suitable place on the sea coast. Ewen must be in a large town . . . where there are good doctors. I am trying to get a cook because Ewen cannot bear me out of his sight and cooking, washing up, nursing, and marketing deprives him of my Company too much. I wished to get a professional nurse as I am, of course, not sufficiently experienced but Ewen is so against having a stranger around, & the idea put him in a high fever, that I gave up the idea. . . . Dr. Sandberg ordered Ewen 4 or 5 eggnogs a day, but Dr. Terry has instructed them to be discontinued as he does not approve of the mixture of eggs, sugar, milk & whiskey—only of milk & eggs. I hired a wheelchair with the intention of wheeling Ewen down to the sea every day, but he has only been in it once to sit out in the sun close to the cottage. . . .

Much love to you all.

[P.S.] The Dr. injected dead microbes yesterday which produced the hoped for symptoms today, now he thinks he is on the track of the right microbe causing Ewen's illness.

Thus began a painful series of tests to determine the cause of Ewen's illness, all of which proved inconclusive. The doctor finally pronounced that this was an "obscure case." On March 19, 1915, Evelyn told Ewen's brother what happened next:

My dear Allan,

You will be anxiously awaiting news of Ewen. I have had Dr. Brainard, a nerve specialist, down from Los Angeles & he diagnosticated Ewen's complaint as hemiplegia due to brain pressure by abscess or tumour. Probably caused by concussion of the brain which Ewen suffered in 1889 & 1897. In 1889 he was unconscious for 24 hours when a mare in Illinois threw him. . . . He suffers great pain at times in the paralysed limbs combined with severe headachs—these are relieved by massage & carrying him from the bed to the lounge. The latter gives him instant relief lasting from a few minutes to an hour & he says it is like going from hell to heaven. His outings in a wheeled chair have had to be stopped at his request, the motion & fatigue augmented his pains. When he feels up to it, I put him on a lounge on the porch of the bungalow. Ewen can sit up to his meals propped up with pillows & feeds himself with his right hand, but I have difficulty in restraining his appetite which is wonderful and if he eats much, of course, restlessness & sleeplessness result. Poor old boy, he is so very patient & frequently quotes a passage in the Physician's Vade Mecum—"the condition of a paralytic is truly pitiable." We are living in a comfortable little bungalow consisting of two rooms, bathroom & kitchen. Electric light & gas for culinary purposes. Eucalyptus, mimosa, date palms, & pepper trees alternate along streets and Avenues & the bungalows are surrounded by green grass, roses & creeping plants. Ewen has taken much pleasure in some arum lillies close to our door. I have been fortunate in securing a sympathetic little Spanish-American woman to cook, do the marketing & housework. She has pleased Ewen by the way she prepares his favourite dishes. Her wages are $20 a month. Her hours are from 8:30 a.m. till 3:30 p.m., otherwise I attend to Ewen entirely. . . . This letter has been written at odd intervals during the day while Ewen slept so please excuse the jerky sentences. I feel sure we will pull dear old Ewen through somehow so don't worry too much. With much love from both to you, Jessie & the boys,

Ever your affectionate sister,

Evelyn

Despite the optimistic conclusion to the letter, Evelyn was desperately worried, and she turned to more unconventional cures, including a Christian Science healer in whom she had little confidence, and osteopathic treatments that involved vigorous manipulation of Ewen's bones and muscles. Ewen dictated to Evelyn a letter for Janet Williams in which he

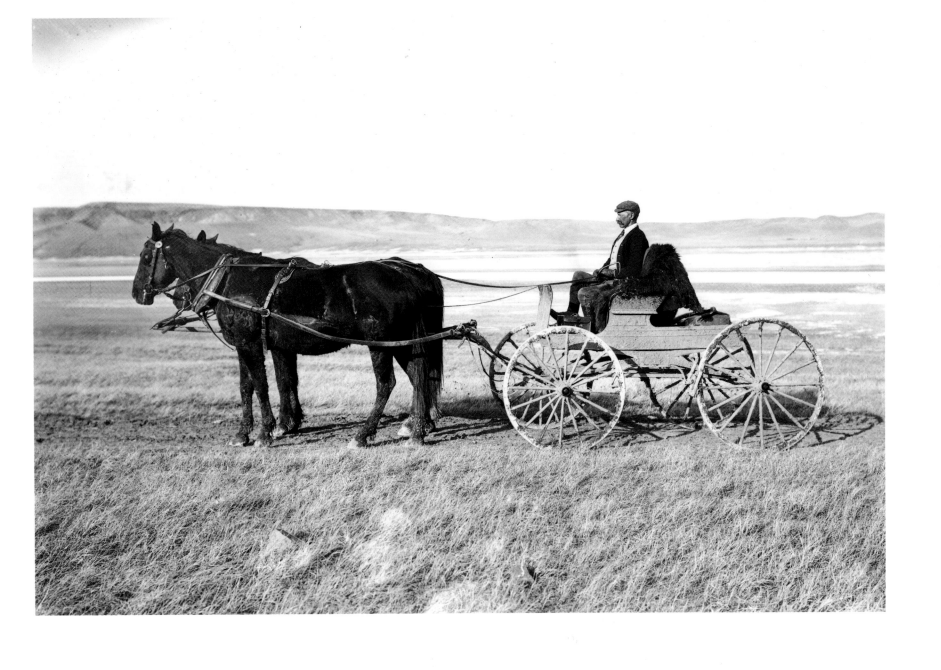

Ewen drives across the prairie in an undated photograph, probably taken in his later years when he was ill.

described his first—and, it turned out, last—osteopathic session:

Dear Jan,

I have had the first Osteopathic treatment and he has left me like a limp rag as you said he would. Both Evy, I & the doctor have come to the conclusion that I am too weak for these treatments. In fact, he nearly screwed my head off and lifted me up by my pajamas as a terrier does a rat. His diagnosis was the same as yours, that the trouble was in my neck & that my muscles want releasing as you already said. Osteopaths leave you so tired as though you had a lot of unusual exercise. . . . This is a holiday with me—no doctor & no disagreeable medicines—which I can best spend by writing to you. One way alone can I gain relief from my pains is by getting Madre [Evelyn] to lift me from the bed to the lounge & from lounge to the bed. The nerve specialist Dr. Brainard remarked that I must be as heavy as a sack of flour, but her outdoor work & gardening has stood her in good stead now that she has to lift me around. I am entirely dependent on her: she has to sit me up to all my meals & rub my joints where they cramp and rub my body generally like [the osteopath]. . . . I am looking forward anxiously to the time when I can go home & see you all again & go for rides in your car into which Madre can lift me if I require lifting. I am so frightfully dependent on everybody you cannot imagine how irksome it is; fortunately Madre is tried and true. . . . The effort of dictating this has made me very sleepy which is a good sign, as I suffer so from sleeplessness. When I do get to sleep the cramps in my limbs awaken me and Madre spends nearly her whole time massaging me à la style [of the osteopath]. The doctor says my sleep must not be curtailed, as the more I sleep the stronger I will get. With love to you all. . . .

Toujours votre Père affectionné,

E. S. Cameron

To this, Evelyn added her own P.S.:

Ewen's brain was clearer today as you see. It is cheering to know that he dictated this without undue fatigue. It is 4 long weary days before we can hear from one another. *E.J.C.*

She neglected to say that the pressure of meeting Ewen's round-the-clock demands was taking its toll on her. She had developed excruciating headaches that were relieved only by prayer. And, in the midst of her struggle to save Ewen, she was shocked to discover that they were in danger of losing their ranch in Montana.

The Camerons had claimed land under the Homestead Act to establish the third Eve Ranch, and they had met all of the requirements to gain legal title save one—Ewen had to become a naturalized citizen. He had in fact applied for citizenship, but had been unable to make the required personal appearance in Miles City because of his illness. Now the U.S. Land Office wrote to say that if Ewen did not appear at the government office to be examined about his application, the Camerons would lose their rights to the homestead.

Terrified that all their years of backbreaking work would be destroyed by bureaucratic intransigence, Evelyn fired off a letter to the U.S. Land Office in Miles City explaining the situation. She would not be defeated without a battle. "I [have] the British temperament," she wrote of herself once. "[I am] easy going, confiding . . . but when on the defensive in a righteous cause would fight to the last ditch." And so Evelyn went on the offensive in her crusade to save the ranch: she enlisted the support of a formidable ally to present their case to the U.S. Land Office in Washington. She turned to Dr. C. Hart Merriam, a renowned scientist at the Smithsonian who was familiar with Ewen's research. Merriam had powerful friends in Washington.

Dear Dr. Merriam, *April 23rd*

I am writing to ask you to do my husband a great favor, but first I must give you an account of his distressing illness. . . . My husband [has] an abcess pressing on his brain. . . . In 1889 & 1897 he suffered concussion of the

brain from accidents due to horses falling with him when at top speed. In 1889 he was 24 hours unconscious & no doubt this is the primary cause of his present dangerous illness. He is paralysed on the left side, from the facial muscles to the sole of his foot, & so weak that he cannot turn in bed. The doctor is trying to absorb the abcess with medicines & if they do not have the desired effect, the doctor fears the case hopeless. Now I am troubling you with this account because my husband is so worried—his brain is clear although not normal—about his homestead. All dues are paid, but two naturalization days in Miles City Montana passed without my husband making an appearance to give evidence of naturalization owing to illness. Now the final proof papers will be sent to the General Land Commissioner at Washington D.C. stating he has failed regarding evidence of naturalization & the Land Commissioner will give a final decision on the matter & what that decision will be is problematical. I am presuming on your kindness to see the General Land Commissioner at Washington D.C. on this matter. Please give him a statement of my husband's mental faculties. He has done much work on the migration of Montana birds for the Department of Agriculture & you know his list of Montana Birds published in the Auk. Of late he has given Mr. A. C. Bent matter for publication for the Life Histories of North American Birds & Mr. Bent writes in his last letter "I should also be glad to receive any further communications for publication in the Life Histories of North American Birds." If I was at home I could send many complimentary letters from Dr. Witmer Stone, Editor of the Auk, Dr. W. L. Sclater of the Ibis [another ornithological journal], Dr. J. A. Allen etc. as evidence of his mental faculties being far beyond the requirements of the would be U.S. citizen. I feel sure if my husband's case was put clearly before the authorities that they would waive the usual evidence of naturalization & under the circumstances give him a patent in due course. I enclose the latest communications from the Land Office on the subject. The tissue copy

contains the exact location of the homestead in question. Our address for the next month, & perhaps longer, will be as above. Please excuse me for the trouble I am giving you but I feel this is my only means of setting my husband's mind at rest & now [that] this letter is written he will cease to worry.

Believe me, sincerely yours,

Mrs. E. J. C.

A week later Evelyn wept upon receiving a telegram from Dr. Merriam saying that he had interceded on Ewen's behalf. The ranch was saved. Then, the next day, the doctor informed her that there was no hope for Ewen; she should just do the best she could to make him comfortable.

Evelyn herself was near physical collapse. For months now she had been nursing Ewen day and night. The nights were the worst—he could not sleep and the pain was so intense that he howled in agony. The neighbors began to complain about the blood-curdling screams and the landlord insisted that they leave, even though Ewen was perilously close to death.

On May 11 Evelyn brought her husband to a sanitarium in Pasadena, where the nurses gave him shots of codeine and, at the end, heroin to relieve his suffering. Evelyn stayed with him all night tending to his needs, and tried to distract him during the day. When he was up to it, she carried him outside, laid him on a cot, and read aloud to him. (He found Captain Scott's diary account of his tragic expedition to the South Pole too upsetting for her to finish.) The end finally came on a lovely cool May day, the 25th. Evelyn reported it in her diary in the same unimpassioned way she might record the death of a favorite cow. Written in red ink at the top of the page was:

Ewen died 1:40 p.m.

She went on to say: "I was with him alone at the last. Poor old boy, it was a blessed relief." The autopsy revealed that he had been suffering from cancer of the liver and brain.

Evelyn now went about arranging an Episcopal funeral

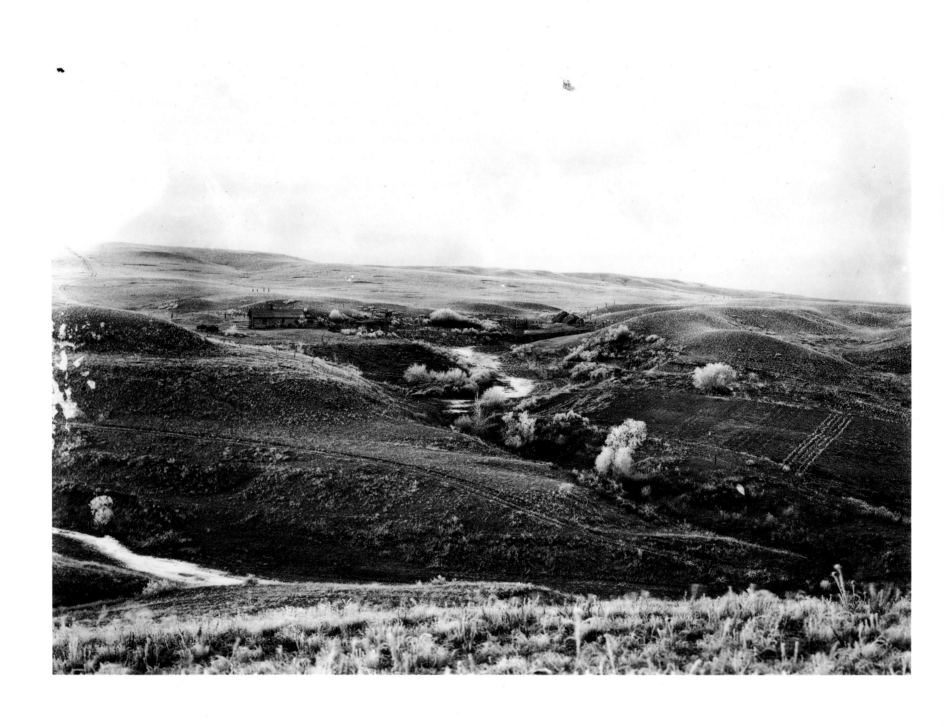

Hoar frost has turned the landscape brittle in this view of the Eve Ranch taken from a hilltop. After Ewen's death in 1915 Evelyn operated the ranch alone for thirteen years.

service for the next day in a completely strange town, far from Ewen's homeland or his beloved Montana badlands. She ordered a black casket for thirty-five dollars, a cemetery plot in Pasadena for forty-one dollars, and bought herself a five dollar hat. She then cabled Ewen's brother:

Ewen died 1:40 p.m. the 25th.
Evelyn

Fortunately for Evelyn, there was one old friend there to help with the final preparations, and stand by her at the graveside. Her compatriot Effie Dowson—with her four Pekinese dogs in tow—had turned up unexpectedly before Ewen's death. The two of them now bid him a quiet farewell.

Evelyn returned alone to Montana where she discovered that in their absence all of their valuables had been stolen, including Ewen's gold cufflinks from Monte Carlo, and her watch and fountain pens. "All trinkets 'cept Cyril's [Lord Battersea's] locket gone! . . . Felt bad, what's it matter," she wrote resignedly on the day of her return, June 4, 1915. She then went outside and plowed her garden. This was Evelyn's solace—hard work—and she had plenty of it to do.

If possible, Evelyn's life, running an entire ranch single-handedly, was more difficult now than it had been before Ewen's death; yet she had no desire to move into town where modern conveniences were making inroads. No electricity or running water for her. And certainly no cars. "I will never own a motor as long as I can throw my leg over a saddle," she declared emphatically.

The one luxury she did enjoy was her Victrola. This was not a new addition to the Eve Ranch. For some years before Ewen died, music could be heard wafting from the windows of the house—though not always to the pleasure of the listeners. Evelyn reported that one man hired to do some work at the ranch expressed his preference for "plain singing," and his distaste for the diva then performing on the gramophone in no uncertain terms: "I'd like to throw dough in her face!" he said.

On March 5, 1916, Evelyn burned a stack of Ewen's old letters, then put on the Victrola and "Danced alone." She was to dance alone for the rest of her life. She never remarried, though she did receive a proposal from a thirty-seven-year-old Irishman who was working on the nearby railroad line. She scarcely knew the man, but he was apparently smitten with her—or perhaps with her well-tended ranch. Evelyn was fifty years old at the time and was flabbergasted. "I asked if he were joshing. . . . Said I was old enough to be his mother," she wrote on April 28, 1918, and dismissed him.

Evelyn had no interest in finding a new husband, and she absolutely refused to hire a full-time ranch hand on the grounds that it would "entail cooking for a hired man, which I abominate." She preferred tending to her herds of cattle and horses by herself, despite the amount of work involved. In a 1921 letter to Janet Williams, she admitted that her days were full to bursting: "I've been as busy as a one armed man with hives." Nevertheless, the prospect of hiring help or sharing her quarters was beyond consideration: "No doubt if I wished, I could find a companion for the winter, but, as Ewen used to say, 'I am a rum old codger' & infinitely prefer & enjoy being alone."

Returning to Great Britain was also out of the question, though her relatives begged her to come. Montana was her home now. "To sell this place would break all ties with the past and I dread doing it," she wrote to her worried sister-in-law in January 1917. "I am living quite alone on the ranch but I have plenty of occupation—cattle, photography, reading etc., that I do not feel lonely."

Despite her bravura, Evelyn did suffer bouts of melancholy. Less than three months after writing that letter, she confided in her diary, writing in French as was her habit when she had something very personal to say:

Curious feeling last 2 days—viz: that it is disagreable to live *seul et qu'il faut que je quit le Ranch, j'espère que se passera. Trop dans la maison peut-être* [alone and that I will have to leave the Ranch, I hope this feeling will pass. Too much in the house perhaps].

Marsh Mont.

In the later years, much of Evelyn's photography centered on the wheat-farming homesteaders who settled the Fallon Flat. The town of Marsh popped up in 1910 along the railroad tracks; it consisted of a grain elevator, general store, bar, and school. Evelyn collected her mail in Marsh, located four miles from the Eve Ranch.

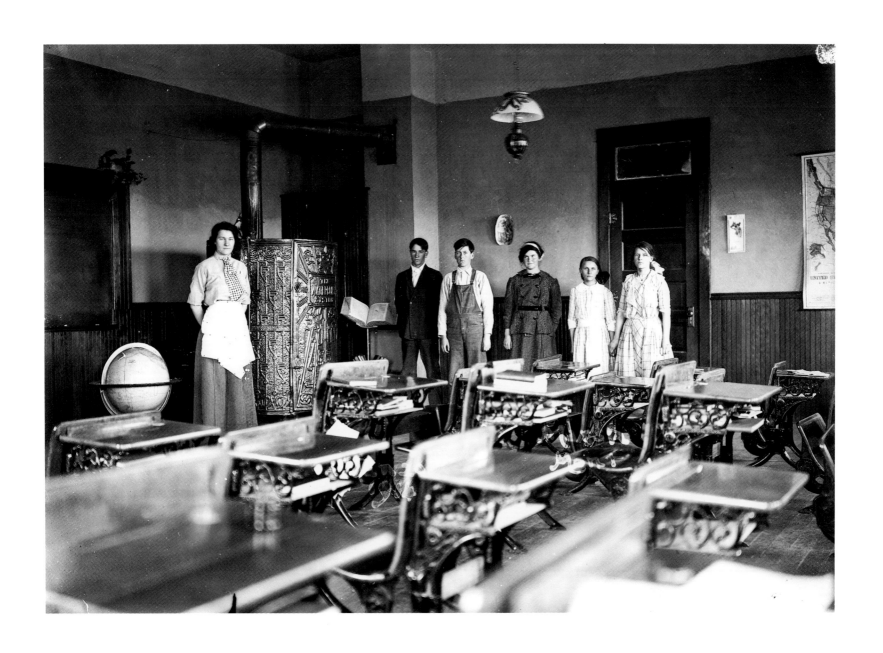

On dark days, light for the classroom at the Marsh school was provided by the oil lamp
suspended from the ceiling. Marsh's schoolhouse burned down one day when
its furnace overheated.

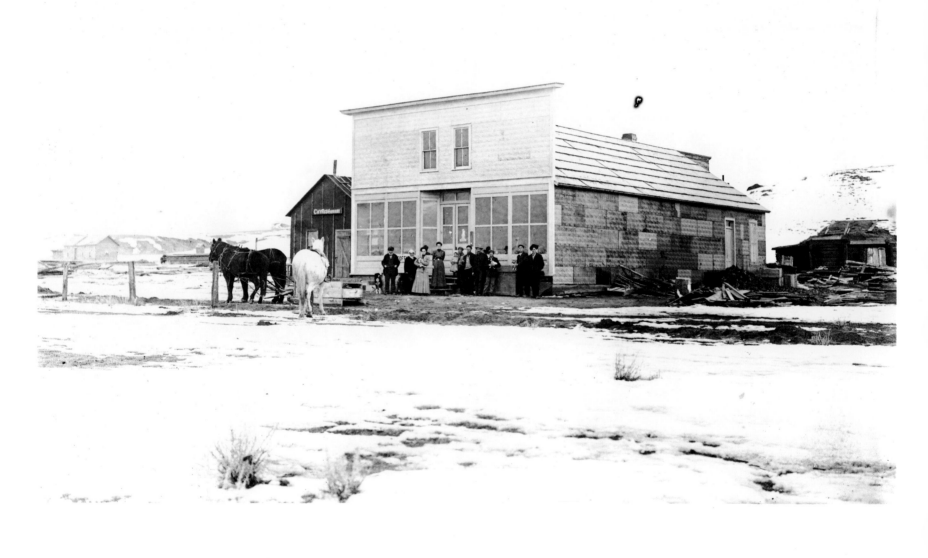

Marsh's combined general store and post office was constructed by Nobel Folger, who dismantled several buildings he owned in Minnesota and shipped the wood to Montana. The tarpaper-covered shack next to it is the City Restaurant. During World War I, Folger's sister asked Evelyn to translate a German-language newspaper, published in North Dakota, which the store sold. Evelyn reassured her that there was "nothing seditious" in it.

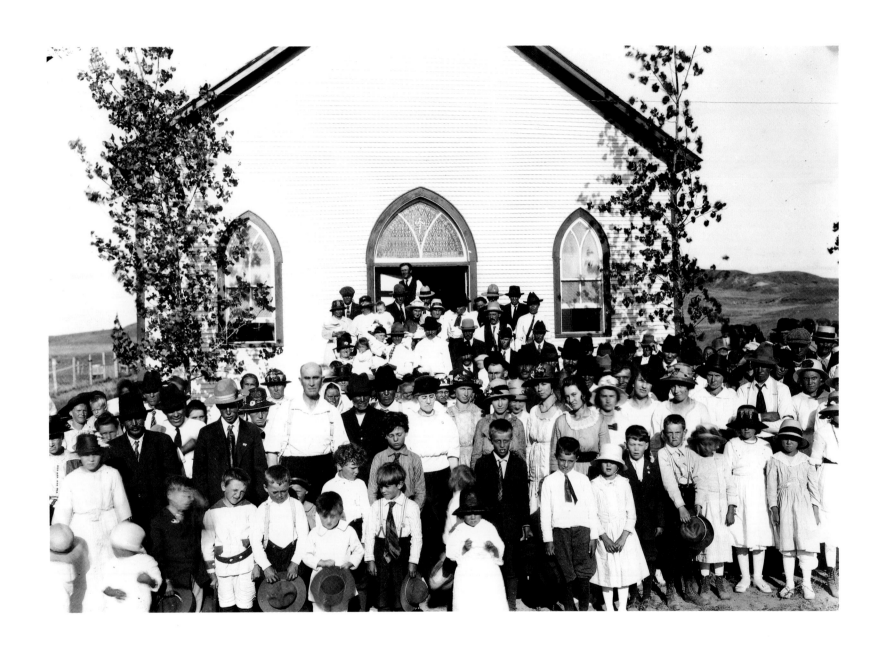

The opening of the German Lutheran church in Marsh in 1920. The congregation had been collecting money to build the church since 1914 (when Ewen reluctantly contributed $10), but construction was undoubtedly delayed by World War I, during which ministers in Montana were forbidden to preach in German.

Yet as time went by, she grew accustomed to—and began to cherish—her solitude. In December 1917 she wrote: "I THINK LIVING ALONE IS VERY AGREEABLE, no dissension, no annoyances from others." And again the next day: "I do like being alone. I was thinking all past miseries are being repaid by present contentment!"

Among the miseries of Evelyn's past had been the years of trouble she had had to endure when her ne'er-do-well brother Alec was living at the Eve Ranch. He had been lazy and demanding, and he had done everything possible to undermine the business—from alienating potential investors to eventually, in 1900, suing the Camerons (and encouraging the other ex-boarders to do likewise) for money he claimed was owed to him. Yet when she received word in January 1921 that Alec's wife had died, she immediately offered him a home with her in Montana, in a letter to the family solicitor, Ralph Flower:

> Hilda in a letter I rec'd about the New Year mentioned the death of Alec's wife. I indeed feel very sorry for him. What are his future plans? . . . As you know, Alec *must live with a trustworthy friend or relation*, otherwise he will tumble into trouble, being quite incompetent to go through life on his own hook. I will give him a home here, where he can live economically & have congenial employment in an irrigated garden which has a ravenous market for its produce.

Alec never accepted her offer, and Evelyn was secretly relieved, but her gesture reveals her great generosity of spirit.

She was similarly large-hearted with her Montana neighbors. She was hardly considered a helpless widow—in fact it was Evelyn, more often than not, who was called upon to lend a helping hand to neighboring ranchers and homesteaders. For example, in June 1918 her neighbor James Whaley found himself in a terrible predicament: the Yellowstone River was in full spring flood, and his cows had wandered onto riverbottom islands that were rapidly disappearing under the rising waters. The prized livestock lowed mournfully while their owner—who could not swim—stood helplessly on the sidelines.

In desperation, Whaley raced to the Eve Ranch to tell Evelyn about the crisis. She in turn hurried to the scene in her bathing suit (stopping just long enough to pack a lunch for her distraught neighbor and his hired help), and immediately plunged into the swirling waters to spend all afternoon swimming against the rapid current of the river to rescue a dozen terrified cows. She returned home at sunset with a painful reminder of her day's heroics—her feet were full of thorns from the thick rose brush under the flood waters.

Evelyn's diary entry for the day noted her dramatic rescue in typical understated fashion. But an Englishwoman traveling through the West wrote with amazement of Evelyn's courageous exploit. The traveler, Marguerite Remington Charter, along with her two daughters and pet cocker spaniel, had walked all the way from Seattle. Everywhere they went in eastern Montana they were greeted with tales of the remarkable Evelyn Cameron; so intrigued were they by these stories that Mrs. Charter and her nineteen-year-old daughter Phyllis (her other daughter and the dog remained behind in Miles City) set out in search of her. They were not disappointed when they found her. After tramping for hours through the badlands, they saw the Eve Ranch as a verdant oasis amidst the parched hills and rangelands, and they dubbed Evelyn "The Lady of the Springs" because of the nine springs that surrounded the house.

Marguerite Charter had planned to write a book about her western experiences, but her own adventures seemed to pale in comparison with the larger-than-life adventures of Evelyn Cameron, and upon returning to New York, she wrote a glowing profile of Evelyn, whom she termed "the most respected, most talked of woman in the whole of the state." Evelyn, embarrassed by such praise, dismissed the article as "awful slush" and took consolation in the fact that it would never be published: "Fortunately we shall never see it in

In July 1919 an English writer, Marguerite Remington Charter, and her nineteen-year-old daughter Phyllis, visited Evelyn at the Eve Ranch and were swept away in admiration for their hostess. Evelyn occasionally had guests draw something in her sketch book as a memento. Phyllis made this pencil sketch of the ranch house.

To accompany the view of the ranch house, Phyllis also sketched its owner. Evelyn loved ranch work and never expressed a desire to return to an easier way of life in England. The symbol at top left is the brand of the Eve Ranch.

print for no editor would accept such arrant rot for publication."

Mrs. Charter took pride in Evelyn as a fellow Briton; and Evelyn's neighbors took pride in her as the quintessential pioneer woman who embodied the frontier spirit of Montana—hardworking, fiercely independent, ever resourceful, modest, compassionate, and generous. They undoubtedly shared her joy when she became a United States citizen on April 9, 1918. She took her citizenship seriously. Despite a driving snowstorm and the flu epidemic then raging in town (Evelyn wore a mask to protect herself from contagion), she rode an hour and a quarter on horseback to the schoolhouse in Fallon that November to cast her first vote in a U.S. election. After exercising her right as a citizen

she penned a note to Janet Williams: "Have just voted—for honor & integrity."

In effect, Evelyn's whole life was a testament to those virtues—the bedrock upon which she built a deep inner strength that helped her weather the good times and the bad with a sense of moral equanimity. She survived both personal crises and historical revolutions—and bore witness to them in her diaries and photographs.

Evelyn experienced the transformation of the region from a largely uninhabited wilderness of scattered ranches to a community of homesteading wheat farmers. The boom years

for the land-seeking homesteaders lasted for about a decade beginning with the completion of the Chicago, Milwaukee, St. Paul & Pacific Railroad line through Montana in 1909. Bumper crops of wheat were produced and prices were unusually high because of the demand created by World War I. Optimism soared, and more and more acres were put under cultivation. Then, abruptly, the seven-year cycle of ample rainfall that had commenced in 1909 came to an end. The drought began in 1917, and by 1919 the entire state was devastated. That, combined with a worldwide downswing in farm prices after the war ended, led to the collapse of the homestead boom.

Evelyn had already been an eyewitness to the inevitable cycles of drought and rain, boom and bust, that wreaked havoc with the economy of eastern Montana. In an earlier day the great open-range ranches had been driven into bankruptcy. Now it was the homesteaders' and small ranchers' turn. Many lost their land.

Evelyn, however, hung on. She survived the drought and the plague of locusts that descended in the 1920s, just as she had survived earlier catastrophes. But she never lived to see the end of that decade. Ironically, this tower of strength died at age sixty after a routine appendectomy.

In December 1928 Evelyn was experiencing such pain that she packed her bag and went to the nearest hospital some 30 miles away. She had an intimation that something might go wrong, so before entering the hospital she killed her favorite horse. Her instinct to observe and record the world around her was still strong. She brought her diary with her to the hospital, noting with amusement on the eve of her surgery that the doctor did not plan to use a full dose of ether "as I had nerve." How, she wondered, did he come to that conclusion? The entries then end abruptly; Evelyn Cameron died on December 26th of heart failure following the operation.

Evelyn's death was headlined on the front page of the local newspaper. The funeral was held in Terry, and the paper reported that the church was "filled to overflowing, all of the old pioneers of the section being present." As her coffin was lowered into the grave a wreath of red pepper berries, picked from the trees near Ewen's grave in Pasadena, was placed on top of it. The obituary mourned the passing of this inspiring frontier figure, but noted the sentiments that Evelyn had written herself in one of her diaries:

I think of death as a delightful journey that I shall take when all my tasks are done.

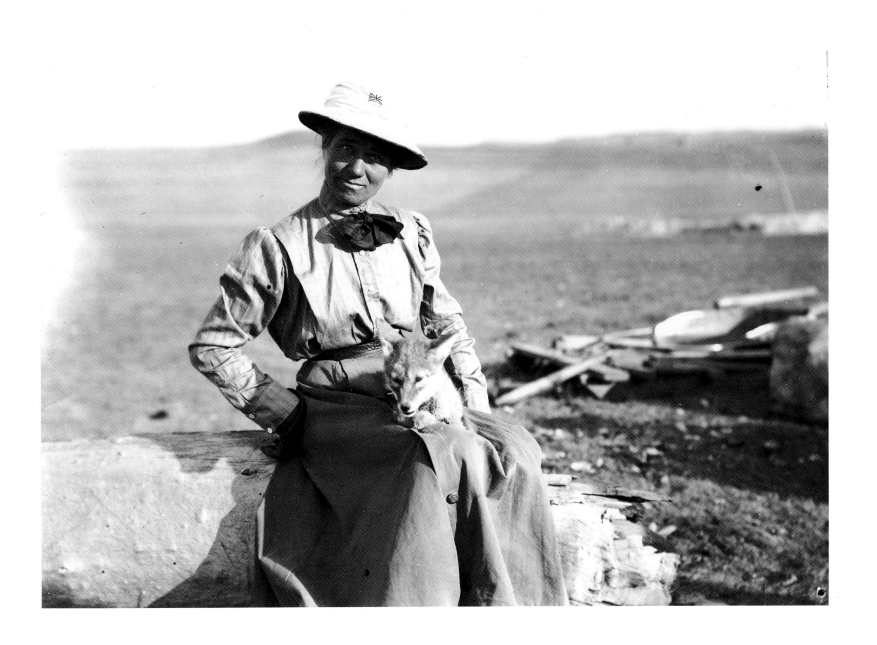

With a small British flag pinned to her pith helmet, Evelyn sits with a coyote on her lap. Proud of her British background, she nonetheless became thoroughly American in outlook, cherishing the independence of her rugged pioneer life in Montana. In her article about Evelyn entitled "The Lady of the Springs," Marguerite Charter said: "Never was she described as English or American by her admirers. They just called her a Montanan . . . for she is the very embodiment of the spirit of that great state."

Bibliography

BIBLIOGRAPHICAL NOTE

In writing her diaries, Evelyn Cameron often omitted punctuation marks and used abbreviated words in order to save space on her small diary pages and to speed the writing process. (For example, her diaries make frequent references to "E."—Evelyn's shorthand for "Ewen.") In presenting diary extracts in this book, I have inserted some punctuation and filled out some of her abbreviations for the sake of clarity. I have not corrected Evelyn's occasional lapses from proper grammar or her erratic spelling, except in a few places where her meaning would have been unclear to the reader.

The text is based primarily on Evelyn's original diaries, letters, articles, albums, scrapbooks, and other documents. I have also made extensive use of Ewen's published articles and unpublished manuscripts, as well as his detailed field notes. For background material on the Camerons and the homesteading era, I used the local newspaper, *The Terry Tribune*, which began publication in 1907, and I conducted numerous interviews with Terry's citizens, including Janet Williams and Ivy Brubaker. I also used information from an interview held with Jesse Trafton that was part of the "Montanans at Work Project" sponsored by the Montana Historical Society.

Abbot, E. C. ("Teddy Blue"), and Helena Huntington Smith, *We Pointed Them North: Recollections of a Cowpuncher.* Norman: University of Oklahoma Press, 1955.

Abdy, Jane, and Charlotte Gere, *The Souls.* London: Sidgwick & Jackson, 1984.

Alderson, Nannie T., and Helena Huntington Smith, *A Bride Goes West.* Lincoln: University of Nebraska Press, 1942.

Alwin, John A., *Eastern Montana: A Portrait of the Land and Its People.* Helena: Montana Magazine, 1982.

Aslet, Clive, *The Last Country Houses.* New Haven: Yale University Press, 1982.

Athearn, Robert G., *Westward the Briton.* New York: Charles Scribner's Sons, 1953.

Atherton, Lewis, *The Cattle Kings.* Bloomington: Indiana University Press, 1961.

Baedeker, Karl, *Great Britain: Handbook for Travellers*. Leipzig: Karl Baedeker, 1910.

Battersea, Constance, *Reminiscences*. London: Macmillan & Company, 1922.

Blodgett, Harriet, *Centuries of Female Days: Englishwomen's Private Diaries*. New Brunswick: Rutgers University Press, 1988.

Bowen, Ezra, "Fresh Buffalo a la Mode," *Sports Illustrated*, November 13, 1967.

Brisbin, General James S., *The Beef Bonanza; or, How to Get Rich on the Plains*. Norman: University of Oklahoma Press, 1959 (Reprint).

Brown, Mark H., *The Plainsmen of the Yellowstone: A History of the Yellowstone Basin*. Lincoln: University of Nebraska Press, 1961.

Brown, Mark H., and W. R. Felton, *Before Barbed Wire: L. A. Huffman, Photographer on Horseback*. New York: Henry Holt and Company, 1956.

———, *The Frontier Years*. New York: Henry Holt and Company, 1955.

Cameron, Evelyn J., "The 'Cowgirl' in Montana," *Country Life*, June 6, 1914.

———, "The Prong-horn as a Pet," *Country Life*, January 16, 1909.

———, "Sheep in Montana," *The Breeder's Gazette*, vol. xlvii, no. 13, March 29, 1905.

Cameron, Ewen S., "The Birds of Custer and Dawson Counties, Montana," *The Auk*, vol. xxiv, no. 3, July 1907.

———, "The Birds of Custer and Dawson Counties, Montana," *The Auk*, vol. xxiv, no. 4, October 1907.

———, "The Birds of Custer and Dawson Counties, Montana," *The Auk*, vol. xxv, no. 1, January 1908.

———, "Changes of Plumage in Buteo Swainsoni," *The Auk*, vol. xxv, no. 4, October 1908.

———, "The Ferruginous Rough-Leg, *Archibuteo Ferrugineus* in Montana," *The Auk*, vol. xxxi, no. 2, April 1914.

———, "Nesting of the Golden Eagle in Montana," *The Auk*, vol. xxii, no. 2, April 1905.

———, "Nesting of the Great Blue Heron in Montana," *The Auk*, vol. xxiii, no. 3, July 1906.

———, "Notes on Swainson's Hawk (Buteo Swainsoni) in Montana," *The Auk*, vol. xxx, no. 2, April 1913.

———, "Notes on Swainson's Hawk (Buteo Swainsoni) in Montana," *The Auk*, vol. xxx, no. 3, July 1913.

———, "Observations on the Golden Eagle in Montana," *The Auk*, vol. xxv, no. 3, July 1908.

———, "Sheep and Coyotes in Montana," unpublished manuscript.

———, "Sport in the Badlands of Montana U.S.A.," unpublished manuscript.

———, "The Wolf in Montana," unpublished manuscript.

Charter, Marguerite Remington, "Evelyn Cameron, The Lady of the Springs," unpublished manuscript.

Clarke, Norm, *Tracing Terry Trails*. Terry: Terry Country Centennial Celebration, 1982.

Coburn, Walt, *Pioneer Cattleman in Montana: The Story of the Circle C Ranch*. Norman: University of Oklahoma Press, 1968.

Davis, Richard, *The English Rothschilds*. London: Collins, 1983.

"Distinguished Devotees of the Camera," *Windsor Magazine*, September 1900.

Drybrough, T. B., *Polo*. London: Vinton & Company, Ltd., 1898.

Duke, Cordia Sloan, and Joe B. Frantz, *6,000 Miles of Fence*. Austin: University of Texas Press, 1961.

Elmhirst, Captain Edward Pennell, *Fox-Hound, Forest, and Prairie*. London: George Routledge and Sons, 1892.

"Mrs. Evelyn Cameron, Pioneer of Eastern Montana, Passed Away in Hospital at Glendive," *The Terry Tribune*, January 4, 1929.

Farnsworth, Martha, *Plains Woman: The Diary of Martha Farnsworth, 1882–1922*, edited by Marlene Springer and

Haskell Springer. Bloomington: Indiana University Press, 1986.

Farr, William E., and K. Ross Toole, *Montana: Images of the Past*. Boulder: Pruett Publishing Co., 1978.

Fischer, Christiane, editor, *Let Them Speak for Themselves: Women in the American West, 1849–1900*. New York: E.P. Dutton, 1978.

Guggisberg, C.A.W., *Early Wildlife Photographers*. New York: Taplinger Publishing Company, 1977.

Jensen, Joan M., and Darlis A. Miller, "The Gentle Tamers Revisited: New Approaches to the History of Women in the American West," *Pacific Historical Review*, vol. 49, no. 2, May 1980.

Lambert, Angela, *Unquiet Souls*. New York: Harper & Row, 1984.

Luchetti, Cathy, and Carol Olwell, *Women of the West*. St. George, Utah: Antelope Island Press, 1982.

McElrath, Frances, *The Rustler*. New York: Funk & Wagnalls, 1902.

McElrath, Thomson P., *The Yellowstone Valley: A Hand-Book for Tourists and Settlers*. St. Paul, Minnesota: The Pioneer Press, 1880.

Malone, Michael P., and Richard B. Roeder, *Montana: A History of Two Centuries*. Seattle: University of Washington Press, 1976.

Middleton, Dorothy, *Victorian Lady Travellers*. Chicago: Academy Chicago, 1982.

The Montana Historical Society, *Not in Precious Metals Alone: A Manuscript History of Montana*. Helena: Montana Historical Society Press, 1976.

Myres, Sandra L., *Westering Women and the Frontier Experience, 1800–1915*. Albuquerque: University of New Mexico Press, 1982.

Newhall, Beaumont, *The History of Photography*. New York: The Museum of Modern Art, 1982.

"Prairie County," WPA Files. Special Collections of the Montana State University Libraries.

Prairie County Historical Society, *Wheels Across Montana's Prairie*. Terry: Prairie County Historical Society, 1974.

Proctor, Henry, "Ephraim and Manasseh," *The National Message*, vol. 1, January 14, 1922.

Randall, Isabelle, *A Lady's Ranche Life in Montana*. London: W. H. Allen & Co., 1887.

Reiter, Joan Swallow, and the Editors of Time-Life Books, *The Women*. Alexandria, Virginia: Time-Life Books, 1978.

Riley, Glenda, "'Not Gainfully Employed': Women on the Iowa Frontier, 1833–1870," *Pacific Historical Review*, vol. 49, no. 2, May 1980.

Robinson, Elwyn B., *History of North Dakota*. Lincoln: University of Nebraska Press, 1966.

Roosevelt, Theodore, *Ranch Life in the Far West*. Flagstaff, Arizona: Northland Press, 1968 (Reprint).

———, *Stories of the Great West*, edited by Marquis E. Shattuck. New York: Appleton-Century Company, 1940.

Russell, Jim, *Bob Fudge: Texas Trail Driver Montana—Wyoming Cowboy, 1862–1933*. Denver: Big Mountain Press, 1962.

Schlissel, Lillian, *Women's Diaries of the Westward Journey*. New York: Schocken Books, 1982.

Snow, Richard, *Coney Island: A Postcard Journey to the City of Fire*. New York: Brightwaters Press, 1984.

Stansell, Christine, "Women on the Great Plains, 1865–1890," *Women's Studies*, vol. 4, 1976.

Stewart, Elinore Pruitt, *Letters of a Woman Homesteader*. Boston: Houghton Mifflin, 1982 (Reprint).

Stith, Beryl, *Terry Does Exist*. Terry: Reprinted on the Occasion of the Terry Country Centennial, 1982.

Stratton, Joanna L., *Pioneer Women: Voices from the Kansas Frontier*. New York: Simon and Schuster, 1981.

Tanner, Ogden, and the Editors of Time-Life Books, *The Ranchers*. Alexandria, Virginia: Time-Life Books, 1977.

Terres, John K., *The Audubon Society Encyclopedia of North American Birds*. New York: Alfred A. Knopf, 1987.

Webb, Walter Prescott, *The Great Plains*. New York: Ginn & Co., 1931.

Weinstein, Robert A., and Larry Booth, *Collection, Use, and Care of Historical Photographs*. Nashville: American Association for State and Local History, 1977.

Welling, William, *Photography in America: The Formative Years, 1839–1900*. New York: Thomas Y. Crowell Company, 1978.

"A Woman's Big Game Hunting," New York *Sun*, November 4, 1906.

Acknowledgments

The photographs and diaries of Evelyn Cameron might still be moldering in a Montana basement if not for the generous support of the National Endowment for the Humanities.

Many people have been instrumental in the creation of this book, but none has been as important—or as memorable—as Janet Williams. At age ninety-five she invited me to her home and shared her memories and treasured collection with me. Getting to know her was one of the unexpected pleasures of undertaking this project. Another was meeting her friend and neighbor, John Latimer. Not only did he help in the early printing of some Cameron negatives, but he also introduced me to the wonders of the Montana badlands.

My thanks go to Janet Williams's niece, Janet McCulloch, who helped convince her aunt that a book should be done, and who has waited patiently ever since. Other members of the Williams family were also very helpful, including the late Margaret Deppe, her husband, Bill, and daughter, Marilyn.

The citizens of Terry, Montana, provided invaluable assistance. Ivy Brubaker was my all-round consultant and expert on the local families. Paul Renn and the members of the Prairie County Historical Society were also important contributors.

Other Montana institutions and people I would like to thank include the Montana Historical Society and its Photograph Curator, Lory Morrow; Steve Jackson, Curator of Art and Photography at the Museum of the Rockies, Montana State University; Minnie Paugh, formerly head of Special Collections at the Montana State University Libraries; the Miles City Public Library and its research staff, especially Linda Hieb and Nancy Luther.

Andrew Bush and John Keenen made magnificent prints from the Cameron negatives under very difficult conditions. Edward Novak helped in the transcription of the diaries. Nicholas Bennett carefully tracked down the Cameron and Flower family genealogies in England. Lyn Stallworth lent advice on the pioneer culinary arts. Moira Lucey helped in the original conception of the book. Jane Colihan assisted me in sorting through the photographs, and offered on-the-spot translations of diary extracts written in French. George Gilbert, editor of *Photographica*, helped to clarify technical de-

ACKNOWLEDGMENTS

tails about Evelyn's cameras and photographic techniques.

I am very grateful to my agent, Helen Merrill, and to my editors at Knopf, Victoria Wilson and Corona Machemer. Thanks must also go to their able assistants, Antoinette White and Charles Hargreaves.

On a personal note I would like to thank Jim Kalett for his early advice, and Peggy and Jimmy Thorne for their services, which went way beyond the call of duty. Finally I want to thank my husband and son, who provided the inspiration, love, and encouragement that helped me pursue—and finish—this project.

D.L.

Index

JOHN SMART PHOTO

About the Author

DONNA M. LUCEY, who discovered these previously unknown photographs in the care of Janet Williams of Terry, Montana, spent seven years uncovering the life and work of Evelyn Cameron. Lucey received two grants from the National Endowment for the Humani-ties for her work on *Photographing Montana*. A freelance writer and photo editor, Lucey has worked for Time-Life Books and National Geographic Books. She and her husband, author Henry Wiencek, live in Charlottesville, Virginia, with their son.

A Note on the Type

This book was set in a typeface called Baskerville, a modern recutting of a type originally designed by John Baskerville (1706–1775). Baskerville, a writing master in Birmingham, England, began experimenting in about 1750 with type design and punch cutting. His first book, published in 1757 and set throughout in his new types, was a Virgil in royal quarto. It was followed by other famous editions from his press. Baskerville's types, which are distinctive and elegant in design, were a forerunner of what we know today as the "modern" group of typefaces.

Composed by The Sarabande Press, New York, New York
Duotone separations by CCS/Clearwater, Clearwater, Florida
Printed and bound by Cayfosa, Barcelona, Spain
Designed by Peter A. Andersen